DEMOCRACY ON THE WALL

GLOBAL LATIN/O AMERICAS

FREDERICK LUIS ALDAMA AND LOURDES TORRES, SERIES EDITORS

DEMOCRACY ON THE WALL

STREET ART OF THE POST-DICTATORSHIP ERA IN CHILE

GUISELA LATORRE

THE OHIO STATE UNIVERSITY PRESS

COLUMBUS

CONTENTS

List of Illustrations ix

Acknowledgments xiii

INTRODUCTION Street Art, Visual Democracy, and the Chilean City 1

CHAPTER 1 The Return from Clandestine Anonymity: Muralist Brigades, Revamped and Renewed 28

CHAPTER 2 Open-Sky Museums and the Decolonization of Urban Space 64

CHAPTER 3 Tagging the Chilean City: Graffiti as Individualized and Collective Praxis 101

CHAPTER 4 Public Interventions and Gender Disruptions: Graffiteras' Urban Transformations 132

CONCLUSION Transnational Incursions in Chilean Street Art: Globalizing the Local and Localizing the Global 171

Bibliography 215

Index 225

ILLUSTRATIONS

FIGURE 0.1 "Art is on the streets" (2015), entrance of the Museum of Visual Arts 2

FIGURE 0.2 David Alfaro Siqueiros, *Death to the Invader* (1941–42), mural 15

FIGURE 1.1 Mono González working on a mural as a trazador 37

FIGURE 1.2 Children working on a mural as rellenadores 37

FIGURE 1.3 Colectivo Brigada Ramona Parra, Untitled (2012), mural 41

FIGURE 1.4 Brigada Ramona Parra, Untitled (2017), mural 47

FIGURE 1.5 Brigada Ramona Parra painting with children (2017) 48

FIGURE 1.6 Brigada Ramona Parra, lunch with local community (2017) 50

FIGURE 1.7 Brigada Ramona Parra with Mapuche *machi* (2017) 51

FIGURE 1.8 Brigada Ramona Parra, planting araucaria tree (2017) 52

FIGURE 1.9 Brigada Chacón, *Ley de Pesca . . . Otro regalo pa' los empresarios* (2012), papelógrafo 60

FIGURE 1.10 Ricardo Rodríguez working on *¿Hasta cuándo la prensa y fiscalía protegen a Piñera?* (2017), papelógrafo 62

FIGURE 2.1 Jorge Peña y Lillo, Basti, Gesak, Hozeh, Pobre Pablo, and Pato
 Albornoz, *Los Prisioneros* (2010), mural 74

FIGURE 2.2 12 Brillos Crew, *Homenaje a los trabajadores que luchan* (2010),
 mural 77

FIGURE 2.2A 12 Brillos Crew, *Homenaje a los trabajadores que luchan,* detail
 (2010), mural 79

FIGURE 2.2B 12 Brillos Crew, *Homenaje a los trabajadores que luchan,* detail
 (2010), mural 79

FIGURE 2.3 Aislap, *Meli Wuayra* (2010), mural 81

FIGURE 2.4 Mono González and Julien "Seth" Malland, *Integración* (2011), mural 87

FIGURE 2.5 Alfredo Guillermo Fernández, Seba, El Año, Pati, Tikai, and
 Plek, *La Pincoya* (2014), mural 93

FIGURE 2.6 Con Nuestras Manos, *En Memoria a Carlos Fariña* (2013), mural 94

FIGURE 2.7 Colectivo Amancay, Nestha, Seba, Plek, DP, Amaranta, Jae,
 Pecko, Cagde, Defos, Injusticia, Jano, Degra, Vidaingravita,
 Causa, Sam, Rouse, Fabi, Richy, Sofrenia, Naturaleza, Boa, Yono,
 and PP, *Intervencionismo Yanki en Latinoamerica* (2012), mural 97

FIGURE 3.1 Anti-Graffiti Banner, the Municipality of Santiago 104

FIGURE 3.2 Anti-Graffiti and Vandalism Banner, the Municipality of Santiago 105

FIGURE 3.3 12 Brillos Crew, Untitled (2011), graffiti mural 114

FIGURE 3.4 Fisek (2015), graffiti throwup in process 121

FIGURE 3.5 Fisek (2015), graffiti throwup in process 121

FIGURE 3.6 Fisek (2015), graffiti throwup in process 122

FIGURE 3.7 Fisek (2015), finished graffiti throwup 123

FIGURE 3.8 Las Crazis and Nocturnas (Tikka and Pan), Untitled (2010),
 graffiti mural 127

FIGURE 3.8A Las Crazis and Nocturnas (Tikka and Pan), Untitled, detail
 (2010), graffiti mural 129

FIGURE 4.1 Dana, Untitled (n.d.), graffiti 150

FIGURE 4.2 Dana, Untitled, detail (2009), graffiti 152

FIGURE 4.3 Dana, Untitled, street view (2009), graffiti 153

FIGURE 4.4 Alterna, *Niña* (c. 2010), graffiti mural 155

FIGURE 4.5 Alterna, *Devuélvenos la Imaginación* (2011), graffiti mural 156

FIGURE 4.6 Alterna, *Adopta un Gato* (2010), graffiti mural 158

FIGURE 4.7 Abusa Crew, *Espíritu de Mujer* (2014), graffiti mural 159

FIGURE 4.8 Anis, *Puta 2* (c. 2010), graffiti mural 162

FIGURE 4.9 Gigi (Turronas Crew), Untitled (2011), graffiti mural 164

FIGURE 4.10 Gigi (Turronas Crew), *Luisa Rayando a Zade* (2011), graffiti mural 166

FIGURE 4.11 Gigi (Turronas Crew), *Luisa Playera* (2013), graffiti mural 167

FIGURE 4.12 Gigi (Turronas Crew), *Luisa del Bosque* (2012), graffiti mural 168

FIGURE 5.1 Inti, Untitled ("Ekeko") (2012), graffiti mural 177

FIGURE 5.2 Inti, Untitled ("Ekeka") (2012), graffiti mural 177

FIGURE 5.3 Inti, *Don Quijote de la MaRcha* (2014), graffiti mural 186

FIGURE 5.4 Roa, *Horse* (2011), graffiti mural 191

FIGURE 5.5 Mono González, Feminist Print Workshop 196

FIGURE 5.6 Ohio State University student, Feminist Print Workshop 197

FIGURE 5.7 Jenn Eidemiller, Feminist Print Workshop 198

FIGURE 5.8 Jessica Lieberman, Feminist Print Workshop 199

FIGURE 5.9 Mono González, Maria DiFranco, and Katerina Harris working
 on the Transit Arts mural 201

FIGURE 5.10 Maria DiFranco, Federico Cuatlacuatl, Katerina Harris, and
 others working on the Transit Arts mural 202

FIGURE 5.11 Mono González and Katerina Harris holding up completed
 Transit Arts mural 203

FIGURE 5.12 Mono González and others, Transit Arts mural (2015), acrylic
 on canvas 204

FIGURE 5.13 Gigi (Marjorie Peñailillo), *Formación* (2016), digital sketch 208

FIGURE 5.14 Tess Pugsley and Guisela Latorre, outlines for *Formación* (2016) 210

FIGURE 5.15 Lynaya Elliott, Jackie Stotlar, and Tess Pugsley working on
Formación (2016) 211

FIGURE 5.16 Gigi (Marjorie Peñailillo), Lynaya Elliott, Guisela Latorre, Tess
Pugsley, and Jackie Stotlar, *Formación* (2016), graffiti mural 212

ACKNOWLEDGMENTS

THE WORD *acknowledgment* can be defined as an expression of gratitude and appreciation. For me, it is also a public recognition of the interconnectedness and interdependence between people, an acknowledgment that our achievements are never solely our own and that we are privileged and blessed when we have a strong system of support. This book was the result of hard work and dedication on my part, to be sure, but the encouragement and loving guidance of family, friends, artists, and colleagues injected the necessary energy into everything I did. I would like to recognize here the individuals and organizations that made *Democracy on the Wall* a possibility. Thus, I acknowledge that the community of support that I was fortunate enough to have was a privilege that not all scholars and researchers enjoy.

Having the opportunity to speak and interact with Chilean street artists was simply exhilarating. They continually inspired me with their boundless creativity, social commitments, and incredible generosity. I was humbled and honored by their support of my research. In large part, Democracy on the Wall was a project intended to give them overdue recognition, a recognition that was and continues to be inadequate and even nonexistent in Chile and abroad. Among the numerous visionary talents that I encountered in the course of my research was graffiti artist, educator, and creative guide Gigi (Marjorie Peñailillo). Gigi met with me countless times and was a tireless advocate of my work. Her positive energy, inspiring artwork, and unique per-

spectives influenced the intellectual direction of my book. In the process, Gigi became a dear friend, collaborator, and colleague who has also worked with me on projects outside of this book.

Legendary muralist and printmaker Alejandro "Mono" González showed me nothing but kindness and generosity, in spite of his busy schedule and his renowned reputation as an artist. Aside from his amazing artistic trajectory that dates back to the 1960s, his knowledge of Chilean history, politics, and culture was astounding. His quiet, unassuming, and humble demeanor often hid a sharp intellect and a ferocious artistic talent. El Mono ("the monkey")—as he is affectionally known among his peers, friends, and loved ones—was and continues to be an artist who transcends generations and insists upon bridging the gap between the muralists of the '60s and '70s and the younger graffiti artists who came of age at the turn of the millennium. Speaking with him and seeing him in action—climbing scaffolding and laying out his characteristic *trazados* (outlines) on city walls—helped me form the foundations of this book.

Aside from Gigi, I had the fortune of conversing with numerous other women artists who challenged Chilean gender scripts and ventured into the streets to tag and intervene in male-dominated spaces. The members of the Abusa Crew, Anis and Wend, shared with me their group's unique history and the important bond they had with one another as collaborating artists. Five members of Las Crazis Crew–Cines, Dana, Naska, Bisy, and Shape—had an exciting discussion with me and with each other about what it meant to be in an all-girl graffiti group that valued both individual and collective action. Alterna and Luna Lee, two other *graffiteras,* spoke with great passion about the ideals and aspirations that animate their street tagging. The testimonies and histories that all these women related to me gave me crucial insights into what feminist street art looks like.

The history of Chilean graffiti was a difficult one to document in *Democracy on the Wall,* as written sources on the subject were scant, fragmented, and incomplete. I was fortunate then to be able to speak to two *graffiteros* who possessed a profound knowledge of that history. Fisek described to me the early years of the graffiti movement in Santiago. His accounts combined exuberant tales of his tagging excursions as an adolescent in the 1990s and his keen observation of the various developments and phases that have occurred in the Chilean street art scene since then. Fisek also invited me to watch him paint a derelict wall in Santiago, one that he adorned with a colorful wildstyle tag of his name. Hozeh, member of the well-known 12 Brillos Crew, was able to tell me all about the intersection between graffiti and activism in Chile, as his praxis as a street artist could not be disentangled from his political alli-

ances with Mapuche communities. Both Fisek and Hozeh provided me with a wealth of historical gems that I could not have found elsewhere.

Though the history of the Chilean muralist brigades has been more thoroughly documented in primary and secondary sources, many finer details and nuanced dynamics have been left out of the historical record. Certainly, Mono González was an important source for that information, but I should also recognize Ricardo Rodríguez, member of the Brigada Chacón (BC), who gave me his thorough, insightful, and at times even brutally honest recollection of the complex and contentious history of the brigades and their connection to political parties. Ricardo did not like to talk publicly about his work with the BC because it took away from the anonymity and collectivity of the group. For this reason, I was particularly grateful that he took the time to meet with me in his studio. I was also quite impressed with his ability to talk to me while, at the same time, working on a BC *papelógrafo,* the long paper banners that are characteristic of this brigade.

During my site visits to Chile, I became aware of the important coordinating and administrative work related to some street art initiatives. Thus, speaking with community leaders and project coordinators became the means by which I could better understand the larger impetus behind certain mural and graffiti sites. Community organizers Roberto Hernández, David Villarroel, and José Bustos offered me instrumental information about the creative and activist visions that led to the emergence of astounding street art sites in Santiago. Moreover, Hernández, Villaroel and Bustos all spoke eloquently of the powerful interactions that happened between local communities and artists in these mural and graffiti locales.

I cannot stress enough the incredible support and relentless encouragement I received back in the United States and in my academic home, the Department of Women's, Gender, and Sexuality Studies (WGSS) at The Ohio State University (Columbus, Ohio). My colleagues there were constant champions of my research, having taught me much about what it means to be a loving colleague within the competitive and at times cutthroat world of academia. I would like to highlight in particular the caring mentorship and friendship that professors Jill Bystydzienski, Shannon Winnubst, and Lynn Itagaki provided me. Both Jill and Shannon served as department chairs while I was doing the writing and research for *Democracy on the Wall.* They both guided me through the process of securing institutional support for my work and often offered me a sympathetic ear in times of adversity. Lynn was my reliable writing partner and dear friend who sat with me in numerous coffee houses in the Columbus area to finish our work together. Much of the writing in this book was produced during those coffee house sessions!

It is relevant to mention here that I also consider the administrative staff in WGSS to be important colleagues in my department. They too played a significant role in the production of *Democracy on the Wall*. Aside from guiding me through the baroque university bureaucracy, Lynaya Elliot, Tess Pugsley, and Jackie Stotlar worked tirelessly to bring Gigi to the Ohio State campus so that we could paint our collaborative graffiti mural *Formación* (featured in this book's conclusion). Needless to say, Lynaya, Tess, and Jackie went well beyond the expectations of administrative personnel on a college campus.

My onsite research in Chile, of course, would not have been possible without the generous financial support of various units and entities at Ohio State. Grants from the Research Enhancement and Grant-In-Aid programs coming out of the College of Arts and Sciences were instrumental in defraying the costs of travel, photocopying, photography, and other research-related expenses. In addition, I received funding from the Coca-Cola Critical Difference for Women Grant, which helped me tremendously with chapter 4, where I focused on the women street artists of Chile. My home department of WGSS also stepped up whenever I needed research funds to complete my work on *Democracy on the Wall*. In addition, they secured a research assistant for me. Kristen Kolenz, a PhD student and emergent scholar herself, painstakingly transcribed some of the oral history interviews I conducted.

Credit is also due to the editors and staff of the Ohio State University Press who believed in my project from the very start and treated me with the utmost respect and professionalism. Editor-in-Chief Kristen Elias Rowley always showed great enthusiasm for *Democracy on the Wall* while also skillfully guiding me through the publication process. Professor Frederick Aldama, editor of the press's Global Latin/o Americas series, gave me crucial advice during the latter stages of my manuscript preparation. Moreover, I've been incredibly fortunate to count Frederick among my long-time mentors. I would also be remiss if didn't acknowledge the hard work and thoughtful feedback of the external readers who read my manuscript with impeccable attention to detail and an eye toward publication.

As always and ever, my family was with me every step of the way. My dear daughter Judith—who blossomed into an intelligent and compassionate teenager with a fierce feminist consciousness—was always by my side during my travels to Chile. She also witnessed and greatly appreciated the beauty of the Chilean street art scene and, in the process, became quite a beloved figure among many of the artists I met. I could not imagine doing this book without her. Judith's unconditional love and affection made it all possible. She is and will always be the most important person in my life.

My parents, Guillermo Latorre and Teresa Huerta, were my staunch allies too. When they found out I was writing a book about Chile, they were thrilled and lent me their full support without question. Aside from all the affective labor that parents often do for their children, they provided me with their own insights into Chilean politics, history, and letters, ideas that were helpful for the arguments in my book. As faculty emeriti from the University of Southern Indiana, they understood what life in the academy is like and that understanding has been a tremendous blessing. However, their enthusiasm for *Democracy on the Wall* was unlike that of any other project I had ever undertaken. My mother even took on the challenge of translating the entire book to Spanish, with the plan to disseminate the text among Chilean and Latin American audiences. It was deeply gratifying and encouraging to see her so involved in my project. Simultaneously, my siblings Carolina, Miguel, and Yiyo further bolstered this encouragement by standing by me in moments of doubt and uncertainty.

As is the case with other diasporic subjects, my familial bonds expand beyond national boundaries. During my trips to Chile, my extended family in Santiago always offered me their warm hospitality. My aunt Guadalupe Huerta took great care of Judith and I, always picking us up from the airport, cooking delicious homemade meals, and keeping us great company. My cousins Catalina, Pablo, and Miguel Marchese were also immensely welcoming and thoughtful with us. My memories of working on *Democracy on the Wall* are intertwined with my recollections of our wonderful times spent together.

In sum, these acknowledgments should serve as a testament that this book was not merely the result of my personal achievements. Indeed, this text was the product of the multiple collective and communal engagements that enabled me to tell the powerful history of Chilean graffiti and muralism.

Street Art, Visual Democracy, and the Chilean City

CHILEAN STREET ART AND SOCIAL JUSTICE

In the critically acclaimed Chilean film *Machuca* (2004), the two main characters, preteen boys Pedro Machuca and Gonzalo Infante, forge an unlikely friendship across social class and race during the days that lead up to the 1973 military coup in Chile. A turning point in their friendship happens when upper-class Gonzalo visits Pedro's home after school, which forces the former to cross the socially demarcated urban boundary between his well-to-do neighborhood and Pedro's precarious house in his impoverished *población* (working-class neighborhood). The border between the two is visually signaled in the film's narrative by two important urban signposts in Santiago, namely the Mapocho River and a mural painted by the arts collective Brigada Ramona Parra (BRP). Aside from functioning as a boundary marker, the BRP mural also signals the entrance into a more democratic and less socially constrained space than the one inhabited by Gonzalo's dysfunctional and highly prejudiced upper-class family. However, near the end of the film and in the wake of the 1973 military coup, the camera pans across the same wall that is now whitewashed while Pedro's población lies in ruins as the result of the violent raids by the Chilean military. The message is clear here: the presence of the street mural embodies the hope for social justice and its subsequent erasure forebodingly predicts the coming of sixteen years of repressive rule.

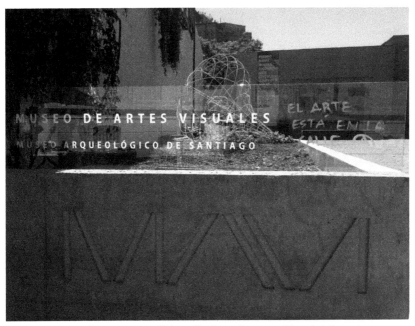

FIGURE 0.1. Anonymous graffiti tag, "Art is on the streets" (2015) at the entrance of the Museum of Visual Arts, Santiago, Chile. Photograph: Guisela Latorre.

The film thus underscores how murals and street art in Chile are coded with meanings related to egalitarian social relations and liberated urban spaces.

I was reminded of the connection between street art and democratic ideals established in *Machuca* when, on December 26, 2015, I walked by the Museum of Visual Arts in Santiago's Lastarria neighborhood and saw that someone had scribbled the words "El arte está en la calle" [Art is on the streets] next to the museum's name (see figure 0.1). This simple tag indicated to me a kind of impromptu protest of the museum's role in establishing hierarchies of artistic production while also operating as a public proclamation of Chile's rich and dynamic history of radical street art. What the film and this anonymous tag ultimately signified for me was how graffiti and muralism had become almost synonymous to liberatory visions of public space in Chile, a perspective certainly not shared in other parts of the world.

It is this convergence of street art and social justice embedded in muralism and graffiti in Chile that is the central theme of *Democracy on the Wall*, which seeks to critically document the history of street art in the country during the post-dictatorship era (1990–present.) This era in Chile has seen an explosion of public art expressions. Writing in 1990, Chilean artist Alberto Diaz Parra spoke with great hope, anticipation, and expectation about what

was beginning to happen with public art: "In the marginal walls of the Chilean poblaciones, the street mural—with more strength than ever—will embrace the dreams, grievances, sentiments, cries, poetry, slogans [and] homages of the poor."[1] Though Diaz Parra was using a highly romanticized and utopian language here, he was accurate in predicting that city streets would become quintessential sites for artists to communicate alternative knowledges and new aesthetic discourses in spaces otherwise saturated by mass media messages promoted by corporate and government interests. Their participation in street art has been facilitated by the loosening of restrictions over freedom of expression brought about not only by the advent of democratic rule in 1990 but also by the feelings of discontent toward the unfulfilled promises of the post-dictatorship era. Mistrustful of hegemonic discourses promoted by government and corporate media, the artists I discuss in this book utilize graffiti and muralism as an alternative means of public communication, one that does not serve capitalist or nationalist interests.

Democracy on the Wall extends arguments I first introduced in my book *Walls of Empowerment: Indigenist Chicana/o Murals of California* (2008), where I championed the democratic and decolonial potential of street art. The Chicana/o artists that I featured in that text had taken their creative expression into the public sphere as a political and cultural response to the systemic exclusions they experienced as people of color in the United States. Their challenges to the US nation-state were not unlike those that Chilean street artists would undertake after the end of the dictatorship and beyond. Both groups of artists also understood the way a mural or graffiti piece could radically transform urban sites where power is so often contested. Writing *Democracy on the Wall* was thus the logical next step after *Walls of Empowerment* because I knew that street art would retain its radical potential across different locales in the Americas. The power of potentiality within these public expressions, however, is more fully explored in *Democracy on the Wall*. Through the public format of murals and graffiti, artists can investigate the multiple possibilities for social justice, ones that may or may not have practical applications. The space of potentiality is also one of complete openness where the dynamic character of creativity can be unleashed. How then can muralists and graffiti artists promote potentiality through their work? Their direct and indirect demands and expectations of democracy in Chile can be positioned within the space of potentiality where the vision of an inclusive society is constantly imagined and reimagined.

1. Comité de Defensa de la Cultura Chilena, *Muralismo Wandmalerei Peinture Murale Mural Painting Pittura Murale*, 12.

THE MEANINGS OF DEMOCRACY

A guiding argument throughout my text will be that Chilean mural and graffiti artists are enacting what I call a visual democracy, a form of artistic praxis that seeks to create alternative images and messages to those produced and disseminated by institutions of power. Practitioners of visual democracy aspire to communicate ideas and expose realities that the state and other social institutions fail to address. Such practices are a symptom of broader transnational activist engagements that, according to cultural theorists Kit Dobson and Aine McGlynn, are connected "at times directly and at other times more abstractly with cultural production."[2] These artists or cultural producers are keenly aware of Latin America's colonial legacy and deeply flawed democratic processes, circumstances that make it difficult and even impossible to create legitimate inclusion and social equality. In other words, these artists understand that Latin American democracies are oftentimes highly undemocratic political systems that are based on discriminatory and hierarchical ideologies. The insistence on using the visual as a means of promoting a more democratized system of communication stems from the power of images as movers and shakers of human behavior. Furthermore, these practitioners place much importance on visual display because of the ways in which governments and the corporate sector also use the very tools of the visual to legitimize their power.

Moreover, my references to democracy in relationship to muralism and graffiti imply not idealistic visions purporting that street art can single-handedly usher in more democratic and egalitarian social relations. Instead, the word *democracy* in this text will refer to an ongoing process and project that seeks to improve social relations while at the same time trying to formulate an idea of what a productive democracy looks like. Jacques Derrida's concept of "democracy to come" is useful here. In his later work, the French theorist made important distinctions between the present enactments of democratic processes and their "potential futures," to borrow Paul Patton's words.[3] "Democracy to come" for Derrida was the always unfulfilled promise of a more egalitarian society, one that could be projected onto the future. The meaning of "democracy to come" for Derrida pointed to something "not yet arrived, not yet bygone . . . a meaning in waiting empty or vacant."[4] The concept, Patton tells us, "intervenes in or structures the actions of agents in the

2. Dobson and McGlynn, *Transnationalism, Activism, Art*, 4.
3. Patton, "Derrida, Politics and Democracy to Come," 771.
4. Derrida, *Rogues: Two Essays on Reason*, 8.

present by reference to a future event."[5] Though the promise of "democracy to come" is indeterminate and unclear, it requires social action in the present. The ungraspable nature of democracy that Derrida points out presents challenges for social justice projects with pragmatic goals. How can equality be accomplished if we don't really know what democracy really looks like? Yet I concur with Patton that this ambivalence can also open up spaces for possibility and even creativity. Another element in Derrida's conceptualization of "democracy to come" points to the role that pleasure and desire play in our quest for a more democratic society: "We must never dissociate the question of desire and pleasure when we treat the political, and specially the democratic, the question of conscious and unconscious pleasure, from the calculation and the incalculable to which desire and pleasure give rise."[6] The notion that desire is a phenomenon that is always unfulfilled certainly lends credence to the idea that democracy is also, by definition, in a constant state of formation. Thus, what we see with Chilean street artists is a constant search for a democratic ideal, often fueled by a magnanimous and at times utopic desire for a more egalitarian society. Most of the artists featured in this book were highly driven by the idea of continuous creation, that is, the notion that they needed to be incessantly painting walls and intervening in urban spaces with no end in sight, if that were possible. I contend that this desire is part and parcel of the "democracy to come" that is embedded in the practice of graffiti and muralism in Chile. Moreover, Derrida reminds us that "'democracy to come' does indeed translate or call for a militant and interminable political critique," calling it a "weapon aimed at the enemies of democracy" whereby individuals have the "right to criticize everything publicly, including the idea of democracy, its concept, and its name."[7] The mural and graffiti movement in Chile enacts "democracy to come" by not only engaging in a continual critique of state-sanctioned democratic reform but also by encouraging such thinking in its spectators.

Both the concepts of visual democracy and democracy to come provide discursive spaces for the possibility of a radical and progressive politics. These epistemologies stand in contrast to Tomás Moulian's notion of a "protected democracy," the kind of democracy that was put in place after the official end of the dictatorship. Moulian explains that a protected democracy is one where the interests of power elites are guarded and actively defended, regardless of any past actions of violence and repression. Moulian asserts that a protected democracy is in fact a semidemocracy where "the minority is not only pro-

5. Patton, "Derrida, Politics and Democracy to Come," 773.

6. Derrida, *Rogues: Two Essays on Reason*, 15.

7. Derrida, *Rogues: Two Essays on Reason*, 86–87.

tected against the abuses of the majority, but [it] is transformed into what is not, into majority power."[8] I will thus contend that the practices of visual democracy and democracy to come enacted by Chilean street artists decenter the hegemony of the protected democracy in the country, often exposing, questioning, and suspending the protected status of power elites and of the institutions of inequality.

POST-DICTATORSHIP

My use of the of the expression *post-dictatorship* throughout this text points not to some contrived understanding of Chilean history during the late twentieth and early twenty-first centuries. Augusto Pinochet's departure as head of the Chilean government in 1990 did not signal a clean break from oppression, inequality, and rigid social hierarchies in the country. In fact, he did not truly depart government after the transition to democracy. Chileans during the post-dictatorship era were haunted by his continued presence. Shortly after the presidential election of Patricio Aylwin in 1990, Pinochet would be sworn in as senator-for-life and serve as commander-in-chief of the armed forces until 1998. Writing six years after the transition to democracy, Tomás Moulian commented on the arrogant impunity with which Pinochet carried himself during those days: "He was not only forgiven, but he was also granted a kind of majesty: he speaks surrounded by pomp, the pomp of the republican and democratic kind. He speaks in the name of honor and loyalty because he has been allowed to perform the 'clean hands' simulacrum."[9]

The great majority of these systems of domination that Pinochet had instituted also remained in place. The step toward democracy in 1990 was marked by a "gradual and negotiated transition that prioritized political stability" and a "persistence of authoritarian enclaves in Chilean political life."[10] The extreme inequality fostered by the military regime had not changed during the first two decades of the twenty-first century:

According to a 2011 study by the Organization for Economic Co-operation and Development—the international economic development organization for developed countries, which Chile joined in 2010—Chile ranks as the

8. Moulian, *Chile actual: Anotomía de un mito,* 49.
9. Moulian, *Chile actual: Anotomía de un mito,* 33.
10. Quay Hutchison, Miller Klubock, Milanich, and Win, *The Chile Reader,* 521.

country with the most unequal distribution of income in the developed world, more unequal than Mexico or Turkey.[11]

Conservative and right-leaning politics that mirrored Pinochet's policies have continued to hold great power in Chile. Ricardo Rodríguez, member of the mural collective Brigada Chacón (featured in chapter 1 of this book), argued that the political right is pervasive in the country; it is not only found in conservative parties such as Renovación Nacional (National Renewal) and Unión Democrática Independiente (Independent Democratic Union); it can also emerge in left and center-left parties like Democracia Cristiana (Christian Democracy), Partido por la Democracia (Party for Democracy) and in certain sectors of the Partido Socialista (Socialist Party.)[12] So the word *post* in *post-dictatorship* refers not to a negation of the dictatorship, nor to any notions suggesting that all was well after Pinochet left. Rather, post-dictatorship speaks to the continuing cultural and institutional legacy of the military regime since 1990. I thus adhere to how feminist sociologist Nicole Forstenzer uses the term, insisting that the concept of a post-dictatorship reveals "the crucial role the dictatorship has played in the current political context's genesis."[13] The post-dictatorship era also refers to a historical moment when Chileans grapple with the failures of democracy and look beyond the state and beyond institutions of power to create possibilities for social change. For artists and cultural producers working during the post-dictatorship era, the end of blatant censorship and the opening of cultural spaces after Pinochet[14]—including those located on city streets—becomes an auspicious moment for them to express democracy's discontents. Graffiti and muralism thus emerge, in my opinion, as one of the quintessential art forms that define the ethos and angst of the post-dictatorship era.

A NOTE ON TERMINOLOGY

In *Democracy on the Wall,* I will adopt a distinct vocabulary to refer to street artists in Chile. In the country, the words *graffitero,* for men, and *graffitera,* for women, are part of the common lexicon among street artists. The plural *graffiteros* is often utilized to speak more broadly about more than one artist, thus

11. Quay Hutchison, Miller Klubock, Milanich, and Win, *The Chile Reader,* 523.
12. Interview with Ricardo Rodríguez and Mono González, March 25, 2017, Santiago, Chile.
13. Forstenzer, "Feminism and Gender Policies in Post-Dictatorship Chile (1990–2010)," 167.
14. Quay Hutchison, Miller Klubock, Milanich, and Win, *The Chile Reader,* 524.

reflecting standard Spanish usage which stipulates that one should use male nouns and pronouns to speak for all gender expressions. I found the "Chilenization" of graffiti-related words refreshing and productive, as they signaled to me how this art form has been adapted to the Chilean reality. However, the gendering of these terms was unsatisfactory and deeply problematic to me. In this book then, I will modify Chilean graffiti expressions to accommodate a language that is more gender inclusive. *Graffitera* will be used for female self-identified artists and *graffitero* will still refer to the individuals whose gender expression aligns with maleness. The word *graffiterx* though will denote street artists (singular or plural), irrespective of gender. During my field research on the Chilean street art scene, I did not encounter any individuals who openly identified as lesbian, gay, bisexual, transgender, queer, and/or gender non-conforming, which made it difficult to find more gender-sensitive wording. Because of this challenge, I am not presenting these terms and their usage as a definitive vocabulary on Chilean graffiti. Rather, I am providing my rationale for a terminology that is far from perfect but that can embrace the possibility of gender diversity among all graffiterx.

Terminology that refers to the different media and art forms featured in this book also requires clarification and explanation. While the scholarship on muralism in Latin American has more or less standardized the vocabulary it utilizes for artistic media and for categories of wall painting, the literature on graffiti across the globe is considerably less settled when it comes to naming different forms of creativity on walls and city streets. The fluidity of this vocabulary certainly reflects the mutability of graffiti practices themselves. For the purposes of this book, however, I will use the word *mural* to refer to works on walls that are created with brushes and with some form of acrylic and/or oil-based paint. *Mural* will also be loosely connected to works that may betray the figural or social realist styles of early twentieth-century muralism in Latin America. I will generally use the word *graffiti* to name the works by artists who utilize at least some measure of spray paint in their wall surface treatments. *Graffiti*, in most cases, will refer to work that possesses the more abstract and stylized forms of spray paint, which include wildstyle lettering, cartoon-like characters, and other types of abstractions that veer away from purely figural styles. In some instances, I found the expression *street writing* useful when describing text-based graffiti pieces. While *muralism, graffiti,* and *street writing* may have specific meanings, I regard *street art* as an umbrella term that includes muralism and graffiti but that could also potentially comprise other forms of creative expression that take place in urban spaces. But because these terms do not really have fixed meanings—often overlapping and intersecting with one another in dynamic ways—I will also be relying

heavily on the terminology that individual artists, collectives, and crews use to describe their own work.

RESEARCH METHODS

The multiple research methods I employed in this book reflect my commitment to interdisciplinary inquiry and research as a scholar trained in the field of art history but informed by the intellectual traditions of ethnic, gender, and cultural studies. Of particular importance to me in this text is the use of oral history research. Talking directly to artists, so that I could ask them about their life and work but also about the broader history of Chilean graffiti and muralism, has been a critical component of this study. Their testimonies were important foundations for the larger histories that I lay out in *Democracy on the Wall*. My approach to oral history research consists of open-ended and conversational interviews where I approached artists and a few project coordinators with the purpose of learning about their work but also with the aim of sharing ideas with them about the intersection of street art, politics, and history. I did not present myself as a dispassionate, removed, and objective observer; instead, I openly expressed my passion for the subject matter, disclosed my feminist politics, and shared my experience growing up in Santiago as a child and adolescent. I knew that this information would sometimes make me more likable and trustworthy to my interviewees but other times not. Regardless, it was important to me that they have a sense of who I am and how I would approach the subject of Chilean street art. While I queried these artists with specific issues and questions in mind, I nevertheless allowed their own interests and subjectivities to determine the direction of our conversation, thus engaging in nonhierarchical exchanges. "The interview is a transaction between the interviewer and the interviewee," feminist historian Sherna Berger Gluck insists, "and their responses to each other form the basis for the creation of the oral history."[15] Gluck observed that oral testimonies are indeed a form of legitimate history that signals a rejection of patriarchal predilections for linear chronologies and male historical icons who can somehow singlehandedly shape all courses of events. I was careful not to treat these artists' testimonies as individual accounts of their creative activities but rather as critical components of a largely unwritten history of street art in Chile. Norma Smith argues that oral history as a research method has the potential to highlight the important relationship between individual and collective action:

15. Berger Gluck, "What's So Special About Women? Women's Oral History," 13.

I propose using oral history both because it is history made by participants in, rather than just observers of, historical events, and also because of its capacity to illuminate the relationships among individual lives, communities, and what has conventionally been seen as larger (national and world) history.[16]

I should mention that interviewing artists was not the only means by which I captured their voices in my book. Aside from finding some of their quotes and statements in published texts, I investigated the online presence many mural and graffiti artists have cultivated over the years. Streaming videos on sites such as YouTube, Vimeo, and others proved to be valuable resources for my research. While these sources did not permit me to interject and participate in an active dialogue with artists, nor did they allow me to share my own thoughts with them, these internet texts nevertheless exemplified how many muralists and graffiterx chose to represent themselves within a public sphere other than the streets, namely the virtual locales of the internet. The online videos I cite in this book were generally produced by the artists themselves or created by others with the artists' express approval. I regarded a great number of these sources as examples of self-representation, ones that were designed to broadcast, promote, and/or disseminate these artists' work and ideas.

Given that Chilean muralism and graffiti, like most other forms of public art, is so heavily informed by site, location, and place, it was imperative that I visit the places where these works lived. Part of the goal of these visits was to document these works and I did so by taking photographs and jotting down a few notes about their location. An equally if not more important goal, however, was to experience the city itself, as it is the larger canvas upon which the murals and graffiti are inscribed. A great deal of my incursions involved taking public transportation (mostly the Santiago Metro) and walking for blocks on end to find these works of art. Google Maps was an essential tool for me to get around. Some of these excursions resulted in a treasure trove of great finds with the discovery of multiple street art pieces in one location while others came up completely empty. In both cases though, moving through the streets informed my understanding of how Chilean muralism and graffiti interacts with the urban space, for I was always taking in the experience of the city (i.e. the sites, the sounds, the smells, etc.) Moreover, these in-person visits allowed me to pause and reflect on the ethos of specific sites. Were these murals or graffiti located in busy parts of the city with heavy foot and car traffic? Were they situated in commercial districts or residential areas? What important

16. Smith, "Oral History and Grounded Theory Procedures as Research Methodologies for Studies in Race, Gender and Class," 121.

landmarks were to be found nearby? What were the implications of class, gender, race, and other social identities for those specific locales? What were the political histories of those sites? How do these considerations inform the possible readings, meanings, and/or interpretations of the art works? The various reflections that I formulated on a work's location throughout this book were a result of the ruminations I made in situ while carrying out research.

Mapping a history of Chilean graffiti and muralism in the post-dictatorship era was also a central motif in my investigations in the field. Fragments of this history could be appreciated in the testimonies and memories of the artists themselves as well as in the locales where murals and graffiti pieces are located. Nevertheless, significant chapters of that history were also recorded in primary and secondary sources housed in national repositories. Thus, I complemented the oral histories and field observations with archival work. I combed through the different holdings on Chilean muralism, graffiti, art, and general history at the Biblioteca Nacional, the Museo de Bellas Artes, and the library at the Centro Cultural Gabriela Mistral (GAM). The variety of sources I found—which included books, pamphlets, posters, newspaper clippings, and other ephemera—provided me with important clues about past and present arts movements in Chile. These materials contained the historical backdrops that often animated my analyses of individual works of art.

The oral history interviews, the on-site investigations, and archival research that I carried out compelled me to insert myself into the queries I formulated on the subject matter. In other words, I openly and unabashedly recognized that my own subjectivity as a Latina immigrant to the United States and as an individual born and raised in Chile played an important role in the framing of my arguments and analyses. Indeed, this text is the result of both a personal and intellectual journey through which I explored the politically liberating potential of street art and rediscovered the urban spaces of my youth. But how did my personal investments become implicated in my research methods? What important insights could I gather from mining my personal history and from evoking my subjective reactions to Chilean street art? It is in the conclusion of this book that I grapple most insistently with my own identity and explicitly discuss my individual responses to certain mural and graffiti initiatives. This open subjectivity allowed me, in part, to reflect upon my own relationship to the artists and their social spaces. As ethnographer Fawzia Haeri Mazanderani notes, feminist research "is often characterized by heightened reflexivity and a recognition of the subjective nature of knowledge claims."[17] Highlighting my subjectivity and recognizing my posi-

17. Mazanderani, "'Speaking Back' to the Self: A Call for 'Voice Notes' as Reflexive Practice for Feminist Ethnographers," 80.

tionality—including my privilege as an academic working in a large research university—was part of the longer tradition of feminist ethics in research. Nevertheless, I also wanted to legitimize myself as an important speaking subject beyond merely personifying the "voice of the scholar." I certainly avoided talking excessively about myself and falling into what Mazanderani calls "a form of solipsism."[18] But I was determined to lay bare the personal journey that involved the production of *Democracy on the Wall* because I believed that my experience could provide readers important insights into how others—including Chilean diasporic subjects like myself—could actively participate and intervene in the history of Chilean graffiti and muralism. I articulate how these participations and interventions can take place in the concluding chapter of this book, where I discuss the activities of muralist Alejandro "Mono" González and graffitera Gigi (Marjorie Peñailillo) on my university campus during visits that I personally coordinated.

TWENTIETH-CENTURY CHILEAN ART HISTORY

While the 1990s and beyond certainly represent an important time in the history of graffiti and muralism in a country with an unprecedented and rapid growth in artistic activity, it is crucial to underscore that this explosion of creative expression in the realm of public art did not emerge without important art historical precedents that provided both an impetus and foundation for the artists working from the 1990s to the present. In subsequent chapters in this book I discuss the significance of the long tradition of street protests in the country as an important antecedent to street artists, but the country was no stranger to radical public art by the time the decade of the 1990s rolled in. The highly influential work of the BRP and other mural collectives from the late 1960s and early '70s, which are discussed in chapter 1 of this book, were undoubtedly powerful inspirations for younger generations of artists who have come of age since the 1990s. Nevertheless, socially engaged mural art in Chile began forming during the first half of the twentieth century. The influence of the Mexican school of muralism of the 1920s through the '40s was undoubtedly key for Chilean artists, as Ebe Bellange explained: "We find the influence of Mexican muralists in the preoccupation [among Chilean artists] for the laborer, in their rejection of individualism and in the monumentality of their figures."[19] In 1940 famed Mexican muralists David Alfaro

18. Mazanderani, "'Speaking Back' to the Self: A Call for 'Voice Notes' as Reflexive Practice for Feminist Ethnographers," 83.

19. Bellange, *El mural como reflejo de la realidad social en Chile,* 45.

Siqueiros and Xavier Guerrero visited Chile with the purposes of establishing the Escuela México in the city of Chillán, an arts academy dedicated to the teaching of muralism.[20] Shortly thereafter the School of Fine Arts in the University of Chile followed suit and began to offer classes in the murals arts.[21] By the time he arrived in Chile, Siqueiros had cemented his reputation as an artist who combined public art, social critique, political activism, and aesthetic innovation. He had been exiled from Mexico due to his radical ideologies and actions, and had also been deported from the United States where he had made two highly politicized murals in Los Angeles, namely *Street Meeting* in the Chouinard School of Art and *America Tropical* in Olvera Street (1932), two wall paintings that would become highly influential for Chicana/o muralists active in the 1970s.[22] Chilean artist and critic Eduardo Castillo Espinoza has argued that Siqueiros introduced to Chile the idea of muralism with radical content. Castillo referred to *Death to the Invader* (1941–42; see figure 0.2), an ambitious mural Siqueiros painted inside the Escuela México in Chillán, as "the first manifestation of social muralism in Chile."[23] In this work, the Mexican artist aspired to represent, as Castillo further observed, "the historic evolution of both countries [Chile and Mexico]" while also underscoring the union of the people from both nations.[24] To create the dynamic and enveloping composition of the mural, he built a structure of curved wood panels that would enhance the images' sense of movement. He wanted to create a continued mural surface that would be uninterrupted by sharp angles and breaks. The artist sought to depict various historical figures from both Chile and Mexico to indicate that they were united in the struggle against foreign invaders, which could be interpreted as European colonizers of the

20. Castillo Espinoza, *Puño y letra: Movimiento social y comunicación gráfica en Chile*, 53.

21. In spite of the fact that Siqueiros greatly inspired Chilean artists to pursue wall painting, the muralism classes offered at the School of Fine Arts in the University of Chile clearly had no intent to radicalize or politicize their students. According to a lesson plan produced by the school in the 1940s, muralism's ultimate mission was to complement architecture with the purposes of decoration, avoiding any references to propaganda. Moreover, according to this document, the roots of mural practice in Chile were situated in Europe, not the Americas, so Mexico was completely omitted as an important site of mural history. The reasons for this omission are not completely clear, but it would not be a stretch to presume that the radical and anticolonial politics of Mexican artists like Siqueiros did not sit well with the conservative ideologies of the Chilean elite. Lesson plan document reproduced in Castillo Espinoza, *Puño y letra: Movimiento social y comunicación gráfica en Chile*, 52.

22. For more information on Siqueiros's influence on Chicana/o artists, see Latorre, *Walls of Empowerment*, 38–52.

23. Castillo Espinoza, *Puño y letra: Movimiento social y comunicación gráfica en Chile*, 53.

24. Castillo Espinoza, *Puño y letra: Movimiento social y comunicación gráfica en Chile*, 53.

past or US interventions of the present.[25] The section of the mural dedicated to Mexico depicts, among other figures, the revered warrior and last ruler of the Aztecs, Cuauhtémoc, while the Chilean side of this wall painting shows us Lautaro, the Mapuche warrior who led a revolt against Spanish invaders in the sixteenth century. By exposing spectators to indigenous resistance in the northernmost and southernmost countries of Latin America, Siqueiros alludes to ubiquitous forms of anticolonial struggles in the continent. Though both the images of Cuautéhmoc and Lautaro were utilized by the Chilean and Mexican governments, respectively, with the purpose of homogenizing and assimilating native peoples to the nation-states, Siqueiros cast them here as subversive revolutionaries rather than heroes of the nation. Such depictions were made all the more radical by the aesthetic, technical, and formal innovations he introduced to the Chilean public, as Christopher Fulton explained: "[*Death to the Invader*] was situated in a modern building which Siqueiros partially reshaped, and the mural's design and execution were carried out with new technologies such as cameras, slide projectors, airbrushes, and in the industrial medium of pyroxylin."[26] Through these techniques, the Mexican artist also sought to transform the spectator experience from that of a passive and somewhat detached observer to that of an active spectator, which Fulton described as "one who would move freely through the room to take in the swelling forms and forceful diagonals painted on the ceiling and detect through physical reconnoitering the unity of the pictorial composition."[27] The coupling of radical and denunciatory content together with new, bold, and dynamic visual vocabularies would be a lesson learned for subsequent generations of Chilean muralists and graffiterx who understood the impact and political power behind such a coupling. However, the active spectator of more contemporary forms of street art in Chile would move freely through the streets, rather than a single room, and would engage in an act of reconnoitering not a mural's sense of unity but rather the ways in which it intervenes and disrupts business as usual in the urban landscape.

Radical mural history in Chile would have to wait another two decades to reemerge when in 1963 Salvador Allende would initiate his third presidential campaign (prior to the formation of the BRP and other brigades who would join him in his fourth and successful bid for the presidency in 1970.) At that

25. Fulton, "Siqueiros against the Myth: Paeans to Cuauhtemoc, Last of the Aztec Emperors," 71.

26. Fulton, "Siqueiros against the Myth: Paeans to Cuauhtemoc, Last of the Aztec Emperors," 74.

27. Fulton, "Siqueiros against the Myth: Paeans to Cuauhtemoc, Last of the Aztec Emperors," 71.

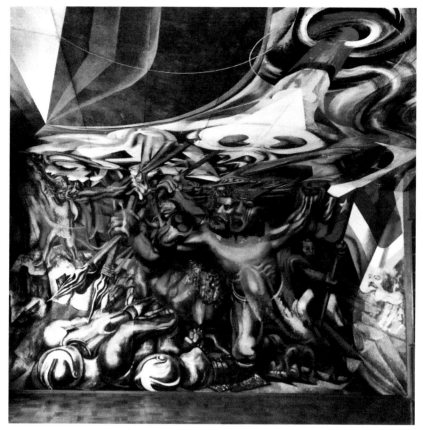

FIGURE 0.2. David Alfaro Siqueiros, *Death to the Invader* (1941–42), mural, Chillán, Chile. © 2018 Artists Rights Society (ARS), New York / SOMAAP, Mexico City.

juncture, the politician found himself with a poorly financed campaign that was dwarfed by the promotional and media resources at the disposal of his opponent, Eduardo Frei Montalva. Because there were many artists at the time who were members of the communist party and other left-leaning political alliances, the idea of using their skills at the service of Allende's campaign seemed like a viable option. Castillo has indicated that it was a group of young artist and designers—Jorge Osorio, Alejandro Strange, Patricio Cleary—who came up with what was then an innovative way to promote Allende's candidacy. The idea was to produce graphic imagery similar to that of billboards, street signs, and protest banners but paint it on street walls.[28] This formula proved to be successful in terms of the effects on the campaign and its relative

28. Castillo Espinoza, *Puño y letra: Movimiento social y comunicación gráfica en Chile*, 64.

affordability so it was massively replicated. An added benefit was, according to Julio Strange, "the contingent of enthusiastic workers and residents who were always willing to take on tasks."[29] Camilo Trumper described the group of artists who worked with Allende in to the following way:

> [They were a] small group of university trained artists who supported Allende's 1964 campaign [who] provided the most direct link to Unidad Popular-era muralism. Trained in a tradition of politically motivated work, and members of the Communist Party, this group of young artists formed the vanguard of a new generation of Chilean artists, and their work would have repercussions through the dictatorship, where they became leading members of performance art groups that publicly challenged the silencing of political and cultural expression.[30]

The mural initiative associated with Allende's third campaign was crucial to understanding the historical connection between muralism and radical politics that happened in Chile, but it was also instrumental in grasping the active participation of women in those early years of politicized muralism. Luz Donoso emerged at that time as a highly visible figure who made significant mural interventions into Chilean streets on behalf of Allende's political cause. She had just finished taking muralism classes in the School of Fine Arts in the University of Chile and was prepared to put those skills into practice. Some of the most notable wall pieces she did in collaboration with Carmen Johnson and Pedro Millar included a series of small panels in Santiago's Ramón Barros Luco Hospital. What made these murals quite remarkable for their time was the recurring presence of female figures within the walls' iconographic language. In an untitled panel that Donoso, Johnson, and Millar painted on an exterior wall of this hospital in 1964, the artists provided passersby with an image extolling the special brand of "family values" that an Allende presidency would supposedly bring about. In this mural, we find a family group of sorts accompanied by the following caption: "We will maintain the family unit under a people's government with better salaries, living conditions, health, [and] education." In some ways, Donoso and her colleagues were promoting very traditional notions about the role that women should play within the nation-state, namely that of mothers and supportive family members. The image thus depicts female figures performing the conventional nurturer role. One woman is seen holding a young boy's hand while another braids a little

29. Castillo Espinoza, *Puño y letra: Movimiento social y comunicación gráfica en Chile,* 65–66.

30. Trumper, *"A ganar la calle,"* 226.

girl's hair; their demeanor is clearly nonthreatening, and their clothing and overall appearance conforms to patriarchal gender expectations. Nevertheless, the fact that this family group is composed almost entirely of women does not neatly align with nationalist discourses of republican motherhood. The absence of a clearly designated patriarch in the family decenters the primacy of the heterosexual couple as the foundation upon which the nation is forged. In its place is a homosocial space composed primarily of women who have their own political identities. The references to salaries (i.e., labor), housing, health, and education in the mural's text, inscriptions that are located in close proximity to figures in the image, suggest women's active participation in the private and public spheres of the new nation-state ushered in by Allende's presidency. Moreover, the two women who hold a banner with the words "The 10th Commune is with Allende" betray a body language that suggests same-sex intimacy and female homosociality. Though this mural was created with the purposes of campaign support, Donoso and her colleagues were also making a public statement about the inclusion of women within the social equality discourse espoused by the Chilean left. For women like Donoso and Johnson, intervening in the public sphere in the mid-1960s with the creation of female-centered iconography was an unapologetically radical act that directly challenged the gender politics of urban space in the country. Such an experience of working in the public sphere would lead Donoso to continue doing public interventions and enacting art happenings well into the 1970s and '80s, many of which were thinly veiled denunciations of the dictatorship's repression. "Practicing proselytism, agitation and denunciation, disturbing and altering order," Donoso would once remark, "all form part of art as action and it is the same creative language of the exploited masses."[31] Chilean art historians and critics have referred to Donoso's art as a body of work that "confronts conditions of inequality, repression and the normalization of social and cultural events in constant conflict."[32] Thus Donoso would lay the groundwork for other Chilean women artists who would be inspired by her courage to intervene in public spaces.

In 1964, the same year of the Barros Luco Hospital mural, Donoso together with Johnson, Millar, and Hernán Meschie would paint a much larger and centrally located wall that would become perhaps one of the most iconic images of Allende's 1964 presidential campaign, namely *Chile's Future*, painted on the retaining walls of Santiago's Mapocho River. This was one of the first, if not the very first, radical murals painted in this location, which would go

31. Luz Donoso, artist's statement published in *Una acción hecha por otro es una obra de la Luz Donoso*, 7.

32. Paulina Varas, "Un obra termina al volverse una acción," 2.

on to become a favorite site for future Chilean street artists. Trumper, who has investigated Chilean pre-dictatorship graphic imagery in public spaces, observed that the mural "re-imagined Chilean history around the images of the historical figures of the Chilean left."[33] In a frieze-like composition, Donoso together with her colleagues provided the Chilean public of the time with a long procession of figures, both identifiable and anonymous, that were meant to allegorize various populations who were behind Allende's political platform. A central figural group in the mural included Chile's eleventh president, José Manuel Balmaceda, who had become a national hero of sorts for the Chilean left due to the social policies he instituted during his presidency (1886–91), in particular, his attempts to curb British control of the country's nitrate industry in the late nineteenth century. Paraphrasing the work of Hernán Ramírez Necochea, historian Michael Monteón observed that "British economic imperialism had removed the nitrate wealth from the country, and when Balmaceda moved to stop this looting of the nation's riches British interests led by John Thomas North, 'the Nitrate King,' financed the overthrow of his government."[34] In this mural, Balmaceda is depicted holding a large sign with a statement often attributed to him by Chilean poet laureate Pablo Neruda in his famous *Canto General* (1950): "This land, this wealth will belong to Chile, I will turn this white material [nitrate] into schools, into bread for my people." According to Neruda, who himself was a prominent figure of the Chilean left, Balmaceda had uttered these words after returning from a visit to Chile's nitrate mines in the north.[35] Immediately to the right of Balmaceda, the artists rendered the figure of Luis Emilio Recabarren, a revered labor activist who in the early decades of the twentieth century organized Chile's Socialist Workers Party together with nitrate workers in the city of Iquique. The pairing of these two figures was meant to crystalize the idea that the nationalization of the country's riches had a long history that was intimately connected to the welfare of the poor and the laboring classes. It is no coincidence then that adjacent to the figures of Balmaceda and Recabarren were the images of numerous anonymous Chilean miners who, the muralists seem to imply, are the backbone of the national economy. The use of repetitive figural forms here implies that there is power in numbers; in other words, the country's working classes are large and, as such, demand greater inclusion and agency.

Even though Donoso and Johnson's participation *Chile's Future* represented the important role that women artists played in the Chilean left during the 1960s, this mural's iconography remained decisively male-centered,

33. Trumper, *"A ganar la calle,"* 226.

34. Monteón, "John T. North, the Nitrate King and Chile's Lost Future," 60–70.

35. Neruda, *Canto General,* 146.

ignoring, for the most part, how gendered experiences affected the country's class struggle and how sexism was rampant in Chilean society. Nevertheless, women do have a visible presence in this mural's imagery, albeit a secondary one to the men. To the left of Balmaceda and Recabarren, Donoso, Johnson, Millar, and Meschie painted a compacted but large group of women who would represent the female vote in support of Allende. Trumper described this group as "women fulfilling their potential roles under the *Frente de Acción Popular* (FRAP), an Allende-led coalition government, engaged in a 'new way of building the new Chile.'"[36] Echoing the mural Donoso and Johnson had completed in the Barros Luco Hospital that same year, here again we see a group of women who are inhabiting a female-centered space that is presented as an important component of Chilean society. In many ways, they mirror the strength-in-numbers visual effect embodied in the figures of the all-male miners on the other side of the Balmaceda and Recabarren images. Though their appearance and style of dress is that of a conventional *ama de casa* (housewife) and some of them are even shown caring for children, it is nevertheless clear that the new vision of a better Chile that Allende promised would be incomplete without the support of women.

Chile's Future was meant to be a premonitory mural not only because it predicted Chile's positive changes to come under Salvador Allende's leadership but also because it foretold of the active role that public murals and street art would play in the country's democratic processes. These promises of a "democracy to come," to borrow Derrida's concept once again, were cut short less than ten years later when the country would be violently shaken by a military coup, the work of Chile's armed forces under the command of Augusto Pinochet and with the support the US Central Intelligence Agency (CIA.) This tragic political and social rupture signaled the severe repression of radical street art in Chile for the next sixteen years, as Bellange observed: "Administrative dispositions caused the premature death of numerous murals by ordering their destruction."[37] The new military government began a systematic campaign to erase and whitewash all murals associated with Allende and his political positions as well as most wall pieces that hinted at social justice concerns. These measures were made all the more repressive by the outlawing of all political parties, justified under the pretext that Chile was under a state of emergency due to the so-called threat posed by Communism, Marxism, and other left-leaning political movements. Bellange observed that the 1970s saw the disappearance of most, if not all, BRP murals together with works by

36. Trumper, *"A ganar la calle,"* 227–28.
37. Bellange, *El mural como reflejo de la realidad social en Chile,* 53.

Julio Escámez, Osvaldo Reyes, Hernán Alvarez Reyes, Fernando Marcos, and even renowned abstract surrealist painter Roberto Matta.[38] The very act of painting, tagging, and/or marking up a public wall became an act of subversion regarded as a direct attack on the military government, an action that was often met with violent repression. In spite of the surveillance and control that Pinochet's regime exerted over public space, artists continued painting murals, albeit behind the veil of anonymity and secrecy. Mostly located in poblaciones, these works often denounced the social inequities and human rights abuses carried out by the dictatorship, but, as Bellange indicated, were quickly erased and destroyed, which made it nearly impossible to document them.[39] What these ephemeral wall pieces indicated, however, was the persistent belief that radical street art continued to be an effective and transformative means to communicate the sentiments of those sectors of the population who were rendered invisible and mute by Chilean institutions of power.

In spite of the strict controls placed on creative expression during the dictatorship, Chile still enjoyed a rich and complex history of socially engaged art between 1973 and 1990, one that traversed different spheres of the country's society. Contemporary street artists were also influenced by the arts from this era. The government's systems of control did not so much eliminate politicized forms of arts praxis as much as transform them in terms of their aesthetics and their creative strategies. Many artists such as Eugenio Dittborn, Catalina Parra, and Lotty Rosenfeld embraced the coded and encrypted language of Conceptualism to exact critiques against the regime, messages that generally flew under the radar of government censors. But perhaps the most influential among this group of artists active during the dictatorship were CADA, Colectivo de Acciones de Arte (Art Actions Collective), which included Rosenfeld among its members, but also Fernando Balcells, Juan Castillo, Diamela Eltit, and Raúl Zurita. Founded in 1979, CADA focused on staging art actions in public spaces throughout Santiago. These actions, while not blatant in their subversive intents, sought to disrupt the "conditions of life during dictatorial Chile."[40]

More grassroots forms of creative expression such as the so-called popular arts and crafts, forms that exist outside anointed art circuits, also betrayed the language of subversion. Their exclusion from the world of the "fine arts" allowed them to circulate more freely through national and transnational dissident circles. Perhaps the most visible of these forms were the *arpilleras,*

38. Matta collaborated with the BRP to create a mural in the public pool in the Municipality of La Cisterna, Santiago. Bellange, *El mural como reflejo de la realidad social en Chile,* 53.

39. Bellange, *El mural como reflejo de la realidad social en Chile,* 55.

40. Zurita, "Colectivo de Acciones de Arte (CADA)."

vernacular vs " *fine art* ".

quilt-like collages made of fabric scraps created by women from the families of the disappeared and the political prisoners of the regime. Jacqueline Adams referred to this kind of underground and vernacular approach to subversive art making as "artistic expression aimed at survival or active resistance."[41]

Street artists of the 1990s to the present inherited the strategies developed out of necessity by artists in the '70s and '80s. Much of the graffiti and muralism featured in this book tends to be implicitly rather than explicitly political. These artists understood that their work represents an intervention into the public sphere, one that is in itself disruptive and political regardless of the content of the work. The conceptual language of artists from the '70s and '80s then proved to be instructive when creating a politicized visual vocabulary that was open ended and idea driven. Moreover, the traditions of social justice and popular arts and crafts provided street artists with cues about transformative art practices that could survive and even thrive outside of museum and gallery circuit.

Arts practices more closely associated with the mainstream museum and gallery scene in Chile starting in the 1990s also provided important referents to many street artists in the country. Alejandra Wolff has argued that this period in the nation's artistic development has been characterized as one that seeks to compensate for the genealogical and theoretical pause in art practice caused by the dictatorship, which was highly suspicious of artists and cultural producers. The practice of intense experimentation, innovative techniques, and aesthetic explorations have been common approaches among contemporary artists who reveled in the relative freedom provided by the transition to democracy. The creation of FONDART (Fondo Nacional para el Desarrollo Cultural y las Artes or National Fund for the Development of Culture and the Arts) and the Consejo Nacional de la Cultura y las Artes (National Council for Culture and the Arts) in 1992 also marked a shift in national attitudes about art as these organisms signaled the nation's response to the suppression of creative expression under Augusto Pinochet. According to Wolff, such institutions sought to "position artists in public space, funding the creation and dissemination of projects according to evaluation criterion established by experts in the field themselves."[42] Wolff further contends that the state tried to promote arts movements that were either "postponed or interrupted" during the dictatorship. With a few exceptions, however, muralism and graffiti

compare

41. Adams, *Art against Dictatorship*, 1.

42. Wolff, "Marcos y perspectivas de la postdictadura: Narrativas de la pintura en Chile," 76.

in Chile did not benefit from this new era of greater state support,[43] as these government initiatives focused primarily on work that adhered to avant-garde, purely aesthetic, and nonpolitical notions of art.

Nevertheless, the shifting cultural attitudes toward the positive role of art in society, legitimized by state funding and promotion, would indirectly provide an impetus for street artists to regard their work as a means to enrich people's lives. Such an impetus, notwithstanding, is not without a critical stance toward the Chilean cultural establishment, as arts funding and support from the state is heavily embroiled in politics, bureaucracy, favoritism, controversy, and even corruption. A case in point were the "light murals" devised by Chilean artist Catalina Rojas, who is known for creating art pieces consisting of massive projections of her paintings and drawings upon urban surfaces such as major public buildings and city walls. In 2011 the artist received generous funding from the municipality of Santiago, the Bicentennial Commission, the Council on National Monuments, and Enersis, a multinational electric power company, to create her Museo Arte de Luz (Art of Light Museum.)[44] This project consisted of light projections of her expressionist and impressionist-inspired paintings along the retaining walls of the Mapocho River between the Pio Nono and Patronato Bridges, a very central and highly trafficked part of the city. This was an ambitious and costly project that required Rojas to secure twenty-six state-of-the-art projectors that were shipped from Denmark. The artist also digitized her paintings, which she then sent to Italy so that they could be "printed on small circular pieces of glass with a laser."[45] These river walls, however, were the site of numerous graffiti and community murals, such as the work of highly respected street artists Grin, Saile, Aislap, Piguan, and others.[46] In order to prepare the site for the Museo Arte de Luz, city workers simply painted over these works, effectively destroying them. Though the artist defended herself from the outcry that such destruction caused by stating that the disappearance of the graffiti murals was related to a city initiative to clean and renew the river and that it was not directly connected to her project. She also met with some of the affected artists as a gesture of goodwill toward them, though

43. During the course of my research, I only encountered one instance of a mural/graffiti initiative receiving major government funding through a FONDART grant and that was the creation for the Museo a Cielo Abierto, San Miguel. For more information on this initiative, see chapter 2 of this book.

44. Yrrarázaval, "Invitación al museo/Invitation to the Museum," 15.

45. Rojas, "Museo Arte de Luz/Art of Light Museum," 59.

46. The site where Rojas created her Museo Arte de Luz was also the location where artists associated with Salvador Allende and the Popular Unity coalition of the 1960s and '70s had painted murals.

the meeting was a clearly tense one where a visibly nervous Rojas made the following statement: "I will do everything within my reach . . . to try to make amends in whatever way I can to make you [the muralists and graffiterx] feel compensated for what happened." She also stated that she would try to reimburse the artists for the materials they used in the disappeared murals and speak with the responsible authorities about finding a space for the graffiterx to make other urban interventions.[47] It is unclear whether Rojas ever followed up with those commitments, but what is clear is that, during the original inception of the Museo Arte de Luz, the artist did not seem to acknowledge or even recognize the works painted in that locale, as Rojas herself recounted:

> In the beginning, my friends accompanied me and endured the pestilent stench of the place in order to conduct my rudimentary experiments on the waters and shores of the river, but I always had the illusion that someday someone would clean up our river. Finally, in 2009, my dream came true: the wastewaters were channeled and are currently being treated.[48]

While in her statements to the graffiterx Rojas seemed to distance herself from the cleaning projects that were allegedly responsible for the destruction of the murals, in the comments above—made a few years earlier—she suggests that she was somewhat complicit with them. What is also remarkable is that nowhere in the artist's discussions about the creation of this Museo did she make reference to the preexisting murals. Moreover, her desire to "clean" this part of the city certainly referred to the raw sewage and contamination of the Mapocho River, but it also made the affected graffiterx feel like their murals were part of the "pestilent stench" of the area that needed to be eradicated. In addition, the preferential treatment that Rojas received vis á vis the graffiterx made clear who the state regarded as a true artist and thus more deserving of public monies, support, and urban space.[49]

The Chilean government's management of resources, coupled with the still elitist field of academic arts and scholarship, have led street artists, espe-

47. These statements made by Catalina Rojas were contained in a video posted by the graffiti collective KELP. http://www.kelp.cl/cgi-bin/mt/mt-search.cgi?IncludeBlogs=2&search=mapocho (accessed on April 28, 2016).

48. Rojas, "Museo Arte de Luz," 59.

49. The state approval of Catalina Rojas's Museo Arte de Luz was further cemented when then-president of the country Sebastián Piñera, Santiago mayor Pablo Zalaquett, and Enersis CEO Pablo Yrrarázaval—all major power brokers and right-wing supporters who exerted tremendous influence over government and corporate affairs in Chile—attended to the opening of this Museo.

a powerful history of political activism, an activism often enacted through bodily disruptions by residents taking to the streets in social protest. Given these histories, community leaders there saw that their neighborhoods were ideal sites for the creation of MCAs. Started in the late 2000s, these mural and graffiti initiatives sought to beautify the historically marginalized space of the población, to raise awareness about social inequities, and to work collectively with the community. Ultimately the MCAs function as a symbolic and physical reclamation of urban spaces commonly controlled by the state and the corporate sector.

While in chapters 1 and 2 I mostly investigate traditional mural making, in chapter 3 I shift my attention to the emergence of graffiti in the country. Influenced by older muralists and the global graffiti scene, young artists turned to street writing as a means of self-expression and affirmation after the end of the dictatorship. Working individually or in crews, Chilean graffiterx have taken it upon themselves to beautify the city using "wildstyle" lettering, aerosol painting, and irreverent imagery, all part of graffiti's signature style. Given the ambiguous and lax legislation against street writing in Chile, the country since the early 1990s has become somewhat of a haven for street writers who do not have to fear the violence of law enforcement when they are working in the streets. Standing in sharp contrast to the criminalization of graffiti in countries like the United States, Chilean cities have become more accessible platforms for this form of street art. This chapter will also address the relationship between graffiterx and muralists, one that, unlike in other parts of the world, is one of mutual respect, admiration, and collaboration. I argue in this chapter that the merging between these two kinds of street art that happens in Chile is indicative of a systematic challenge to traditional hierarchies of public art, hierarchies that would define muralism as a legitimate and time-honored art form and graffiti as pseudo-criminal vandalistic activity.

Though I argue throughout the book that graffiti and muralism alike represent liberating forms of public expression, in chapter 4 I problematize the gender politics of these arts practices. The masculinization of the public sphere coupled with Chile's troubling history of gender inequity serves as a social backdrop here for the discussion of women graffiti artists, or graffiteras, who seek visibility in the male-dominated practice of street art. Suspicious of the institutional discourses promoted by the government and mass media, Chilean graffiteras use street art as a means of alternative communication that often contests national, capitalist, and patriarchal interests. I contend that not only we can situate their activities within the broader history of public art in Chile, but we can also understand their interventions as a new feminist or

female-centered incursion into Chilean public life. Ultimately, the graffiteras featured in this chapter seek to democratize the urban space by making it more accessible to greater portions of the population including women, children, and the elderly.

I bring this book to a close with the conclusion, where I highlight the transnational aspect of the mural and graffiti movement in the country. Though this public art directly responds to the political, social, geographic, and historical specificity of Chile, muralists and graffiterx also espouse a global vision on their walls, making their work about Chile but also about the world. I thus turn my attention here not only to transnational themes in their mural imagery but also to Chilean artists like Mono González and Inti, who paint both in Chile and abroad. Of great importance in this conclusion too are non-Chilean muralists and graffiterx like Seth (France) and Roa (Belgium) who come to Chile to paint, attracted to the country's vibrant and embracing attitude toward street art. I address the transnational also through personal reflections of my own experience as a Chilean who immigrated to the United States in the late 1980s and whose work on this book has taken me back to the urban spaces of my childhood and adolescence, which took place almost entirely under the dictatorship. This transnational reconnection I sought out led me to invite Chilean artists Mono González and Gigi (Marjorie Peñailillo) to my university campus in 2015 and 2016 so that they could intervene in social spaces here and teach my university community what it means to do collective and socially empowering art, Chile style. How do these artists' desire for visual democracy in the urban sphere then intersect with transnational aesthetics? What are the implications of making statements about globalization and transnational connections within the inherently local and site-specific locales of muralism and graffiti? I address these open-ended questions in the conclusion not with the intention of providing definitive answers but rather with the hope of promoting future dialogues and debates about the role that muralism and graffiti can play in democratic process within the urban sphere in Chile and elsewhere.

CHAPTER 1

The Return from Clandestine Anonymity

Muralist Brigades, Revamped and Renewed

THE FORMATION of muralist brigades in Chile starting in the mid-1960s established an intimate and organic relationship between political activism and public art-making in the country. In other words, they have embodied what Chela Sandoval and I have called the practice of artivism, "a hybrid neologism that signifies work created by individuals who see an organic relationship between art and activism."[1] While this relationship had already been cemented elsewhere in the Americas in countries like Mexico, Brazil, the United States, and others, Chilean muralists' commitment to collectivity and artivist actions have offered new, noninstitutionalized and democratic forms of radical art making. This chapter will thus focus on two important mural brigades in Chile, namely the Brigada Ramona Parra and the Brigada Chacón. "This type of urban practice or performance," historian Camilo Trumper maintains, "was one of the distinctive markers of Chilean politics under [Salvador] Allende, and one of the first targets of oppression by the military regime that deposed him."[2] Both the BRP and the BC originated in the 1960s; the BRP worked in close connection to the Juventudes Comunistas (JJCC, Communist Youth), and the BC had close ties with the Communist Party and the political campaigns of Senator Volodia Teitelboim. When the

1. Sandoval and Latorre, "Chicana/o Artivism," 82.
2. Trumper, *Ephemeral Histories*, 2.

military coup gripped the country in 1973, the BRP and the BC went underground. Some of the members of these collectives ceased to work all together, others worked clandestinely while still others continued painting in exile. The return to democratic rule, however, saw the BRP and the BC emerge from the shadows, so to speak, with some of its original members, including Mono González, Boris Rivera, and Danilo Bahamondes along with younger artists. The resurgence of these brigades—while indicative of the reconstitution of a powerful artivist movement in Chile—was also a difficult and contested one where different members of these collectives vehemently disagreed about the politics of their work, which led to divisions and fissures among them. I will address these discords as symptoms of the challenges that are intrinsic to the post-dictatorship era. This era can be characterized by a certain political "messiness" where there is no consensus about what democracy and liberation truly look like, in particular among the left-of-center groups and political parties. Moreover, both the BRP and the BC have had strong ties to political parties on the left, many of which have been bitterly divided along ideological lines. These divisions were even felt back in the heyday of the Unidad Popular coalition in the 1960s and '70s. Tomás Moulian argued that Salvador Allende's government was "constantly overcome by the extreme right and extreme left groups who would take over the streets."[3] These contradictions, conflicts, and fractures are also captured in the history of the brigades during the post-dictatorship era. Nevertheless, my argument will be that these difficulties themselves can also be productive sites where visual democracy potentially thrives as it compels *brigadistas* (brigade members) to renew and refine their praxis.

While I will focus here on the post-dictatorship work created by both of these muralist brigades, it is relevant for me to highlight the extremely repressive tactics that the government of Augusto Pinochet adopted to silence public artists. Historian Ebe Bellange indicated that during the dictatorship, the government of Augusto Pinochet engaged in a systematic campaign to erase, cover up and destroy murals associated with leftist politics.[4] Alejandra Sandoval, in her book on the Brigada Chacón, explained that muralist brigades were actively persecuted under the Pinochet regime, with some members even executed in front of their own murals.[5]

Moreover, the dictatorship had engaged in a concerted initiative to eradicate all forms of cultural production and symbolism associated with the Unidad Popular (UP), the political coalition connected to Salvador Allende. In its place, Pinochet's regime embarked on a massive, pervasive, and sustained

3. Moulian, *Chile actual: Anotomía de un mito,* 23–24.

4. Bellange, *El mural como reflejo de la realidad social en Chile,* 53.

5. Sandoval, *Palabras escritas en un muro,* 43.

campaign to remake national culture in a way that bolstered the legitimacy of the power of the military government. Luis Hernán Errázuriz and Gonzalo Leiva Quijada called this campaign *el golpe estético,* or the aesthetic coup d'état, thus asserting that the dictatorship imposed its dominance not only through institutional and policy changes—often enforced through the use of violence—but also through the control of nearly all forms of public communication and cultural expression. Errázuriz and Leiva argued that this golpe estético could be felt in nearly all aspects of Chilean cultural life, "from the content of the school curriculum to the control of emblematic museums."[6] Urban spaces, however, were among the most ubiquitous sites for the dictatorship's aesthetic control; public monuments, military parades/rituals, and even the burning of literary texts associated with the UP were all staged on city streets.[7]

A key component of the dictatorship's golpe estético was an initiative that the military regime called *operación limpieza* (operation cleanup). This operation, which consisted of the above-mentioned eradication of all cultural markers associated with the UP, also implied that Allende and his coalition signified "failure, disorder and, in a sense, dirtiness."[8] As a result, most brigadistas were driven into exile or clandestine anonymity; their political activity on the streets during the dictatorship years was, in many cases, relegated to quickly spray-painted slogans, or *rayados* (scribblings), and cheaply produced paper pamphlets that denounced the military regime. However, the BRP still managed to complete full-fledged murals in poblaciones in the city, despite the persecution. "[The murals] would appear in those moments of confrontation," Mono González remarked, "when we were fenced in by repression."[9] The vast majority of these street works, however, were quickly erased or disposed of by the government, leaving behind little trace of their existence. However, some of these works were captured by the photographic lens of Kena Lorenzini, member of the Asociación de Fotógrafos Independienes (AFI, Association of Independent Photographers), a group of journalist photographers opposed to the dictatorship. The AFI would go out into the streets to document antigovernment protests along with the brutality of the regime.[10] These ephemeral inscriptions into the urban sphere also served the pragmatic role of letting the public know about upcoming protests and demonstrations, as Carla Peñaloza explains: "All this information circulated through pamphlets and street ray-

6. Errázuriz and Leiva Quijada, *El golpe estético,* 7.
7. Errázuriz and Leiva Quijada, *El golpe estético,* 23.
8. Errázuriz and Leiva Quijada, *El golpe estético,* 15.
9. "El Arte del Muralismo Callejero Brigadista Chileno."
10. Peñaloza, "La memoria en imágenes," 115.

ados, true means of communication for Chileans."[11] Juan Chinchín Tralma vividly recalled the limited imagery they could produce under the repression and surveillance of the dictatorship: "The most we could do was a letter 'R' with a circle surrounding it and a star on top. The circle represented unity . . . the 'R' resistance, and the star meant that the Brigada Ramona Parra was still alive."[12] It is unclear how many of these street markings were actually done by brigadistas, either from the BRP or BC, but what is clear is that the dictatorship years were not devoid of political activity for many of the street artists who had come of age before the 1973 coup d'état. Moreover, the production of quickly created street rayados and political pamphleteering did not end with the advent of democracy; these street actions continued together with more elaborate and composed mural imagery created by the likes of the BRP and BC who, in turn, adopted some of the strategies from the ephemeral street markings done during the dictatorship years and beyond. What is also clear is that the BRP and BC, in their reconstituted states after the end of the dictatorship, sought to challenge the lingering effects of the golpe estético that could still be felt in the urban sphere long after the end of the dictatorship. The post-dictatorship era saw an end to these overt and brutal tactics against artists. Moreover, Patricio Rodríguez-Plaza has argued that this period is characterized by various forms of political mobilizations taking place in the public sphere, many of which were accompanied by a powerful visual component in the form of murals, posters, and banners.[13] The colorful and vibrant street art that began to take root was in stark contrast to the "grey sterility of the dictatorship."[14] As such, visuality and urban demonstrations were organically fused to one another.

During this post-dictatorship era, the brigades' tendency to situate their work in city streets, particularly in working-class neighborhoods and politically charged sites, signaled a desire to politicize audiences and passersby who encountered these works while also challenging government and corporate control of these spheres. The relative uniformity and recurring iconography produced by these muralist brigades endowed their murals with recognizable "signature" styles that were ingrained in their audience's collective consciousness through repetition. Moreover, the idea of artists coming together under the banner of a brigade implies a militancy of approach and a commonality of cause. The word brigade recalls military-type action while also denoting a

11. Peñaloza, "La memoria en imágenes," 120.

12. Long, "The Chilean muralists who defied Pinochet."

13. Rodríguez-Plaza, *Pintura callejera chilena*, 47.

14. Díaz Parra cited in Comité de Defensa de la Cultural Chilena, *Muralismo Wandmalerei Peinture Murale Mural Painting Pittura Murale*, 10.

group dynamic of collective agreement. Unlike other mural collectives in the Americas and elsewhere, these brigades operated under the assumptions that their murals would be ephemeral and momentary, as former member of the BRP Eduardo "Mono" Carrasco explained:

> Our foundational concept was the following: what we paint today can be changed tomorrow with other symbols, colors, and drawings; because the happenings of life evolve, they do not have a long duration in time, because [the murals] were giant blackboards and informational sites of everyday events.[15]

Some muralists regarded this ephemerality as an opportunity for constant renewal of their praxis, as Ebe Bellange explained: "When [these murals] are repainted or restored, the content is renewed and updated according to the needs and requirements of the social and political moment that [the muralists] wish to reflect."[16] The fleeting quality of these works point to what Kit Dobson and Aine McGlynn regard as the characteristic disposability of street art, which "is antithetical to the preciousness associated with many artistic products."[17]

The striking simplicity and boldness of the visual design coupled with decisively radical politics embodies the very essence of the BRP and the BC. This simplicity of design was connected to what Mono González called the new spectator:

> The new spectator [is someone] who is generally on the move or taking public transportation; it is not someone who stands still to look at the details of the work. For this reason the image had to be very simple, very direct, so it could be read quickly and easily.[18]

Though there was a clear pragmatism to the understanding of these new spectators—they were the most likely audience to be found on city streets—this new attitude toward spectatorship also challenged Eurocentric notions around art appreciation and the need for a learned audience to understand the work of art. This new spectator is thus part and parcel of the deployment of visual democracy by the BRP and the BC. The city dweller is confronted with these artists' radical statements in the midst of the information overload that char-

15. Carrasco, *I Sogno Dipinto / El sueño pintado / O sonho pintado,* 36.

16. Bellange, *El mural como reflejo de la realidad social en Chile,* 55.

17. Dobson and McGlynn, *Transnationalism, Activism, Art,* 11.

18. Cited in Castillo Espinoza, *Puño y letra,* 106.

acterize the Chilean city streets, as articulated by Patricio Rodríguez-Plaza: "[These images] superimpose themselves upon the large advertisings, the storefronts, the urban signs and the government information in a perverse but also exciting game of perceptual rearrangements."[19] Rodríguez-Plaza here refers to the cognitive shifts that spectators enact when street art forces them to discard the complacency often promoted by corporate- and government-sponsored imagery. Thus, the BRP and the BC sought to democratize not only the mural itself but also its intended audience.

Both the BRP and the BC came together because artists and activists realized that mass media outlets often promoted the interests of the elite and the political right. Mono González has explicitly argued that his work and that of other muralists in Chile has emerged in large part as a challenge to hegemonic systems of communication:

> Mass media has never been in the hands of progressive forces or in the hands of the left. It has always been on the side of economic power, on the side of those who govern. It is through these means that they control culture, mass communication and what is said and how it is said. Deep down inside, this grassroots struggle [muralism and street art] has been about breaking the fence and in order to break the fence we had to occupy public spaces.[20]

For his part, Danilo Bahamondes, a founding member of the BC, argued that his work with the collective was to combat censorship and misinformation on the part of the media by providing the Chilean public with what he called "information solidarity."[21]

BRIGADA RAMONA PARRA

As mentioned earlier, the late 1960s and the political campaigns of Salvador Allende gave rise to the BRP, a collective that "rapidly became the most established, organized, innovative and effective representative of [a] new form of political organization."[22] The emergence of this collective was also part of a larger cultural project spearheaded by Allende's Unidad Popular coalition, an initiative that had "the support of many artists and state institutions."[23] Central

19. Rodríguez-Plaza, *Pintura callejera chilena,* 70.
20. "El Arte del Muralismo Callejero Brigadista Chileno."
21. Castillo Espinoza, *Puño y letra,* 77.
22. Trumper, *"A ganar la calle,* 231–32.
23. Errázuriz and Leiva Quijada, *El golpe estético,* 13.

to this project was a new understanding of the role of the artist in society, as art critics Milan Ivelic and Gaspar Galaz explained: "[Artists] did not situate themselves on the margin of crucial problems that affected the community; they were not neutral observers of spectacles destined for purely visual or formal explorations. They situated themselves at the very center of these problems so that they could address them through art."[24] The BRP fully embraced the idea that artists had a responsibility to work in a community and put their creativity at the service of social justice movements. Many brigadistas regarded Allende and the UP coalition as purveyors of such ideals for a better society.

Even though artists, scholars, and historians alike often refer to the brigade as a single collective, the fact of the matter is that the BRP "brand" replicated itself throughout Chile with dozens of different satellites or branches of the collective spread throughout numerous cities and towns in the country.[25] Speaking some four decades after the original inception of the BRP, Chinchín Tralma would recall the primary objectives and methods utilized by the collective:

> When the brigades formed, it was made up of laborers, high school students and college kids. Nobody had studied art. Our function was to develop political propaganda and our objective was to get Allende to the presidency. That motivated the creation of images and iconography such as the pigeon or the raised fist. . . . We would place a pencil in the raised fist and that became the icon of the struggle of the students. If we interchanged the shovel for the pencil, then that would come to represent the struggle of the copper miners.[26]

Indeed, the BRP's aesthetic was defined by the use of recurring iconographic motifs such as a Chilean flag, raised fists, doves, hammers, and sickles, all of which were painted with flat colors and thick black outlines. The symbolism of these images was to remain fairly basic, as Mono González made clear:

> There is a hand and a face, a fist, which has to do with struggle, an open hand, which has to do with generosity and commitment. . . . There are only two or three elements. The flag . . . has to do with nation, with identity, with struggle, with human relations. . . . The themes are simple.[27]

24. Ivelic and Galaz, *Chile, arte actual,* 154.
25. Manquez, *BRP "Huellas de Color."*
26. Quoted in Lord K2, *Street Art Santiago,* 69.
27. Quoted in Trumper, *Ephemeral Histories,* 104.

González argued that the BRP murals were created "just like the art of the primitive Christians in the catacombs which was made of symbols and letters."[28] The name Ramona Parra was that of a young communist activist who in 1946 was slain by police in Plaza Bulnes, a public square in the heart of Santiago.[29] She along with five other victims became the symbol of the Communist struggle against government forces.

The BRP pioneered a mural technique that allowed them to make murals quickly and effectively. "They began to employ a strict division of labor," Camilo Trumper explained, "emphasizing speed and efficiency in their work."[30] Writing in 1972, Ernesto Saúl interviewed an anonymous member of the BRP who explained to him in great detail the development of the brigada's style:

> The work of the brigades requires practice. During the campaign of the comrade president, Salvador Allende, we worked on the margins of the law, running away from police. Things had to be done well and quickly. We painted lines the thickness of a house paintbrush, at arm's length and using only one color. The end result were images with paint drips and no aesthetic vision. Then we realized that we could do things better. We began making wider letters with careful outlines. We used two colors and painted the surface of the walls that were dirty until we finally figured out how to use three colors: a background, an outline and a letter of another color. By the end of the electoral campaign we had a great number of pieces all across the country.[31]

Though this artist made these comments during Allende's presidency and before the coup d'état, the working technique of coalescing pragmatic and aesthetic needs as a group proved itself highly valuable and transformative after the dictatorship. So even to this day, when the BRP take to the streets to make a new mural, they divide the labor into three groups of artists who attack the wall more or less at the same time: *trazadores* (designers), *rellenadores* (fillers), and *fondeadores* (backgroundists). The trazadores are the ones who draw the basic outlines of the figures and objects in the mural (see figure 1.1.), outlines that are then repainted with the thick black lines, which are characteristic of the BRP aesthetic: "The *trazado* was born out of necessity for speed and communal practice, but it was a technical innovation that ultimately defined the brigade's aesthetic identity and potential role in political communication."[32]

28. González, "El arte brigadista."
29. Sandoval, *Palabras escritas en un muro,* 28.
30. Trumper, *"A ganar la calle,"* 235.
31. Quoted in Saúl, *Pintura social en Chile,* 91–92.
32. Trumper, *Epehemeral Histories,* 100.

The rellenadores fill in those outlines with flat color usually following the lead of the trazadores who indicate to them which colors to use (see figure 1.2). The fondeadores then paint the background of the figures first traced by the trazadores. While this approach to working collectively was born out of a pragmatic necessity to work quickly and avoid confrontations with law enforcement, it also defined the trademark aesthetic of the BRP. Even in circumstances where expediting mural making is not a necessity, the BRP still retained this modus operandi. Not only did it promote the BRP's trademark style, but it also facilitated the recruitment of local community members for the creation of the mural. From its inception in the 1960s, this collective "imagined a community of citizens who could participate in constructing an alternative vision of the state and nation."[33] For example, individuals not trained in the arts, including children, can easily take on the role of rellenadores or fondeadores. Moreover, the BRP approach this division of labor in clearly nonhierarchical fashion, as the trazadores rarely if ever take the credit of being the artistic "masterminds" behind the mural, instead opting to work anonymously under the banner of the BRP. Such a tactic for collective action then establishes a continuum between the mural's style, the means of its production, and its capability for community engagement; in other words, rather than having these three elements function independently from one another, they operate as an organic whole. The BRP's practice of visual democracy thus entails a conscious convergence of art making, collectivity, and political action.

After the return to democracy, the BRP regrouped with its original members, some of whom had returned from exile, and younger artists such as Mario Carrasco, Verónica Loyola, Francisca Muñoz Tralma (Juan Chinchín Tralma's granddaughter), and others. Carrasco, who began working with the BRP around 2003, when he was only thirteen years old, argued that he had to prove himself before the older artists: "In the Brigada Ramona Parra you have to start at the bottom so I began by cleaning brushes. . . . But then I improved and they let me draw and paint."[34] Mono González explained that these artists started going into the streets at this time with the purpose of "rescuing memory and recuperating spaces for truth and justice."[35] Sebastián González, Mono's son, joined his father and the newly constituted BRP during the early to mid-2000s: "It is a duty for me as a son to continue with the legacy of the brigade, to continue with the historical responsibility of recuperating memory, the graphic and historical memory."[36] Juan Chinchín Tralma

33. Trumper, *Epehemeral Histories*, 97.
34. Long, "The Chilean muralists who defied Pinochet."
35. Carrasco, *I Sogno Dipinto / El sueño pintado / O sonho pintado*, 138.
36. Manquez, *BRP "Huellas de Color."*

FIGURE 1.1. Mono González working on a mural as a trazador, Santiago, Chile, 2014. Photograph: Guisela Latorre.

FIGURE 1.2. Children working on a mural as rellenadores, Santiago, Chile, 2014. Photograph: Guisela Latorre.

described the second generation of artists who joined the BRP as repressed youth who considered themselves "the children of the dictatorship."[37] In other words, they were artists who were born during or shortly after the military coup of 1973 and who had not lived in a democratic Chile until 1990. The act of remembering a lost history and connecting with younger generations was

37. Bolsillos Vacíos Producciones, *Brigada Ramona Parra: Rayando en la Clandestinidad.*

crucial to the activities of the BRP in the 1980s, as BRP member Boris Rivera recalled: "Because of the dictatorship, we had to forget several things. During our conversations [in the 1980s], many of the experiences we had together [as artists and activists] begin [to] flower to the surface."[38] The older artists then passed on their knowledge to the younger artists as a means of rescuing this memory and assuring a historical continuity for the BRP. Isabel Piper Shafir has argued that artists and activists who create sites of memory in Chile seek "to materialize a particular relationship between the past, present and future [by] appropriating and inhabiting certain spaces through actions of remembering which give meaning to the past."[39]

During the late 1980s and on the eve of the referendum that allowed Chileans to vote on whether Pinochet should stay in power or not through a simple "yes/no" ballot, BRP murals began to emerge in various parts of the country. The dictatorship was still in power, but authorities had somewhat loosened their tight grip on censorship, as transnational human rights groups were closely watching what would become a transition to democracy in the nation. In 1988, the BRP painted an untitled mural along the major freeway thoroughfare called the Panamericana Sur, near the mostly working-class commune of La Cisterna in Santiago. In this mural, we see powerful symbols associated with the ideals of the Chilean left, such as the Communist hammer and sickle and the acronym of the BRP. Coupled with these symbols are the figures of Chilean citizens who rejoice as the winds of change sweep the country. The slogan "¡A La Calle!" [To the streets!] complements the other visual signifiers in the mural and operates as a call to action to drivers and passersby who are encouraged to engage in public protest. During this phase of the BRP, the members of the collective changed their slogan from the 1960s and '70s, "¡Pintaremos hasta el cielo!" [We will paint to the sky!], to the slightly modified statement "¡Contra la dictadura, pintaremos hasta el cielo!" [Against, the dictatorship, we will paint to the sky].[40]

The BRP's continued work on the streets is certainly connected to the group's enduring commitment to social justice, as Tralma explained: "We fell in love with an ideal society and we are still in love, we continue fighting."[41] However, the post-dictatorship era presented the group with challenges associated with the country's problematic transition to democracy and with the bitter divisions among left-of-center political parties. As mentioned earlier, the reintroduction of democracy in Chile was mired by the continued

38. Manquez, BRP "Huellas de Color."
39. Piper Shafir and Hevia Jordán, Espacio y recuerdo, 13.
40. Castillo Espinoza, Puño y letra, 152.
41. Quoted in Lord K2, Street Art Santiago, 69.

power held by Pinochet and by the impunity he enjoyed in spite of the blatant human rights abuses and crimes committed by his government. For the BRP, there was no clear and unanimous step forward among its members and protagonists. Nevertheless, during the mid-2000s veteran brigadistas such as Mono González, Chinchín Tralma, and Boris Rivera—individuals who had worked with Allende during the early days of the BRP—came together as an arts collective to teach and share their knowledge with younger members and participants of the brigade, as González maintained: "At that time, the function of that collective was for us old people to transfer our experiences to the young folks without the intention of forming another brigade on the side."[42] But González stated that a small number of brigadistas did just that; they began working independently from the larger activities of the BRP and formed another group called Colectivo Brigada Ramona Parra (CBRP). While this group created murals that generally reflected the aesthetic of the BRP and worked with social justice themes, they did not proclaim political alliances. Speaking in his capacity as a member of the CBRP, Tralma publicly stated this group's independence from political parties: "We have said something that has bothered some, [but] culture has neither party politics, nor religious affiliations."[43]

As mentioned earlier, the BRP was created to provide a propaganda platform for the JJCC and to work for the Allende presidential campaign. The JJCC is a group that has operated as the youth contingent of the Communist Party since the early decades of the twentieth century.[44] The CBRP's separation from JJCC thus seemed to be a disrespect toward the origins of the BRP. As a matter of fact, the issue of the origins and the participation history of the BRP became critical sites of contestation for many individuals who had once worked with the group. González himself became increasingly concerned about individuals who claimed to be in the trenches during the struggles against the dictatorship, but were not: "They were there during Allende's government, but from there they went on [sic] exile. They were abroad and went about their lives. After things were settled down and conquered during democracy, they reappeared."[45] González's words signal a tension between those who were exiled and those who stayed in Chile during the dictatorship. This tension, among others, created bitter disagreements about who was enti-

42. Phone interview with Guisela Latorre and Mono González, Columbus, Ohio, and Waterloo, Canada, June 14, 2017.

43. Bolsillos Vacíos Producciones, "Brigada Ramona Parra: Rayando en la Clandestinidad."

44. For more information on the Juventudes Comunistas (JJCC,) see their website: https://jjcc.cl/ (accessed on June 21, 2017).

45. González phone interview.

tled to lay claim to the struggles against oppression and whether it was even politically acceptable for a person to tout their individual contributions within the collective structure of the brigades. González would eventually dissociate himself from the artists who formed the CBRP stating that they were not the BRP but merely a collective that took the Ramona Parra name and that operated on the streets with only a handful of people.[46] Yet, in the various interviews and public appearances made by artists associated with the CBRP, it is clear that they see themselves as part of the broader lineage of the BRP and not as a separate collective.[47] Moreover, it is also unclear if the larger Chilean public knows that there is a difference between these groups. Nevertheless, the BRP proper continues to operate in various cities throughout Chile, often painting in poblaciones while still maintaining their affiliation to the JJCC. The group is composed of young artists and activists, most of whom have maintained a certain degree of anonymity. For González, who professes his affiliation to the BRP but not the CBRP, it is this group of young street artists who are truly carrying the banner of the BRP into the twenty-first century.[48]

I will now turn to the work of both the CBRP and the BRP created in 2010s, for I argue that both brigades have provided a range of alternatives and possibilities for the enactment of visual democracy. The imagery that they produced and the community interactions that they enabled represented radical and meaningful interventions into public space. In November 2012, the CBRP participated in "Hecho en Casa," the first festival of urban intervention that took place in Santiago and sponsored by the city municipality, the Ministry of Tourism, the Gabriela Mistral Cultural Center (better known as the GAM), and other government agencies. For their contribution to this festival, the CBRP painted an untitled mural that focused on the political struggles of the past and present in Chile while also underscoring the figures of marginalized and disenfranchised populations in the country (see figure 1.3).

Placing such figures within the context of the GAM building bears mentioning as well. Built in 1971 during Allende's administration and with the name Centro Cultural Metropolitano Gabriela Mistral (CCMGM), the structure was created to host the Third United Nations Congress on Trade and Development in April of the following year. After the conclusion of this congress, the building was dedicated to showcasing a wide array of cultural activities including the creation of the Museo de la Solidaridad (the Solidarity

46. González phone interview.

47. To see the interviews and public appearances of the CBRP, see Long, "The Chilean muralists who defied Pinochet," and Bolsillos Vacíos Producciones, "Brigada Ramona Parra: Rayando en la Clandestinidad."

48. González phone interview.

FIGURE 1.3. Colectivo Brigada Ramona Parra, Untitled (2012), mural, Centro Cultural Gabriela Mistral, Santiago. Photograph: Guisela Latorre.

Museum),[49] which Allende himself described as the first in the "Third World" to "bring closer to the masses the highest manifestations [of] contemporary art."[50] With the military coup, however, the CCMGM was quickly transformed into the center of military operations during the early years of the Pinochet regime. In 1975 the government would change the structure's name to Edificio Diego Portales, named after the nineteenth-century statesman and entrepreneur who had championed conservatism and constitutional authoritarianism, thus becoming an important allegory for the dictatorship. Much of the art associated with the UP that was on display in this building was removed and replaced by portraits of national heroes and emblems approved by the regime. Moreover, the government surrounded the compound with gates, thereby making it largely inaccessible to the population at large. "Put simply, the military world imposed its own codes, flags and heroes [on the building]," Errázuriz and Leiva Quijada commented.[51] In 2006, in a time of democracy, part of the building was consumed by a fire, an event that prompted the first administration of Michelle Bachelet to "reestablish its original function and return it to the citizenry."[52] The building was redesigned (parts of it rebuilt), opened to the public, and renamed the Centro Gabriela Mistral. Trumper has rightfully observed that this structure has been "fluidly reimagined and reinvented over its forty-five years."[53] The CBRP mural in this location clearly made an intervention into this charged history as the participating artists attempted to align this locale to the histories of struggle and political mobilization among the Chilean population.

In the iconography of the CBRP's GAM mural, the artists focused on the figures of a fisherman, a Mapuche male, a school-age adolescent, and a copper miner. All these individuals allegorize the current and past struggles of underserved populations in Chile. The fisherman alludes to the 2012 *La Ley de Pesca* (Fishing Law), which granted a small group of wealthy families and transnational corporations control over the fishing profits in the country, at the expense of the livelihood of artisanal fishermen and women who function as autonomous, independent, and self-sufficient entities in relation to national and transnational corporations. Environmentalists have long regarded artisanal fishing, or *pesca artesanal,* as a more sustainable and less damaging fishing practice than the large-scale fishing operations carried out by corporations, which often damage and deplete marine wildlife and ecosystems. In

49. For more information of the Museo de la Solidaridad, see chapter 2 of this book.

50. Cited in Errázuriz and Leiva Quijada, El *golpe estético,* 91.

51. Errázuriz and Leiva Quijada, *El golpe estético,* 97.

52. "Historia."

53. Trumper, *Ephemeral Histories,* 17.

this mural, the CBRP renders the figure of the artisanal fisherman as a being who is in tune with the natural movements and shapes of nature as his arms curve echoing the undulation of the ocean waves behind them and the shape of the fish he holds in his hand. A monster-like bulldozer that approaches the fisherman, however, threatens his livelihood. This machine represents the large corporations that contribute to the economic marginalization of artisanal fishing in the country. The CBRP muralists also hold the Chilean government accountable for this impending doom as we see that La Moneda, the presidential palace, sits on top of this ominous apparatus.

As spectators walk from the right of the mural to the left, they will encounter the imposing figure of a Mapuche man who is being offered a *clava* and a *chos* symbol by a pair of disembodied hands. The clava is a hand-club that denotes power, authority, and prestige for the bearer while the chos symbol represents the sun as well as notions of renewal connected to the earth's agricultural richness. The chos is also a political symbol for indigenous struggles over self-determination as it is featured in the *wenufoye,* the Mapuche flag. The growing activism among *pueblos originarios,* or first nations, in Chile has brought to light the bitter, persistent colonial legacy that still affects this country. Of particular concern to Mapuche activists has been the return of ancestral lands in the southern region of Araucanía. Many of these lands are owned by Chilean logging and farming companies that export wood to the United States and elsewhere, thus pitting indigenous activists against neocolonial institutions of globalization. Mapuche activists, however, have been met with often-brutal responses from the Chilean government, which enacts the 1984 Pinochet-era counterterrorism law to deal with Mapuche activists. This law basically doubles the penalties for acts of violence and public disturbance if authorities determine these to be acts of terrorism against the state. Both transnational human rights groups and the United Nations have publicly denounced this law. In this CBRP mural, however, the artists depict this Mapuche man neither as a terrorist nor a victim. He defiantly returns the gaze of the viewer as if demanding recognition and autonomy while also proudly showcasing the cultural symbols that surround him.

The political struggles of the Mapuche man are then followed by the activism for educational reform that has been taking place in the country for almost a decade now, personified in the figure of a teenage figure dressed in a school uniform. Displaying indeterminate gender characteristics, this adolescent is flanked by two flags with the following inscriptions: "We want excellence in education for all Chileans!" and "Free and inclusive education, now!" Similar to the Mapuche man, this figure is also confronted by a series of disembodied hands with attributes connected to education, namely books

and pencils. One of the books reads "(True) History of Chile . . . and Indigenous Languages." The artists created this mural in the context of the larger student protest movement that began nearly a decade ago and has continued to this day. Students and educators alike have taken to the streets demanding the reform or end of the mostly privatized and decentralized school system in Chile that places profit above and beyond the needs and interests of students. This neoliberal approach to education has spawned generations of inequality in the country leading protesters to occupy various public schools in the process. J. Patrice McSherry and Raúl Molina Mejía have argued that the current state of education in Chile is a relic from the dictatorship's social reforms: "The student-led mass movement is demanding the democratization of the Chilean state and economic model bequeathed by Pinochet."[54] These student activists represent primarily a youth movement belonging to a generation born after the end of the dictatorship: "In contrast to those who endured the savagery of state-sponsored terror, they are not afraid of government threats and repression."[55] Such courage and resolve is embodied in the figure of this student painted by the CBRP as their gaze, not unlike that of their Mapuche comrade, unflinchingly confronts the spectator. Their demands, however, are not only for greater access to educational opportunities and for an end to the for-profit system, but they are also for a more culturally diverse curriculum. The demand for a true history of Chile and indigenous languages, as indicated on the cover of one of the books the teenager holds, points to the biases and voids that currently fill the curricula of the educational system where contributions to Chilean history—most notably those of its Mapuche populations—have been trivialized at best or completely ignored at worse.

The liberatory discourse that comes out of the student activists has also embraced other seemingly unrelated causes. In their discussions and negotiations with the Chilean government, the leadership of the student movement has suggested that the government use some of the profits from the increasingly profitable copper industry to invest in education. It was fitting then that the CBRP would include the figure of a copper miner adjacent to that of the student activist. Copper is Chile's most important and profitable export, with the state-owned company CODELCO running the majority of its mining operations. The nationalization of the copper industry was completed during the administration of Salvador Allende, a move that made him into a pariah among capitalist countries including the United States, who had numerous stakes in that industry. In the mural, we see the figure of the quintessential

54. McSherry and Molina Mejía, "Chilean Students Challenge Pinochet's Legacy," 29–30.
55. McSherry and Molina Mejía, "Chilean Students Challenge Pinochet's Legacy," 30.

copper miner next to the tools of his trade: a hammer, a pickaxe, and shovel. Behind him is the arid topography of the Chilean desert in the north, where most of the copper mines are located. A banner to his left reads "El cobre para Chile ahora" [Copper for Chile now], which reflects workers' resistance to recent attempts to reprivatize parts of the industry on the part of investors and the business sector in Chile and abroad. The figure of the copper miner and this banner refers then to the political and economic debates that surround the copper industry in Chile. Even though copper miners are perhaps the best paid and most empowered blue-collar workers in the country, the dangerous and physically taxing nature of their work simultaneously marks them as a vulnerable population. So rather than celebrating the material and financial gains brought about by copper, the CBRP muralists instead focus on the working body and activist mind of the miner, without whom the world would not benefit from the wealth of Chile's mineral resources.

While all the political issues the CBRP addresses in this mural are distinct and individual, all with their own specific histories and debates, they are also part of a larger matrix of radical social action that is integral to Chilean society. The CBRP underscores the interrelatedness of these social struggles through the use of repeating forms, lines, and colors throughout the mural. Recurring iconographic motifs, such as the disembodied hands and background landscape elements, further bind these figures together. Implicit here is also the link between the CBRP muralists themselves and the figures depicted on the wall, as they also share a commitment to social justice. The kinds of visual and thematic symbioses the muralists establish here are characteristic elements of visual democracy that signal an aesthetic that recognizes convergences and intersections between creative expression and political activism.

Even though this CBRP mural largely succeeded in illustrating how different activist causes relate to one another in Chile, it clearly overlooked how gender has played a role in the country's history of social inequality. As it is represented in this mural, the process of empowerment and liberation is experienced by a group of mostly male figures who share affinities with one another. With the possible exception of the student figure, all the individuals painted on this wall are decisively coded as male. Moreover, the artists failed to register the fact that gender oppression, be it sexism or queer phobia, is a significant driver of social injustice in Chile, one that intersects and interacts in insidious ways with racism and class discrimination. The limited vision of oppression coupled with the masculinization of empowerment in this mural reflects the regressive gender politics of so-called revolutionary struggles in the country. Attempts to democratize social relations in Chile after the dictatorship privileged class over other forms of oppression and subordination

such as sexism, racism, and homophobia, as will be discussed in greater depth in chapter 4. Mural production was and continues to be affected by limited views of equality and social struggle.

The CBRP mural in the GAM was quite a high-profile piece located in a prime location of Santiago. The artists enjoyed generous funding from the state, yet still managed to retain creative autonomy when it came to the political message and imagery they depicted on the wall. By contrast, however, the murals created by the BRP in the 2010s did not have as much visibility as the wall secured by the CBRP in the GAM, yet they made equally significant interventions into the public sphere. In 2017 the BRP worked closely with the local community in the Población Chacabuco to create a mural intended to promote a sense of pride and belonging among residents of this población, especially the children (see figure 1.4).

Located in North Santiago within the commune of Recoleta, Chacabuco was built in 1966 during the presidency of Eduardo Frei Montalva. Though the history of poblaciones in Chile will be detailed in greater depth in chapter 2 of this book, it bears mentioning here that Chacabuco possessed a complex political history that was important to the members of the BRP. Large portions of this población were built by residents themselves who had received support from a state housing program developed by Frei Montalva's administration. But, in spite of government funding, the labor required to build the población was grueling to an extreme, even leading to the death of some residents/laborers who toiled for excessively long hours.[56] Nevertheless, the history of Chacabuco's "self-construction" also stimulated a culture of solidarity, pride, self-determination, and collective action among its pobladores. Women were particularly active in creating solidarity networks among residents. During moments of scarcity, when pobladores were lacking basic necessities such as food and proper nutrition, they organized soup kitchens and pooled different resources among the community.[57] In times of dictatorship, however, the culture of solidarity was deeply fractured in Chacabuco, as government forces infiltrated the población, forcing some residents to blow the whistle on Communist "agitators" in the community.[58] Soon the culture of solidarity was replaced by a culture of fear and suspicion. Thus, the post-dictatorship era for

56. Zenteno Sotomayor, "Población Chacabuco, una aproximación a la dimension simbólica del sujeto poblador," 97.

57. Zenteno Sotomayor, "Población Chacabuco, una aproximación a la dimension simbólica del sujeto poblador," 99.

58. Zenteno Sotomayor, "Población Chacabuco, una aproximación a la dimension simbólica del sujeto poblador," 100.

FIGURE 1.4. Brigada Ramona Parra, Untitled (2017), mural, Población Chacabuco, Recoleta, Santiago. Photograph courtesy of Nicanor Huayón.

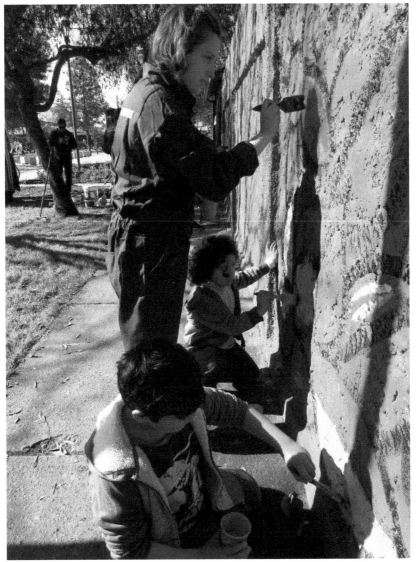

FIGURE 1.5. Brigada Ramona Parra painting with children (2017), Población Chacabuco, Recoleta, Santiago. Photograph courtesy of Nicanor Huayón.

Chacabuco represented an opportunity for the recovery of the población's history of solidarity and self-determination.

The BRP mural in the Población Chacabuco was meant to further promote the culture of pride and solidarity that was at the root of local history there. This work's iconography depicted an idyllic representation of the población

where flowers, birds, and a bright sun punctuate the urban landscape. This space is a safe and nurturing one for children who are seen enjoying outdoor activities such as soccer and kite flying while a neighborhood dog looks on. The themes of safety and well-being are ones that counteract the culture of fear and suspicion that the población once had. Large allegorical figures, operating as bookends in the composition, personify the surrounding natural landscape and appear to protect the neighborhood and their inhabitants. The inscription "Cuidemos nuestro barrio" [Let's take care of our neighborhood], written next to one of the allegorical figures, encourages pobladores to love and protect their community and living spaces. Such a message was a public reminder to residents that Chacabuco has a powerful history of autonomy and self-determination. All this imagery is rendered in classic BRP style: thick black outlines, flat colors, and direct messaging. Added to this familiar aesthetic, however, is the child-like quality and style of the mural. Indeed, the BRP wanted to make clear that children had actively participated in the creation of this wall painting (see figure 1.5). Such a gesture was indicative not only of the BRP's commitment to broad community engagements but also of their recognition that Chacabuco was a space fashioned and contoured by the pobladores themselves, including the youngest ones.

The images painted on that wall in Chacabuco became only one of several means by which the BRP engaged the spirit of solidarity that was endemic to the población. The very site of the mural became a space of generosity where acts of collectivity took place between artists and pobladores. As a form of gratitude to the artists and activists of the BRP, local residents prepared a lunch meal that they laid out on a long table in close proximity to the mural (see figure 1.6). Eating and sharing food together became a simple yet profound act of solidarity through which differences between artists, activists, and pobladores were rendered indistinguishable. The very site of the mural was thus charged with a sense of kinship among those present.

A Mapuche community then joined the BRP in their celebrations of this new mural in Chacabuco. This group's *machi,* a traditional healer and spiritual leader,[59] directed the group of participants into a ritual invocation that called for everyone to reflect on "our connection to nature" (see figure 1.7).[60]

In a highly symbolic gesture, the participants proceeded to plant an araucaria tree close to the mural. The tree was also depicted in the mural's iconography (see figure 1.8). Araucarias are native to Chilean soil and are considered one of the oldest species of its genus. These trees are sacred to the Mapuche

59. For more information on machis in Mapuche culture, see chapter 2 of this book.

60. Description of the BRP mural in Población Chacabuco posted by the brigade in the group's Facebook page: https://www.facebook.com/BRP.JJCC/ (accessed on June 22, 2017).

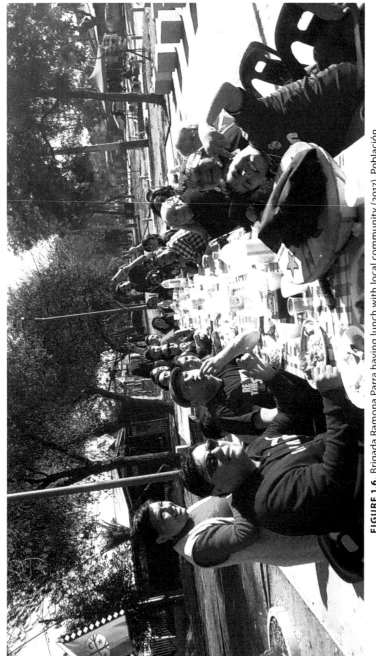

FIGURE 1.6. Brigada Ramona Parra having lunch with local community (2017), Población Chacabuco, Recoleta, Santiago. Photograph courtesy of Nicanor Huayón.

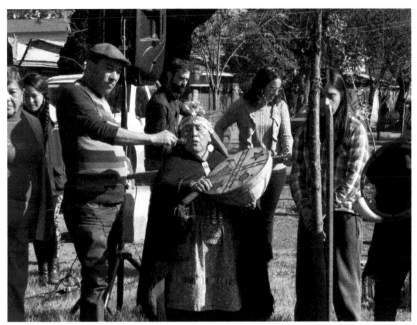

FIGURE 1.7. Brigada Ramona Parra with Mapuche *machi* (2017), Población Chacabuco, Recoleta, Santiago. Photograph courtesy of Nicanor Huayón.

Pehuenche community, for these indigenous populations used their *piñones* (seeds) for medicinal and nutritional purposes.[61] The presence of this tree in Chacabuco was a reminder to the pobladores that they stood on native land. Within this context then, the mural's call for the protection and safeguarding of the población not only included the built structures and their people but also the natural landscape that surrounded them. Solidarity thus could be extended to the environment. Ultimately, the work of art that the BRP created with the pobladores in Chacabuco included the mural itself, but it also encompassed the collective, performative, and coalitional work that made the imagery on the wall all the more meaningful.

BRIGADA CHACÓN

By contrast to the BRP, the visual repertoire of the BC consists simply of long paper banners called papelógrafos pasted along city streets, which contained politically charged statements meant to provoke audiences and authorities

61. "Araucaría, pehuén."

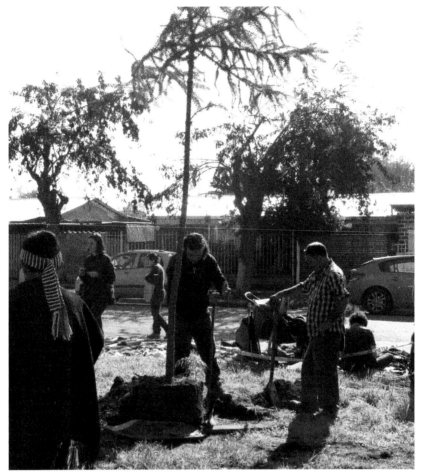

FIGURE 1.8. Brigada Ramona Parra helping to plant araucaria tree (2017), Población Chacabuco, Recoleta, Santiago. Photograph courtesy of Nicanor Huayón.

alike, often using irony and humor. The idea of creating these papelógrafos came from BC member Antonio Rojas who one day showed his fellow briga-distas a "new invention," so to speak. He pasted one flyer next to the other on a long piece of paper, an idea that was met with great approval by his com-rades given the format's potential for visual impact.[62]

The BC was named after Juan Chacón Corona who was a laborer and early militant of the Communist Party in Chile as well as a revered leader of the political left in the early twentieth century.[63] Ricardo Rodríguez, long-

62. Interview with Ricardo Rodríguez and Mono González, March 25, 2017, Santiago, Chile.

63. Sandoval, *Palabras escritas en un muro,* 63.

time member of the BC, has argued that the collective was also inspired by Chacón's political antics: "When he arrived in parliament, . . . he often used irony and irreverence during debates with other political powers. That is why we honor and recognize the old Chacón."[64] As mentioned earlier, the BC originated in the 1960s when Communist politician Volodia Teitelboim needed help promoting his campaign for the Santiago senate, as Rodriguez recounted: "The Communist Party did not have a propaganda brigade to campaign for Teitelboim so they took people from the BRP, among them Danilo [Bahamondes], and they gave them to the party to conform the propaganda brigade for Teitelboim. That is how the first Chacón was formed."[65]

In 1987, still in times of dictatorship, the BC was reconstituted as a result of a special request from the Chilean Communist Party: "Suddenly in the year '87 we are contacted by the Communist Party to entrust us with a propaganda gig."[66] It was then that Rodríguez met Danilo Bahamondes, one of the founding members of the BC. These years were characterized by the development of varied and complex skills to work on the streets, as explained by Rodríguez: "It was complicated work. You had to have military knowledge to move and manage yourself on the streets."[67] Such street smarts were coupled with the creation of public statements about the current state of affairs in Chile. The various members of the brigade were energized as a collective when in the late 1980s Chile was thrust into the international spotlight because the US Food and Drug Administration discovered that two grapes exported from Chile were injected with cyanide. As a result, the FDA imposed an embargo on all fruit from Chile, causing losses in the millions of dollars for the country's agricultural businesses. Carlos Cáceres, who was minister of the interior during the last year of Pinochet's regime, made the controversial and unfounded claim that it was the Communists in Chile who poisoned the grapes.[68] Their first papelógrafo was made in direct reaction to the government's response to this economic crisis, criticizing it for its gross vilification of the Communist Party and the Chilean left, as a whole. This banner read simply "Cáceres les miente" [Cáceres lies to you]. During this period in the late 1980s, the brigade still operated illicitly, avoiding parts of the city that that were too crowded, which could make the brigadistas visible to law enforcement. As the transition to democracy and the 1989 referendum came near, however, they became more

64. Brigada Chacón interview with Ignacio Franzani.
65. Rodríguez and González interview.
66. Rodríguez and González interview.
67. Valenzuela, "Ricardo Rodríguez, líder de la brigada muralista del PC: 'Ojalá que de aquí a dos años no sea necesaria la Chacón."
68. Sandoval, *Palabras escritas en un muro,* 55–56.

daring, taking on walls in the Alameda, Santiago's principal avenue. The heavy foot and vehicle traffic along this avenue could also help the BC maintain their anonymity: "You can get lost among [so many] people," Rodríguez recalled.[69] In some instances, pedestrians who were present at the moment of a BC intervention offered the brigadistas support by protecting them. Within a few years of posting antidictatorship papelógrafos, the BC had acquired a certain degree of fame and mystique among the public. People began to wonder who were those bold radicals who dared posting militant messages in the streets. "It was very easy [in those days] because you could just post 'down with Pinochet' and the whole world would adore you," Rodriguez explained. "It was a lot easier politically. It is not like now. Now it is a lot harder," he further commented.[70] Speaking in 2017, Rodríguez's comments about the present day refer to the difficulty in articulating a progressive agenda in a Chile where the many parties and ideologies of the political left do not represent a unified front and where right-leaning politics cut across different ideological persuasions.

Even though the BC's work is primarily text-based, I include it in this book as an important proponent of visual democracy because the effect of the papelógrafos is largely visual. This visual component rests on the intentional simplicity of their lettering, the stark contrast between the white and black coloring and the strategic placing of their pieces, often located in places where they can make the greatest aesthetic and political impact. "We target the site with our message," Rodríguez has said; "it's not willy-nilly."[71] Patricio Rodríguez-Plaza called their papelógrafos "daring, direct, contingent, rebellious, and politically iconoclastic texts."[72] The BC's original decision to do paper-based murals stemmed from the uncertain political reality Chile was experiencing during the transition to democracy. Bahamondes, Rodríguez and their fellow brigadistas were palpably aware that the public sphere was still being surveyed and policed by the military and law enforcement, thereby still making it dangerous for artists to take to the streets. Thus, the papelógrafo functioned as a "pre-made" mural ready to be installed in a matter of minutes.[73] While this decision was forced by circumstance, in time, the format and practice of the papelógrafo became integral to the BC's aesthetic. Moreover, the papelógrafo inhabited the uncertain middle ground between murals, protest banners/signs, and political posters, thus fitting in quite well with the hybrid nature of the urban sphere while also paying homage to all these artivist traditions.

69. Rodríguez and González interview.
70. Rodríguez and González interview.
71. Brigada Chacón interview with Ignacio Franzani.
72. Rodríguez-Plaza, *Pintura callejera chilena,* 65.
73. Rodríguez-Plaza, *Pintura callejera chilena,*159.

The BC's mission also stemmed from their roles as radical, alternative, and unofficial overseers of Chile's transition to democracy, a process that was met with a great deal of skepticism on the part of these artists, as Bahamondes explained: "We were critical of many of the attitudes from people in La Concertación who negotiated the transition with people in the military. A case in point, Pinochet was offered the position of senator for life."[74] Political alliances, however, were the sources of heated debate and ardent disagreement within the ranks of the BC. In 1994 the group experienced a critical break due to ideological differences. Members of the brigada, including Danilo Bahamondes and Ricardo Rodríguez, were at odds with one another regarding social justice issues. "There were a lot of problems with people's unhappiness, with the Concertación, with democracy, and we [the BC] were posting crap about clean air, about saving the whales."[75] By the 1990s, a number of the BC members were displeased with the political direction of the collective, feeling that the messages they were positing were not sufficiently in tune with current Chilean social problems and that they didn't seem to follow the political stances of the Communist Party. As Rodríguez explained the course of events to me, Bahamondes told him in the mid-1990s that the Communist Party had expelled the BC from its ranks and then invited him and other brigadistas to join a well-funded group of former members of the Communist Party. It was clear that some members of the BC had become embroiled in power games between the different parties belonging to the political left and center-left, as Mono González indicated to me:

It is very important to say that at that moment the Communist Party was not with the Concertación. They were the opposition, not like today [in 2017] that they are part of the Nueva Mayoría [New Majority].[76] One of the things that was happening is that the Concertación was trying to bring in the Communist Party, and if they could not bring them in, they tried to divide them. So there was a political game which was the most visible part of that division [within the BC].[77]

74. Sandoval, *Palabras escritas en un muro*, 69.

75. Rodriguez and González interview.

76. The Nueva Mayoría ("New Majority") is a political coalition that brought together left and center-left parties. It was formed in 2013 in conjunction with the second presidential campaign of Michelle Bachelet who remains the coalition's leader, as of this writing. Though the proponents of the Nueva Mayoría asserted that the coalition represented a new commitment to the Chilean people—one that learned from the mistakes and missteps of the Concertación— critics and skeptics have called this political merger "the same thing with different clothing." See Campos, "Voces fuera del pacto Nueva Mayoría: 'Es la misma cuestión con otra ropa.'"

77. Rodríguez and González interview.

As a matter of fact, the history of separation, control, and marginalization of the Communist Party in Chile was not new, as Tomás Moulian explains: "In 1947 communists were separated from the government and in 1948 the paradoxically named 'Law for the Defense of Democracy' was approved."[78] This law proscribed the party from participation in government. Speaking more broadly about Chilean social movements, Florencia Mallón maintains that shifting allegiances and internal ruptures are important elements of their developmental history:

> Understanding how these struggles are embedded in the state . . . means understanding the diversity and internal hierarchy of popular struggles— their divisions along regional, ethnic, class, cultural and gender lines—and how state actors and institutions used, deepened and reorganized these divisions through alliance and coalition.[79]

Clearly, the BC became a pawn in the quarrels between the Concertación and the Communist Party. Because of these political skirmishes, Rodríguez would later find out that the BC had not been expelled from the Communist Party but, rather, that Bahamondes had decided to take the brigade elsewhere due to irreconcilable differences he had with the party. Both González and Rodríguez regarded this move as a betrayal and a deception on his part. González—though not a member of the BC but an important insider to the Chilean brigadista culture—argued that Bahamondes ultimately considered the BC to belong to him,[80] an individualist posture that was a clear affront to the collectivity of the brigades. As a founding member whose history with the brigade harkened back to the days of Volodia Teitelboim in the 1960s, Bahamondes might have felt a personal investment and perhaps a sense of leadership entitlement when it came to the BC. Political disagreements notwithstanding, Rodríguez was nevertheless categorical in his recognition of Bahamondes as a key figure in the history of the BC: "I think that the contribution that Danilo made as a founder, a creator and instigator in the brigade is undeniable. We cannot dismiss that. . . . He was the one who did the work, who did the painting and who carried the banners. We followed his lead."[81] This rift within the BC ultimately led Bahamondes to take the brigade to the center-left Partido por la Democracia (PPD, Party for Democracy) and work on the political

78. Moulian, "La vía chilena al socialismo: Intinerario de la crisis de los discursos estratégicos de la Unidad Popular," 44.

79. Mallón, "Decoding the Parchments of the Latin American Nation-State," 50.

80. Mallón, "Decoding the Parchments of the Latin American Nation-State," 50.

81. Mallón, "Decoding the Parchments of the Latin American Nation-State," 50.

campaign of president Patricio Lagos, while Rodríguez and other brigadistas continued their alliance with the Communist Party. "There were two propaganda brigades on the streets; one belonging to the PPD and the other to the Communist Party," Rodríguez recalled.[82] This break did not mean the end of the BC, but it did signal the political complexities and contradictions that often fuel the practice of socially engaged art in Chile.

Even through the conflicts and changes in the political affiliations, the Brigada Chacón has maintained a fairly consistent style and approach to urban intervention. They have mined the power of direct, brief, and simple statements that respond to the current state of affairs with a certain degree of immediacy. Their effective and clever use of economy of words led Rodríguez to jokingly tell me that they were the ones who actually invented Twitter,[83] the social media site that allows users to post messages of only 140 characters or less. The group did join Twitter in 2009, where they post images of the most recent papelógrafos they put up on the streets. The members of the BC also use this site to make additional commentaries on Chilean politics and to establish dialogues with other interested social media users thus making this Twitter site into a virtual and interactive papelógrafo.[84] Having said that, Rodríguez has publicly criticized social movement proponents who are only active online:

> There is a character that I call the "enter" revolutionary. These people go on Facebook or Twitter, give their opinions, curse people out, and do all kinds of things, and then they press "enter." All their stuff goes on the internet, and with that their work is done. After that, they go and drink a Coca-Cola or have coffee in Starbucks. That's how far their political conscience and revolution will go. Our thing is the street; that's what gives us mystique, that's what nourishes us in the brigade.[85]

Rodríguez's statements allude to the BC's need to have a physical presence in urban spaces, one that signals true social commitment, in his opinion. His references to Coca-Cola and Starbucks, however, also operate as a thinly veiled criticisms of US commercial investments in Chile. The "enter" revolutionaries'

82. Valenzuela, "Ricardo Rodríguez, líder de la brigada muralista del PC: 'Ojalá que de aquí a dos años no sea necesaria la Chacón.'"

83. Informal conversation between the author and Ricardo from the Brigada Chacón on the site of a mural, April 5, 2014, Santiago.

84. As of the time of this writing, the BC Twitter account had a total of 8,473 followers, amassing over 25,000 tweets: https://twitter.com/brigadachacon/media (accessed on April 4, 2016)

85. Brigada Chacón interview with Ignacio Franzani.

consumption of such products further illustrates their questionable political commitments. The BC's Twitter presence serves to promote or augment their street work rather than replace it.

Even though the BC predates the popularity of social media and the digital "sound bite," their presence in the Chilean urban landscape capitalizes on audiences who are culturally and cognitively predisposed to uncomplicated and straightforward statements. This simplicity is a ruse, however, for the messages contained in the BC's papelógrafos are quite complex, provocative, and subversive in their implications. Some of these messages require spectators to have a certain familiarity with Chilean politics, a kind of insider knowledge, while others may incite them to inform themselves on topics not fully disclosed by the mainstream media. Part of the brigade's mission is to disseminate information that traditional media outlets may not deem newsworthy. The BC routinely unsettles any sense of complacency that might come about as a result of exposure to the discourses and rhetorical messages espoused by Chilean politicians, in particular those associated with conservative and right-leaning ideologies. Their process of making decisions about what statements should go up on a wall is one that is organic and dependent on the current moment and on debates within the Communist Party. "All we do is use common sense," Rodríguez observed, "[the statements are written] among various people. At times, we don't even use our own phrases. Some of these are just thoughts people use without thinking that they could be transformed into a political slogan."[86]

The papelógrafos produced by the BC in the late 1980s and early '90s centered primarily, as mentioned earlier, on the country's transition to democracy coupled with concerns that La Concertación, the center-left coalition that would govern Chile until the election of Sebastián Piñera, was making too many concessions to the outgoing dictatorship. Perhaps one of the BC's most emblematic banners at that time read, "¡El cambio de verdad! Democratizar la democracia" [Real change! Let's democratize democracy], a papelógrafo that spoke directly to the BC's concerns over the transition to democracy. With this intervention the artists sent a cautionary note to passersby about the difficulties of establishing democratic rule after the culture of repression had so deeply ingrained itself in Chile's social fabric. Thus, the banner here implies that what politicians from la Concertación understood as democracy was not truly democratic. The fact that the abuses of human rights and state-sponsored violence were not properly addressed or criminally prosecuted indicated

86. Valenzuela, "Ricardo Rodríguez, líder de la brigada muralista del PC: 'Ojalá que de aquí a dos años no sea necesaria la Chacón.'"

that the process toward democratic rule was flawed and uneven. With this papelógrafo then the BC encouraged Chileans on the streets to actively participate in this process of transition by speaking out and making politicians from la Concertación accountable for their actions. Moreover, by calling for a "democratization of democracy," the artists put into question the very nature of democracy and its claims to equality and collectivity.

Aside from mastering the art of the sound bite, the members of the BC have become quite adept at finding strategic spaces for the installation of their papelógrafos. The artists focus their public intervention in the center of Santiago, which possesses heavy locomotive and foot traffic, understanding that audience reception of their work will be affected by the places where their banners are seen, as Rodríguez points out:

> We claim as ours all the interventions that happen in the center of Santiago. Anything outside that perimeter is not our responsibility. [But] we teach people from other parts [of the city] such as Renca, Pedro Aguirre Cerda, [and] La Florida [how to do this.] So many people also paint and some of those groups don't have our same sense of critique.[87]

A favorite locale for the BC and other street artists is the underpass where the Alameda, Avenida Carmen, and Diagonal Paraguay intersect in Santiago, quite possibly the busiest and most hectic urban junction in the city. It was here, for example, where they posted a banner with the inscription "Ley de Pesca . . . otro regalo pa' los empresarios" [Fishing law . . . another gift for business people] in 2012 (see figure 1.9).

Like the CBRP, the BC also publicly expressed their discontent and anger with this fishing law that so blatantly disempowered artisanal fishermen. In no uncertain terms, they underscored how business elites benefit from this legislation thereby augmenting their social and financial capital at the expense of the Chilean working class. I argue then that such a critique is quite fitting in this location, which is a locus of several intersecting and overlapping interests and subjectivities. Nearby one can find the Cerro Santa Lucía and the Feria Artesanal Santa Lucía, both important tourist and leisure spots in Santiago. Just across the Alameda, pedestrians will encounter the Biblioteca Nacional (National Library), which archives important books and materials documenting state-sanctioned Chilean history. Finally, the intersection is also the site where national and transnational corporations advertise their prod-

87. Valenzuela, "Ricardo Rodríguez, líder de la brigada muralista del PC: 'Ojalá que de aquí a dos años no sea necesaria la Chacón.'"

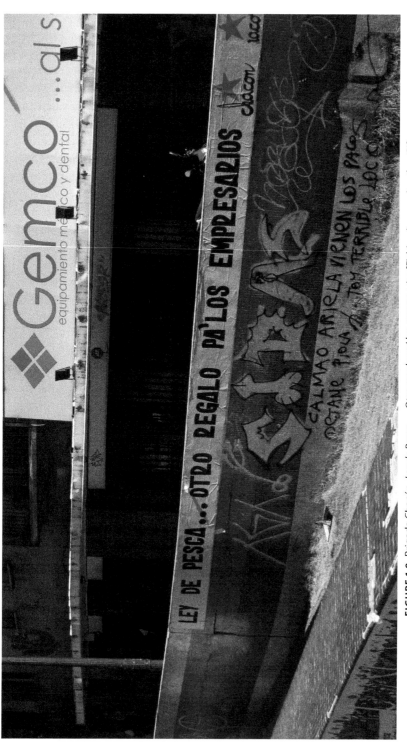

FIGURE 1.9. Brigada Chacón, *Ley de Pesca . . . Otro regalo pa' los empresarios* [Fishing Law . . . Another Gift for Business People] (2012), papelógrafo, Santiago. Photograph: Guisela Latorre.

ucts; gargantuan billboards promoting everything from athletic shoes to the latest Pixar movie can be found here. So, in essence, the state and the corporate sector largely control this particular space of the city, constantly negotiating their different interests. It comes to no surprise then that the BC would place a papelógrafo here that denounces the intimate and often corrupt relationship that exists between the government and big businesses. The fishing law is a prime example of the state creating legislation that further enriches the corporate elite. Though small and temporary, the BC's confrontational and unapologetic banner then operates as a radical and disruptive element situated precisely within the belly of the beast.

The BC's strategic use of location not only targets general audiences or casual passersby but also seeks out sites that are close to the headquarters of political parties, such as the socialists and the Christian democrats, groups that many brigadistas felt did not fully commit to policies promoting equality and social justice. In some instances, they even post papelógrafos adjacent to government facilities where politicians currently in power debate and create policy. The general area located in the intersection of Morandé and Catedral streets in Santiago is where the Chilean senate building is located. "When state representatives, senators, and ministers go to congress in Valparaiso, they take Santo Domingo (street) to get on the freeway," Rodríguez observed. "They have to drive by the place where we put papelógrafos."[88] This strategy on the part of the BC not only demonstrates a heightened awareness of urban spaces but also an acute understanding of human movement within the city. When I met with Rodríguez in March of 2017, he was preparing a papelógrafo with this location in mind. The inscription in this work read "¿Hasta cuándo prensa y fiscalía protegen a Piñera?" [How long will the press and prosecutors protect Piñera?] (see figure 1.10). The reference here was to Sebastián Piñera, who in early 2017 had launched another presidential campaign after having been president of Chile from 2010 to 2014. The entrepreneur-turned-conservative politician had come under fire due to questionable business dealings that had occurred while he was still president. His detractors charged that Bancard, a business linked to the former president, had invested considerable funds into Empresa Pesquera Exalmar SA, a Peruvian fishing conglomerate. These investments were taking place while the International Court of Justice in The Hague was debating an important case regarding maritime borders between Chile and Peru. The final ruling favored Peru, a nation that gained an additional 50,000 square kilometers of ocean territory as a result.

88. Rodríguez and González interview.

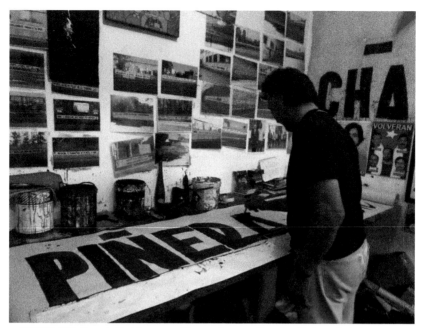

FIGURE 1.10. Ricardo Rodríguez working on the papelógrafo *¿Hasta cuándo la prensa y fiscalía protegen a Piñera?* [How long will the press and prosecutors protect Piñera?], March 25, 2017. Headquarter of the Brigada Chacón, Santiago, Chile. Photograph: Guisela Latorre.

While Chile was the loser in this court case, Exalmar was a big winner, having gained financially from this ruling. Piñera, as indirect investor in the Peruvian company, also saw financial gain.[89] This case put an uncomfortable spotlight on Piñera's conflicts of interest and on his failure to disclose his business dealings while leading the country. In spite of this dubious conduct, he was able to move forward with his campaign and ultimately win the presidency. The BC's papelógrafo thus denounced the press and the Chilean legal system as complicit in their unwillingness to make Piñera accountable. The location, in full view of lawmakers and politicians, suggested that the government—not just the press and courts—needed to be reminded of their responsibility to properly vet and root out candidates for the presidency. With this papelófrafo, the BC brought together their keen understanding of space and movement within the city, their knowledge of current Chilean politics, and their talent for creating bold and direct visual disruptions into a complacent public sphere.

89. Santiago Escobar and Ivan Weissman, "Los negocios de Piñera en Perú siendo Presidente y en medio del fallo de La Haya."

CONCLUSION _→ space_

The striking graphic work of the BRP and BC has its roots in the 1960s-style of street art and activism, yet their approach retains relevance and appeal in the twenty-first century. The distinct and recognizable characteristics of their imagery enhances the militancy of their message, as their work is unambiguous and uncompromising in its radical and progressive politics. Yet their imagery is easily legible across Chilean party lines. While public art has taken many forms in Chile, the walls done by muralist brigades have emerged as critical modes of cultural production that demand audience engagement and attention through these artists' deployment of visual democracy. This work operates under the rubrics of "democracy to come," to borrow Jacques Derrida's concept (discussed in the introduction of this book), for it looks toward a future that is more inclusive than any other present-day attempts at true inclusion and egalitarianism. "If two years from now the Brigada Chacón becomes unnecessary," Rodríguez wistfully stated, "I would be very happy. This would mean that we achieved everything we wanted, more equality, more justice. It would mean that we are finally walking on a better path."[90]

The BRP and the BC make a visual impact upon the urban space not only through their use of imagery and text, but also through the strategic placement of their work. They are deeply aware of how each locale within the city is charged with social and political meaning and how the distribution of urban space reflects unequal relations of power in Chile. However, street artists in the country have also enhanced their critical understanding of urban space through the creation of museos a cielo abierto or "open-sky museums," as will be demonstrated in chapter 2 of this book. These mural and graffiti environments demand visibility in monumental ways while also seeking to challenge neoliberal distributions and allocations of city space.

90. Valenzuela, "Ricardo Rodríguez, líder de la brigada muralista del PC: 'Ojalá que de aquí a dos años no sea necesaria la Chacón.'"

Open-Sky Museums and the Decolonization of Urban Space

THE POLITICS of urban space have been strong motivational impulses behind the creation of community mural projects in Chile and elsewhere. The history of community muralism and graffiti has been intertwined with that of city life and movement. How does the allocation and organization of urban space affect a community's life? How do these spaces promote or enforce social stratification, marginalization, and segregation? How can public artists transform the colonial and neoliberal politics that govern city streets? Starting with the post-dictatorship era in Chile, public artists such as muralists and graffiterx became increasingly conscious of how the social establishment wielded its power through the control of the urban sphere. They were also cognizant that populations marginalized within the city, in particular the urban poor, actively sought to challenge their socio-spatial segregation through political activism. Chile's complex history of housing rights and land seizures is indicative of how city spaces are complicated sites of power and contestation. Many working-class activists such as squatters often "focused attention on the inability of the state to fulfill its promises of urban modernity to a vast segment of the Chilean citizenry."[1] While modernity might have been a desirable objective among poor populations in the city, modernization became a kind of crucible: "The popular sectors . . . were the principal victims of the

1. Murphy, "In and Out of the Margins," 70.

undesirable cons[...]ation."[2]
Economist Patri[...] of most
inequable natic[...]rritorial
component."[3] M[...]conclu-
sions as they so[...]e egali-
tarian urban sp[...]1 in the
emergence of m[...]

THE [...]

MCAs are defin[...] created
within a single [...] ost basic
terms as a working-class neighborhood or housing project. These paintings
are not to be seen as single works of art but rather as interrelated pieces of an
artistic whole. MCAs thus operate as mural environments, a concept I formu-
lated during my past research of the Chicana/o community mural movement,
where I contended that the "ultimate purpose of these environments [was] to
create or transform particular urban spaces so that they become more attrac-
tive and livable for the communities that inhabit them."[4] The concept of an
open-sky museum, however, implies not only a redefinition of the urban space
but also a rethinking of the museum itself. As repositories of a nation's artistic
patrimony and harbingers of institutionally approved "fine art," museums in
Latin America have clearly played a hegemonic and colonial role when it came
to processes of nation building. Moreover, in his research on Argentine muse-
ums Alvaro Fernández Bravo has also called them "*theaters of memory,* spaces
where fables of identity are enunciated by means of collections of objects,"
while also stating that "museum displays [attempt] to colonise and appropriate
external referents, changing their context."[5] The open-sky museums or MCAs
featured in this chapter in many ways actively disrupt such museum practices,
as they are not in the business of collecting objects nor do they seek to instill
state-sanctioned visions of historical memory. Their public location and acces-
sibility figuratively break down the walls that are designed to contain and con-
trol meaning within the museum building. In many ways, MCAs function like
the "errata exhibitions" that Karen Mary Davalos highlights in her research on

2. Moulian, *Chile actual,* 127.

3. Aroca, "Territorial Inequality and Regional Policy in Chile," 280.

4. Latorre, *Walls of Empowerment,* 142.

5. Fernández Bravo, "Material Memories: Tradition and Amnesia in Two Argentine Museums," 79.

Chicana/o art, for these also provide a space for "opposition and activity that invites public discussion among multiple audiences."[6]

The concept of the MCA in Chile has roots in the early '70s, when Brazilian art critic Mario Pedrosa worked closely with the administration of Salvador Allende to establish a new and radical museum of modern art called the Museum of Solidarity. He envisioned such a museum not as a warehouse of "masterpieces" but rather as an experimental "house of experiences" that would attract and educate all sectors of society, most notably the poor and working classes.[7] Natalia Jarra Parra argued that Pedrosa's vision of a modern art museum in Chile consisted of the breaking down of "barriers that separated the visual arts language and everyday life."[8] While Pedrosa did not specifically talk about museums in open spaces within poblaciones, his ideas about a more intimate connection between public displays of art, social justice, and marginalized populations left a critical imprint on Chilean street artists and activists involved in MCAs.

The focus of this chapter then will be to address how community arts intervene in the dynamics of spatial inequalities in Chile. What kinds of strategies do the artists and community activists who create MCAs adopt in order to minimize the negative effects of spatial segregation? Edward Greaves defines the spatial segregation that has happened in Chile as "a mechanism for socially cleansing urban space in order to make it available for the construction of modern, neoliberal space."[9] Spatial segregation then seeks to "beautify" the urban space by "sanitizing," "depathologizing," and "making more decent" poor and working-class areas often at the expense of its residents.[10] So the core of the MCA mission is also to beautify, but from a grassroots, bottom-up perspective, with the ultimate purpose of better serving the lives of those marginalized by the state and neoliberal politics. Moreover, these initiatives often come from the efforts of community members themselves who regard input and agency of the urban poor as central to the process of improving the city space.

6. Davalos, *Chicana/o Remix*, 22.

7. Jarra Parra, "El arte como ejercio experimental de la libertad," 15.

8. Jarra Parra, "El arte como ejercio experimental de la libertad," 19.

9. Greaves, "Dilemmas of Urban Popular Movements in Popular-Sector Comunas of Santiago, Chile," 96.

10. In his work on spatial politics in Santiago, Edward Murphy has argued that Chilean urban developers in the mid-twentieth century believed that abject poverty promoted "promiscuity and degeneracy," so the goal was to "modernize and beautify" peripheral neighborhoods thus attempting to sanitize rather than alleviate poverty. Murphy, "In and Out of the Margins," 76.

This chapter will thus center on two prominent MCAs located in Santiago, namely the Museo a Cielo Abierto en San Miguel and the Museo a Cielo Abierto en La Pincoya. These two locales are poblaciones with a powerful history of political activism, an activism often enacted through bodily disruptions by residents taking to the streets in social protest. Given these histories, community leaders there saw that their neighborhoods were ideal sites for the creation of MCAs. Started in the late 2000s, these mural and graffiti initiatives sought to beautify the historically marginalized space of the población, to raise awareness about social inequities, and to work collectively with the community. Ultimately the MCAs function as a symbolic and physical reclamation of urban spaces commonly controlled by the state and the corporate sector.

THE CHILEAN POBLACIÓN

The emergence of poblaciones has a very specific history in the city's development and growth: "Santiago's poblaciones took their shape in the 1940s when Santiago's industrial boom encouraged immigration from the poorer countryside."[11] By the 1970s, approximately one quarter of Santiago's population lived in a población where most of its residents were "packed into two-room houses with limited access to electricity and drinking water."[12] The meaning of the word *población* has connotations that go well beyond simply denoting a working-class area of the city. The term carries a powerful stigma in Chilean society. These are not just places ravaged by poverty; they are locales unequivocally defined by their undesirability and extreme alterity. The población is where all that is wrong with society happens, according to elitist discourses in Chile. Admitting to living in a población is not only admitting to being poor, which is in itself a source of shame and embarrassment, but also aligning oneself with criminality, vice, and degeneracy. Murphy contends that Chilean social elites have long argued that the poverty experienced in the población produces "marginal, destructive, and pathological behavior."[13] During the dictatorship, these working-class neighborhoods were further denigrated by the government's insistence that they were hotbeds of Communist, terrorist, and seditious activity. Growing up in Chile in the 1970s and '80s, during times of dictatorship, I was warned not to go into poblaciones. My family, who identified as middle class, and the Chilean media alike instilled in me the idea that these were crime-ridden areas of the city where I could

11. Schneider, "Mobilization at the Grassroots," 95.

12. Trumper, *Ephemeral Histories*, 5.

13. Murphy, "In and Out of the Margins," 76.

be stabbed, raped, robbed, or even killed. While these warnings came from a justifiable concern for my personal safety and from the knowledge that social inequity does breed violence, I also came to realize that entering into the space of the población potentially tainted me with a negative stigma; in other words, I could be mistaken for a población resident and therefore damage my perceived social class. The creation of the MCAs challenges in radical ways any stigma and negative connotation associated with the población. The artists and organizers of MCAs generally highlight the nature of these locales by engaging in a reclamation, resignification, and humanization of the población. Though poverty and hardship are realities of life there, dignity, resilience, activism, and solidarity are equally if not more prevalent in these emblematic neighborhoods. What the MCAs do then is bring to the foreground the history, the complexity, and the culture of resilience in the población.

MCAs also highlight the importance of poblaciones as sites of struggle for social justice and democracy. These struggles have not only contested and denounced state policies and practices but have also proposed different kinds of social relations between poblaciones and the state. These mobilizations visualized "a new way to construct society from below" thus functioning as projects for autonomy, an autonomy that allows *pobladores* (población residents) to exercise self-determination while also expecting greater inclusion within the nation-state.[14] Poblaciones "became particularly well organized and militant in [the late '60s and early '70s] and turned to public action in order to achieve their political goals."[15] During Allende's presidency, the state recognized "pobladores as valid interlocutors with whom the government was willing to negotiate the handover of public resources in exchange for support of their domain."[16] After the military coup d'état, however, much of the activism enacted by pobladores happened because of the dictatorship's so-called "emergency legislation," which "strengthened private industry [providing it with labor stability] and prevented the hatching of mass protests against the neoliberal shock policies."[17] The MCAs featured in this chapter were created during the post-dictatorship era, but they challenged neoliberal politics rooted in the economic and social policies established during the Pinochet years. Neoliberalism is perhaps the most enduring and persistent element of the dictatorship's legacy. The liberal reforms instituted by Pinochet starting in the mid- 1970s continued well into the post-dictatorship era and most remain in place to this day. His administration put an end to state intervention and government cen-

14. Pinto, Candina, and Lira, *Historia contemporánea de Chile*, 123.
15. Trumper, *Ephemeral Histories*, 5.
16. Pinto, Candina, and Lira, *Historia contemporánea de Chile*, 129.
17. Pinto, Candina, and Lira, *Historia contemporánea de Chile*, 123.

tralization in relationship to economic markets in addition to privatizing most of the state-owned industry. "With these privatizations also came an influx of transnational corporations that entered into partnerships with several Chilean conglomerates," anthropologist Clara Han has explained.[18] Han further indicates that the presence of these transnational corporations was hyper visible in the urban spaces of poblaciones like La Pincoya:

> Within the boundaries of the municipality of Huechuraba, La Pincoya is bordered on the west by new upper-middle-class condominiums. The Ciudad Empresarial, or Business City, constructed in the late 1990s, also part of the municipality of Huechuraba, forms La Pincoya's eastern border. It is populated by high-rises that contain international advertising firms, global news outlets such as CNN, and offices for international banks and software engineering companies.[19]

For the local residents of this población, the proximity of these corporations was a reminder not only of the ubiquity and power of the private sector industry but also of the extreme forms of inequality that neoliberalism brought about. Because of neoliberalism's persistence well beyond the Pinochet years, for many Chileans—in particular población residents—life in times of democracy was not much different from the dictatorship. Thus, the MCAs pushed back against the ubiquity and pervasiveness of the neoliberal presence in the urban sphere.

MUSEO CIELO ABIERTO IN SAN MIGUEL: BEAUTIFICATION AND LEGITIMIZATION

The initiative to create the Museo a Cielo Abierto en San Miguel began in 2009 when two community activists, namely Roberto Hernández and David Villarroel, began having conversations about starting a beautification project that would involve murals in the Población San Miguel, a working-class housing project in the southern sector of Santiago. This población consists 41 buildings with a total of 1,026 apartments where 6,000 to 7,000 residents live. The settlement was originally populated in the 1960s when the families of copper industrial workers settled in the area. Hernández recalled what his own life was like growing up in this población as part of a family of twelve: "That

18. Han, *Life in Debt*, 9.
19. Han, *Life in Debt*, 11.

was our reality 50 years ago. Families were large. The concept of birth control was not at all adopted at the time."[20] Since those early days, the población characterized itself for its communal and civic culture, which included activities such outdoors recreational sports, music festivals, neighbor committee meetings, among other public events. These practices, however, were considerably limited, if not eliminated altogether, during the 1970s in the wake of the military coup of 1973.[21] Celebrated queer writer and performance artist Pedro Lemebel spent most of his childhood and adolescence in the larger commune of San Miguel, where this MCA is located, and would later call the area "the first dignified living space [my family] had after roaming through many areas of south Santiago." He argued that locales such as these were "historical places in the course of the country's biography [. . .] where the struggles against tyranny took place."[22] By the turn of the millennium though, the Población San Miguel was deteriorating as a result of blatant neglect from the municipality. As Hernández explained: "We spent a lot of time thinking that the población was dying. It was as if we were waiting for death, the death of our community." José Faundéz, resident of the población since 1962, remembered that during the times of steady decline in the población "buses didn't even come out here,"[23] which was indicative of the marginalization experienced by the local population there. This decline was coupled with a general hopelessness among pobladores who didn't think anything could be done to remedy the situation.[24]

In spite of the substandard living conditions and the neglect there, the Población San Miguel retained its strong sense of community pride and belonging. This culture in the población provided a fertile ground for Hernández and Villarroel to spearhead the project. The timing of the project was fortuitous as well. Heading into the year 2010, the Chilean government was making preparations for the bicentennial celebrations. One of the initiatives connected to these celebrations was an increase in arts funding for community-driven projects through FONDART. As Hernández explained: "They were willing to consider any initiative from community organizations that improved people's sense of belonging through cultural activities. . . . We understood that this was a golden opportunity that we could not let pass. If we did, we were done for."[25]

20. Hernández interview.
21. Centro Cultural Mixart, *Museo a Cielo Abierto en San Miguel,* 24–25.
22. "Trazo Mi Ciudad: Pedro Lemebel, Santiago, Chile."
23. "Museo a Cielo Abierto de San Miguel."
24. Hernández interview.
25. Hernández interview.

As they moved forward with the project of creating an MCA at the Población San Miguel, Hernández and Villarroel realized that the powerful history of working-class pride and social action that was deeply rooted in the población required a curator and artistic director who shared in the political and social impetus of the community there. Veteran muralist, printmaker, and cofounder of the BRP Mono González was thus invited to fulfill this important role. Even though González began working as an artist in the 1960s with the BRP, as explained in chapter 1, the respect and admiration he garnered from young street artists made him someone who could bridge connections between different generations. Aside from painting two murals in the MCA, González also led a series of printmaking workshops for local residents, both adults and children. The ultimate goal was to transform the población into a space that was welcoming toward community interaction and nurturing of creative expression. Even though most of the artists were not local residents of the población, the process established by the organizers of the MCA required them to interact with those who lived there, consulting with them about the subject matter, imagery, location of murals, and other matters. As población resident Camila Vargas recalled: "They began asking us what buildings we wanted to have painted. They brought us sketches. They never imposed anything. It was fun picking out the paints, seeing the artists who came, sharing with them, giving them a glass of water, a plate of food."[26] Hernández remembered being categorical to participating artists about the importance of resident input. "You gave a great challenge," he recalled telling them. "You may think your sketch proposals are just fine, you may pass the muster of the artistic director . . . but the ones who ultimately approve your sketch are the residents of the población."[27] As a result, Hernández continued, "no one adopted the stance of street art diva or superstar."[28] Such interactions between artists and residents also promoted creativity outside the confines of the MCA project, as Vargas also explained: "We are now surrounded by graffiti wherever we go. Children want to do graffiti. We are now surrounded by music everywhere thanks to the famous murals."[29] It should be reiterated here, as will be noted again in chapter 3, that the negative connotations associated with graffiti in the United States were not relevant here, as the MCA and other street art initiatives across Chile effectively undermined much of the stigma of criminalization associated with the practice. Vargas's comment about children

26. Hernández interview.
27. Hernández interview.
28. Hernández interview.
29. Hernández interview.

wanting to do graffiti then was meant as honest praise of the work done by the artists and community organizers who have inspired children to be creative.

The various themes and iconographic motifs of the wall paintings at the MCA in San Miguel vary widely, yet the sentiments that fueled the original creation of this mural site seem to inform much of the work done there. The idea of not only beautifying the environment but also celebrating local and national histories is endemic to many of the subject matters there. In many ways, the government funding from FONDART determined this overarching theme, as it sought to support projects that would highlight national culture on the occasion of Chile's bicentenary. On the surface, it may seem that the artists and coordinators of the San Miguel MCA were merely following the state's directive to create hegemonic, uncomplicated, and unifying images of national identity. In most cases, however, the murals in this locale subverted the facile and unitary notions of the national; if anything, they tended to promote an open dialogue about of what it meant to be Chilean in the twenty-first century and what constituted national culture. Directly or indirectly, they called attention to the communities that are often overlooked or ignored in the master narratives of Chilean national identity and belonging, such as blue-collar laborers, indigenous populations, women, and others.

If compared to murals and graffiti found in other poblaciones throughout Santiago, however, the works in the San Miguel MCA were *less* overtly political and left-leaning than in other working-class neighborhoods. While never conciliatory, noncommittal, or assimilationist, the wall paintings reflected the general social attitudes of the residents, for they were the ones who would ultimately approve design sketches drawn by the participating artists. "I was surprised to see that my neighbors would distance themselves from political themes," Hernández explained, "taking into consideration that this was a población that also suffered from the oppression of the dictatorship."[30] While in peripheral poblaciones like La Pincoya, Villa Francia, and others, the dictatorship emboldened and galvanized the left-leaning and radical politics of its residents, in San Miguel the effect was one of polarization between those for and against Pinochet, as some sectors in the area *did* benefit from the policies of the dictatorship.[31] The strategy among the residents in this locale was then

30. Hernández interview.

31. Though I did not live in the Población San Miguel where this MCA is located, I was born and raised in the larger commune of San Miguel and nearby La Cisterna during the 1970s and '80s. The political polarization that Hernández referred to was indeed endemic to this sector of Santiago, which housed a somewhat hybrid mix of poor, working-class populations and more upwardly mobile residents who laid claims to middle-class status, including some who aligned themselves with the ideologies of the dictatorship. I myself grew up with two aunts who were ardent Pinochet supporters while my sister had a classmate whose father worked for

not to open the old wounds of polarization again with murals that espoused overtly radical politics of dissent. Trying to forget the painful past was not just part of a state-sanctioned posture of post-dictatorship governments. Tomás Mullion tells us that the politics of forgetting also became a coping mechanism among some of those traumatized by the past: "What would be the point of reliving the pain, of reviving every instant of the nightmare? Why reinstate this divisive, exhausting and at times frightening matter on people supersaturated by bereavement and tears?"[32] Having said this, many of the murals in the San Miguel MCA still present images that actively seek to dislodge hegemonic notions of national identity while simultaneously expanding the narrative about citizenship and national belonging. These themes then work toward the larger goal of reclaiming the urban space for historically marginalized and neglected communities of the city. The beautification process that was underway in this MCA was very much about promoting messages that would transform the energy and spirit of this locale through the production of alternative iconographies denoting national identity.

The first mural to launch the MCA in San Miguel had to be one that could speak eloquently about local neighborhood pride while also creating a unifying sense of belonging. It had to legitimize the experiences and sentiments of the pobladores (población residents.) Thus, the inaugural mural titled *Los Prisioneros* (2010) was created by an artistic collective that included Jorge Peña y Lillo, Basti, Gesak, Hozeh, Pobre Pablo, and Pato Albornoz (see figure 2.1). The subject of this initial mural was one familiar to *san miguelinos,* or natives of San Miguel: a representation of beloved Chilean musical icons Los Prisioneros (The Prisoners), perhaps some of the most visible public figures to come out of San Miguel during last few decades of the twentieth century. This legendary *rock en español* (rock in Spanish) group rose to fame during the height of the dictatorship in the 1980s by characterizing themselves through their sardonic social criticism in their song lyrics, which was coupled by a punk/new wave sound and a challenge to the ideologies promoted by the Pinochet regime. In a confrontational and unapologetic manner, they sung about class hierarchies, educational inequality, US imperialism, gender oppression, over-sexualized media imagery, among other themes. They spoke for an entire

the CNI (Central Nacional de Informaciones), the government's notorious and ruthless secret police, largely responsible for human rights abuses. This polarization created a climate of fear and mistrust as the subject of politics became a taboo topic of conversation even among family members, who bitterly resented one another for their differing views about the government. In addition, we were cognizant of the clear and present danger of government informants amongst us, which further exacerbated this atmosphere of fear and suspicion.

 32. Moulian, *Chile actual,* 32.

FIGURE 2.1. Jorge Peña y Lillo, Basti, Gesak, Hozeh, Pobre Pablo, and Pato Albornoz, *Los Prisioneros* (2010), mural, Museo a Cielo Abierto San Miguel, Santiago. Photograph: Guisela Latorre.

generation of disillusioned and angry youth who had lived all their lives in a dictatorship and saw little hope for the future. The artists of this mural indicated that Los Prisioneros were "just like" the población residents and that "they had reached an important place with their rebellious music against the system, beyond our borders."[33] Thus, Los Prisioneros would serve as an example of san miguelinos who "made it big" in Chile and abroad, but most importantly, they became role models for locals seeking to find a voice of dissent and resistance within an oppressive system of power. Though Los Prisioneros' heyday occurred in times of dictatorship, their language of resistance was still relevant in times of democracy, a democracy that remained deeply flawed.

The representation of Los Prisioneros in this first mural of the MCA is unusual as far as images of "rock stars" are concerned. They are not shown performing or holding musical instruments, the tools of their trade. In fact, the artists included no iconographic clues that would indicate that this is a group of musicians. Instead, we see the three members of the group—Miguel Tapia, Jorge González, and Claudio Narea, from left to right—standing on the mural's foreground, close to the spectators and slightly above their eye level. They are recognizable only to an audience that has inside knowledge of Chilean popular culture. The artists have situated Los Prisioneros squarely within the neighborhood of the población, as indicated by the apartment block behind them. They stand in front of a series of fruit and produce crates while Miguel Tapia takes a bite from an apple. These crates serve dual symbolic purposes: one speaks of life in the población and another alludes to the country's national economy. The crates are common sites in the neighborhood when, twice a week, *la feria* (the local produce market) sets up its stalls in the Población San Miguel. La feria provides the pobladores with the opportunity to buy more affordable fruits and vegetables than in the supermarket chains. National statistics tell us that *ferias libres* (free markets) provide 70 percent of the Chilean population with fresh produce, but this percentage is considerably higher among the poor and the working classes, which is closer to 90 percent.[34] These are also sites of cultural expression where it's not uncommon to see street musicians, jugglers, dancers, and other types of performers. Most importantly though, la feria is also a crucial hub of social activity where the community comes together to fraternize with one another but also to share in their experiences with hardship and injustice. The crates of produce then allude to how important forms of community bonding and even coalition building can happen in la feria. Like Los Prisioneros themselves, la feria is also

33. Centro Cultural Mixart, *Museo a Cielo Abierto en San Miguel*, 36.

34. "Historia," Confederación Gremial Nacional de Organizaciones de Ferias Libres, Persas y Afines: http://www.asof.cl/historia-2/ (accessed on January 26, 2015).

a broader icon of national identity, but one that has not been readily accepted by social elites in Chile. La feria and Los Prisioneros operate as oppositional symbols of the nation that are rooted in the equally oppositional space of the población.

Directly behind the figures of Los Prisioneros, we see the easily recognizable cityscape of the Población San Miguel stretching into the background. The identifying signifier of place here is the apartment block depicted prominently in the mural. The artists rendered this building with three rows of windows and a clothesline on the west façade of the structure. On the south wall, the artists have included a rather whimsical and self-referential element. Two figures climb a ladder propped up on that very wall. The younger and smaller of the two, presumably a little girl, sits on the shoulders of an adult male who struggles to keep his balance. She reaches high upon the wall to spray paint the words "Museo a Cielo Abierto en San Miguel." As the MCA's inaugural mural, this image was intended to introduce the población to the idea of the mural transformation about to take place in the neighborhood. This transformation, however, is an all-inclusive one that counts on the active participation of pobladores. The cartoon-like style and humorous quality of these two figures, which stand in sharp contrast to the more traditional rendering of Los Prisioneros, also communicate the idea that diverse aesthetics will comprise this MCA. The clear hierarchies of art that often pit popular culture imagery against "fine art" are to be disregarded in the murals of the Población San Miguel. By the same token, hierarchies that regard muralism as a legitimate and time-honored form of public art and graffiti as mere criminal acts of vandalism on city streets would also be rejected.

The struggles of the poor and working classes in Chile figure prominently in the murals of the Población San Miguel, which often visualize the relationship that these sectors of the population have with broader national and transnational realities. Such images are meant to provide a sense of greater belonging to the residents of the población, many of whom are themselves blue-collar workers. Their labor is often denigrated by social elites who devalue the poorer classes yet depend on the work that they do. In the 2010 mural, *Homenaje a los trabajadores que luchan* ("homage to the workers who struggle"), the graffiti collective 12 Brillos Crew depicted these workers as essential elements of the land and natural environment of Chile (see figure 2.2).
"I believe [this mural] was approved by our neighbors because they saw that it was a recognition of our reality as población residents," Hernández observed.[35] As a group, the 12 Brillos Crew came together in 2007 seeking to express ide-

35. Hernández interview.

FIGURE 2.2. 12 Brillos Crew, *Homenaje a los trabajadores que luchan* (2010), mural, Museo a Cielo Abierto San Miguel, Santiago. Photograph: Guisela Latorre.

als of social justice and protest in their work by mixing the styles of political muralism and graffiti.[36] In this población wall, however, it is the mural aesthetics rather than the graffiti stylings that are most salient. In their artist statement, the 12 Brillos Crew eloquently described the spirit of their mural:

> The mural represents the struggles of the workers in this land. Their strength and unionization, represented through symbols and images, demonstrates that the farmworker, the miner, the fisherman and the artisan, among others, are of vital of importance to the uplifting of society.[37]

In *Homenaje*'s iconography, we see a hybrid landscape tilting upward, almost seeming to collapse upon the space of the viewer. At the bottom center of the landscape, an agricultural field is being cultivated by a female farmworker whose back is turned to the spectator. As our eyes move up the composition, we see that the field rises skyward to reveal a plentiful harvest of carrots, pumpkins, and radishes. But this land and its crops quickly morph into a fishing boat that is maneuvered by the steady hands of an artisanal fisherman[38] who is rowing through the turbulent waters of the Pacific Ocean (see figure 2.2a).

Even though his catch is abundant, the weariness and exhaustion of his expression betrays the hardships and dangers faced by artisanal fishers who risk their lives in the open sea and labor on precarious nonmotorized rowboats. The waters then transform into a tapestry of sorts woven by an indigenous female artisan (see figure 2.2b). This figure allegorizes the artistic and cultural labor of indigenous women of Chile, in particular the Mapuche. The weariness of the fisherman below is mirrored in her face too, as she appears to look down at her work with a forlorn and woeful expression. She bears the brunt not only of the country's painful colonial history but also of the current forms of racist and sexist discrimination suffered by native women in Chile. Her weaving of the ocean itself makes way for a sharp transition in the mural's imagery, namely to the world of the mining and manufacturing in the country. The cool hues of the water are abruptly bisected by the representation of Chile's soil substrata, rendered in warm hues of auburn and crimson. Embedded within this stratum are the figures of protesting mine workers who carry a sign with the motto "Unionize and fight" as they defiantly confront the gaze of the viewer. Above them, another miner is hard at work drilling into the mineral riches of the soil; he is most likely extracting copper, a

36. Centro Cultural Mixart, *Museo a Cielo Abierto en San Miguel,* 86.

37. Centro Cultural Mixart, *Museo a Cielo Abierto en San Miguel,* 86.

38. For more information on artisanal fishing (*pesca artesanal*), see chapter 1 of this book.

FIGURE 2.2A. 12 Brillos Crew, *Homenaje a los trabajadores que luchan,* detail (2010), mural, Museo a Cielo Abierto San Miguel, Santiago. Photograph: Guisela Latorre.

FIGURE 2.2B. 12 Brillos Crew, *Homenaje a los trabajadores que luchan,* detail (2010), mural, Museo a Cielo Abierto San Miguel, Santiago. Photograph: Guisela Latorre.

metal that comprises approximately 20 percent of the country's GDP and 60 percent of its export products.[39] Their labor is closely related to that of the steel manufacturing worker who is captured here in the process of welding while metal beams loom behind him.

In *Homenaje,* the 12 Brillos Crew then deploy a series of symbols that are meant to affect the public's reading of the image. For example, the birds and stones found in the upper half of the composition have a particularly significant meaning, as the artists themselves explain: "We also included elements such as birds and stones flying which symbolize the search for liberty and the escape from oppression of the labor movements in this country."[40] This theme of freedom and empowerment in the face of political repression and social constraint is one that is echoed in the lower registers of the mural as well. Gigantic tree-like hands surface from the soil to flank the figure of the artisanal fisherman. The hands also appear to unfurl a banner with an inscription that reads "the hands of workers uplift this land." The aforementioned tilting of the pictorial space metaphorically reinforces the idea of the workers "uplifting" the land. The powerful relationship between the country's proletariat and its land is more than just an essentialist trope that likens poor and indigenous people to nature. Land here is clearly equated to nation and to the very specific contributions that workers make to the country's economy. Their labors and accomplishments are celebrated in this mural but not idealized, as these are not docile working bodies that happily toil and abide by the state's every directive. Their ability to organize, form unions, strike, and lead labor movements makes them into active agents of change and resistance; their presence in this mural demands visibility, recognition, and fair treatment in a society that renders them invisible.

The struggles of the working classes, as they are depicted in the San Miguel MCA, are often complemented by imagery that alludes to Chile's ethnic minorities, most notably the Mapuche, such as in the mural *Meli Wuayra* (2010), which was created by the graffiti crew Aislap and composed by artists Juan Moraga and Pablo Aravena (see figure 2.3). Though this wall painting does not specifically address the experiences of colonization and neocolonization endured by native people in Chile, it does advocate for greater recognition and legitimization of Chile's first nations. Using a symmetrical and geometric composition, the artists place the monumental figure of a Mapuche *machi* at the very center of the mural. In Mapuche culture, machis are traditional healers who have great wisdom and knowledge about spirituality,

39. "Mining in Chile Copper Solution," *The Economist,* April 27, 2013.
40. Centro Cultural Mixart, *Museo a Cielo Abierto en San Miguel,* 44.

FIGURE 2.3. Aislap, *Meli Wuayra* (2010), mural, Museo a Cielo Abierto
San Miguel, Santiago. Photograph: Guisela Latorre.

medicine, and society. Though both men and women can fulfill this role in Mapuche society, female machis are more common. The figure of the machi in the Chilean national imaginary, however, represents contested terrain. Anthropologist Ana Mariella Bacigalupo indicated that machis and Mapuche culture in general have been utilized by the state to promote a nonthreatening and hegemonic image of national identity. In August 5, 1999, for example, Chilean president Eduardo Frei participated in a televised Mapuche ceremony featuring Machi María Ángela in which he vowed to create a more egalitarian society for the indigenous people of this country. In spite of his seeming gesture of legitimization, his government and the one of Ricardo Lagos, who succeeded him, "built a series of hydroelectric plants along the Bío-Bío River in the Mapuche-Pewenche communities," Bacigalupo explained, "and a highway that ran through other Mapuche communities," while also making use of draconian legislation to suppress resistance to these actions.[41] Moreover, Mapuche imagery and culture have been repeatedly exoticized and trivialized to promote nationalist and capitalists interests, even in times of dictatorship. Bacigalupo, nevertheless, was quick to point out that Mapuches themselves have engaged this nationalist discourse in both subversive and contradictory manners:

> Mapuche have developed responses to national images of themselves that range from embracing folkloric, gendered images of *machi* and *longko* [male tribal chiefs] to transforming those images and challenging nationalist discourses through resistance movements. Machi, in turn, draw on national images of male and female, tradition and modernity in order to devise their own gendered strategies for negotiating with national and Mapuche political authorities.[42]

In many ways, the indigenous imagery evoked in *Meli Wuayra* straddles the conflicted terrain of Mapuche representation, as the members of Aislap do not identify as Mapuche themselves yet their mural does not serve the interests of assimilation, commodification, and neocolonization either. The working-class space of the Población San Miguel, coupled with the connotations of rebellion and protest connected to graffiti and muralism in Chile, make this machi image into a larger symbol of self-determination and empowerment for disenfranchised communities, be they indigenous or not.

41. Bacigalupo, *Shaman of the Foye Tree*, 141–42.
42. Bacigalupo, *Shaman of the Foye Tree*, 144.

The machi's role as healer is significant in *Meli Wuayra,* for the practice stands as a metaphor for this población's process of renewal after urban neglect. For the Mapuche in general, healing involves "physical, spiritual, and emotional balance as well as good social relationships."[43] Much of contemporary Mapuche healing and spiritual practices "is tied closely to the history of Spanish colonialism, missionizing by Catholic priests, resistance to Chilean national projects of assimilation and development, and Mapuche people's incorporation and resignification of Chilean majority discourses."[44] The existence of evil spirits, for instance, is often equated with the negative results of colonization,[45] effects that have endured even after the end of the dictatorship as Mapuche land continues to be threatened by the construction of freeways, damns, and other modernization projects. Mapuche resistance to these threats is often met by harsh measures as a result of an antiterrorism law established in Chile in 1984. Thus, processes of healing assisted by machis are often interwoven with direct or indirect strategies of decolonization and resistance. The emancipatory forms of healing connected to these indigenous practices is then highlighted in this mural by Aislap where the machi is clearly shown within her role as healer and sage. The artists depict her wearing her traditional attire adorned by characteristic Mapuche jewelry such the *trarilonco* (headpiece) and the *trapelacucha* (pectoral adornment.) In her hand, she holds a potted flower, a reference to the machi's use of herbs and plants for medicinal purposes. Surrounding her hands is a circular motif that resembles a *kultrun,* the sacred drum played by machis. Bacigalupo has argued that the kultrun represents a "gendered tool for healing" among these spiritual practitioners, as its drumming can call up ancestral nature spirits, which have female and male properties. This drum is generally adorned with intersecting lines that divide the kultrun's surface into four registers that represent the four corners of *mapu,* the Mapuche earth.[46] This conceptualization of the earth is also reflected in the overall composition of the mural, as the pictorial space is divided into four spaces as well. Moreover, the title, *Meli*

43. Bacigalupo, *Shaman of the Foye Tree,* 29.

44. Bacigalupo, *Shaman of the Foye Tree,* 33–34.

45. Bacigalupo has explained that many evil spirits in Mapuche cosmology take the form of European colonizers who rob indigenous people their identity and humanity: "The *witranalwe* is a spirit in the form of a tall, thin Spanish man mounted on a horse. He is the image of the feudal *criollo* landlord who took Mapuche land, exploited his Mapuche workers, and raped Mapuche women. His wife is the *añchümalleñ,* a small, white, luminescent being with iridescent eyes, who is often associated with urban models of femininity. Her lips are red from sucking her victims' blood; she cries like a baby, not like an adult; and her blonde hair marks the devouring power of foreignness." Bacigalupo, *Shaman of the Foye Tree,* 34.

46. Bacigalupo, *Shaman of the Foye Tree,* 52.

Wuayra [Four Winds] further reiterates the theme of the four spheres. Three of these four spheres also feature eye motifs, two on the left and right halves of the composition and one on top above the machi's head acting as a third eye. In eastern religions like Hinduism and Buddhism as well as in New Age spiritualties, the third eye refers to an invisible organ or seeing device that is capable of looking into inner realms. Those who possess or have access to the third eye are endowed with exceptional spiritual knowledge and insight.[47] Such an iconographic motif in *Meli Wuayra* further reiterates the machi's powerful capability as a healer and sage.

The healing powers of the machi coupled with the rethinking of space that the artists present in this mural have a powerful effect in the specific locale of the Población San Miguel. Knowing that the healing process is not only individual but also communal, Aislap put the powers of the machi at the service of the residents of the población who have likely shared struggles and hardships in common with the larger Mapuche population. Hers is a healing gesture that is cognizant of the injustices that cause social, physical, and spiritual ailments. The pictorial space representing indigenous worldviews creates a challenge or, at the very least, an alternative view to the neoliberal and colonial distribution of urban space. Like *Homenaje* by the 12 Brillos Crew, which also depicts a rethinking of space, the spiritual and physical realms depicted in *Meli Wuayra* provide a window into an organization of the world that is quite distinct from the hierarchical and segregationist distribution of urban space that state and corporate institutions devise.

Aislap in *Meli Wuayra* extend their representation of indigenous cultures to other first-nation people in Chile. In the upper registers of the mural, we see figures that correspond to the Aymara populations—originally from the northern Altiplano region of Chile, Peru, and Bolivia—and the Selk'nam people, who once populated the Patagonia region of Chile and Argentina before disappearing during the 1970s and '80s.[48] The choice of these two figures was neither coincidental nor random. The Aymaras, though small in number compared to the Mapuches and the larger mestiza/o population in Chile, have a powerful history of resistance and political activism, in particular in Bolivia where they have been instrumental in organizing the coca farmers movement, which helped to elect the country's first indigenous president, Evo Morales,

47. For more on the third eye, see Swami Satyananda Saraswati, *Kundalini Tantra* (Bihar, India: Yoga Publications Trust, 8th ed., 2001).

48. Anne Chapman, who has written one of the few books on the Selk'nam published in the United States, indicated that in 1980 "only one or two of these people remain." She did recognize, however, that Selk'nam ancestry most likely still endures among the largely mestizo/a population of Chile. Chapman, *Drama and Power in a Hunting Society*, 1.

who is of Aymara descent. Juxtaposing a native population that has been virtually eradicated with one that is hyper visible in decolonial struggles over self-determination gave the residents of the Población San Miguel two polar extremes of the possible effects of colonialism, capitalism, and neoliberalism on native populations. Nevertheless, both figures are afforded the same importance in the mural. The Selk'nam man stands on a globe-like sphere centered in the middle of the mural. He is adorned with a mask, headpiece, and ritual paint all over his body, reflecting the practices of the Hain ceremony, which was an important rite of passage that transitioned young men into adulthood.[49] Standing on the other side of the sphere, the Aymara figure likewise is dressed in traditional garb with a colorful poncho and a fedora-like hat that is typical of men among this population. Thin rays of light emanate from the candle held by the Aymara man and from the palm of the Selk'nam figure. These rays intersect with the third eye motif above them and with the machi woman below, indicating that they share in her knowledge of the earth and the spirit world.

In the lower register of *Meli Wuayra,* Aislap complemented the presence of the machi, the Selk'nam, and the Aymara with figures representing the Polynesian Island of Rapa Nui (Easter Island), embodied here by the iconic moai sculptures that allegorized deified ancestors for the native people there. Also inhabiting this lower register is an enigmatic male figure that the artists themselves described as "an emerging man from the digital era."[50] The inclusion of this "digital man" may seem out of place in a mural about native people of Chile, yet his presence is nevertheless quite relevant here. Though indigenous people in Chile have had lesser access to digital tools, their worldviews and spiritual knowledge are equated to the power of the digital sphere in this mural. The artists thus are contrasting what US Native American scholars Vine Deloria and Daniel Wildcat see as the differing and even conflicting views of technology between indigenous peoples and those of European descent:

[Here we have] a deeply seated (metaphysically based) Western view of technology as science applied to industrial (manufacture) and commercial objectives, versus a (metaphysically based) American Indian, or rather indigenous, view of technology as practices and toolmaking to enhance our living in and with nature. The Western conception and practices of technology are bound up in essentially human-centered materialism: the doctrine

49. Chapman, *Drama and Power in a Hunting Society,* 1.
50. Centro Cultural Mixart, *Museo a Cielo Abierto en San Miguel,* 42.

that physical well-being and worldly possessions constitute the greatest good and highest value in life. Indigenous conceptions and practices of technology are embedded in a way of living life that is inclusive of spiritual, physical, emotional, and intellectual dimensions emergent in the world or, more accurately, particular places in the world.[51]

So the tools of indigenous spirituality depicted in this mural—the kultrun, the potted flower, the body paint, the moais—are technologies too, in some ways not unlike high speed computers, smart phones, fiberoptic cable, and the like. Both seek enhanced access to knowledge and communication. As Deloria and Wildcat elucidate, however, the indigenous tools facilitate, rather than obfuscate, the interconnectedness and relatedness between different ways of perceiving and understanding the world. The fact that the "digital man" is squarely situated within an indigenous realm signifies not only a legitimization of indigenous technologies but also a leveling effect between Western and indigenous ways of knowing.

While the previously discussed works in the San Miguel MCA engaged radical politics through subject matter, others did so more through medium and style, suggesting that formal elements are not devoid of social justice implications. Moreover, the combination of muralists and graffiti artists working together in this one locale gave rise to collaborations across different artistic praxes. The blending and legitimization of diverse modes of street art in this MCA coupled with the coming together of different generations of artists promoted open and dynamic conceptualization of art on the part of artists, residents, and passersby alike. Many of these artists were seeking to disrupt the graffiti-muralism binaries that have historically divided the different styles of wall painting in public spaces, ones that regard muralism as a legitimate and time-honored art form and graffiti as illegal or quasi-illegal urban markings.

In the mural *Integración* (2011; see figure 2.4), MCA curator Mono González and French graffiti artist Julien "Seth" Malland precisely politicized the practice of street art by providing spectators and pobladores with a composition that infused specific meanings into form and medium. This wall painting presents spectators with two female figures who allegorize different yet complimentary histories of street art. González covered most of the mural's pictorial space with a woman's face in profile using a style that is overtly and unambiguously connected to the Brigada Ramona Parra, thus paying homage to that uniquely Chilean tradition of muralism. The thick black

51. Deloria Jr. and Wildcat, *Power and Place*, 70.

FIGURE 2.4. Mono González and Julien "Seth" Malland, *Integración* (2011), mural, Museo a Cielo Abierto San Miguel, Santiago. Photograph: Roberto Hernández.

outlines coupled with flat areas of unmodulated color, typical of the briga-dista style, evoke a street art style that is recognized by a large portion of the Chilean public as contestatory and oppositional, harkening back to the politi-cal campaigns of Salvador Allende and the heyday of the left-leaning Uni-dad Popular coalition of the late 1960s and early 1970s. As cofounder of the

Brigada Ramona Parra and a veteran muralist with a career that spanned over four decades, González emerged as a decisive signifier of a radical approach to street art. By contrast, Seth represents a younger generation of street artists who embody the global and transnational reputation of graffiti. Based in Paris, Seth was part of a coterie of international artists invited to paint walls in the San Miguel MCA. His invitation to paint in Chile and his encounter with González left a lasting impression on the Parisian artist, who commented that the muralist's "philosophy and simplicity impressed me forever." He further stated that González became for him "a bit like a spiritual father" after working closely with the Chilean muralist.[52] A self-professed "globe painter," Seth had done graffiti throughout Europe, Asia, and the Americas prior to arriving in Chile. His trademark imagery consisted of graffiti characters resembling young children who roam the urban sphere engaging in mysterious, whimsical, and even magical acts.

In *Integración,* one of Seth's iconic characters, in this case a young girl, kneels in front of González's brigadista woman with a *brocha* or house paint brush in hand. A clear metanarrative or metamural soon emerges here. Rendered with spray paint in the irreverent and playful style of graffiti, we find this girl caught in the act of painting this very mural as she suspiciously looks to the side knowing that street art is a subversive, rebellious, and often censured act. The metanarrative in *Integración* then resides in the fact that this is a mural *about* a mural, a self-referential image that calls attention to its own construction. While the mural pays homage to the long-standing tradition of brigadista muralism in Chile, it refuses to present it as a privileged master narrative of an essentialist origin story. A young girl who would not yet be alive during the formative period of the Brigada Ramona Parra is nevertheless executing a brigadista image. Through the stark contrast of different styles and formal vocabularies that are, at the same time, complimentary and dialectic, the artists comment on how street art in Chile is constantly reflecting on its own praxis, making evident the "constructedness" of its imagery. The juxtaposition between the overwhelming flatness of the brigadista woman and the more volumetric rendering of the young girl (contrasting aesthetics facilitated by the artists' use of different media) creates a leveling effect between the traditions of muralism and graffiti. Artists who create a mural that highlights its own inner workings and dismisses hierarchies of artistic production are clearly refusing to present themselves as privileged subjects of knowledge in the public sphere. This desire to democratize artistic media operates jointly then with an attempt to transcend different conceptual binaries that inform the practice of street art.

52. Anissa, "Seth Interview."

The title of the mural, *Integración*, evokes a coming together, a melding, or consolidation of ideas that are traditionally believed to be distinct. Notions of "youth" versus "older age" are nullified through the collaboration of two artists belonging to different generations, a concept that is further accentuated through the representation of a woman and a young girl in the mural. Ideas about the "national" and "transnational" are also undermined as *Integración* was the product of a Chilean and French artist for whom national origin and citizenship are ambiguous, fluid, and not clearly delineated categories. In this mural, González and Seth made clear that the transgression of these binaries already existed in Chilean city streets so the artists' aim was to highlight the constant blurring of socially constructed boundaries that occurs in the urban space. So through the strategic use of medium and style, González and Seth made a political statement that was more conceptual in nature than others in this MCA; they promoted the need for a more democratic and nonhierarchical appreciation of street art that did not necessitate master narratives and that did not essentialize what it meant to be a muralist and/or graffiterx in Chile.

The presence of the murals in the Población San Miguel went well beyond the mere beautification of the urban space. The creation of this MCA led to real and tangible improvements to the living conditions of its residents. Given that the ambitious mural initiative there was entirely community driven, thus demonstrating the resourcefulness and commitment of the residents within the población, local city officials responded in kind. The regional director of the Ministry of Culture as well as the mayor of San Miguel both visited the población, both of whom committed to improving the surrounding areas of the apartment blocks. They established a permanent system of trash collection for the residents, thus preventing the health and environmental risk of *microbasurales,* improvised trash heaps that emerge in neglected and marginalized sectors of the city where basic services are lacking. They improved the sidewalks, planted grassy areas, and installed various seating benches. The municipality also set up more public lighting, including fixtures that would illuminate the murals themselves at night. "We forced the hand of big brother," Hernández remarked, "the municipality understood that they could not remain idle before what was happening here."[53]

The tangible improvements brought about by the MCA in the Población San Miguel were also coupled with more qualitative or abstract effects that positively changed the lives of the residents. In the year 2012, the población's Junta de Vecinos (Neighbors Committee) carried out a survey among five hundred of its residents asking them what elements of the población made them

53. Hernández interview.

feel most proud and happy to live there. The survey gave them multiple-choice answers to select from: public lighting, grassy areas, location, social harmony, the murals, or anything else. The responses were astounding to the coordinators of the MCA, as 80 percent cited the murals as the source of greatest pride among the residents.[54] The survey spoke volumes about the strong sense of connection to place that the murals had inspired in its residents. Hernández commented that when his neighbors were asked where they live, the response was usually "in the población with the murals," as the MCA has become a powerful signifier of location and belonging. "The murals have changed the codes of where we live," he further asserted.[55] Thus, the new consciousness brought about by the existence of the MCA points to a continuum that runs from the presence of murals in a particular locale, through the transformation of the social space and to the way people relate to the aforementioned locale. This continuum, however, is not unidirectional, as it doesn't end with people's new relationship to space; nor does it necessarily begin with the murals themselves. Rather, the continuum runs in a rhizomatic fashion with each element of this dynamic constantly feeding off one another with no clear and absolute ending and beginning. The inherent democratic elements of an MCA such as the one in San Miguel rests on this rhizomatic dynamism between street art, urban space, and its audience, which is itself composed of casual passersby, visitors wishing to see the murals, and residents who live with the murals on an everyday basis. The murals thus promoted engagements with these different kinds of publics while at the same time celebrating the important connections between underserved communities and the spaces where they live.

MUSEO A CIELO ABIERTO IN LA PINCOYA: POLITICIZING MEMORY

The success of the MCA in San Miguel provided a strong impetus for the creation of other open-sky museums in Santiago. The población of La Pincoya, which had an even more visible history of activism specifically related to urban space than the Población San Miguel, soon became an ideal site for another major MCA. Located in the commune of Huechuraba (north Santiago) with a population of approximately 55,000 residents, La Pincoya was initially populated through a series of land takeovers led by residents of nearby poblaciones starting in the late 1960s. Rosemary Barbera recounted that one

54. Hernández interview.
55. Hernández interview.

of the most important takeovers occurred on "the morning of October 26, 1969, when 5,000 *allegados* (people without homes of their own) in the northern section of Santiago raised their flags high and converged on an empty lot on Avenida Guanaco to take it over."[56] Historians Julio Pinto, Azun Candina, and Robinson Lira argue that land takeovers represent powerful expressions of self-determination on the part of pobladores who refuse to rely on the state: "Land takeovers and the formation of poblaciones made the project for a 'better life' a material reality [for pobladores]. Public institutions had either failed or delayed this project *ad eternum* [forever]."[57] The independent spirit associated with poblaciones, in particular those born out of land takeovers like La Pincoya, called the attention of the most visible members of the political left in the late '60s and early '70s.

Soon after its founding, La Pincoya counted, among the recognition and legitimization of the most visible Communist, Socialist, and Marxist figures of the era in Chile, such as poet Pablo Neruda, activist Gladys Marín, and Allende himself who visited La Pincoya.[58] These high-profile public visits became ingrained in the collective consciousness of this población, becoming an integral part of the political identity of this locale.

The process of establishing La Pincoya was one carried out in a collective and communal fashion with residents actively participating in the eventual purchase of the land and in the installation of basic services (electric power, running water, schooling, transportation, health centers, etc.).[59] Often called a *población emblemática* (emblematic neighborhood), this locale is well known across Chile for the aforementioned leftist politics and open opposition to the government during the Pinochet regime. In fact, La Pincoya also bore the brunt of many human rights abuses during the dictatorship as many of the residents there were detained and eventually disappeared at the hands of the police and military. The Communist leanings of this población and many others in Santiago made their residents into "victims of the violent interventions of the armed forces whose goal was to find the principal sympathizers of the deposed government [of Salvador Allende] and repress any attempt at an uprising."[60] The Pinochet government had determined that leftist sympathizers threatened the national unity of Chile and thus sought to destroy this "enemy from within."[61]

56. Barbera, "Community Remembering: Fear and Memory in a Chilean Shantytown," 74.
57. Pinto, Candina, and Lira, *Historia contemporánea de Chile*, 127.
58. Molina Jara and Molina Vera, "Expresiones de la lucha contra la dictadura," 55.
59. Barbera, "Community Remembering: Fear and Memory in a Chilean Shantytown," 75.
60. Pinto, Candina, and Lira, *Historia contemporánea de Chile*, 50.
61. Pinto, Candina, and Lira, *Historia contemporánea de Chile*, 51.

Because of the highly politicized history of the población, the murals in the MCA of La Pincoya, led by coordinator José Bustos, focus on themes that are explicitly and unambiguously related to social justice and radical protest. The original vision of this mural site was to create wall paintings that highlighted the specific history of the working-class struggle in La Pincoya while also contextualizing these struggles within broader concerns over social justice in the Americas. In the mission statement for this MCA, Bustos stated that the community in La Pincoya could not "build [its] future without recognizing [its] people's history."[62] Murals and graffiti then became a means of writing an oppositional history that was recognizably local but also decisively transnational. The visual histories depicted in the murals of the MCA in La Pincoya were also part and parcel of a larger project related to the recuperation of memory, a project that had been underway in the población since the return to democracy. The murals here stand in stark contrast to what Isabel Piper Shafir called "the memorialistic politics of state institutions that prioritize the search for reconciliation far and above the defense of memory."[63] Bustos and the organizers of the MCA in La Pincoya regarded the public mural as a "tool that seeks social transformation while also looking to beautify and bring happiness in places where desolation is most evident."[64] Thus, the combination of history, memory, social transformation, and beautification that is at the core of this mural initiative in La Pincoya make most of these wall paintings into incredibly rich and complex works of public art.

Specific references to La Pincoya's local history figure prominently in the iconographic program of this MCA. Providing residents with a sense of neighborhood pride and belonging is a key component of the claims over urban space that the murals here establish. These claims are, in turn, a reminder of the history of land takeovers that founded the población. The mural simply titled *La Pincoya* (2014; see figure 2.5) was created as a collaborative effort between Argentine street artist Alfredo Guillermo Fernández (better known as Freddy Filete) and local graffiti artists Seba, el Año, Pati, Tikai, and Plek. The wall painting is simply composed of stylized and highly decorative lettering that reads the words "Población la Pincoya." The style of the font used by the artists is vaguely reminiscent of the Old English styles commonly found in graffiti art in the East and West Coasts of the United States while also nodding to the tradition of memorial graffiti pieces made in honor of the dead within

62. "Museo a Cielo Abierto en la Pincoya: Construyendo sueños de unidad."
63. Piper Shafir and Hordán, *Espacio y recuerdo,* 23.
64. Museo a Cielo Abierto en la Pincoya website.

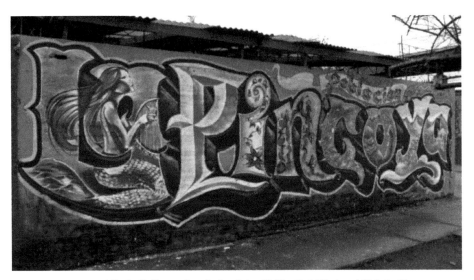

FIGURE 2.5. Alfredo Guillermo Fernández, Seba, El Año, Pati, Tikai, and Plek, *La Pincoya* (2014), mural, Museo a Cielo Abierto La Pincoya, Santiago. Photograph: Guisela Latorre.

inner city neighborhoods in the US as well.[65] Though not directly related to death, memory is clearly embodied through the specific urban space of the población as seen in this mural's iconography. First and foremost, the muralists pay homage to the mythical figure that gave the población its name, La Pincoya. Originating from folklore legends in the islands of Chiloe off the coast of Chile, La Pincoya is said to be a mermaid-like water spirit who lives in the waters of the Pacific. Her ritual dance can attract fish to shore for a plentiful catch. Broadly speaking, this is a legend that is concerned with the survival and welfare of working-class populations in Chile. In the mural, she is depicted with long violet hair while she wistfully plays a harp, implying that she is looking out for the welfare of the pobladores. Her gaze leads our eyes then to more documentary and historical images concerning the history of activism and resistance in La Pincoya. Within the letter "o" in this text-based mural, a hooded figure, an *encapuchado,* looks on toward the hills of the población as he prepares to launch a Molotov cocktail. The letters "y" and "a" then reveal a sepia-colored panoramic vista of the housing in the población, an image that recalls the initial settlements of La Pincoya. These images memorialize the oppositional history of the población, a history that is

65. For more information on graffiti memorial art in the United States, see Cooper and Sciorra, *R. I. P. Memorial Wall Art.*

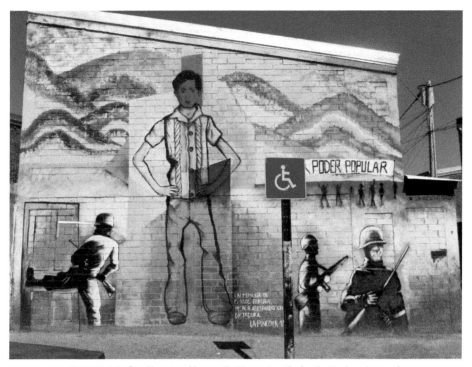

FIGURE 2.6. Con Nuestras Manos, *En Memoria a Carlos Fariña* (2013), mural,
Museo a Cielo Abierto La Pincoya, Santiago. Photograph: Guisela Latorre.

defined by radical social action and collectivity, without which this emblem-
atic sector of Santiago would not have come into existence.

The specter of the political violence experienced by residents of La Pin-
coya is a recurring theme in several of the murals painted there. These images
are not meant to be mere references to past horrors as they often remind
passersby that the possibility of state-sponsored violence and repression is
always a clear and present danger. In the mural *En Memoria a Carlos Fariña*
[In Memory to Carlos Fariña] (2013; see figure 2.6) the artistic collective Con
Nuestras Manos [With Our Hands] promoted a form of communal memory
among residents and pedestrians while also disrupting any sense of compla-
cency about past histories. The act of remembering is not only one of recalling
the past but also reconstructing fragmented and forgotten histories.

Such a strategy for enacting memory also requires active and critical
witnessing on the part of the spectators, for they are encouraged to inject
new meanings into past events. The allegory of remembering in this mural
then becomes the figure of Carlos Patricio Fariña Oyarce, a thirteen-year-old

boy from La Pincoya who was detained and eventually killed at the hands of authorities during the month of October in 1973. For the next four years, his mother would tirelessly search for him, visiting detention centers, police head-quarters, and other institutions for any information about her son. Her fruit-less search ended when she succumbed to cancer and died in 1977. No further information was known about Fariña until the year 2000 when construction workers found his skeletal remains underground near Pudahuel Airport. The boy's bones revealed that he had died from multiple bullet wounds. The case of Fariña's death and disappearance cast an uncomfortable light on crimes committed against minors during the Pinochet regime and on the impunity that continued well beyond his administration. Using a fairly straightforward design and composition, the artists rendered the figure of Fariña at the very center of the pictorial space, surely drawing from the family photograph of the child that would circulate in the press and among human rights groups after his disappearance. Superimposed on Fariña's body are differently colored flat planes that fit together almost like a puzzle. These planes signify the fragments and remnants of his life that the dictatorship left behind, pieces that the artists symbolically pieced together as an oppositional and defiant act of remember-ing. Behind Fariña we see the hills that characterize the urban landscape of La Pincoya, motifs that endow the image with the specificity of place. On the foreground and flanking Fariña himself are menacing black-and-white images of soldiers kicking down a door while brandishing weapons. These are the haunting images of the violent and invasive raids that occurred in La Pincoya. The contrast between these monochromatic representations of the military and the colorful palette elsewhere in the mural become symbolic juxtaposi-tions between the grey austerity of repressive rule and the rich vibrancy of a democratic utopia. In order to accentuate the idea of utopian collectivism, the artists included a group of población residents walking along the horizon carrying a banner that reads, "Create a people's power." In a direct and easily legible fashion, the artists' quest for the recuperation of memory challenged the politics of forgetting that permeated Chilean official discourses since the early 1990s. Such rhetoric of oblivion was particularly salient for the younger generations who were too young to remember the dictatorship or were sim-ply born after the dictatorship's official end. The choice of a young adoles-cent as the central subject matter in this mural also indicated how the artists were seeking to appeal to the younger people of the población, individuals not unlike Fariña himself. These spectators are then asked to remember and wit-ness a history they never lived, prompting them to inject their own more con-temporary subjectivities into the images thus, reviving the memory of Fariña

once again. Moreover, the figure of Fariña is a reminder that young people in La Pincoya have been important protagonists "in the struggle against the [Pinochet] regime, actively participating in protest duties."[66]

While the murals of La Pincoya's MCA promoted a politicized awareness about local histories, they also encouraged a transnational consciousness that connects the local to the global, thus enhancing the viewer's awareness of social justice. This awareness was not only disseminated within the physical space of La Pincoya but also in other significant parts of the city, thus prompting Bustos and the artists associated with this MCA to go "on the road," so to speak. The fact that not all murals were done *in* the población itself but were still using the name "La Pincoya" as a kind of trademark speaks of the organizers' desire to extend the spirit of this emblematic población. The name La Pincoya has come to signify the specific locale in northern Santiago where its residents live, but it has also come to denote a particularly radical politics of dissent in Chile, a politics that is both dependent and independent of the physical space of the población. The mural *Yankee Interventionism in Latin America,* painted by a large collective of mural and graffiti artists that included Colectivo Amancay, Nestha, Seba, Plek, DP, Amaranta, Jae, Pecko, Cagde, Defos, Injusticia, Jano, Degra, Vidaingravita, Causa, Sam, Rouse, Fabi, Richy, Sofrenia, Naturaleza, Boa, Yono, and PP, precisely takes the political message of La Pincoya to a different sector of the city, namely the interior patio of the University of Valparaiso in the Santiago campus (see figure 2.7). Simultaneously, this mural also encourages its most likely audience, the college students who attend this university, to make a cognitive leap from local knowledge to global consciousness.

The artists here took on a denunciatory and highly critical stance toward the troubling history of US intervention throughout the Americas. The target of their critique is the actions of the School of the Americas, now known as the Western Hemisphere Institute for Security Cooperation, which is a defense institute created by the United States government that trains US-allied troops throughout Latin America. Critics of the institution, most notably the School of the Americas Watch (SOAW), which is a US-based advocacy association formed in 1990, have described the institute as an organization that produces "assassins, death squad leaders and human rights abusers for dirty work in Latin America since its founding in 1946."[67] The artists took inspiration from

66. Molina Jara and Molina Vera, "Expresiones de la lucha contra la dictadura," 50.

67. "School of the Americas, Western Hemisphere Institute for Security Cooperation," explanatory map providing an overview of US intervention in Latin America produced by the School of the Americas Watch (SOAW), n.d.: http://www.soaw.org/presente/images/stories/artists/ilcinkhighressm.jpg (accessed on June 23, 2017).

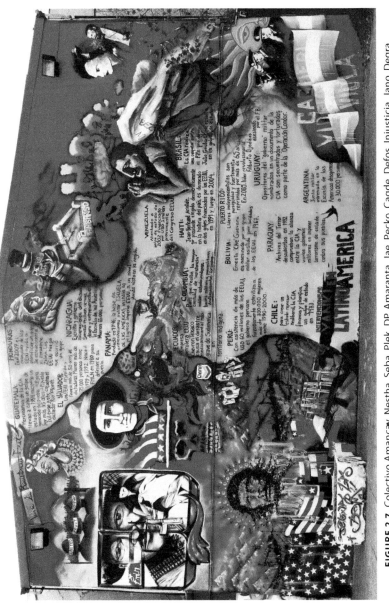

FIGURE 2.7. Colectivo Amancay, Nestha, Seba, Plek, DP, Amaranta, Jae, Pecko, Cagde, Defos, Injusticia, Jano, Degra, Vidaingravita, Causa, Sam, Rcuse, Fabi, Richy, Sofrenia, Naturaleza, Boa, Yono, and PP, *Intervencionismo Yanki en Latinoamerica* (2012), mural, University of Valparaíso, Santiago Campus. Photograph courtesy of José Bustos.

a map that SOAW produced that detailed the various acts of interference in the internal affairs of Latin America. The motif of the map that they reproduce in the mural is a powerful signifier of place but also a symbol of military domination and power. Maps don't simply denote geographic space; they can also depict ideological geographies and power relations that are anchored to physical spaces. Art historian Cody Barteet has argued that the principal purpose of the cartographic document is to exert "power over the peoples and the physical and conceptual spaces of the Americas."[68] Nevertheless, Barteet also observed that the map has a hybrid history that has endowed these documents with the potential for subverting the power of the image.[69] Within this hybrid history, a map can also function as a document of resistance. In such a manner, the map recreated in this mural as well as the map produced by SOAW both demonstrate a subversive way to look at Latin America's geography, from the vantage point of resistance rather than power.

The artists of this mural render a more intuitive rather than accurate silhouette of the Americas, purposely ignoring the colonial borders of each country. Contained within this cartographic silhouette are the various histories of US intervention, which are written in a concise and direct fashion. Each history is accompanied by a visual representation of the events being documented. For example, Guatemala is included in the upper right-hand corner of the composition with the following inscription: "CIA mercenaries carry out a coup d'état in 1954, initiating a genocide of indigenous people for more than 35 years. The Ixil community demands justice against the dictator Rios Montt." This narrative takes on added meanings through the images that accompany it: a Maya Ixil woman looks on with anguish and desperation at a group of armed soldiers who confront a large group of indigenous people. These indigenous figures look small and defenseless before the monumental power of the soldiers whose helmets bear the words "United Fruit Company." The transnational agricultural corporation United Fruit Company played an indirect role in the political repression that Maya communities would suffer after the country's 1954 coup d'état. During the better part of the twentieth century, this company exercised a monopoly over the distribution of bananas by controlling the railroads in Guatemala. With the democratic presidential election of Jacobo Arbenz Guzmán, the situation for the company became more complex, for this newly elected president sought out agrarian reforms and labor rights that demanded the expropriation of "four-fifths of the company's Tisquisate

68. Barteet, "Contested Ideologies of Space in Hispanic American Cartographic Practices," 27.

69. Barteet, "Contested Ideologies of Space in Hispanic American Cartographic Practices," 23–24.

and Bananera plantations and offered $1,185,000 as compensations for properties that UFCO [United Fruit Company] valued at $19,350,000."[70] The United Fruit Company then initiated various aggressive lobbying campaigns to pressure the US government to intervene, campaigns that resulted in the aforementioned coup d'état assisted by the CIA.[71] A young military official by the name of Efraín Ríos Montt, trained in the School of the Americas a few years earlier, was among the Guatemalan figures that would work with the US government during this power struggle. Almost 30 years later, Rios Montt became dictator of Guatemala through another violent coup d'état, eventually massacring thousands of Ixil Mayas, a period known as the "Mayan Holocaust."[72] Through a combination of text and image, the artists of this mural elucidate the interrelated dynamics of repressive government power and capitalist interests, dynamics that manifested themselves through the racist violence against the indigenous people of Central America. As the eye moves across the composition of this mural, spectators are encouraged to find similar patterns of power elsewhere in the Americas, including Chile. In the mural's section on Chile, the artists wrote on the wall's surface a succinct explanation the 1973 military coup in Chile: "In order to create a repressive neoliberal state, the CIA finances and plans a coup d'état in 1973." The relationship between capitalist power and political repression emerges here again through the mention of the words "neoliberal" and "finances." Like in other sections of the mural, the images expand the content of the narrative. Deposed president Salvador Allende is depicted here holding up an AK-47, a gift from Fidel Castro, while the presidential palace of La Moneda burns in the background. A series of Chilean flags to one side appear fragmented and divided, symbolizing the fragmentation and destruction of the state as a result of the coup. José Bustos has indicated that Allende's figure was meant to show the former president at the moment when "he takes up arms when [the] presidential palace is attacked."[73] Such a representation of Allende stands in sharp contrast to the images of a passive and defeated president promoted by canonical histories of Chile. The appropriation and claims over urban space in the MCA of La Pincoya transcend the specificity of the University of Valparaiso by including most of Latin America in this mural. The map, as an emblematic tool of resistance, incites the college students and other potential spectators of this mural to see that their local geography is part of a larger web of political relations where the US

70. Dosal, *Doing Business with Dictators*, 1.

71. Dosal, *Doing Business with Dictators*, 1.

72. Garrard-Burnett, *Terror in the Land of the Holy Spirit*, 7.

73. Museo a Cielo Abierto La Pincoya, "Intervencionismo Yanki en Latinoamerica," explanatory and didactic poster produced in conjunction with the mural of the same name, n.d.

has played an imperialist and colonialist role. Political resistance then, the artists seem to imply, needs to include an awareness of how physical space, be it that of the city of Santiago or the larger territory of Latin America, contributes to neoliberal and colonial oppression.

CONCLUSION

The concept of an "open-sky museum" as a means of democratizing the urban sphere has been refined and enhanced in San Miguel and La Pincoya. The hegemonic definition of the museum as a space for privileged artists and spectators is routinely challenged and problematized in these locales. The artists and organizers associated with these MCAs desired to create more accessible museums that did not solely cater to Chile's social elites. The very act of putting a museum in a población contributed to the larger project of forging a visual democracy in Chile, a mission shared by other street artists. But perhaps what distinguished MCAs' contribution to visual democracy from other street art projects in the country was the way in which these radical museums sought to transform and redefine neoliberal and neocolonial distribution of urban space through the creation of street art environments.

The inclusion of work done by graffiterx in these MCAs (not just by traditional muralists) also contributed to the promotion of visual democracy in Chile, as the coordinators and organizers of these street art initiatives refused to uphold clear hierarchies of artistic production that cast muralists as legitimate artists and graffiterx as vandals. But the presence of graffiti work in these MCAs was also broadly indicative of how this art form came to be regarded in Chile since the 1990s. In what follows in chapter 3, I will document the recent history of graffiti in the country while also addressing how this form of street art has avoided the virulent stigmatization commonly seen in countries like the United States.

Tagging the Chilean City

Graffiti as Individualized and Collective Praxis

Tagging is a way to develop your style and express your disapproval with society. Never give up tagging. It's essential. It's a radical form of expression.
—Fisura[1]

I don't like tagging as it is dominated by the ego. Writing my name everywhere so that everybody knows who I am doesn't encourage evolution.
—Faya[2]

DURING AN INTERVIEW with Lord K2 (AKA David Sharabani, a London-based artist, writer, and photographer), two Chilean graffiterx uttered the statements above, pronouncements that embody an ongoing ideological battle among these artists in Chile: Has the emergence and growing visibility of graffiti in the country enabled egocentric public expressions among its producers or has it promoted more socially engaged and egalitarian forms of creativity in urban spaces? It is no coincidence that the issue for artists Fisura and Faya centers on the specific practice of tagging—that is, the act of writing or spray painting one's own name on public buildings or other city structures. While Fisura implies that the tag is inherently radical and revolutionary, Faya sees it as a futile act of self-aggrandizement. Graffiti scholar Lisa Gottlieb has taken notice of the inherent contradictions in tagging by stating that the practice is "a form of self-expression that both mocked and embraced the emblem of success which defines mainstream consumer-culture: seeing one's name broadcast across the city."[3] Within the historical, political, and cultural specificity of twenty-first-century Chile, then, how should we interpret the act of inserting and/or imposing the self onto the public sphere? The matter becomes further complicated if we consider that public self-expression, even if it is highly indi-

1. Lord K2, *Street Art Santiago,* 124.
2. Lord K2, *Street Art Santiago,* 124.
3. Gottlieb, *Graffiti Art Styles,* 36.

vidualistic and seemingly apolitical, has been necessarily subversive within an urban space that is often controlled and monopolized by state and corporate interests. Graffiti's intervention and disruption of institutional and hegemonic ownership of such spaces actively complicates a clear distinction between the individual and collective impetus behind street art. The fact that graffiti in Chile emerges in force during the 1990s, shortly after the end of Pinochet's dictatorship, indicates that the rise of this art form in the country cannot be disentangled from the country's political history. We should also keep in mind that Chilean graffiti has by no means represented a homogeneous artistic movement; while some practitioners see the socially altruistic and politically revolutionary potential of the medium, others see it as a more individualized and purely aesthetic artistic endeavor.

Thus, in this chapter I will focus on the distinct history of graffiti in Chile while underscoring how these artists are constantly straddling the fine line between the self and the communal. The very act of making oneself more visible within the impersonal and often dehumanizing character of city streets is part and parcel of the push toward visual democracy enacted by Chilean street artists. Moreover, though graffiterx in Chile have very different reasons and motivations for painting the streets, a sizable percentage of this community is openly and unapologetically political about their praxis, as members of the 12 Brillos Crew have stated: "The government's manipulation of the media has served as a great source of motivation to turn to the streets and expose what they attempt to hide."[4] The dichotomy between individualism and collectivity in Chilean graffiti is an ongoing struggle, as explained by Hozeh, also from the 12 Brillos Crew: "What happens with graffiti is that no one wants to touch the space of the other [artists]. It is very individualist. We [the 12 Brillos Crew] wanted to break from that practice but it generated a lot of conflict because Chile was not accustomed to that."[5]

THE LEGALITY/ILLEGALITY OF GRAFFITI IN CHILE

Since the rise of graffiti in Chile in the 1990s, the country has become a haven of sorts for street artists. The lax and ambiguous antigraffiti laws in the country have created a less hostile and noncriminalizing atmosphere for artists seeking walls to do their work. Though it is illegal to paint on public property in Chile, the enforcement of such laws is inconsistently practiced. How-

4. Lord K2, *Street Art Santiago*, 80.
5. Hozeh interview.

ever, graffiterx have to be mindful about where they paint, as Naska explains: "If you paint on a governmental or law enforcement building, you will be arrested. In general [though] I have never had problems."[6] Unlike in many countries in Europe and North America, graffiterx in Chile can go out and paint during the daytime with relatively little fear of police intervention. None of the artists I interviewed for this book were ever detained or sanctioned by law enforcement. Moreover, the public perception of graffiti in Chile is considerably more positive than it is in the United States, where the practice is heavily criminalized. Feminist scholar Jessica Pabón, in her own research in cities like Santiago and Rio de Janeiro, observed that "the public generally perceives multicolored graffiti art as a beautification of the cityscape."[7]

As of this writing, however, we see indications that the freedom that street artists have enjoyed in Chile for the past twenty years might be compromised in the coming years. In 2011, for example, attempts were made on the part of legislators to prohibit the sale of spray paint cans to minors (eighteen years old or younger) as part of an antidrug campaign, an initiative that was publicly repudiated by muralist Mono González: "Kids should be using all those materials, all those elements, but if they prohibit [the sale of spray paint], deep down inside they are repressing ideas. . . . Moreover, they are treating graffiti as if it was an addiction, with respect to drugs."[8] Three years later in 2014, lawmakers in the city of Curicó decided to paint public buildings with antigraffiti paint, which creates a nonstick surface on walls, and heighten police surveillance in areas frequented by graffiterx.[9] Most recently and of greatest concern, however, is the 2015 ordinance passed in the city of Valparaiso, one of the most iconic locations for street art in Chile. It stipulates that anyone painting walls can be subject to a fine of 220,335 pesos (approximately US$360), which for most graffiterx is a hefty sum. The ordinance further states that exceptions can be made for designs with "artistic merit" or for muralists who secured the proper permissions.[10] The language of the ordinance assumes that "artistic merit" can be easily ascertained by law enforcement while also reifying the false dichotomy between a muralist and a graffiterx. Moreover, the years 2014 and 2015 saw the emergence of public service campaigns that urged Santiago residents to care for their city by abstaining from tagging and spray painting

6. Lord K2, *Street Art Santiago*, 52.

7. Pabón, "Be About It," 89.

8. Video uploaded to Chile Estyle, Facebook blog by León Calquín: https://www.facebook.com/chileestyle/posts/104120769682870 (accessed August 24, 2015)

9. "Autoridades inician inédita campaña anti-graffitis en el centro de Curicó," *Vivimos la Noticia*.

10. Valentina Espejo, "El largo papeleo que tendran que hacer los graffiteros en Valpo."

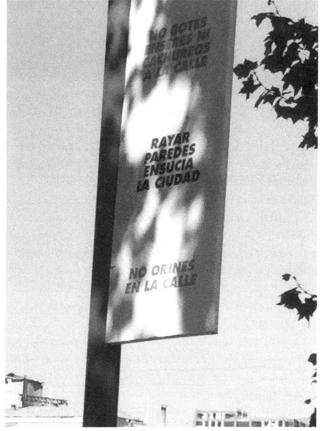

FIGURE 3.1. Anti-Graffiti Banner, the Municipality of
Santiago, 2015. Photograph: Guisela Latorre.

public property. For instance, the municipality of Santiago installed a series of
banners with the following statements: "No seas 'rayuo.' Quiero mi ciudad sin
tu suciedad" [Don't be a "scribbler." I love my city without your dirt"] (see fig-
ure 3.1), and "No botes enseres ni cachureos a la calle. Rayar paredes ensucia
la ciudad. No orines en la calle" [Don't throw garbage and junk on the street.
Tagging on walls dirties the city. Don't urinate on the street] (see figure 3.2).

All these statements equate tagging and public "scribbling" with the act of
dirtying and polluting the city. While many of the graffiterx and muralists I
interviewed were unconcerned with these campaigns, arguing that such efforts
were focused more on the quick scribbles and unrefined tags that are present
all over Chile's major cities (rather than on more elaborate graffiti composi-

FIGURE 3.2. Anti-Graffiti and Vandalism Banner, the
Municipality of Santiago, 2015. Photograph: Guisela Latorre.

tions and murals), I still saw them as possible indicators of changing attitudes
toward street art in Chile. Only time will tell if these measures will affect the
practice and culture of street art in Chile in the long run; suffice it to say that
at the time of this writing the country remained a fairly receptive and even
nurturing space for graffiti. Such an atmosphere has provided Chilean art-
ists with an open platform for the development of a rich and complex graffiti
aesthetic while also allowing them to explore the fascinating middle ground
between the self and the communal where street art often resides. Though the
urban sphere in Chile is far from being an egalitarian space, the presence of
street artists is felt in a space that is still not fully controlled and policed by
institutions of power.

THE ROOTS AND MOTIVATIONS OF CHILEAN GRAFFITI

[handwritten margin note: mural vs graffiti]

Like other forms of street art and urban creative expressions, graffiti gathered steam in Chile in the 1990s, which was an emblematic decade in the country, defined by the great promise of a new democracy. These sociopolitical changes coincided too with the explosion of graffiti on a global scale. By the 1990s, graffiti had ceased to be a street art expression relegated solely to the working-class and predominantly African American and Latinx neighborhoods of the Bronx in New York. Aided by the growing popularity of rap music (a genre often associated with graffiti,) tagging, "bombing," and street writing traveled transnationally, a rapid move documented by Nicholas Ganz:

> With hip-hop, graffiti entered almost every Western and Western-influenced country and then started to edge out further afield. Asia and South America caught on later, but their graffiti culture is now growing at a phenomenal rate and has already reached a high standard, particularly in South America.[11]

[handwritten margin note: global]

Though Ganz's reference to "Western and Western-influenced" countries and his comment about Asia and South America being located "further afield" betray some binary colonial thinking (West versus East, center versus periphery), his descriptions of the transnational appeal of graffiti do reflect the realities of street art at the turn of the millennium. Ganz further articulates the dynamic dialogue that happens between the local and global attributes of the art form by stating that "local differences still exist to some extent but have been inspired by styles from all over the world."[12] Thus, Chile's graffiti scene became the result of a convergence between the national and transnational flow of art and culture.

Chilean street writers certainly availed themselves of the opportunities afforded to them by the changing local and global landscapes of the late twentieth and early twenty-first centuries. The artistic formations of many of them began as pastimes during their adolescence, a time when the act of tagging and painting on walls on the weekends signified an escape or respite from the structures of school and home. These formations were decisively informal where friendship was the key foundation. For some of these young artists, graffiti became a long-term lifestyle or career decision, while for others it became a means by which to make important social and political statements. For young practitioners, the streets had opened themselves for all sorts

11. Ganz, *Graffiti World,* 9.
12. Ganz, *Graffiti World,* 10.

of urban interventions. Certain key locations in the city became important points of assembly for graffiterx and other youth interested in hip-hop culture. Estación Mapocho, Santiago's central train station originally built and in the early twentieth century by architect Emilio Jecquier,[13] became a well-known hub for graffiterx, rappers, break-dancers, and others. It is even said that rapper Ana Tijoux and pop/funk band Los Tetas, both of whom eventually gained national and international fame, would frequent Estación Mapocho in those days. In the late 1980s, the station was closed down and abandoned, leading to years of deterioration and decay until the administration of President Patricio Aylwin, the first freely elected president after Pinochet, decided to renovate and revitalize it in 1991 turning it into a cultural center that would be officially inaugurated in 1994. It is no coincidence that graffiterx would choose as a meeting point a space that was, like themselves, in the process of redefining itself in a moment of political transition.

For many of these practitioners, doing graffiti was part of a highly individualized process of identity formation, a process that allowed them to figure out a unique style that set them apart from others. However, the fact that this process needed to happen within the collective culture of hip-hop also indicated that these emerging artists were seeking to connect to a larger community. Any clear distinctions between the individual and the collective then were effectively obscured during those formative years of the Chilean graffiti scene. Socialization became a central component for the development of individual styles. Getting to know one another among graffiterx was just as important as gaining individual fame. Social bonds among artists were created in informal and organic ways. These bonds were forged primarily by word of mouth and casual encounters. "A friend of a friend would know someone who painted on the street," graffitero Fisek would recount, "and that was the guy who knew the other guy whose work I saw while riding the bus. I would then find out that all those people would meet in so-and-so place."[14]

Graffiti's inception in Chile was undoubtedly prompted by the country's transition to democracy. Many of the artists who participated in the scene where the adolescent or young adult children of political exiles who were now returning home. For many of them, using graffiti as a tool to democratize the urban space was directly related to their politicized upbringing. However, the growing visibility of global hip-hop culture, particularly from the US, gave them important cues about how to intervene and reclaim the public sphere. Documentaries about hip-hop culture such as *Beat Street* (1984) and rap music

13. Centro Cultural Estación Mapocho.
14. Fisek interview.

videos from abroad provided Chilean youth in the 1990s with rich sources of inspiration and emulation. The multiple forms of creativity that informed hip-hop culture in Chile and the varied avenues for expression were compelling for Chilean youth in the 1990s.

Because both graffiti and community muralism in Chile saw an important emergence and reemergence in the post-dictatorship era, the two forms of public art developed a dialectic relationship with one another. Unlike in the United States, where muralism and graffiti were often pitted against one another,[15] in Chile the two represent complementary and mutually validating ways to make nonhegemonic interventions into public space. Graffiterx often admire muralists of the older generations, such as Mono González and members of the various brigades active in Chile, because they painted during politically volatile times and at the risk of their own lives. Likewise, muralists tend to admire the creative energy and aesthetic innovations presented by the younger graffiterx. Moreover, the meanings of graffiti and muralism can get conflated with one another, in part, because these two types of wall painting have repeatedly converged since the early 1990s. Certain forms of street art, such as tags, throwups, bombs, stencils (created with spray paint), and stickers, are securely positioned within the category of graffiti. Yet, more elaborate compositions done by graffiterx are often categorized under the more ambivalent classification of "graffiti mural." A "graffiti mural" is a term Chilean street artists use to refer to a wall piece that has characteristics of both art forms. These works may contain the radical and bold forms of graffiti such as wild-style lettering and cartoon-like characters together with the more narrative and political content associated with muralism. These hybrid aesthetics are then further accentuated by the use of paint brushes and rollers, the tools of the muralist, and spray paint, the preferred medium of graffiterx. Given the ubiquity, visibility, and popularity of street art in Chile, the "graffiti mural" is a common site on city streets. In my conversations with Fisek, he pointed out to me that the fusion between graffiti and muralism that happens in Chile developed over time.[16] When street art exploded in the 1990s, the two forms were quite distinct and separate from one another, but with greater artistic "maturity," graffiti and muralism began to naturally overlap. What this hybrid phenomenon indicates is not only the organic relationship that happens amongst the two in the country but the persistent blurring between the individual and the collective that such a relationship implies. Mono González, among other artists, has often spoken about what he saw as the more collective nature of

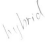

15. For more information on the historical and social tensions between graffiti and muralism in the United States, see Latorre, *Walls of Empowerment.*

16. Fisek interview.

muralism versus the individualism of graffiti: "Muralism in Chile has a collective connotation of teamwork. Anyone who doesn't know how to paint can participate, in contrast to graffiti, which is more personal, and where graffiti artists work alone or in groups of three or two."[17] Fisek, for his part, has indicated that while graffiti represents an artist's individual style, muralism signals a Chilean national style.[18] If graffiti indeed represents a more individualist approach to street art and muralism operates more collectively, the "graffiti mural" is yet another indication of the fluid movement between the two.

COMMERCIALIZATION

Like in other parts of the world, the capitalist co-optation and commercial assimilation of graffiti is also an important part of the scene in Chile. Speaking more broadly about the global graffiti scene, Lisa Gottlieb has argued that "graffiti has become a means of selling and promoting that which has little (if any) connection either to hip-hop or fine art."[19] Artists and practitioners seeking financial gain from graffiti have worked on behalf of advertising campaigns for multinational companies like Nike, Coca-Cola, and others, demonstrating that the radical and grassroots aesthetics of graffiti can also be subsumed under the ideological frameworks of neoliberalism in the country. The policy of nonintervention into financial markets that was established by the Pinochet regime and that continued to be in place well into the twenty-first century made public spaces into havens for corporate interests. For many graffiterx, this reality meant competing against but also working along with the private sector, often with the goal of financial sustainability, as graffitero Yisa candidly explained: "If a brand trusts me and gives me the liberty to do what I want to do, and if I like the brand, good. I live in a capitalist system and at the end of the day I will have to pay my bills with money."[20]

The potential for the commercialization of graffiti in Chile may appear then to compromise the collective, communal, and even radical characteristics of street art, as it may suggest that an artist is forgoing the collective in favor of the individual. However, the notion that graffiterx can fully embrace one or the other—the individual or the collective—is a fallacy and a near impossibility in public spaces where the self cannot be extricated from the subjectivities of others. Even the most self-centered artists who work on the streets will

17. Lord K2, *Street Art Santiago,* 40.
18. Fisek interview.
19. Gottlieb, *Graffiti Art Styles,* 7.
20. Lord K2, *Street Art Santiago,* 126.

inevitably respond to collective urges that present themselves in a public and urban environment. Moreover, the search for individual fame, often regarded as the ultimate indicator of graffiti's egocentrism, can be deployed with different goals and purposes, as Hozeh made clear to me: "I want my work to be known because my work speaks. There are other kids who want to be known because they want to sell it."[21] The question then becomes not whether or not artists pursue graffiti for personal gain and individual visibility but rather how do these artists use that visibility and fame within the urban space.

POWER, PERMISSION, AND CLASS

Many graffiterx take pride in the fact that they do their work without the permission of public authorities in Chile. For them, those who are in power, be they politicians or large corporations, have a general disregard for democratic rule and ethical behavior. "Like many countries in Latin America," tagger and bomber Jony explained, "Chile experienced a dictatorship and those who currently govern the country are heirs to this matter and were those who imposed the dictatorship and the police that worked for them. In contrast, graffiti is for the people."[22] This artist indicates then that graffiti can function as a means by which to speak back to power as the country continues to grapple with the legacy of the dictatorship and as institutions fail to deliver on the promise of democracy. Complicit with these mechanisms of power is mass media, which often operates as a mouthpiece for the country's hegemony. Reacting to the pervasiveness of such imagery, graffitero Olfer pointed out that "visual advertising is ninety-nine percent of what we see and it saturates us to death without respect to humanity. It's a form of contamination. Our objective is to conquer the wall, leave a message and democratize the wall."[23] Such an approach to street art operates as a direct contestation to the claims that graffiti pollutes the urban sphere; quite the opposite, it is seen by this artist and others as the remedy to mass media's hostile and unwanted takeover of city streets.

Without falling into romantic notions about graffiti as some form of urban salvation, it is, nevertheless, important to reflect why many graffiterx in Chile refuse to seek out permission to paint in public spaces. In Chile, as it the case in many parts of the world, mass media companies secure "permission" to mark up and intervene in public space through the trafficking of money and

21. Hozeh Interview.
22. Lord K2, *Street Art Santiago*, 21.
23. Lord K2, *Street Art Santiago*, 116.

influence, to put it simply. For many graffiterx, the very notion of permission then is complicit with power asymmetries promoted by institutions of power, be they corporations or the state, so the decision to not seek out authorization, in many cases, represents a direct or indirect denunciation of unequal access to "permission" that exists in neoliberal states.[24]

Through their work, graffiterx often directly or indirectly challenge the politics of neoliberalism in the urban sphere, and by doing so, they also challenge the power held by the ruling classes in Chile who benefit the most from these politics. Though graffiterx come from many walks of life, graffiti can become a kind of antidote for the country's socially stratified culture. Though the experiences with precarity and poverty endured by some graffiterx can put them at a disadvantage in relationship to street artists with more resources and access to arts training, the street art scene in Chile tends to create a leveling effect where no amount of class privilege can truly make up for inventiveness, resourcefulness, and creativity. When speaking of his experience growing up in a población, Hozeh recounted how he often came in contact with young street writers "who were very skilled at graffiti and who came from precarity, but were able to develop styles in spite of that precarity, in spite of having nothing."[25] This dynamic of making do, so to speak, was deeply cemented in the country by the muralist brigades that began painting during the late 1960s. The thick outlines and flat colors of the Brigada Ramona Parra, for instance, came about as a result of the aesthetics of necessity, an approach to art making that prompts practitioners to make stylistic decisions based not on artistic sensibility but rather on pragmatic needs and constraining circumstances. The BRP were thus conditioned to make creative decisions that would allow them to paint murals quickly with an easily legible visual language. Nevertheless, the aesthetics of necessity imply more than mere art practices that adjust to adverse circumstances; they involve strategies of resistance that lead to radical, innovative, and exceptionally imaginative work that defied the constraints of power. The look and style of this work endures, even when the circumstances no longer demand it. The creative work of subaltern groups in Chile is deeply imbued with the aesthetics of necessity, which has informed graffiti

24. It should be noted that a number of graffiterx do ask for permission to paint in certain circumstances. Commissioned pieces done by well-established artists are important examples. Such is the case of Cekis's mural in the Quinta Normal subway station and Inti's work adjacent to the Bellas Artes station, just to cite a few. I should also point out that street artists will often approach private homeowners and residents asking them if they can paint the outer walls of their houses, quite a common practice in Valparaiso. These instances, however, represent only a fraction of graffiti work in Chile with the vast majority the wall pieces still done "illegally," in other words, without the express consent and benediction of public authorities.

25. Hozeh interview.

production as well as other forms of street-based creative expression. The public sphere constantly compels artists to deploy the aesthetics of necessity as the unpredictability of working conditions in urban spaces often require it. In this respect, graffiti in Chile has become a more egalitarian art practice in relation to more institutionalized forms of art and, as such, has become of a powerful proponent of visual democracy.

GRAFFITI ARTISTS AND CREWS

Having provided a social and political history of Chilean graffiti as well as an analysis of the different ways in which street artists in the country are constantly straddling the fine line between individual and collective concerns in the public sphere, I will now turn to discussions about how individual graffiterx or crews intervene in urbanscapes while creating public visibility for themselves and others. The artists featured here are well known among the larger community of graffiterx in Chile and abroad, having devoted anywhere between ten to twenty years to the practice of street writing and tagging. Through their testimonies and creative work, I was able to understand the nuances of graffiti's still fairly short history in Chile while also appreciate their unique imprints on the public sphere.

One of the most openly political graffiti collectives in Chile, the 12 Brillos Crew, solidified its membership and artistic mission in the early 2000s when many of its members moved into a "casa ocupada," an abandoned dwelling that they occupied in the Yungay neighborhood of Santiago. This dwelling was the site of various arts workshops which, according to Hozeh, was the place "where we came in contact with people who made art to transform society."[26] As a consequence, the crew became involved and affiliated with various social movements such as the Revolución de los Pingüinos ("the revolution of the penguins," the student activist mobilizations), initiatives for equality in health care, and the Mapuche resistance. The Mapuche cause became particularly important to Hozeh, who stated that this indigenous group in Chile has been under a perpetual "dictatorship" since Spanish colonization. The crew thus became a mouthpiece for the political mobilization of activist groups whose voices were silenced or ignored by mainstream media outlets: "With murals, one has to speak," Hozeh remarked, "one has to announce that there are strikes, conflicts and/or public petitions going on . . . so that people are informed." As a result, the 12 Brillos Crew came to be known as a politically

26. Hozeh interview.

conscious graffiti collective who could be called upon by grassroots activists seeking to utilize socially engaged art practices. In spite of the serious sense of social commitment in the crew, the collective still retained the ludic and playful element of hip-hop and graffiti culture, that element that refuses to take itself too seriously. The name 12 Brillos Crew ("12 Shines Crew"), for instance, came from the friendly banter and joking between the different members of the collective who sought a tongue-in-cheek way to seek visibility in the public sphere, as founding member Hozeh explained: "[The name] was just a joke that came from the visual affects you add to graffiti. Later people thought it was something super vain, but it was just a joke."[27]

The numerous wall taggings, bombs, and murals created by the 12 Brillos Crew can be found in poblaciónes throughout Santiago and elsewhere. The powerful working-class sensibility of the crew has made them conscious of the importance of making visible interventions into locales that have charged histories of social struggle. Their 2011 untitled graffiti piece created in the Población José María Cano exemplifies the biting social critiques that are characteristic of the crew (see figure 3.3). Utilizing a combination of graffiti text and popular imagery, but also a clear narrative, the artists presented the residents of this población with an apocalyptic vision of the current political status in Chile. Two buses are on a collision course with one another as the city that surrounds them is in a state of infernal disarray. Two hooded protesters, or *encapuchados,* are captured at the very moment when they are about to launch a stone and a Molotov cocktail at *carabineros* (police). Clad in full riot gear, the carabineros appear robotic—nameless and faceless as they attempt to contain the social unrest. A *guanaco* (water cannon truck) looms ominously over them as it prepares for the attack.[28] On their side, however, are pernicious symbols of corrupt power. The representation of Chile's political leaders is allegorized by a monumental figure sporting a business suit and a presidential sash. Instead of a human head, this leader possesses a fish head, alluding to the absurdity of his political decisions and ideas. This image also makes reference to a common vernacular expression in

27. Hozeh Interview.

28. Water cannon trucks in Chile are generally known as *guanacos,* named after the Andean camelid animal that can spit at a three-to-six-foot range. While carabineros in Chile consider these trucks to be legitimate tools for ground control during public demonstrations and street protests, the use of these vehicles has been linked to serious injuries. For example, on May 21, 2015, twenty-eight-year-old college student and proeducation activist Rodrigo Avilés was participating in a demonstration in Valparaiso when he was hit almost point-blank by the powerful water blast from one of these trucks leaving him in a vegetative state due to a severe head injury. Chamy, "Rodrigo Avilés, el estudiante en coma por el que miles se movilizan en Chile." *BBC Mundo.*

FIGURE 3.3. 12 Brillos Crew, Untitled (2011), graffiti mural, Población José Maria Cano,

Chile. "Hablar cabezas de pescado" [speaking fish heads] refers to the act of talking nonsense or saying nothing of true consequence. Such an expression is often utilized to describe the empty rhetoric of Chilean politicians. While this leader spouts incoherent logic, he also literally and figuratively squeezes the life out of the country's natural and human resources. He holds in one hand a hydroelectric plant with its waters running down his fingers. The construction of this plant could be one of several ones that Mapuche activists have denounced due to their infringement upon native land. In his other hand, this unscrupulous leader has imprisoned blue-collar workers whose blood drips down his knuckles. If this figure represents a corrupt and abusive government, the character next to him stands with an institution that has been complicit with the state, namely the Catholic Church. A skeletal specter dressed in a bishop's hat and robe points his finger forward as if ordering the carabineros to attack the two agitators on the street. References to Santiago's urban topography are made explicit in the background with landmarks such as Cerro Santa Lucía, Cerro San Cristobal, the city skyline, and working-class poblaciónes clearly visible in the background. The sky above the city is gray, smoke-filled, and overcast. A police helicopter watches over these tragic events while a passenger airplane, which has caught fire, plummets to its doom.

Witnessing this chaotic and apocalyptic scene is an enigmatic figure engulfed in flames positioned on the left-hand side of the composition. Such a motif is reminiscent of Mexican muralist Jose Clemente Orozco's *Man of Fire* mural (1938–39) painted in the Hospicio Cabañas in Guadalajara, Mexico. Like the 12 Brillos Crew, Orozco had presented the viewer with a figure

Santiago, Chile. Photograph courtesy of Lord K2.

covered but not seemingly hurt by flames. Painted on the dome of the Hos-
picio, Orozco rendered his man of fire using extreme foreshortening making
it appear as if he is walking high above the spectator. Art historian Desmond
Rochfort has argued that the motif of fire in the work of the Mexican artist
stood as an apocalyptic symbol of pain, purification, conflict, and inspira-
tion.[29] Rochford further maintained that Orozco fashioned his man of fire in
a way that made it seem as if he was disintegrating but also rising "like a phoe-
nix from the ashes."[30] Fire was a powerful metaphor for the artist, Rochfort
tells us, for it represented destruction and social struggle while also denoting
enlightenment and rebirth.[31]

In their graffiti mural, the 12 Brillos Crew adopted, updated, and retrofit-
ted Orozco's man of fire so that the allegory became relevant to twenty-first-
century urban strife in Chile. The fact that this figure, who is more gender
ambiguous than Orozco's, wears a baseball cap with the number 12 on it is
revealing in that this number is a direct reference to the 12 Brillos Crew them-
selves. We can thus regard this graffiterx of fire as a self-portrait or proxy for
the entire graffiti collective who worked on this mural. This graffiterx looks at
the scene of destruction and violence before them with a paint bomb in hand.
The implication then is that they are about to join the encapuchados in con-
fronting the police but will do so through the use of radical art actions. This
emblematic figure is a critical witness to the harsh conditions of inequality
while also serving as a powerful allegory for new possibilities. Like Orozco's

29. Rochfort, "A Terrible Beauty," 75
30. Rochfort, "A Terrible Beauty," 86.
31. Rochfort, "A Terrible Beauty," 86.

Man of Fire, this graffiterx signifies the opposing concepts of conflict, pain, and destruction as well as purification, inspiration, and renewal. It is the street artist then who holds the key to a more democratic, inclusive and egalitarian urban space. Such a vision of the graffiterx as a committed social actor dislodges notions of individualism and egocentrism in street art.

While the narratives that the 12 Brillos Crew established in this graffiti mural created a decisively denunciatory critique of the Chilean social system, the artists also availed themselves of graffiti aesthetics to further radicalize their message. Aside from including tags with the crew name throughout the graffiti mural, the artists also "tagged" several "surfaces" within the pictorial space of the image. The two buses and the water cannon truck have been marked up with meta-graffiti tags, in other words, with graffiti about graffiti, which calls attention to street writing as a politicized practice of urban intervention. All these meta-tags also operate as public denunciations and condemnations of oppressive social realities in Chile. The fact that most of these are inscribed on the buses and the water cannon truck—apparatuses that symbolize the policies and instruments of the state—suggests that the artists are actively contesting the power technologies of the government. While tagging one's own name can denote an individualized act of self-promotion, tagging other different kinds of words can imply a posture of resistance and opposition to the space or object being marked up. For example, the water cannon truck is covered with paint bombs and with the tags "NO + LUCRO" [No more profit] and "WALLMAPU LIBRE" [Free Mapuche territory]. Both of these inscriptions are meant to challenge the connotations of state authority and power symbolized by the truck. Moreover, the "NO + LUCRO" tag was reminiscent of the work created by the collective CADA (Colectivo de Acciones de Arte), the Chilean radical arts group mentioned in the introduction of this book. In 1983 and 1984 the artists tagged the inscription "NO +" [No more] throughout various locations in Santiago. Soon thereafter the artists discovered that someone had "completed" their tags in the following way: "No + Muerte" [No more death], "No + Torura" [No more torture], "No + Desaparecidos" [No more disappeared]. Chilean poet and member of CADA, Raúl Zurita, called this intervention "a textual web of counter-dictatorial graffiti."[32] By making allusions to dictatorship era taggings, the 12 Brillos Crew also continued the practice of "completing" the radical and subversive work that CADA had created almost three decades prior, thus establishing a direct genealogy between dictatorship and post–dictatorship era street interventions.

32. Raúl Zurita, "Colectivo de Acciones de Arte (CADA)."

The buses represented in this graffiti mural also sport numerous political tags that defiantly denounce the politics of the state. The tag "PIÑERA LADRON" [Thief Piñera] is of course a reference to Sebastián Piñera, the billionaire businessman, investor, and politician who served as president of Chile between 2010 and 2014 and who was in power at the time of the making of this graffiti mural. Adjacent to the Piñera tag, we find the inscriptions "FUCK MONSANTO" and "MOSANTO ASESINO" [*sic*] [Monsanto murderer]. Monsanto is a transnational agricultural and biotech company with a large presence in Chile. Piñera's presidency introduced a bill that came to be known as the "Monsanto Law," which granted large agricultural companies like Monsanto exclusive patent rights to seeds that they developed. As Michelle Ma has written, Monsanto has been sharply criticized "for its aggressive farmer-directed litigation efforts to protect proprietary, genetically modified seed technologies through patent litigation lawsuits."[33] Indeed, the bill caused outrage and massive protests among rural communities, small scale farmers and indigenous groups in Chile. Ivan Santandreu, member of the activist group Chile sin Transgénicos [Chile without GMOs], elaborated on the negative effects of the bill: "This law puts seeds into the hands of a few transnational companies. This measure does not contribute to the innovation and wellbeing of independent farmers at all. What it does is put food sovereignty at risk by making it dependent on big corporations."[34]

Even though this bill would eventually be defeated at the beginning of Michelle Bachelet's second presidential term in office, the fact that the 12 Brillos Crew would place the Piñera and Monsanto tags fairly close to one another makes explicit the intimate relationship that exists between government and corporate interests. These tags, like graffiti itself, required an insider knowledge for its proper legibility. Letters in wildstyle graffiti, for instance, are often mostly legible to other graffiterx as opposed to the general public. In this case, however, the legibility is not one of style but of political content. The 12 Brillos Crew demanded that their spectators be familiar with social justice frameworks through the deployment of keywords such as "NO+LUCRO," "WALLMAPU," and others, terms that are meant to trigger larger social justice discourses familiar to many Chileans such as the student and indigenous movements. In sum, these rough and unrefined tags are often criticized by other graffiterx and the larger Chilean public who see them as vandalism or irrelevant *rayado* (scribbling). The 12 Brillos Crew here, however, underscore the productive resistance and political viability that these quick and direct markings can have.

33. Ma, "Anticipating and Reducing the Unfairness of Monsanto's Inadvertent Infringement Lawsuits," 691.

34. Cited in Andrea Germanos, "'Monsanto Law' Brings Uproar to Chile."

While the 12 Brillos Crew represents a more openly politicized graffiti crew, many other graffiterx in Chile do not espouse overt social justice messages while still remaining committed to the idea that graffiti in Chile operates as a generous and altruistic art form that attracts a more inclusive audience and improves the urban environment. These artists were also enticed by the exhilarating experience of painting on the streets, by the opportunity to connect with a larger community of hip-hop youth cultures, and by the respite from the rote repetition of the daily routines of school and work that street art provided. When I asked some of these artists why they did graffiti, the responses were usually quite simple and seemingly unremarkable: "Because I like it." "My friends were doing it." "I've always liked to draw." They were often unambiguous and unapologetic about their personal and individualistic reasons for becoming graffiterx, yet their motivations were often bound up by a general dissatisfaction with the Chilean state of affairs.

Graffitero Fisek, who began tagging and bombing on Chilean city streets when he was only thirteen years old in the 1990s, became involved in the street art scene for reasons of personal development and youth identity formation. As a young adolescent, he loved comic books and joined soccer fan groups in Chile, otherwise known as *barras bravas* or *barras de fútbol*. These male-dominated cultural activities were and continue to be important means of male socialization in the country. Because comic books inspired him to draw characters and the barras de fútbol that he was involved with would often tag team names on the streets demanding urban visibility, graffiti became a kind of cultural clearinghouse where his varied interests were transacted, combined, and supported. Because online and digital means of communication such as email, social media, and cell phones were not yet widely available and accessible in Chile in the early 1990s, information about graffiti was difficult to come by. Fisek, like many of his peers, could only learn about graffiti by seeking out others with similar interests and by exploring the city in new ways. Early on he became attracted to wildstyle lettering; he was particularly enthralled with the ways in which this element elicited an original style on the part of its practitioners. "Wildstyle is something you need to learn on your own," Fisek remarked. "It is very difficult for someone to explain it to you, except for some basic stuff because the point is to generate your own style."[35]

As an active graffitero for over twenty years, Fisek had been witness and participant of a large part of Chile's graffiti history. In spite of the fact that street art is done in public, Fisek regarded his graffiti work as deeply personal with little to no collective implications, often simply enjoying the feelings of

35. Fisek interview.

freedom he experienced: "I need graffiti because it is my only filter, my only moment of feeling free. I can do it where I like and with whatever colors I want."[36] These feelings of individual freedom and gratification, however, were always mediated by collective engagements with others, especially fellow graffiterx. These engagements would eventually lead to his participation in the Stgo Undercrew, together with highly visible Chilean street artists such as Inti, Saile, Hesoe, and others. Going out to paint, tag, or bomb meant for Fisek an opportunity to reconnect with friends from his adolescence as well as forge ties with younger graffiterx. Friendship rather than personal gain or search for "artistic quality" in others, he insisted, should be the foundation of any graffiti collaboration. While some of his peers might refuse to work side-by-side with a "toy," an inexperienced and unskilled graffiterx, Fisek insisted the street art scene in the country does not uphold such hierarchies: "Everyone knows one another here in Chile and there is a good vibe."[37] So even though he maintained, under no uncertain terms, that his work was not political and that his activities on the streets served no major altruistic function, I found that one of Fisek's major motivations to do graffiti work was the collective process it involved and the numerous opportunities it afforded him to further enhance the web of social relations he had been cultivating since the 1990s.

Because of Fisek's fascination with the medium's process as well as its potential for socialization and connectedness, on March 27, 2015, I accompanied the artist together with Black, a younger graffitero, on a street writing outing. The term *street writing,* which can sometimes be used interchangeably with the word *graffiti,* refers to the act of creating primarily text-based wall tags, throwups,[38] and bombs. Street writing is a particularly apt term to describe Fisek's work given his propensity for wildstyle lettering. This street writing outing, however, was unlike ones that might happen elsewhere in the world. Such incursions in North America or Europe might be shrouded in a cloud of danger, illegality, and secrecy, most likely occurring in the darkness of night. On that day, however, the graffiti incursion took place in the afternoon in a very visible and even sought-after location: across the street from Parque Fluvial Padre Renato Poblete, which had been officially inaugurated only a few months prior. Even though the park was a highly manicured and

36. Fisek interview.

37. Fisek interview.

38. Throwup in graffiti vernacular refers to a graffiti piece featuring lettering, generally with the graffiterx's street name, that is done relatively quickly with only a few colors. This approach to street writing allowed artists to work at a fast pace as to avoid law enforcement. Even though police surveillance and harassment are not of considerable concerns to Chilean graffiterx, many artists still enjoyed the instant gratification, the gestural quality, and spontaneous character of throwups.

ordered space for leisure, it was only a few steps from a rundown plant partially covered by a long concrete wall. This wall was likely built by the city to cover up this urban "eyesore" from park goers. The wall was meant to clearly demarcate and distinguish these very different spaces within the city, one for industry and the other for recreation. The concrete wall, which was covered with graffiti, unintentionally operated as a kind of buffer or border zone between these two locales. Street writing as a social and art practice seemed quite appropriate here, as it can straddle both the realms of leisure and industry. Historically, graffiti came out of a postindustrial society whereby practitioners utilized the remnants of manufacturing, most notably spray paint, to work their craft, which at the same time, came to be regarded as a leisurely pastime among some of its participants.

When I arrived on this location adjacent to the Parque Fluvial Padre Renato Poblete, Fisek and Black had already found space on this already graffitied wall to work on their pieces. Focusing on the creation of fairly simple throwups, the artists "attacked" the wall with little to no hesitation. They worked with layers of color whereby each layer added greater depth and dimensionality to the wildstyle lettering. The roughness and unevenness of the wall surface called my attention yet the free flowing and generous movement of aerosol paint allowed Fisek and Black to visually flatten and level this rugged and irregular "canvas" (see figure 3.4).

Speaking more specifically of Fisek's piece, his first paint layer consisted of a solid black amorphous shape (see figure 3.5) that revealed little of the overall design. As he added additional layers of color, the distinctiveness and playfulness of his wildstyle lettering began to emerge. Using a pale pink color for high contrast (see figure 3.6), Fisek methodically traced the outlines and volume of the letters. His many years of experience with street writing had endowed him with great precision when it came to applying spray paint; his confident strokes glided seamlessly across the wall, creating broad and thin lines, flat and modulated color. The more layers of color he applied, the more three-dimensional his overall design became (see figure 3.7).

The bold, graphic, and striking quality of his finished piece reflected his training as a graphic designer, his admiration for the aesthetics of comic books and the influence of the muralist brigades. Both Fisek and Black's throwups that afternoon consisted of highly elaborate, ornate, and stylized name tags, perhaps the most common form of street writing practiced by graffiterx worldwide. The emphasis on the artist's name speaks of a desire to gain visibility, street credibility, and even fame on the part of the graffiterx. In many ways, the graffiti name tag is not unlike the tradition of self-boasting in hip-hop where MCs publicly proclaim their superior rhyming and rap-

FIGURE 3.4. Fisek, (2015), graffiti throwup in process, adjacent to Parque Fluvial Padre Renato Poblete, Santiago, Chile. Photograph: Guisela Latorre.

FIGURE 3.5. Fisek, (2015), graffiti throwup in process, adjacent to Parque Fluvial Padre Renato Poblete, Santiago, Chile. Photograph: Guisela Latorre.

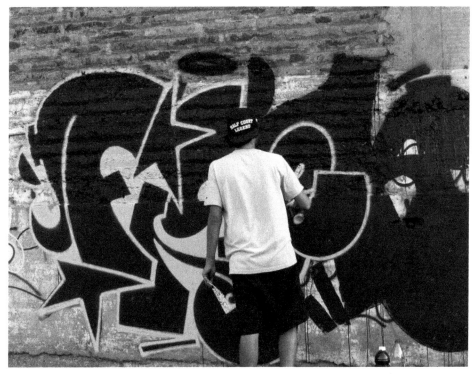

FIGURE 3.6. Fisek, (2015), graffiti throwup in process, adjacent to Parque Fluvial Padre Renato Poblete, Santiago, Chile. Photograph: Guisela Latorre.

ping skills. The name tags created by Fisek and Black demanded the visibility of the self amidst the dehumanizing and deadening anonymity imposed by the city. Given that graffiti in Chile is perhaps one of the most accessible art forms in the country, the opportunity for self-proclamation and aggrandizement becomes available to populations who in the past had no access to such a power. Thus, Fisek and Black's graffiti that afternoon, beyond operating as an act of self-promotion, functioned as a public statement for greater inclusion.

The street art work that Fisek and Black carried out the day I observed them exemplified the unique social relationships that graffiti elicits. The mutually supportive rapport that exists between graffiterx was clearly discernible between the two artists. As the younger and less experienced artist, Black often turned to Fisek for guidance and consultation. Without a doubt, Black benefited tremendously from working side by side with someone possessing more than twenty years of experience and having intimate knowledge of the broader history of Chilean street art. But the learning process for young street artists in Chile happens primarily through observation and emulation. It was

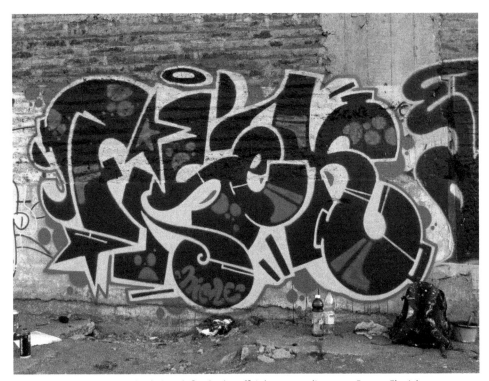

FIGURE 3.7. Fisek, (2015), finished graffiti throwup, adjacent to Parque Fluvial Padre Renato Poblete, Santiago, Chile. Photograph: Guisela Latorre.

quite clear to me that Black was reproducing many of the techniques Fisek was utilizing for his name tag: the black base color, the layers of different colored spray paint, and of course, the wildstyle lettering. So, for passersby and, most importantly, for other graffiterx, having their name tags next to one another and rendered in a similar style communicated to others that the two men were engaged in an informal apprenticeship or mentorship relationship. The ways in which the self and the collective continuously intertwined during this street art outing I witnessed exemplified for me that individual and communal concerns are not mutually exclusive.

Working side by side with one another, like Fisek and Black did that afternoon in 2015, is one of the ways in which street artists engage in collaboration and socialization. The formation of graffiti crews provides further opportunities for street artists to work collectively.[39] Moreover, the activities in these crews perhaps best exemplify the fluid movement that often happens between

39. For a definition and explanation of graffiti crews, see chapter 4 of this book.

individual and collective creativity in Chilean graffiti. Las Crazis Crew, one of South America's first all-female graffiti collectives, came together precisely because its members were seeking to transcend their individuality by forging powerful bonds with other young women of their generation. Over the years, Las Crazis have embodied both the rewards and tensions inherent in collective graffiti work. Their individual identities as artists have enriched but also problematized the stability of their crew. On December 26, 2015, five of the seven members of Las Crazis—Cines, Dana, Naska, Bisy, and Shape—joined me for a conversation about their lives' work and their history of collaboration. The particular moment in which they were living at the time of this conversation was significant, as it signified of reunion or reencounter of sorts for the group after a fairly long hiatus. Las Crazis were inactive for a couple of years due to the diverging life paths each of the members took as they got older. Maintaining a stable membership and consistent participation became increasingly difficult. By late 2015, however, they were in the process of redefining the group's identity, in particular, the collaborative relationship they've had with one another over the years. They were moving toward a looser and less structured configuration where there were no determined "rules" or "requirements" for group membership, confident that their enduring friendship would hold the group together. This new iteration of the group rested upon a simple principle; *both* the individuality of each member *and* the collective profile of the group would coexist at the same time. The group's trajectory outlined below will reveal how Las Crazis have achieved a productive dynamic between their individual sensibilities as artists and their desire for collectivity.

The group began when high school friends Naska and Dana decided to start doing street art together. Jessica Pabón pointed out that these young artists "began painting together because they shared both the experience of isolation as women writers among men and the unrelenting desire to 'write their voices on the walls of the city.'"[40] Indeed, the male-centered and at times even patriarchal culture of Chilean graffiti[41] created a need for connectedness among female writers who in the late 1990s felt they were the only ones making artistic interventions into what appeared to be a males-only practice. In many ways, their desire for collectivity was a pragmatic decision where mutual support and camaraderie meant the survival of the collective. The consciousness about the commonality that emerged from their gendered experiences in the public sphere informed both their graffiti imagery and their social practice. Pabón further observed that since they came together as a group,

40. Pabón, "Be About It," 89.

41. For more on the gender politics of Chilean graffiti, see chapter 4 of this book.

Las Crazis have "matured together as women on the fringes of acceptable behavior."[42]

Since their inception, Las Crazis have been steadily moving toward a model of collaborative work that recognizes the importance of individual creativity. Pabón has rightly argued that female graffiti crews in Chile "articulate a continuity dependent upon virtuosic singularity: each graffitera must contribute her best for the production to be successful."[43] The individual members of the crew articulated similar desire when I conversed with them. "You feel happy when your crew member does something great," Dana commented when asked how she felt when her colleagues did work on their own or even outside the crew.[44] Bisy, who joined the group in 2005, was initially not fully confident in her street writing skills and was always overly critical of her own work. She benefited tremendously from her crew's encouragement to refine her craft so that she could become a better artist at the individual level. "I think it's an issue related to lo femenino [the feminine]," Bisy commented. "There is more empathy in women. The sense of competition is not as present [with us] as it is with men, at least from my generation."[45] These acts of empathy many times manifested themselves through the loving practice of *marking* each other's work. Marking refers to the finishing lines and touches graffiterx do to their work to make it look cohesive. For Las Crazis, this was not an act of unwanted intrusion or a type of controlling intervention but rather a gesture of trust and support. By marking each other's pieces, they were looking out for one another, making sure the individual artistic identities of their fellow crew members were well represented.

A similar egalitarian dynamic informed how these graffiteras signed their work, using their individual street names or that of the crew in an almost interchangeable fashion. The group has held the implicit and unspoken understanding that any member of the collective can sign pieces with her individual street name or that of Las Crazis without approval or consent from the rest of the members. Las Crazis' vision of collaboration and collectivity has thus implied that the whole of the collective could be represented by the individual and that the individual could gain greater visibility and even autonomy through her engagement with the collective. While the notion that the individual and the collective are not mutually exclusive should come as no surprise, the refined and nuanced reciprocity and mutuality practiced by the members of Las Crazis stands as a model of collaboration due to the various ways in

42. Pabón, "Be About It," 93.
43. Pabón, "Be About It," 103.
44. Las Crazis Graffiti Crew interview.
45. Las Crazis Graffiti Crew interview.

which they enact a combination of flexibility and inclusion. The fact that each one of them insisted upon their distinct identities, even their independent and separate art careers, further impressed upon me that the group's foundation was not dependent upon hierarchies and clearly delineated roles, as Bisy explained. "Each one of us is trying to live off graffiti a bit, [but] each one of us [does so] from a diverse particularity, giving us a dynamic character."[46]

Las Crazis' graffiti aesthetics tend to veer toward playfulness coupled with a strategically feminine iconography that seeks to purposely underscore that the crew is composed by an all-female collective. Rainbows, flowers, birds, and doll-like figures are recurring motifs in the crew's visual repertoire. While the artists are conscious of the fact that the femininity associated with these motifs is socially constructed, they adopt it nevertheless to highlight their gendered bodies in the urban sphere. I will later argue in chapter 4 of this book that the deployment of a strategic femininity on the part of Chilean graffiteras points not to an endorsement of gender binaries and essentialisms but rather to a conscious and public resistance to the hyper-masculinity depicted in lot of graffiti imagery. Art historian Rod Palmer described Las Crazis' style as a "mix of characters and typographies, done with bright colors, where a sense of 'radicality' is complemented by femininity."[47] The author assumes that radicality is generally not compatible with any notions of femininity; however, I contend that it is Las Crazis' attempts to make their work overtly feminine that makes it radical within a space that devalues women's creative interventions. "I think it is important to value the work even more when it is done by women," Bisy commented. "It's good when people say that our graffiti is feminine because it is feminine, because I am a woman, I recognize myself as such and I feel proud of my gender."[48] Las Crazis have thus promoted "the feminine" as a badge of honor that disrupts the male domination of street art while also working out an aesthetic that gives creative agency both to the group's individual members and to the crew's collective identity.

The aesthetics of strategic femininity coupled with the group's simultaneous deployment of individuality and collectivity can be appreciated in the graffiti mural Las Crazis created in 2010, located in the street Tucapel Jiménez near downtown Santiago (see figure 3.8). Working on this wall also provided the members of Las Crazis the opportunity to collaborate with Brazilian graffiteras Tikka and Pan, also known as Nocturnas, who were visiting Chile from São Paulo at the time. This transnational alliance allowed Las Crazis to further redefine their membership, even if it was only momentarily, thus creating a

46. Las Crazis Graffiti Crew interview.
47. Palmer, *Arte callejero en Chile*, 66.
48. Las Crazis Graffiti Crew interview.

FIGURE 3.8. Las Crazis and Nocturnas (Tikka and Pan), Untitled (2010), graffiti mural, Tucapel Jiménez Street, Santiago. Photograph courtesy of Las Crazis.

more inclusive and expansive crew identity that included non-Chilean artists as well.

Completed over one weekend during a Saturday and Sunday, the piece was painted over the entrance ways of a small grocery store and a private residence. "Naska used to rent an apartment in the big house," commented Shape, "so she asked the owner and they gave us permission since the wall was always badly tagged up."[49] The pictorial space of this wall in Tucapel Jiménez is populated by the crew's signature doll-like characters. All these characters reside within a fantastical landscape dominated by hues of green and blue. Otherworldly and psychedelic-looking trees, courtesy of Bisy, also punctuate this landscape. Naska took care of the wildstyle lettering with the crew's name. The individual approaches of the artists are palpable as each character and motif is rendered in distinctly different styles with little to no attempt to make them uniform or similar for the sake of stylistic unity. One of Dana's trademark *muñecas* (dolls) "sits" atop a set of the columns that flank the store's entrance way. Her "cutesy" cartoon and child-like features—typical of Dana's work as will be discussed in chapter 4 of this book—quizzically stare back at passersby. The figure of an adult woman, created by Tikka, stands on the other side of the store's entrance way. Her features, dress, and body type suggest that this is a woman who labors in the home, perhaps a mother, housewife, or domestic worker. The reference to home here may also reflect larger feminist politics in Chile that called for democracy "in the streets and the home."[50] Together with Dana's muñeca, all the figures form a family unit of sorts but not a traditionally patriarchal one, as the absence of a patriarch implies nontraditional kinship ties. As the graffiti mural wraps around the uneven architectural façade, we are welcomed to one of Pan's own characters (see figure 3.8a).

Similar to Dana's muñeca, this figure also betrays a style that is endemic to the comic book aesthetic but her assumed sweetness and femininity—indicated by her cherry-print dress—is undercut by edgier characteristics. Her facial expression betrays a combination of mischief and anger as she defiantly returns the gaze of onlookers who might be unsettled by her eyes, which are completely filled in with black paint. Reclining near the other entranceway—the one leading to private residential apartments—is an equally enigmatic female figure with elongated limbs and proportions, a creation executed by Cines. This flamboyant figure sports of head of curly green hair while wearing a pink and blue outfit. As is the practice in graffiti and muralism, Cines worked with the preexisting architectural details of the building's façade: a window becomes part of the woman's pant pattern and a diamond-shape sculptural motif becomes a crown or tiara of sorts. More-

FIGURE 3.8A. Las Crazis and Nocturnas (Tikka and Pan), Untitled, detail (2010), graffiti mural, Tucapel Jiménez Street, Santiago. Photograph: Guisela Latorre.

over, Shape has elaborately decorated the archway leading to the apartments, thus endowing this section of the graffiti mural with an air of ritual regality, a fantastical vision that welcomes the apartment residents every time they enter their homes.

The four figures depicted in this graffiti mural by Las Crazis—the muñeca, the adult woman, the dark-eyed girl, and the reclining figure—provide an unexpected juxtaposition to the advertising signs of this commercial establishment. Prior to painting these walls, the artists also approached the owners of the store for permission to paint, a proposition they happily accepted.[51] The result was a playful and whimsical interplay between the female figures on the wall and the storefront's various text-based signboards advertising products such as bread, coffee, tea, empanadas, and other services. Las Crazis trans-

51. Email exchange between the author and Dana, March 7, 2016.

formed the experience of going to buy groceries or entering into one's own apartment, often considered to be rather mundane domestic tasks, into artful events. The graffiti characters also mark an important threshold between the public and private realms, a transition marked by the entranceways of the store and the apartments. Las Crazis placed these female characters within this liminal space to signal that Chilean women are entitled to full agency in both spheres; their capacity to move seamlessly between the two is part and parcel of their social adaptability.

To both the casual and attentive observer, the distinctiveness of Las Crazis' individual styles is quite palpable in this graffiti mural; it is no secret that this wall piece was executed by multiple artists even though no one signed this piece with their individual street names. Nevertheless, the fact that these different figures populate the same pictorial space and share significant aesthetic affinities with one another indicates that this urban intervention on the part of Las Crazis celebrates collective work, even across national boundaries, as demonstrated by the temporary crew membership of Brazilian graffiteras Pan and Tikka. This collectivity, however, does not translate into an erasure of difference and individuality, as both coexist in mutually nourishing ways.

CONCLUSION

Broadcasting and widely disseminating the self through the practice of graffiti in Chile should not be divorced from the larger project of visual democracy that has shaped post-dictatorship street art in the country. For artists to highlight their subjectivity and individuality as graffiti practitioners does not immediately signify a lack of concern for social issues or a disregard for the transformative interventions of street art. As demonstrated in this chapter, the self is always dependent on collective engagements for Chilean graffiterx. Moreover, in the instances when these artistic selves represent historically marginalized voices, proclamations of individuality take on political dimensions as tags, bombs, throwups, and graffiti murals become public demands for greater visibility. Street artists are thus democratizing the urban sphere by insisting that public spaces should be welcoming locales for a person's individual expression, regardless of social privilege and access to power.

These graffiti aesthetics that seek to close the gap between the self and the collective, however, can be encumbered by the difficult gender politics that take place in the urban sphere and in Chile's patriarchal culture. Like in many other places in the world, city streets can still be hostile places for women in general and for graffiteras in particular. Moreover, the street art scene in

the country is dominated by men, many of whom firmly believe in patriarchal notions of competition and fame. How then do women enact forms of visual democracy in spaces of gender exclusion? What distinct and unique contributions do they make to the street art scene? What is their approach to collectivity? It is these questions that will be the subject of the next chapter in this book, which looks closely at the life and work of some of Chile's most visible graffiteras.

CHAPTER 4

Public Interventions and
Gender Disruptions

Graffiteras' Urban Transformations

IN HER WORK on strategic deployments of the feminine, Hanan Muzaffar has argued that "in order to disrupt the binary system of thought that devalues women, the female, with all those attributes associated with female, has to assert herself as a site of value, thus disrupting the hierarchy imposed by the dual system of thought and which dictates that 'male' and its associations are more valuable than 'female' and its associations."[1] While recognizing that categories such as "male" and "female" are social constructs, Chilean graffiteras have sought to defy the notion that the feminine, even as a cultural fiction, should be devalued because of its association with women. Far from essentializing womanhood, these artists have deployed an unambiguously feminine imaginary to forge a more gender-inclusive and democratic public space. These tactics effectively worked to undermine the assumed maleness associated with urban culture, one that was rooted in the continent's colonial period, for women "did not have a 'protagonist's role' in the process that modeled 'public space' during the Spanish Empire in Latin America."[2]

This aesthetics of the "feminine" are also closely related to these artists' collaborative approach to art making. Similar to their male peers in the streets, their creative process consists of a simultaneous privileging of collective and

1. Muzaffar, "Do You Surprise?" 620.
2. Salazar and Pinto, *Historia contemporánea de Chile, Volúmen IV*, 111.

individual action where one does not negate the other. They see themselves as individual artists with unique styles and points of view who, nevertheless, come together through spontaneous and unforced acts of partnership and affinity. This "coming together" happens through the practice of "hanging out," which María Lugones describes as a tactic that "permits one to learn, to listen, to transmit information, to participate with communicative creations, to gauge possibilities, to have a sense of the directions of intentionality, to gain depth."[3] By sharing physical and discursive spaces with one another and with local communities—that is, by hanging out with each other—Chilean graffiteras enter into realms of unfettered creativity. Lugones further asserts that hanging out is a spatial practice that contests "territorial enclosures."[4] In order to tag the city, graffiteras purposely transgress the enclosures of the private sphere but also the enclosures that separate the different neighborhoods and territories of the city.

Unlike some of the men active in the Chilean street scene, graffiteras see their collaborations with one another as expressions of caring for their fellow artists, which denotes a feminist praxis, as graffitera Wend has observed. "We must have a web of support among us. *It's about making feminism.* If we care and love one another, we will create something different."[5] The continuum between individual and collective work that Chilean graffiteras put into practice is of course reminiscent of the old feminist adage "the personal is political," which posits that a person's individual experiences cannot be extricated from broader political processes and actions. The means by which these artists achieve the convergence of the individual and the collective is through the enactment of an ethics of care, one that recognizes the interdependence of the different subjectivities within the group. Fiona Robinson tells us that the ethics of care "starts from a theory of the self as relational." "Identity and subjectivity are thus not developed in isolation from other actors," Robinson continues, "rather, identities are mutually constituted."[6] Graffiteras practice the ethics of care by looking out for one another on a personal and artistic level, thus strategically embracing traditional notions of women as natural caregivers and nurturers, notions that the artists simultaneously understand as social constructs.

The ethics of care for Chilean graffiteras are implicated as well in a decolonial love that seeks to break down the colonial split between the self and other. US Latina feminist scholar Carolyn Ureña defines decolonial love as

3. Lugones, *Pilgrimages/Peregrinajes*, 209.
4. Lugones, *Pilgrimages/Peregrinajes*, 221.
5. Toledo, "El nuevo graffiti femenino," 26 (italics mine).
6. Robinson, *The Ethics of Care*, 4.

"a form of ethical intersubjectivity premised on imagining a 'third way' of engaging otherness beyond Western binary thinking."[7] Chicana philosopher Chela Sandoval calls it "another kind of love, a synchronic process that punctures through traditional, older narratives of love that ruptures everyday being."[8] The dynamic movements between individual subjectivities and collective appeals that happen in the work by these artists signal a desire for a communal care and loving that is also capable of creating new knowledges. These knowledges emerge from the "third way" that Ureña mentions and are made manifest in the liberatory and antipatriarchal iconography that graffiteras inscribe upon city walls. The rupturing effect that Sandoval cites can be seen in the unexpected and purposely disruptive way that graffiteras intervene in the urban space.

The tactics of strategic femininity, care ethics, decolonial love, and hanging out that Chilean graffiteras utilize should be contextualized within the period corresponding to the late twentieth and early twenty-first centuries in Chile. The decreased policing of urban spaces after the dictatorship has allowed not only for the emergence of an effervescent street art scene in the country's major cities, as mentioned in the previous chapters of this book, but also for the increased visibility of women's actions in the streets. Yet the official end of Augusto Pinochet's regime by no means meant the end of social inequality and women's oppression. Nor did it signal an era of truly participative democracy and gender equality. I thus argue that these graffiteras' work on the streets challenges both the repressiveness of the dictatorship's legacy and the neoliberal logics of exclusion, both of which are part and parcel of the country's persistent colonial history. Graffiteras' presence in these public spaces is part of a larger history of women's activism that included the dictatorship era, as historians Gabriel Salazar and Julio Pinto point out:

> The dictatorial period proper characterized itself by a notable presence of women (from all walks of life) in the *deeds of active resistance.* Data indicates that, during the most virulent period of "national protests" (1983–1987), women distinguished themselves as one of the social actors with greatest public leadership, together with pobladores, base militants and students.[9]

This active and uncompromising presence on city streets also worked to change the culture of the Chilean public sphere, which included the physical spaces of the urban landscape but also the national discourses about neoliber-

7. Ureña, "Loving from Below," 88.

8. Sandoval, *Methodology of the Oppressed,* location 1767 [Kindle Edition].

9. Salazar and Pinto, *Historia contemporánea de Chile, Volúmen IV,* 197 (italics in original).

alism. The radical potential of caring and decolonial love for them represents an affront to the dominant narratives of self-sufficiency and toughness that permeate these concrete and discursive spaces. These neoliberal discourses about individualism have also permeated certain aspects of the Chilean graffiti scene itself, as the male-dominated culture of street art still sees the graffiterx as someone who is driven primarily by their desire to assert their individuality in the public sphere and who doesn't have to answer to the concerns or needs of others. By contrast, the graffiteras featured in this chapter regard street art as an altruistic act that is, more often than not, driven by a desire to care for their surroundings and for those who inhabit them.

THE ETHICS OF CARE/LOVE AND NEOLIBERALISM

Chilean graffiteras decide to identify with one another and with the communities that surround them as a way to challenge the arrogant perceptions that neoliberalism promotes. Scholar of Chicana/o art Karen Mary Davalos maintains that the "simultaneous position of self/other is the foundation of identity formation, creative expression, solidarity, and collective action."[10] Drawing from the work by Marilyn Frye, Lugones argues that a failure to identify with others is a failure to love.[11] Virginia Held contends, for her part, that an ethics of care "usually works with a conception of persons as relational, rather than as the self-sufficient independent individuals of the dominant moral theories."[12] This practice thus challenges clear and binary distinctions between the individual and society, the self and the other, and the public and the private. Lugones reminds us that "'I' is identified in some sense as one and in some sense as a plurality"[13] and that hangouts (like the ones graffiteras routinely perform) are "spaces that cannot be held captive by the private/public split."[14] The feminist foundation of the ethics of care, as seen in the work of Sara Ruddick, Carol Gilligan, and Nel Noddings,[15] is concerned with the idea that the practice of caring should be enacted with a social justice goal in mind. By that same token, Ureña defined decolonial love as "an anti-hege-

10. Davalos, *Yolanda M. Lopez*, 89.

11. Lugones, "Playfulness, 'World'-Travelling and Loving Perception," 4.

12. Held, *The Ethics of Care*, 13.

13. Lugones, "Playfulness, 'World'-Travelling and Loving Perception," 13.

14. Lugones, *Pilgrimages/Peregrinajes*, 221.

15. For early work on the ethics of care, see Nell Noddings, *Caring, a Feminine Approach to Ethics & Moral Education*, Sarah Ruddick, "Injustice in Families: Assault and Domination," and Carol Gilligan, "Images of Relationship."

monic, anti-imperialist affect and attitude that can guide the actions that work to dismantle oppressive regimes."[16] Famed African American feminist writer Audre Lorde further radicalized the act of care and love by stating that, in a world that actively injures and damages marginalized populations, caring "for myself is not self-indulgence, it is self-preservation, and that is an act of political warfare."[17] Furthermore, the social justice frameworks that inform care ethics refuse to naturalize the idea that women are natural caregivers; instead, they postulate that caring should be embraced by populations of all gender expressions. Moreover, Held tells us that by caring for others we are not just passively trying to be kind as individuals without questioning social structures. Caring and loving as a feminist praxis aspires to transform "the structures within which practices of care take place, so that they are no longer oppressive."[18] Many Chilean graffiteras regard the practice of care as a significant component of their work on the streets, one that is critical of power hierarchies, whether these exist in society at large or within the street art scene itself.

Care ethics and decolonial love also challenge the capitalist culture of Chilean public spaces. Advertising billboards, banners, and ads produced by multiple and diverse national and transnational companies communicate to the public that individualism and self-sufficiency are desirable traits that can be accomplished through consumption. Many graffiteras, by contrast, operate under the conviction that individuals are defined by their relationships to others and that those relations need to be mutually supportive and loving ones. In order to forge such relations, graffiteras practice what Lugones calls "world-travelling," a radical dynamic movement that allows them to enter into the social spheres and inner subjectivities of others:

> There are "worlds" we can travel to lovingly and travelling to them is part of loving at least some of their inhabitants. The reason why I think that travelling to someone's "world" is a way of identifying with them is because by travelling to their "world" we can understand what it is to be them and what it is to be ourselves in their eyes. Only when we have travelled to each other's "worlds" are we fully subjects to each other. . . . Knowing other women's "worlds" is part of knowing them and knowing them is part of loving them.[19]

16. Ureña, "Loving from Below," 87.
17. Lorde, *Burst of Light,* 132.
18. Held, *The Ethics of Care,* 9.
19. Lugones, "Playfulness, 'World-Travelling' and Loving Perception," 17.

But in the Chilean context, "world-travelling" and loving perceptions stand in sharp contrast to dominant ideas about democracy. The liberalization and opening of the national economy supported by the governments of Augusto Pinochet, la Concertación, Sebastián Piñera, and the Nueva Mayoría have promoted the idea that individualism, arrogant perceptions, and the refusal to identify with others are synonymous to democracy. Robert McChesney has indicated that the ideologies of neoliberalism in Chile have sought to create "a passive, depoliticized populace" that confuses consumerism for civil liberty and freedom of expression. I thus argue here that the work of Chilean graffiteras operates as the antithesis of hegemonic media in the country given that this form of public art seeks to create critically informed and empowered citizens who can deploy loving perceptions of others. These artists achieve these goals by competing for public space with the large corporations and conglomerates that attempt to monopolize the public sector. On the one hand, we can classify these graffiteras' activities as part of this artistic movement that challenges the control of the urban sphere by the mass media, but, on the other, we can also regard these interventions as feminist urban incursions that compel public actors to forge loving relationships with their surroundings.

The ethics of care, world-travelling, and hanging out coupled with the strategic femininity deployed by Chilean graffiteras ultimately afforded them greater movement between different social spaces in the country. As such, we can align their work and praxis with what Salazar and Pinto call *feminismo popular* or the "people's feminism" in Chile:

> Feminismo popular has its own long history where women not only developed public and private conducts as *alternatives* to the "patriarchal system," but also [created] their *own cultural spaces and micro-social powers,* which allowed them to move with greater flexibility and [more] solidarity than men. . . . [These conducts also endowed them with] greater boldness in *personal* confrontations with authorities of the dominant system.[20]

I contend that the practices of care and strategic femininity enacted by Chilean graffiteras correspond to the public and private conducts that define feminismo popular. It is these practices that afford them the ability to world-travel in the Lugonian sense, that is, to move seamlessly through different spaces on the streets while forging loving relations among themselves and with the communities that surround them.

20. Salazar and Pinto, *Historia contemporánea de Chile, Volúmen IV*, 209 (italics in original).

GRAFFITERAS' SOCIAL ACTIONS AND VISUAL LANGUAGE

This chapter will focus on the work of five graffiteras who entered the Chilean public art scene in the late '90s and early 2000s, namely Gigi, Alterna, Dana, Anis, and Wend. Collectively, their work is indicative of a new aesthetic that places love and caring at the center of their practice as street artists. Their status as gendered subjects within this space, however, provides a challenge to the male domination of city streets. Their work and activist praxis signals an egalitarian and feminist approach to graffiti art, a desire to transform the cityscape into a more democratic and decolonial sphere. These artists situate their work within a continuum that straddles their own subjectivity as individual artists and the collectivity embodied by the communities that surround them; in other words, they, like many other graffiterx in Chile, seek to reconcile the individualism of their praxis with the collectivity of the public sphere, as discussed in chapter 3 of this book. This continuum is further facilitated by the existence of what Rodríguez-Plaza calls *cultura ambiente* (atmosphere culture), which refers to an "auditory, object-based and visual system that situates and sets up the Latin American city in all its complexity."[21] I would argue that the continuum articulated within this cultura ambiente is a characteristic property of graffiteras in Chile whereby their differential gender identities allow them to regard individual and collective empowerment as organically intertwined. This continuum between the self and the collective is a necessary component of the care ethics and world-travelling enacted by these artists.

While this chapter focuses on the social implications behind these artists' creative actions on the streets of Chile, I will also underscore the innovative and transformative quality of the iconographic and stylistic elements that define their graffiti art. In many ways, their style is not unlike that of their fellow Chileans street writers, regardless of gender identity. The use of highly stylized lettering, or wildstyle,[22] and reliance on graffiti characters[23] is very

21. Rodríguez-Plaza, *Pintura callejera chilena*, 15.

22. Wildstyle has become a term used by graffiti artists worldwide to refer to a type of lettering that is difficult to read because of its extreme stylization, flow, and intricate decorative elements. Arrows, curves, three-dimensional elements, and bright colors are all part of the wildstyle aesthetic. Even though the lack of clear legibility characterizes wildstyle, graffiti practitioners and insiders to street art culture can easily read these tags. Thus, the appreciation and recognition of wildstyle requires special deciphering skills and alternative literacies. For more on wildstyle, graffiti aesthetics and the use of graffiti as an instructional tool, see Jessie L. Whitehead, "Graffiti: The Use of the Familiar." Lisa Gottlieb has traced the origins of wildstyle to the work of New York City graffitero Tracy 168, who first developed this type of lettering in 1974. Gottlieb, *Graffiti Art Styles*, 34.

23. Graffiti characters are cartoon-like figures that are often placed side-by-side to the lettering that street writers make. Often inspired by popular culture imagery such as comics,

much part of these artists' visual repertoire. Nevertheless, their work insists on a certain gentleness and softness that often assuages the boldness and bravado of graffiti aesthetics and the grittiness of urban spaces in cities like Santiago and Valparaiso. This imagery too reflects the ethics of care and loving perceptions that informs their practice. Jessica Pabón observed that Naska, a member of Las Crazis crew,[24] purposely created pieces that were "soft, fluid, and suave" because she was interested in communicating a "message that is not confrontational."[25] Though these artists are also attracted to the boldness of graffiti and the dynamic movement of city streets, they are also committed to the altruistic notion of graffiti as a type of offering to the public and as means of improving *el entorno* or surroundings of the city. In my own conversations with Alterna, the artist made clear to me that as a woman artist she is particularly concerned with improving the visual aesthetics of the urban sphere: "I think that as women we are more concerned with improving our surroundings."[26]

BEING A WOMAN ARTIST AND A FEMINIST

This chapter presented some intellectual challenges for me as a gender scholar who has done work on political and community-engaged art. I am all too conscious that the terms "women's art" and "woman artist" can be both useful and damaging for cultural practitioners and scholars alike. While the categories of "women's art" and "woman artist" recognize gendered experiences of artists and the specificity of their subject positions, it can also become a discursive straightjacket, so to speak, reducing female practitioners to their "feminine condition," as Chilean cultural critic Nelly Richard observed:

> Many women artists reject gender identification because such a classification restricts and reduces the value of women's art from the superior realm of the general-universal (i.e., the masculine) to the inferior realm of the concrete-particular (i.e., the feminine). These artists want to avoid gender criteria that, they feel, serve only as a pretext for discrimination and underestimating women's art.[27]

television, and advertising, these characters often provide a playful and lively complement to the cryptic nature of the lettering.

24. For more information on Las Crazis crew, see chapter 3 of this book.

25. Pabón, "Be About It," 94.

26. Alterna interview.

27. Richard, "Women's Art Practices and the Critique of Signs," 145.

The graffiteras I interviewed for this chapter were particularly concerned with their work being regarded differently from that of their male peers because they were women. Ultimately, they wanted to be recognized for what they put up on a wall rather than their gender. "El muro habla por si solo" [The wall speaks for itself], Wend insisted,[28] alluding to the idea that it is the work of art and not the artist's gender that truly matter.

Some graffiteras' discomfort with the label "woman artist" also extended to a somewhat tenuous and uneasy identification with feminism. In her research on female graffiti crews in Chile and Brazil, feminist scholar Jessica Pabón observed an outright rejection of the label "feminist" among Chilean street writers:

> The label "feminist" has come to signify a variety of stifling, stigmatized, and incendiary stereotypes that alienate young women and fuel the rhetoric of failure and deadness on a transnational level; under these conditions, the future of [the] feminist movement appears bleak. [The] [f]eminist movement seems to be, quite frankly, stuck.[29]

To be clear, Pabón's comments were informed and influenced by the third wave critique of feminism that pushed for a more expansive and inclusive politics of equality and social justice. She further maintained that these graffiteras have *enacted* feminism through their praxis while still not proclaiming it in word. Pabón found their brand of feminist action to be invigorating, proclaiming that "the crews these graffiteras create exemplify the future of [the] feminist movement."[30]

While I share in Pabón's enthusiasm about Chilean graffiteras' new forms of feminist action through the use of creative expression and the enactment of care ethics, decolonial love, and world-travelling, the question of why the words "feminism" and "feminist" remained such discursive minefields for these artists needed more probing. I argue that these graffiteras' responses to the "feminist question" also reflected a larger discourse in Chile that explains social inequality almost exclusively as a symptom of class hierarchies. Because of such views, gender inequality remains tangential to public debates about social justice. Sociologist Claudia Mora has observed that the "irrelevance" or "invisibility" of gender in the country is due to the "naturalization of the public/private dichotomy as masculine/feminine spaces."[31] Even though feminist

28. Anis and Wend interview.
29. Pabón, "Be About It," 91.
30. Pabón, "Be About It," 92.
31. Mora, "La imperceptibilidad del género," position 466 of 6115 [Kindle Edition].

groups have become more vocal since the return to democracy in 1990, domi-
nant discourses in Chile do not see gender as a major obstacle to social equal-
ity, in spite of the fact that statistics speak to the contrary.[32] Such a dynamic
occurred in part due to the seeming threat that feminists posed to the tran-
sition to democracy, as sociologist Virginia Guzmán explained: "In the new
scenario [after Pinochet], feminists went from legitimate allies in the anti-
dictatorship struggles to conflictive allies due to the fact that their emancipa-
tory demands could deepen tensions with the political right and thus weaken
governmentality."[33] In other words, the center-left coalitions of the post-dic-
tatorship in Chile sacrificed gender equality in order to be able to negotiate
with right-wing parties and conservative sectors of the left.[34] These govern-
ments were thus successful in promoting a discourse of equality that margin-
alized and made invisible both gender *and* race in favor of what seemed to be
a "safer" marker of difference, namely class. Though the graffiteras I feature
in this chapter were generally critical and distrustful of state-sanctioned dis-
courses, they were not completely immune to them either. I would then argue
that their uneasiness with feminism can be traced back to the gender-blind
way inequality has been historically conceptualized in Chile.

I should note, however, that during the course of my research for this
book, I witnessed an evolution in attitudes about feminism among Chilean
graffiteras. When I first began speaking with these artists in 2011, many of
them tended to resist calling themselves feminists. Some implied that femi-
nism was an ideology that promoted a kind of reversal of social hierarchies
whereby women would subordinate and marginalize men. Yet they didn't seem
disturbed when I disclosed by own identification as a feminist and a faculty
member at a gender studies department in the US. I often availed myself of
their openness and flexibility to talk to them about feminism's antihierarchi-

32. Feminist social scientists in Chile have provided overwhelming evidence pointing to
the extreme forms of inequality women suffer in the country. For example, in 2006 Chile had
the lowest participation of women in the labor force (38.5%) compared to other Latin Ameri-
can countries (54.2%.) Statistics from 2012 saw an increase in the female workforce, yet the
salary differentials and discrimination experienced by women still indicate persistent and bla-
tant gender inequality. Undurraga, "Mujer y trabajo en Chile ¿Qué dicen las mujeres sobre su
participación en el mercado laboral?" position 1966 of 6115 [Kindle Edition].

33. Guzmán, "Discursos de género e institucionalidad pública," position 3764 of 6115 [Kin-
dle Edition].

34. In "Discursos de género e institucionalidad pública," Guzmán observed that the gov-
ernment of Patricio Aylwin, the first democratically elected president after the dictatorship,
"was particularly sensitive to issues pertaining to violence, poverty and abuse, and less receptive
toward emancipatory gender demands, as these related to the recognition of women's individual
rights which were openly attacked by conservative discourses," position 3793 of 6115 [Kindle
Edition].

cal, decolonial, and intersectional projects, insisting upon the ever-expanding social justice implications of the term. By 2016, I began to realize that a number of graffiteras began to use the word feminist to describe themselves and the work that they do on the streets. Far from thinking that I had anything to do with this shift in their vocabulary, I investigated the changes in public discourses on gender. Indeed, the 2016 introduction of the "3 Causations Bill" by the second administration of Michelle Bachelet proposed decriminalizing abortion under three circumstances: danger to the mother's life, unviability of the fetus, and rape (as of this writing, abortion, under any circumstances, continues to be illegal in Chile.)[35] In addition, 2015 and 2016 saw a sharp increase in the reported crimes of extreme violence against women with media pundits often using the word *femicidio* to refer to these crimes as well as to the 2010 law that increased the punishment for those committing gender violence.[36] The increased visibility of discussions of reproductive rights and violence against women became a springboard for discussions about feminism as a viable political response to gender inequality and oppression.

GENDER AND GRAFFITI

The still scarce scholarship on gender and graffiti culture has focused on the social mechanisms in place that have made women a minority group among street writers and artists. Nancy Macdonald's research on the graffiti scenes of London and New York revealed that many of the street practitioners she interviewed regarded this form of street art as "men's work," citing the "risks and dangers" associated with public spaces as deterrents for women to participate.[37] My own previous work on graffiti turned up similar findings as most of the male graffiti artists from California that I interviewed insisted that it was too dangerous for women to tag on the streets.[38] Macdonald, however, turned to graffiti's male-centered culture itself as a more significant contributing factor for these gendered dynamics arguing that, for many young men, graffiti was an important site for the performance of masculinity. Male writers compete with one another to "prove themselves" as better artists and greater risk

35. "Infórmate Sobre Las Tres Causales."
36. "MODIFICA EL CÓDIGO PENAL Y LA LEY N° 20.066 SOBRE VIOLENCIA INTRA-FAMILIAR, ESTABLECIENDO EL "FEMICIDIO," AUMENTANDO LAS PENAS APLICABLES A ESTE DELITO Y REFORMA LAS NORMAS SOBRE PARRICIDIO," *Biblioteca del Congreso Nacional de Chile.*
37. Macdonald, *The Graffiti Subculture*, 98.
38. Latorre, *Walls of Empowerment*, 109–11.

* *risk-taking = masculinity*

takers. They tout their physical and mental prowess on the streets by showing that "they can confront risk, dominate fear and validate themselves as men."[39] The budding graffiti movement in Chile certainly betrays similar dynamics to those Macdonald observed during her fieldwork whereby young men are also attracted to the risk and adrenalin rush associated with doing "illegal work." Pabón's work, which has paid great attention to issues of gender in the Latin American graffiti scenes, has also pointed to the male-centered and machista culture of graffiti as a contributing factor for the marginalization of women:

> Generally, when people enter [the] graffiti subculture they hang out with more experienced mentors, perhaps an older brother and friend, who then mentors their stylistic and cultural development. Entrance into the culture is often different for women. Experienced writers may not want to "waste" their time mentoring a woman for fear she won't be truly committed.[40]

The prior Chilean tradition of politically engaged muralist production, however, which dates back to the late 1960s with the rise of the muralist brigades who worked on behalf of Salvador Allende's presidential campaigns, as explained in the introduction and chapter 1 of this book, has also informed graffiti practice there. As Rod Palmer explains: "Contemporary Chilean graffiti and street art have inherited much of the generous spirit, emotional force and didactic intent of the brigades' propaganda murals."[41] Thus, it is my contention that the powerful traditions of public art and urban protest in Chile have made graffiti a more egalitarian space for graffiteras because women have always been active participants in the country's history of activism and politically engaged art.

Though masculinity and male posturing are still part of the Chilean scene and male graffiti artists still greatly outnumber women, the graffiteras I interviewed were certainly less concerned and constrained by gendered discrimination than the artists featured in Nancy Macdonald's study. For instance, the women active in the New York and London scenes she spoke with often talked about the need to perform masculinity themselves in order to be respected and legitimized by their male peers: "[Female writers] have to replace all

39. Latorre, *Walls of Empowerment*, 108.

40. Pabón, "Be About It," 94. In addition to the barriers women encounter within the informal graffiti mentorship system, Pabón also observes that women face heterosexist assumptions on the part of other graffiteros who may claim that their work is not their own because they either copied a male artist or slept with him.

41. Palmer, *Street Art Chile*, 14.

signs of femininity (incapability) with signs of masculinity (capability)."[42] When graffiti exploded in Chile during the 1990s, Wend explained to me, some graffiteras also initially felt the need to use these "really tough [street] names to resemble men and to be part of graffiti."[43] But what seemed more commonplace for these artists was quite the opposite, namely the performance of a strategic femininity, a term I discussed in chapter 3's discussion of the work by Las Crazis graffiti crew. Anis and Wend told me that being women oftentimes shielded them from harsher treatment by *carabineros* (Chilean police.) As also mentioned in chapter 3, antigraffiti laws are very ambiguous and inconsistently enforced in Chile, currently making the country a more graffiti-friendly place than the United States. The uncertain legislation around street writing and painting often puts carabineros in the position of deciding whether or not it is even worthwhile to pursue graffiterx. When confronted by carabineros while painting in the streets, however, Wend commented that once she and Anis played the role of "dumb and naïve girls" by responding to their admonitions and harassment with incredulous comments such as, "We had no idea this was bad!"[44] They then proceeded to playfully and somewhat flirtatiously plead the carabineros to allow them to finish their wall. The deployment of this strategic femininity successfully staved off the policemen thus allowing them to finish their project. Such deployments, however, do not prevent carabineros from patronizing them with self-righteous rhetoric about their "proper" roles in society. "You are 25 years-old and a teacher," a carabinero once told Wend. "Don't you think you are way too old to be painting in the streets, to be doing these childish things?"[45] While I am not arguing that their performance of this strategic femininity elicited harassment from law enforcement, I do contend that the carabineros' investment in masculinity in the public sphere often gives them of a sense of entitlement over the activities and movements of women in urban streets.

GRAFFITI CREWS

Many scholars who have carried out research on graffiti such as McDonald, Susan Phillips, Jessica Pabón, Gregory Snyder, among others, have put great emphasis on the culture of graffiti. In other words, they have paid much attention to the lives and experiences of graffiti artists themselves as much as they

42. Macdonald, *The Graffiti Subculture*, 130.
43. Anis and Wend interview.
44. Anis and Wend interview.
45. Anis and Wend interview.

have analyzed their visual production. The roles that graffiti artists/writers play in society and the way they relate to others around them have been of critical importance to these scholars. The emergence of graffiti collectives known as crews speaks volumes of the socialization experienced by artists/writers. Phillips in her 1999 monograph *Wallbangin': Graffiti and Gangs in L.A.* established a great distinction between graffiti crews and urban gangs in Los Angeles:

> Despite some geographic and social links, gang members and taggers are different people; gangs and crews [are] entirely different entities. Crew members may act like gang members in that they are sometimes violent toward one another. But they are not driven by the context of protecting neighborhood space or themselves through the development of a reputation. Their goals always relate to their art: achieving fame and respect for themselves and their crew through graffiti production. Crews are about graffiti, plain and simple.[46]

Phillips also acknowledges that crews provide young writers with an informal apprenticeship system whereby they can learn "the tricks of the trade" from older and more experienced artists. Implicit in the work by Phillips is the assumption that crews provide for male writers a space for masculine homosociality, a loose organization where men both compete and support one another.

The graffiteras featured in this chapter, however, challenged this patriarchal vision of the graffiti crew. The crew provided these women with a source of camaraderie, mutual support, and increased creativity. Moreover, the crew operated as a kind of laboratory for the ethics of care and world-travelling whereby the artists practiced egalitarian relations with one another and then extended them to the assumed spectators of their work. Of the five artists I interviewed, three belonged to all-female graffiti crews. Gigi was a member of the crew known as Turronas, who were active primarily in Valparaiso. Dana belonged to Las Crazis, active in Santiago. Anis and Wend were the sole members of the Abusa Crew, who also did most of their work in Santiago. While their approaches to group work are quite distinct, all four shared a commitment to the collectivity of the group. Gigi, Anis, and Wend were not overly concerned with the distinction between sole authorship versus collective authorship, often interchangeably signing their pieces with their individual

46. Phillips, *Wallbangin'*, 43.

and crew names.[47] The formation of the crew begins with a sense of friendship as a foundational element for subsequent collaborative work. As Gigi, Anis, and Wend explained it to me, a friendship between women involved in arts activities then morphed organically into a desire for artistic collaboration. The commitment to the crew, however, did not mean these artistic collectives were highly organized and structured groups, as Gigi explained: "We make fun of that structure. . . . If you're already painting graffiti, you can't get too grave about it."[48] The crew thus embraced playfulness in their collaborative work. Playfulness, Lugones insists, "is characterized by uncertainty, a lack of self-importance, absence of rules or a not taking rules as sacred, a not worrying about competence, and a lack of abandonment to a particular construction of oneself, others and one's relation to them."[49] This playfulness within the crew provided for these artists a form of socialization whereby their individual subjectivities were expanded and even enhanced, rather than undermined, through collective action. For instance, when I asked Gigi whether she saw a contradiction between her individual creativity and that of her crew, she insisted that working in a crew is not about reconciling contradictions necessarily:

> [Collaboration], more than a contradiction, is an ability. Working collectively is not easy. If you take on an individualist or, better said, an egocentric posture, you will never be able to work collectively. But if you begin to see that, deep down inside, you are part of a whole, your perspective will change because, even though you are part of a whole, your way of doing this [art] will be different.[50]

Gigi's statements are profound in that they assert that an artist's individual subjectivity is both disciplined and liberated within the collectivity of the crew. These graffiteras thus enact what feminist theorist Margaret McLaren describes as a "subjectivity that is both socially constituted and capable of resistance."[51] While the crew does not represent a system of oppression, per se, it does restructure an individual's subjectivity in order to accommodate others' input and participation. This process of engaging the collective and transcending individual aesthetics can, in turn, enhance subjectivity itself. McLaren further maintains that "subjects produced through [disciplines]

47. Anis and Wend interview.

48. Gigi interview.

49. Lugones, "Playfulness, 'World-Travelling' and Loving Perception," 17.

50. Lugones, "Playfulness, 'World-Travelling' and Loving Perception," 17.

51. McLaren, *Feminism, Foucault, and Embodied Subjectivity*, 54.

are not only damaged and limited by them but also gain strength, skills, and resources."[52] The artists I interviewed felt that their own identities as artists were complicated in productive ways by their work in the crew. Nevertheless, the crew provided a more egalitarian social structure to that of society at large. The fact that for many of these artists the foundation of the crew was friendship among women and that the organization of the group was clearly loose, playful, and nonhierarchical created a more egalitarian space that dispelled the notion that collective work stands in the way of individuality and creative agency. Though responding specifically to Michel Foucault's writing, McLaren makes assertions about his treatises on subjectivity that nevertheless ring true about these graffiteras' views on collectivity: "Although Foucault's genealogical works may appear to yield a determined subject, they sketch out a new way to think about subjectivity that breaks from the traditional philosophical dilemma of viewing self and sociality as mutually exclusive."[53] Likewise, Anis and Wend explained to me how their sense of self and membership of a larger collective—which also corresponds to the amalgamation of the individual and the collective I discussed in chapter 3—were effectively fused within the context of the crew. "When you belong to a crew, it's not about your ego, it's not about your name, it's about the crew. . . . A crew is like [a] sisterhood," Wend explained to me. Her collaborator Anis likened their wall creations to children that were metaphorically birthed by both of them and presented to the larger community as an art offering.[54] Though the artists may be utilizing a problematically gendered vocabulary to speak of their work, the idea of doing graffiti for a larger community rather than for individual fame or "street cred" represents a departure from more conventional motives for the practice of street writing. The notion of creating an art offering also falls in line with these artists' commitment to egalitarian forms of caring within an urban sphere that is particularly hostile and uncaring.

It should be noted here, however, that not all the graffiteras I interviewed idealized or celebrated the collaborative and collective work done within graffiti crews. Dana problematized her own membership in Las Crazis. From its inception, the creation of this crew was critical for her formation as a street artist, but as time wore on, it became increasingly more difficult for the members to find time to work together as their individual lives became more complex and demanding. The number of artists who joined the crew increased too, so making collective decisions provided more challenges for the group. The loose, playful, and informal nature that characterized the group in the

52. McLaren, *Feminism, Foucault, and Embodied Subjectivity*, 59.
53. McLaren, *Feminism, Foucault, and Embodied Subjectivity*, 59.
54. Anis and Wend interview.

[handwritten margin note: love → organized [...]]

early 2000s eventually led to a more systematized organizational structure that proved to be impossible to maintain. All these issues lead Dana to distance herself from Las Crazis by 2012, a decision that allowed her to spend more time with her young son and return to college.[55] Notwithstanding, her work with this crew still defined who she was as an artist and provided her with a nurturing and supportive network of women in the male-dominated sphere of the streets. Moreover, by 2015, the artist rejoined Las Crazis, which themselves had redefined collaborative practices, as elucidated in chapter 3.

THE ICONOGRAPHIES OF CARE/LOVE ETHICS

Though these artists' social practices within the graffiti and public art scenes certainly challenge male domination of the urban sphere in Chile's city streets, I would argue that their iconographic and stylistic programs also decenter the assumed masculinity of these locales. The five artists I feature here all believed that graffiteras in Chile offered a gentler, softer, and more "feminine" aesthetic compared to the more aggressive and confrontational imagery of their male peers. While these positions may superficially appear to promote a kind of gender binarism whereby women's work is labeled gentle, soft, and "cutesy" and men's work considered tough, hard hitting, and edgy, I maintain that these comments made by the graffiteras I talked to more accurately point to a desire to transform city streets into a less hostile and more embracing space for all populations, including women, the elderly, children, and so on. Graffitera Camila Blanche explained that the creation of feminine-looking imagery also had to do "with how we position ourselves and recuperate spaces as women within an arts circuit that is very machista."[56] Moreover, this approach is part and parcel of an ethics of care that refuses to cater to more "desirable" audiences for their work. I thus argue that these so-called "feminine" aesthetics, rather than seeking to essentialize these graffiteras' imagery, attempt to democratize the urban sphere along gender lines.

[handwritten margin note: What about the binarism?]

The precepts of the ethics of care and collectivity coupled with the feminist understandings of world-travelling outlined earlier in this chapter are important frameworks to understand the complexity behind the artistic and political praxis that drive the work by these graffiteras. However, this understanding is incomplete without a discussion of individual artists along with a close reading of the content and imagery in their work, making both the process and

55. Dana interview.
56. Toledo, "El nuevo graffiti femenino," 25.

the "end product" equally important. I would like to be cautious though and complicate the very idea of an "end product," a concept that has a certain fixed finality that really doesn't exist in the Chilean graffiti scene. While a graffitera may finish a piece and move on to another project, the ephemeral quality of street art and transient nature of the public sphere make that wall painting an ongoing piece that is continually transformed by its surroundings. Thus, this graffiti work is always in process and never truly finished. The artists that I discuss in the following sections are keenly aware of the organic and fluid relationship between process and "end product."

Santiago-based graffitera Dana (Dana Caster) is a pioneer among women street writers. She entered the street art scene in the late 1990s when she cofounded one of the earliest all-female crews in Chile, Las Crazis (also called Las Locas and LKS.) Like Gigi from the Turronas Crew, Dana saw her work with Las Crazis as an extension of the friendship and camaraderie she felt with her peers, especially Nazca, who was her classmate in high school.[57] Her love of art and drawing was nurtured when she was a small child growing up with a grandmother who was a painter. When she began doing work on the streets, however, she found that the scene was too male-centered and machista with very few women doing graffiti. Without any formal training in the arts, Dana taught herself by observing and experimenting: "Hechando a perder se aprende" [We learn through trial and error], she often remarked.[58] Though she depended on her women cohorts to adopt new skills, she also observed male artists like Cekis and others work their walls. A very powerful impetus behind her wall pieces was to disrupt the assumed maleness of street art: "My purpose was to give it a feminine touch because graffiti was too masculine with its wildstyle lettering."[59] Dana was also frustrated with male graffiteros' assumptions about women's work on the streets. They often refused to believe a woman did a particular piece if it looked too "edgy" or "hard hitting." Rather than proving herself by emulating the rough and tough style of the men, she responded by making her work unambiguously "feminine." She wanted to make sure audiences knew it was done by a woman so she upped the ante, so to speak. She thus introduced her *muñecas* (dolls) to the Chilean urban landscape (see figure 4.1).

Calling them self-portraits ("because they resemble me," she explained), she rendered these figures in black outlines with large heads, small bodies, and cartoon-like features. Their oversized eyes often gaze back at the viewer with quizzical and at times even loving expressions. These figures are clearly

57. Toledo, "El nuevo graffiti femenino," 25.

58. Toledo, "El nuevo graffiti femenino," 25.

59. Toledo, "El nuevo graffiti femenino," 25.

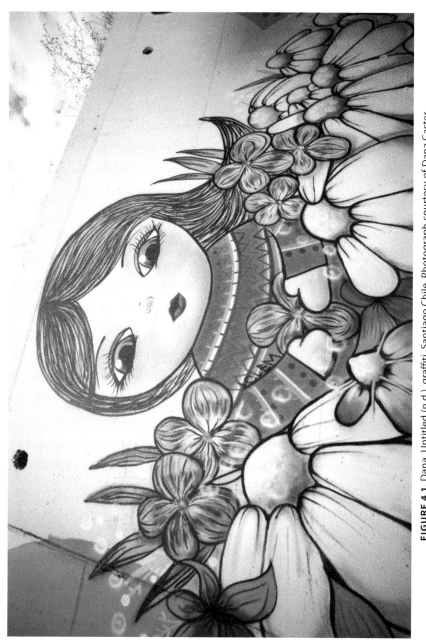

FIGURE 4.1. Dana, Untitled (n.d.), graffiti, Santiago Chile. Photograph courtesy of Dana Caster.

reminiscent of Japanese animé and manga aesthetics, pop culture phenomena that have a significant presence within Chilean society. In her work on Hello Kitty and the global marketing of "kawaii" or "cute" Japanese characters and consumer culture, Christine Yano explores the open discursive field that figures like Hello Kitty offer their consumers. The "cuteness" of these figures can emanate a particular affect of innocence and vulnerability that has appealed to girl subcultures across the world, including Chile. Yano explains that "by dubbing some object or person as kawaii, the viewer proffers a gaze that is both softened and charged with empathy, intimacy and emotion." This writer further explains that for those who employ and consume images of cuteness, they can be "both the cared for and the caregiver, by way of kawaii."[60] With her muñecas, Dana capitalizes on the empathy, care, and softened gaze that images of cuteness can elicit. Viewers can imagine these figures offering them care while also seeing themselves caring for them. The Western split between an active subject and passive object is thus broken down as spectators can enact the gaze while also seeing these muñecas return it back to them in a caring and nonobjectifying fashion. These dynamics of reciprocity and mutual recognition are at the core of the artist's ethics of care and decolonial love.

Dana often coupled her muñecas with tags of her name painted in an equally colorful, playful, and childlike fashion. References to the self through inscriptions of names in graffiti have a social significance that goes well beyond self-promotion. Writing on street art in São Paulo in Brazil, Ana Christina DaSilva Iddings, Steven McCafferty, and Maria Lucia Teixeira da Silva have argued "that people shape their environment through the use of signs, and these signs in turn shape them as part of the complex, dynamic, and nonlinear process in which the environment and its meanings are actively coproduced."[61] Dana's muñecas and her nametags are indeed trademarks of her style, but they also express her desire to offer caring and nonthreatening imagery, as she explained: "Street art connects you with your community. It is a gift for them without cost. You give life to a city that is polluted in every way."[62]

In an untitled piece from 2009 located in Valparaiso's Cerro Alegre, Dana painted a muñeca on a private home on a street corner of the city (see figures 4.2 and 4.3). When painting houses, Dana like other graffiteras usually approached the owners asking permission. In other cases, residents who were already familiar with her work requested or commissioned a piece from her. Such a practice would not be possible in countries like the United States where

60. Yano, *Pink Globalization*, 57.

61. DaSilva Iddings, McCafferty, and Teixeira da Silva, "Conscientização through Graffiti Literacies in the Streets of a São Paulo Neighborhood," 5.

62. Dana interview.

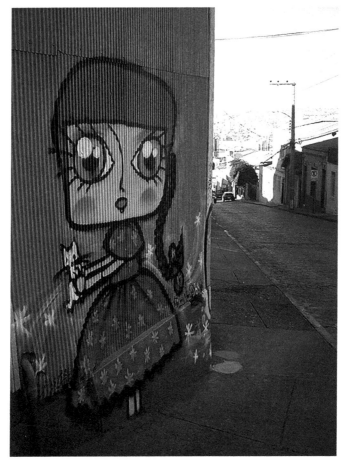

FIGURE 4.2. Dana, Untitled, detail (2009), graffiti, Cerro Alegre,
Valparaiso, Chile. Photograph: Courtesy of Dana Caster.

city laws place strict limitations on how homeowners decorate the exterior
of their homes. In this wall piece, the artist radically transformed the mono-
chromatic color palette of the house with one of her muñecas and nametag,
capitalizing on the unique Valparaiso urban topography. With most of the city
built upon hillsides overlooking the Pacific Ocean, the city's distinct archi-
tecture, which combines colonial churches, vernacular, and eclectic build-
ing façades and an "amphitheater-like layout"[63] has become a favorite site for
graffiti among Chilean and non-Chilean street artists alike. In 2003 the city's
historic quarter was designated a world heritage site by UNESCO, which has

63. "Historic Quarter of the Seaside Port of Valparaiso."

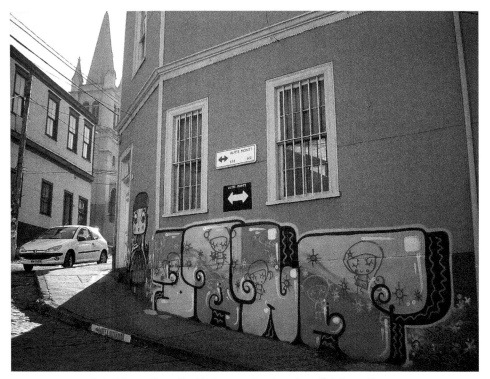

FIGURE 4.3. Dana, Untitled, street view (2009), graffiti, Cerro Alegre, Valparaiso, Chile. Photograph: Courtesy of Dana Caster.

increased tourist interest in the area and thus diversified potential audiences for graffiti work there. Dana's piece here invites the viewer/passerby to turn the corner as her image is painted on the zinc panels that wrap around the house. These panels are a characteristic building material in Valparaiso which harken back to the nineteenth century, when the city emerged as a major shipping port in the Americas and during a time when these panels were used as ballast for the ships that would arrive in the city.[64] The juxtaposition that the artist creates between the century-old architecture and the more contemporary comic book and kawaii style of her aesthetic add to the whimsy and ludic quality of the imagery. The letters of her nametag seem to emulate the consistency of bubblegum while stick figures reside within them. The purple and mustard color palette of the tag further emphasizes the childlike imaginary of the piece. Next to her tag, we see one of Dana's characteristic muñecas wearing a purple dress with pink and yellow flowers as she holds a white

64. "Historic Quarter of the Seaside Port of Valparaiso."

cat. While an image such as this one may appear to border on the excessively "feminine" and overly "cutesy" or on what Yano calls "in-your-face cute,"[65] the seemingly essentialist and feminizing qualities of this piece are subverted by the fact that Dana inserted her own gendered body as well as that of her muñeca into the assumed maleness not only of the urban space but also of the graffiti scene in Chile. The artist's desire to make it obvious that her work was done by a woman, as she asserted during my conversation with her, can be regarded as a form of strategic femininity that serves as a direct affront to the male graffiteros who may believe that they have a monopoly over the street art movement in Chile.

The use of strategically feminized iconography is a characteristic element of other Chilean graffiteras as well. Alterna (Natalia Cáceres) had been active in the graffiti scene since 2007, when male graffiti artist Smides introduced her to the urban art movement while she was in college studying design. Though she was based in Santiago, she painted in many other cities throughout Chile such as Valparaiso, Rancagua, and Valdivia. As a proponent of educational equality in Chile and a self-professed vegetarian and animal rights activist, she infused much of her graffiti art with her social convictions around these issues. Her work in the streets of Santiago was clearly recognizable through her signature motifs, graffiti characters she calls *niñas* (little girls; see figure 4.4), which in many ways function similarly to Dana's muñecas in that Alterna also deploys the affects of cuteness and kawaii.

Informed by her training as a graphic designer, Alterna often depicted her niñas with long flowing hair and cartoon and child-like features using paint brushes rather than spray cans, often regarded as the medium par excellence of the graffiti writer. "Passersby often take pictures embracing or kissing my niñas," Alterna explained to me, alluding to the community interaction and engagement she aspires to achieve with her work.[66] While as apolitical as these figures may appear, they are central protagonists of Alterna's graffiti murals of social protest. In *Devuélvenos la Imaginación* [Give Us Back Our Imagination] (see figure 4.5), the artist presents us with a group of her niñas who stand confrontationally and defiantly before the viewer as an inscription above their heads reads, "Arte y música son parte de mi educación" [Art and music are part of my education].

We can also connect the confrontational stance of these figures to the aesthetics of cuteness that Yano discusses in her research. A "cute-as-defiant-attitude" is another possible attribute that defines the aesthetics of kawaii,

65. Yano, *Pink Globalization*, 3.
66. Alterna interview.

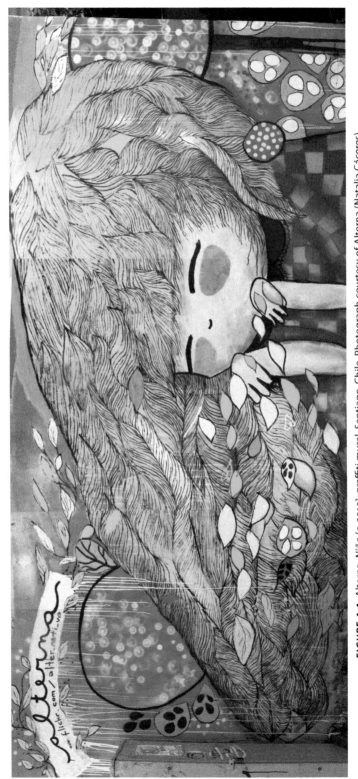

FIGURE 4.4. Alterna, *Niña* (c. 2010), graffiti mural, Santiago, Chile. Photograph courtesy of Alterna (Natalia Cáceres).

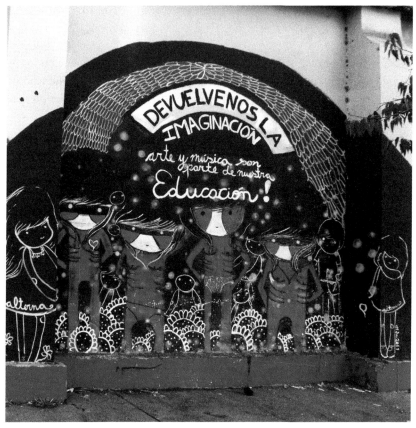

FIGURE 4.5. Alterna, *Devuélvenos la Imaginación* (2011), graffiti mural, Liceo Amunátegui, Santiago, Chile. Photograph courtesy of Alterna (Natalia Cáceres).

an attribute that subcultures have adopted as a symbol of nonconformity.[67] This nonconformity in Alterna's niñas signaled the artist's political response to recent educational policies in Chile. This mural is part of a series of graffiti pieces she did throughout Santiago in reaction to the government-mandated elimination of art and music requirements in Chilean public schools, which, in large part, cater to poor and working-class children. The niñas in this particular wall piece have been stripped naked or nearly naked, exposing the ribs of their emaciated bodies, implying that they had been starved or decimated by a less than nurturing school curriculum. Alterna further asserts that a basic component of childhood development has been denied them, namely their right to an imagination. The artist created this graffiti mural in the context of

then why girls?

67. Yano, *Pink Globalization*, 202.

the larger student protest movement that began in 2006 and has continued to this day. Students and educators alike have taken to the streets demanding a decrease or end of the mostly privatized school system in Chile, which places profit at the center of its agenda. Such a system has spawned generations of inequality in the country, leading protesters to occupy various public schools in the process, including the Liceo Amunátegui where this particular piece is painted.

In her work, Alterna has also extended her vision of social justice to the humane treatment of animals, a vision that reflects her politics of care. "[Being vegetarian] is part of being a human being," she has commented. "It is your relationship to the world, to other people and to your pets. I cannot conceive the idea of eating a *compañero*."[68] So Alterna saw vegetarianism as part of the larger web of social and environmental justice. Her commitment to vegetarianism and opposition to animal cruelty was particularly fitting in a city like Santiago, which has a large population of stray dogs and cats that are woefully neglected, abused, and mistreated. In her piece titled *Adopta un Gato* [Adopt a Cat] (see figure 4.6), Alterna encouraged her audience to perform radical acts of caring toward the city's nonhuman populations. Here one of her trademark niñas tenderly reaches down to pick up a white cat. Her love for animals is made evident in her affectionate facial expression and in the cat print of her black dress. The simplicity and striking quality of this figure reflects Alterna's own training in graphic design and her desire to convey a direct and unambiguous message to passersby. The child-like quality of her niña is meant to appeal to children and adults alike who might encounter this image. The artist chose to paint this graffiti on the wall of an abandoned building, which is often surrounded by trash and urban debris, precisely the kind of locale where stray animals might converge and seek refuge from the dangers of the city. Alterna's call for a more egalitarian and humane relationship with animals was part and parcel of Chilean graffiteras' larger feminist commitment to the transformation of the urban sphere into a space of more democratic, loving, and magnanimous social relations. *→ treat animals well → gendered ?*

Like Alterna, Anis and Wend's graffiti work in the Abusa Crew was also driven by their desire to produce loving and caring gestures on the streets through the radical vocabulary of graffiti and thus improve *el entorno* (environment) of the city. Their graffiti mural *Espíritu de Mujer* [Woman's Spirit] (2014; see figure 4.7) represented the artists' increasingly open and unapologetic embrace of feminism. *→ claiming femininity ?*

68. Alterna video testimonial posted on the website of La Revolución de la Cuchara: http://www.larevoluciondelacuchara.org/ (accessed on June 1, 2014).

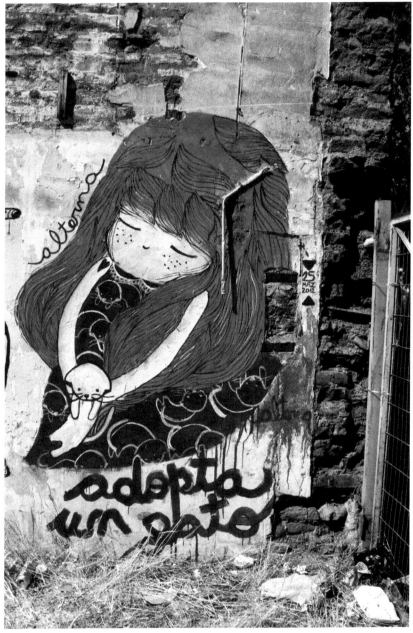

FIGURE 4.6. Alterna, *Adopta un Gato* (2010), graffiti mural, Santiago.
Photograph courtesy of Alterna (Natalia Cáceres).

FIGURE 4.7. Abusa Crew, *Espíritu de Mujer* (2014), graffiti mural, Santiago, Chile. Photograph courtesy of the Abusa Crew.

This commitment to a gender consciousness began as rather timid feminist subtexts in the artists' iconography at the beginning of their career but would eventually flourish into fierce feminist interventions into the urban space.[69] The artists' goal for this graffiti piece was to "physically and spiritually represent the free woman."[70] Painted over a horizontal wall, the Abusa Crew offered the spectator their vision of a woman who exists outside of the power inequalities and violence of toxic masculinity. The central figure, rendered in the nude with mostly hues of blue, emerges from a body of water as she extends her left arm to expose a vine of flowers growing out of her body. Revealed through her chest is her heart, which is connected to the moon and the cosmos via a string of stars. A luminescent mandala looms behind her, symbolizing, in Wend's words, "[the] light and energy that there is in women, capable of opening new paths and opportunities."[71] The Abusa Crew also drew multiple horizon lines behind the central figure, thus endowing the overall composition with a sense of spatial depth. These lines, however, morph into a series of words that inform our reading of this graffiti piece. The artists had female audiences in mind with this wall painting, hoping that these spectators would inscribe their own subjectivities into this image. Inscriptions such as "explore," "imagine," and "create" promote a woman's capacity of thought, intellect, and creativity, thereby operating as public recognitions of women's often-devalued knowledges. But the words "fight" and "revolutionize" point to something else, namely the need to resist, challenge, and decenter the powers of patriarchal hegemonies. The Abusa Crew thus communicate to their audience that women cannot become fully constituted subjects without dismantling the systems of gender oppression that define Chilean society.

It is critical to regard *Espíritu de Mujer* within the context of Chilean gender politics and practices, which are strictly conservative at best and systemically violent at worse. For the Abusa Crew, the "free woman" represented in their graffiti mural is one who has been liberated from the traumas and injuries of gender violence. The increasing reports of murders and gruesomely

69. In 2016 the Abusa Crew organized a women's arts collective in Chile called Muchachitas Pintoras [Girl Painters], a group in which, according to Wend, "feminism and empowerment in public space through the arts is the basis of the project." In 2017 the group carried a multimedia public arts festival in Santiago that became the first of its kind to focus on gender and feminism. Email communication between the author and Wend from the Abusa Crew, July 15, 2018. For information on Muchachitas Pintoras, see "Muchachitas Pintoras, el primer festival de arte urbano con enfoque de género en la RM," *Ministerio de las Culturas, las Artes y el Patrimonio, Gobierno de Chile*, http://www.cultura.gob.cl/agendacultural/muchachitas-pintoras-el-primer-festival-de-arte-urbano-con-enfoque-de-genero-en-la-rm/ (accessed on July 16, 2018).

70. Email communication between Wend and author.

71. Email communication between Wend and author.

violent assaults against women have led to massive demonstrations in cities like Santiago under the hashtag #NiUnaMenos [Not one woman less].[72] The Abusa Crew understood the importance of enacting feminist actions in public spaces against these systemic assaults. Instead of the injured body of the battered woman, the artists instead offered in *Espíritu de Mujer* a vision of what is like for women to be free of the repressive and controlling forces of patriarchal abuse. While intimate partner violence in Chile has been long regarded as a private and domestic matter, the Abusa Crew along with thousands of antiviolence activists have purposely taken their message to the public sphere. Making such statements public underscores how these assaults not only occur in the privacy of the home but also in the hostile environment of city streets. Moreover, Chilean society has developed a permissive culture toward women's public harassment and even groping, which is often dismissed as innocent *piropos,* that is, playful and benign flirting. The Abusa Crew have been all too conscious of how women become targets of gendered violence in and outside the home. Their concern over this issue has also prompted them to lead workshops with children and adolescents on intimate partner violence, using their experience as community artists and public school teachers to develop an accessible language to speak to them.[73] Their actions thus imply an understanding that their own subjective experience as gendered individuals in the public sphere informed their outreach and connection to their communities. Thus, they remind us that an effective ethics of care articulates a notion of the self that is relational and deeply embedded in communal and collective action.

The Abusa Crew's willingness to place their own bodies in the streets of Santiago also extended to their commitment to situate in this same space nonpatriarchal images of women. This radical iconography can be found both in their work as a collective and in the imagery they create as individual artists. Working on her own, Anis tapped into the ludic and irreverent language of graffiti and hip-hop in her wall piece titled *Puta 2* (see figure 4.8), which depicts the figure of a nude woman sitting on an upside aerosol can that is spewing out green paint.

This playful figure here becomes an allegory of the female graffiti artist and writer who inscribes her body into the public sphere. The artist renders this body with large thighs and breasts and an ample midriff area, thus challenging the thin and hypersexualized body ideals more commonly found in advertis-

72. For more information on the #NiUnaMenos campaigns in Chile, see Fernanda Fernández, "#NiUnaMenos: La marcha que se realizará en Chile y Argentina contra la violencia hacia la mujer," *Emol,* October 18, 2016.

73. Anis and Wend interview.

FIGURE 4.8. Anis, *Puta 2* (c. 2010), graffiti mural, Santiago, Chile. Photograph courtesy of the Anis.

ing billboards in Chilean streets. *Puta* (whore) refers pejoratively to a woman of questionable sexual mores and behavior. The more conservative sectors of Chilean society assert that women who spend too much time on the streets undermine their moral integrity. Expressions such as *callejera* (streetwalker) or *mujer pública* (public woman) are thinly veiled codes for "sexually loose" women. The streetwalker concept, however, takes on a subversive meaning when resignified for feminist purposes. "The streetwalker theorist," Lugones asserts, "walks in illegitimate refusal to legitimate oppressive arrangements and logics."[74] Indeed, Anis contests the oppressive logics of gender in public

74. Lugones, *Pilgrimages/Peregrinaciones*, 221.

*⇒ "cuteness"
showing care
≠ conflict
?*

spaces by appropriating the word *puta* to refer to the *mujer callejera* as the graffitera who claims the urban space as her own. Her sexuality denotes not her perdition but rather the creative energy that fuels her work. Unlike other works discussed in this chapter, the resignification of a gendered body that is at play in this graffiti work operates as a direct affront to traditional feminin- *✓* ity. The artist purposely eschews girly, cutesy, and flowery imagery in *Puta 2* *speak to* yet still deploys feminine aesthetics—represented by this clearly female-iden- *"strategic* tified body—to assign value to "the female" in order "to assert herself as a site *femininity"* of value," to borrow Hanan Muzaffar's words once again.

Gigi (Marjorie Peñailillo), from the Turronas Crew, who was active in the seaside cities of Valparaiso and Viña del Mar, was also interested in the bodies of women as important sites of feminist agency and empowerment. The representation of female figures in her graffiti murals directly referred to her call for women to play active roles in urban spaces. Gigi often turned to Andean indigenous imagery as inspiration for much of the female-centered iconography of her graffiti murals. Inscribing city spaces with such imagery was *→ what's* indeed a decolonial move on her part, one that sought to decenter the colo- *that logic?* nial logics that still govern public spaces in Chile. She had long been inspired by the indigenous artistic traditions from the Valdivia (Ecuador) and Moche (Peru) cultures. She had paid particular attention to the syncretic traditions of spiritual festivals such as La Tirana from Chile and Oruro from Bolivia. Her deployment of these influences coupled with her investment in urban culture resulted in a decolonial aesthetic that characterizes her individual and collective work with the Turronas Crew. Moreover, Gigi's gender consciousness further informed the egalitarian and inclusive nature of her visual vocabulary. Her graffiti pieces and murals capitalized on the unique urban geographies of Valparaiso and Viña, locales that are defined by their proximity to the Pacific Ocean and the layered look of their architecture built on hills as mentioned earlier. Part of the artist's signature style included a recurring graffiti character she called Luisa (see figure 4.9).

Gigi often rendered Luisa's body in the nude using warm colors such as reds, oranges, and yellows. With her rather stubby proportions, her body did not conform to patriarchal and Eurocentric notions of feminine beauty, yet the various poses, postures, and attitudes she adopted in Gigi's pieces exuded a sense of self-confidence and even defiance. In her master thesis as well as in an interview she gave in 2013 to a local newspaper *El Observador* from the cities of Quilpué and Villa Alemana, the artist explained that her Luisa figures were the result of the powerful effect that Andean indigenous cultures have exerted on her work:

FIGURE 4.9. Gigi (Turronas Crew), Untitled (2011), graffiti mural, Valparaiso, Chile. Photograph Courtesy of Marjorie Peñailillo.

> Pre-Columbian culture has helped me work with my characters. . . . The women I create represent fertility in art and rebirth. This is why they are women from the Carnival of Oruro or La Tirana, the she-devils. There is a religious but also indigenous theme here. I am very much interested in indigenous cosmovisions.[75]

The Carnival of Oruro from Bolivia and the Festival of La Tirana from northern Chile are both spiritual festivities that reflect the syncretic and hybrid cultures of the Andean region. Characterized by colorful masked costumes and cults to regional manifestations of the Virgin Mary, these traditions also reflect the forms of decolonial resistance enacted by Andean populations faced with the ravages of colonization. "Luisa is a multicultural mix, that is born out of [my] contact with the indigenous cultures from Brazil, Peru, and Bolivia," Gigi explained.[76] The vivid coloring of the Luisas reflected the simi-

75. [No author cited], "El graffiti es un medio de comunicación transversal y tiene el poder de llevar el arte a la calle," 19.

76. Peñailillo Endre, *Graffiti-mural y cultura urbana*, 48.

larly vibrant aesthetics of the Oruro and La Tirana festivities while these figures' stocky and ample bodies are meant to, as Gigi herself articulates, "cite the obesity of the Pre-Columbian Venuses from the Andean plateau."[77] The color, movement, and incredible dynamism of the Oruro and La Tirana celebrations are certainly characteristic features of the Chilean graffiti scene too, but what Gigi most prominently underscored with her Luisas are the central roles that women and female deities play in indigenous cultures. Moreover, the Luisa's larger body size is not a detriment to her power but rather a necessary component of her creative energy. The artist insisted that these monumental women epitomized important concepts from indigenous worldviews such as "nudity, fertility, religiosity, identity and strength."[78] Gigi's deployment of goddess figures also points to the performance of a strategic femininity, for such representations may seem to naturalize and essentialize connections between women and the natural, and thus "uncivilized," world. However, Gigi's representation of indigenous goddesses resembles similar tactics found in Chicana art of the late twentieth and early twenty-first centuries. Laura Pérez posits that Chicana artists, far from romanticizing an indigenous past or promoting the nature-woman paradigm, adopt this goddess imagery to "imagine a future beyond patriarchal cultures" and to exact "a feminist critique of Eurocentric, patriarchal and heterosexist underpinnings."[79] Likewise, Gigi's Luisas and other goddess figures also promote feminist and decolonial critiques of a patriarchal present. *double*

The pairing of indigenous practices and graffiti aesthetics that Gigi sought out with the Luisa figures was appropriate, given the ways such religious festivities and street art engage the public sphere and can operate as decolonial forms of knowledge that challenge the corporate and government control of these spaces. Thus, Luisa's presence in the artist's work could also be linked to the long-standing tradition in graffiti of representing b-boy characters. The b-boy refers to hip-hop dancers known for their dynamic street performance and breakdance routines. Graffiti writers whose praxis is closely related to hip-hop culture have also deployed the image of the b-boy in their street art. In these images, the b-boy is dressed in baggy, sporty clothing characteristic of hip-hop styles; his irreverent and rebellious stance mirrors the culture of graffiti itself and the resourcefulness required to survive in the urban sphere. In *Luisa Rayando a Zade*, Gigi cast Luisa in the role of the b-boy (see figure 4.10); she betrayed the same kind of swagger and subversive antics of this character. Dressed in a bright pink jacket, pants, and cap, Luisa was depicted here

77. Peñailillo Endre, *Graffiti-mural y cultura urbana*, 49.
78. Peñailillo Endre, *Graffiti-mural y cultura urbana*, 48.
79. Pérez, *Chicana Art*, 299.

FIGURE 4.10. Gigi (Turronas Crew), *Luisa Rayando a Zade* (2011), graffiti mural, El Belloto. Photograph courtesy of Marjorie Peñailillo.

in the very practice of street writing with aerosol can in hand. The title of the piece suggested she was intervening in the work of Zade, another well-known graffiti artist in Valparaiso. The word *rayando* in Spanish can be loosely translated into "scribbling," "ragging," or "tagging," and often denotes a less than serious, unrefined, or unskilled form of writing or drawing. Graffiti artists

FIGURE 4.11. Gigi (Turronas Crew), *Luisa Playera* (2013), graffiti mural, El Tabo, Valparaiso, Chile. Photograph courtesy of Marjorie Peñailillo.

in Chile often adopt the term and resignify it to mean the radical aesthetics and subversive practices of street art. Luisa's rayado over Zade's work represented a street challenge between graffiti artists, a kind of thrown down, albeit a respectful one, over artistic prowess and superior aerosol skills. Luisa's challenge to Zade's work could easily be read as a kind of gender struggle between a female and male writer over artistic territory. Luisa, who here stood for the quintessential graffitera, held her own in a field dominated by men.

While Luisa has made numerous appearances in the urban sphere, Gigi has also placed her in strategic spots throughout the natural topography around the Valparaiso area. In *Luisa Playera* [Beach Luisa] (2013; see figure 4.11) and *Luisa del Bosque* [Luisa of the Forest] (2012; see figure 4.12), we saw this figure presiding over local landscapes of the region. Luisa's rather whimsical nude presence on the beach and the forest here likened her to an ocean and/or

FIGURE 4.12. Gigi (Turronas Crew), *Luisa del Bosque* (2012), graffiti mural, Villa Alemana, Chile. Photograph courtesy of Marjorie Peñailillo.

earth goddess. Gigi's use of the surroundings cleverly informed our readings of the Luisas who seem to be situated within their proper element. Painted on an abandoned building next to a small forest, *Luisa del Bosque* reclined in an almost pastoral fashion as she blew bubbles from a heart-shaped rim. *Luisa de la Playa*, for her part, leaned back as she took in the sun and ocean breeze around her. Both figures recalled indigenous nature goddesses whose powers were closely connected to the natural world.

Gigi's interest in Andean goddess figures represented both a continuation and a break with certain artistic traditions. Women artists in the Americas have long embraced ancient and precolonial goddess figures in their work. Feminist artists in the US and Europe during the 1970s, for instance, sought to celebrate women's empowerment by citing female deities in their visual vocabulary. Around the same period, Chicana artists throughout the US Southwest, as previously indicated, celebrated the importance to Aztec goddesses like Coatlicue and Coyolxauhqui with their work. Cuban-American artist Ana Mendieta, for her part, made powerful allusions to Taino deities Guanaroca and Iyaré with her earthworks. In Latin America, famed Mexican painter Frida Kahlo paid homage to Tlazolteotl, Aztec goddess of filth and fertility, in her painting *My Birth* from 1932, while Peruvian artist Tilsa Tsuchiya, active mostly in the 1960s and '70s, did a series of paintings depicting mythical women inspired by Andean indigenous cosmology. While feminists have long dismissed this "goddess worship" as essentialist, reductive, and overly idealized, such a phenomenon reflected a desire to seek nonpatriarchal forms of spirituality and creative expression on the part of feminist artists and cultural producers.[80] For Latin American and US Latina artists in particular, their heightened consciousness about the colonial history of the Americas and the imposition of patriarchal social systems ushered in by the conquest made their interest in indigenous and, in some cases, African-descent spiritualities all the more subversive. Gigi's updating of the pre-Columbian goddess through the aesthetics of graffiti and Chilean street art made her Luisa figure more than a mere artifact from an imagined genderless utopia. Instead, this female-centered iconography was made relevant and pertinent to the twenty-first-century realities of women who lay claims to the Chilean urban sphere.

CONCLUSION

The creative and feminist work taken up by Chilean graffiteras can be considered a powerful example of care ethics and decolonial love enacted in the public sphere. Their strategically feminized iconography carves a necessary space for greater gender inclusion within the urban landscape and within the male-dominated graffiti scene in the country. Moreover, the alternative and altruistic vision that they produce stands in sharp contrast to the neoliberal politics of individualism, consumerism, and arrogant perceptions promoted

80. For more information on women artists' use of "goddess" figures and deployment of "feminist spirituality," see Jennie Klein, "Goddess: Feminist Art and Spirituality."

[handwritten margin note: ↗ self – community]

by the Chilean state and mass media. The impersonal and often hostile atmosphere of the city becomes more inclusive and democratic through the innovative and daring walls painted by the Chilean graffiteras. Their interventions thus make important contributions to the larger and ongoing project of visual democracy enacted by Chilean street artists.

Visual democracy, as articulated in the work by graffiteras and other street artists in Chile, is often attentive to local and national social environments. These images often speak about the realities that are endemic to the country, thus making street art relevant to those who witness and interact with these works on a daily basis. The democratization that these artists enact is dependent on a heightened awareness of site specificity. Nevertheless, many Chilean street artists of the post-dictatorship era reject clear and unproblematic distinctions between the local and the global. Their understanding of how Chile is situated within larger global phenomena is profound, and it challenges any notions that theirs can be regarded as a purely "national art." What are then the different ways in which Chilean street art engages transnational realities? How do these artists become transnational cultural producers? In what ways does Chile itself become a site of transnational intervention? The conclusion of this book will address these questions while also reflecting on how I—a diasporic subject born and raised in Chile but living in the United States for three decades—have been confronted with my own fluid transnational identity as a result of writing this book.

[handwritten margin note: local–global ☆]

[handwritten note:]

female-centered incursion into ...
⟶ accessible to wider spectatorship

[espouse a global vision on ...]

CONCLUSION

Transnational Incursions
in Chilean Street Art

Globalizing the Local and Localizing the Global

THE GEOGRAPHIC and historical specificity of Chile's post-dictatorship era is undoubtedly a critical component of the graffiti and mural art I have discussed in *Democracy of the Wall* thus far. Nevertheless, throughout my work on this text I experienced some anxiety about conceptualizing street art within this geographic and historical specificity. While understanding Chilean spatial politics and histories provided me with numerous fruitful and productive lines of inquiry that allowed me to analyze the remarkable street arts explosion that has occurred in Chile, a strict national lens was insufficient in complexity and scope when addressing the richness of Chilean street arts. Thinking beyond the national and turning a critical eye toward the several ways this street art has literally and metaphorically "spilled" beyond the borders of Chile opened a portal to the multiple transnational dimensions in this public art. This transnationalism, I should be clear, does not negate the national but rather establishes a dialectic relationship between the two. The transnational aesthetics and practices of Chilean muralism and graffiti, far from homogenizing and trivializing local realities, address how the local is affected and shaped by the global. As Ato Quayson and Girish Daswani have pointed out, nations still remain relevant, "but they are no longer the default mode of exemplification."[1]

1. Quayson and Daswani, "Introduction–Diaspora and Transnationalism," 5.

171

On the one hand, the dictatorship made Chile into a fairly insular country whereby people and communities had relatively few ties to places elsewhere in the world. On the other hand, it forced certain forms of transnationalism determined by the practices of oppression. Though the dictatorship sought to prevent the cultural penetration of "foreign ideas" into the country, it promoted and instituted the neoliberal policies crafted by the Chicago School of Economics.[2] Moreover, the government prompted the transnational movement by imposing exile among those deemed to be enemies of the state (members of Communist, Marxist, and Socialist groups as well as those openly critical of the military regime.) Such movement created diasporic Chilean communities in other parts of the world, especially in Europe and North America, but those populations had limited access to communication with Chile. With the restoration of democracy in the 1990s, however, many individuals returned to Chile, bringing with them the experiences of having lived elsewhere. In many instances, they brought with themselves their foreign-born children who also injected different worldviews into the Chilean social fabric. Their vision of visual democracy was thus one based on the fruitful dialogue between the local and the global. Such a dialogue was further enriched at the turn of the millennium with street artists' adoption of digital technologies and social media as a means to disseminate their work and share ideas with public artists in other parts of the world.

THE EFFECTS OF TRANSNATIONALISM ON STREET ART

These transnational dynamics have given rise to important trends within the graffiti and mural scene during the post-dictatorship era. When it comes to subject matter, style, and iconography, street artists certainly root themselves in Chilean influences, histories, and realities, but they also seamlessly incorporate and embrace elements from elsewhere in the Americas and beyond. One need only look at how artists such as Inti and Gigi betray the influence of indigenous cultures from Bolivia in their work, how graffitero Grin draws inspiration from the organic architecture of Antonio Gaudí and the Surrealist dreamscapes of Salvador Dalí and how Mono González pays homage in his murals to the graphic arts traditions throughout Latin America, including Mexico and Cuba. One could say that Chilean street art is as much about Chile as it is about the world. So visual democracy through the lens of transnationalism becomes an expansive vision about an open and free society that

2. Errázuriz and Leiva Quijada, *El golpe estético*, 29.

does not recognize national boundaries, most of which have been imposed by colonial and neocolonial powers. If the transnational element in Chilean street art is also part and parcel of the "democracy to come" embodied in these wall paintings—as I explained in the introduction to this book—then the potential for a more democratic society projected onto a future time necessitates a globalized vision of an equality not strictly rooted in local realities.

The transnationalism in Chilean graffiti and muralism is also defined by diasporic and transnational movements of the artists themselves. The postdictatorship era has facilitated travel and global connections among many artists active in the street art scene. As a result, numerous Chilean graffiterx and muralists have intervened in public spaces outside of Chile, either by invitation or through their own volition. As a matter of fact, the great majority of the artists interviewed for this book had painted abroad at least once in their careers. Such artistic incursions are certainly symptomatic of the great mobility and resourcefulness that Chilean muralists and graffiterx possess, often finding creative ways to finance their travels. These incursions are also indicative of the respect and visibility they have garnered outside of Chile, as a number of these artists have been invited by foreign individuals and organizations. The insertion of a Chilean aesthetic into public spaces in Europe and elsewhere in the world signals a desire for fluid and porous borders on the part of these artists. Moreover, celebrating the richness of Chilean public arts traditions and demonstrating the relevance of these traditions in spaces with very different histories and feelings has been a great impetus behind these artists who seek doing projects abroad. The kinds of transnational dialogues that naturally emerge in such cases—either among artists themselves or between artists and the different communities they encounter—are also contributing factors that compel Chilean artists to work outside of Chile.

The exposure that Chilean muralists and graffiterx receive when they work abroad coupled with the growing transnational visibility of the Chilean street art scene (aided in large part by social media and online communities) has made the country into an attractive site for the creation of wall painting. As stipulated in chapter 3 of this book, the ambiguous antigraffiti laws coupled with the lax enforcement of this legislation has made Chile into a desirable location for street writing. In places like Europe and North America, the virulent pursuits by law enforcement that seek to clamp down on "vandalism" and "illegal writing" are rare, if not nonexistent, in Chile. Working on a wall without the stress of being apprehended is certainly a luxury for many muralists and graffiterx who visit Chile. Moreover, the rich and lively community of street artists in the country coupled with a generally positive attitude among local residents toward wall painting has created a nurturing atmosphere for

artists coming to work in Chile from abroad. In many cases, transnational collaborations occur as a result of these global movements, such as the mural created by Mono González and French graffitero Seth in the Museo a Cielo Abierto, San Miguel (discussed in chapter 2) or the wall piece painted jointly by Las Crazis from Chile and Nocturnas from Brazil (analyzed in chapter 3.) The Chilean art scene thus has become a necessarily transnational one where passersby are almost as likely to see work by the likes of Roa (Belgium), Elliot Tupac (Peru), Lord K2 (England), and others, as they are to encounter "local talent."

MAPPING MY TRANSNATIONAL IDENTITY

My interest in the transnational not only stems from the ethos of Chilean muralism and graffiti itself but also from my own experience with transnationalism as part of the Chilean diaspora living abroad. My family immigrated to the United States from Chile during my late teenage years in the 1980s as a result of the economic and educational inequities of the dictatorship. Though we were fortunate not to be directly victimized by state-sponsored violence, we were, nevertheless, negatively affected by the politics of fear and silence promoted by the military government. Landing in a fairly rural and predominantly white part of the Midwest in the United States, my family's life was not unlike that of many global migrants who experience feelings of displacement, loss, and disconnection in addition to grappling with racism, rejection, and struggles with US immigration law. Even so, I was painfully aware that our middle-class status in Chile afforded us a privileged immigration experience compared to other immigrants from Latin America and elsewhere who suffered multiple humiliations during and after their border crossings. As I entered into adulthood, my status as a perpetual foreigner, signaled by my skin color and accented English, prevented me from fully embracing US cultural citizenship while, at the same time, my prolonged absence from Chile made me an outsider from the place of my childhood and adolescence. Chicana feminist philosopher Gloria Anzaldúa called this in-between and interstitial consciousness "mental nepantlism, an Aztec word meaning torn between ways."[3] Transnational scholars Quayson and Daswani understood this state of being as part of the migratory experience: "Scholarly research on transnationalism views the lives of migrants and those who remain behind as simultaneously connected between two or more nation-states, where homeland ties are

3. Anzaldúa, *Borderlands/La Frontera,* 100.

a defining part of a transnational profile that incorporates recursive modes of nostalgia, sometimes lodged in both homelands and the nations of sojourn at once."[4] The social connections, friendships, and alliances I would forge with other US Latinx, especially Chicanx, would legitimize my fractured sense of self and give me cues about how to live transnationally.

Since migrating to the US, I traveled to Chile for the first time in 2010. This trip marked the beginning of the research stages for *Democracy on the Wall*. Returning after more than two decades was indeed an experience filled with mixed emotions and reemerging memories. It was indeed a strange and exciting sight to see a Chile in times of democracy. It was in the urban spaces, however, where democracy was most apparent to me. The grey sterility and somber atmosphere of the dictatorship was now replaced by more liberated streets that displayed colorful and provocative murals and graffiti. While the legacy of the dictatorship was still palpable, and the social hierarchies of class, race, and gender had not changed significantly since the Pinochet years, the potential for dissent and public dialogue had opened up considerably in the country. The presence of a robust street art movement was both a symptom of that greater freedom and an urban phenomenon that further promoted those very dialogues. Researching and writing for this book had undoubtedly become both an intellectual project and a personal journey of reconnection with Chile, one that would further bolster my own transnational and diasporic consciousness.

TRANSNATIONAL IMAGERY

What was perhaps most striking about the transformed spaces I witnessed upon my return to Chile was the transnational iconography of the street art imagery I encountered on the walls of the city, in particular in the street pieces created by world renown graffitero, Inti. Lauded perhaps as one of the most famous Chilean graffiterx of the new millennium, Inti's work has garnered much attention and recognition, which is made manifest through his transnational presence. Born and raised in Valparaiso with arts training in Viña del Mar's School of Fine Arts, the artist has painted throughout Latin America, Europe, and a few places in the Middle East.[5] With a current residence in Paris (as of this writing), Inti has epitomized the Chilean vision of achievement: he is someone who has been able to succeed abroad. Independently of this

4. Quayson and Daswani, "Introduction–Diaspora and Transnationalism," 5–6.
5. Cuche, "If You Run into Inti One Day," 10–11.

discourse on success, Inti's commitment to transnationalism is deeply embedded with elements of social justice together with subtle and overt critiques of colonialism. Andean indigenous iconography pervades his imagery appearing as decolonial interventions into the public sphere. On countless occasions, the artist has commented that his family raised him to admire the history and culture of the pueblos originarios ("original peoples") of the Americas, understanding that, as a mestizo, he shared in their heritage.[6] Moreover, unlike other graffiterx in Chile, his given name is Inti (the Aymara sun god), which he decided to continue using as his street name. Drawing inspiration from ritualistic, spiritual, and performative figures such as Ekeko and Kusillo, originating primarily from Bolivian native cultures, the artist elevates these allegories of anticolonial resistance and indigenous pride to the level of national monuments. The monumentality of Inti's figures is underscored by the incredibly large-scale format of his murals, at times reaching upwards of 200 feet in height, making his figures demand attention from up close and far away. Inti, who often uses a crane to complete his work, has argued that the large scale of his work is connected to his desire for growth as an artist:

> I like the challenge. When I paint small walls, it's fun and you can have a good time with your friends, but it doesn't generate that adrenalin that tells you that you have this challenge and that you have to solve it. . . . [A large] mural implies a challenge and that challenge motivates you to do something of a better quality.[7]

The large size of many Inti murals also operates as a means to make powerful disruptions to hegemonic, institutional and/or state-sanctioned organizations of urban space.

In November of 2012, Inti took part in "Hecho en Casa" [Made at Home], the first festival of urban intervention taking place in Santiago and sponsored by the city, the Ministry of Tourism, and the Gabriela Mistral Cultural Center (better known as the GAM.) Even though the title of the initiative suggests that the festival was meant to celebrate national talent and local themes within the field of public art, the projects created as a result of this festival were clearly transnational in nature. Inti's contribution to this festival consisted of untitled "twin" graffiti murals located immediately outside of the subway exit for the Bellas Artes station.

Inti's impact.

6. "INTI . . . EKEKOS—METRO BELLAS ARTES."
7. "QUINTANAR PROYECT. INTI & LAGUNA."

FIGURE 5.1. Inti, Untitled ("Ekeko") (2012), graffiti mural, Bellas Artes, Santiago. Photograph: Guisela Latorre.

FIGURE 5.2. Inti, Untitled ("Ekeka") (2012), graffiti mural, Bellas Artes, Santiago. Photograph: Guisela Latorre.

The visual effect of these wall pieces is quite striking; as passersby ascend the stairs of this underground subway station, they find themselves almost enveloped by Inti's distinct imagery. The location was also a significant one as it is in the middle of a bustling restaurant and café scene in Santiago. The Museum of Fine Arts, the Museum of Contemporary Art, the bohemian Lastarria neighborhood, and the north entrance of the Santa Lucía Hill are all within a short walking distance. The location thus is one that encompasses the intersection between commerce, leisure, art, and tourism. The sidewalk directly below the graffiti murals is one often utilized by street vendors and impromptu performers (musicians, dancers, etc.) seeking the attention of the thousands of pedestrians and visitors, both foreign and domestic, who transit the area on a regular basis. Inti's murals operate as a dramatic and monumental backdrop to their activities.

The transnationalism of these two murals by Inti in Bellas Artes resides in his liberal adoption of Andean indigenous aesthetics, in particular Aymara iconography. The Aymara are inherently a transnational population as their territory stretches across Chile, Bolivia, and Peru, an area that does not fully recognize the national border of colonial nation-states. Painted over two very large walls that are situated perpendicularly to one another, the artist here deployed the enigmatic figure of Ekeko and Ekeka on both surfaces. Often referred to as the Aymara demigod of abundance and good fortune, Ekeko has pre-Columbian roots in the Andean region. According to Federico Arnillas, this deity was originally depicted as an "anthropomorphic and hunchbacked figure with a prominent virile member, linked to abundance and fertility."[8] Arnillas also observed that the veneration of Ekeko survived the ravages of conquest and colonization, but his physical characteristics changed dramatically: "To make this survival possible, Ekeko had to change his appearance, adopting that which is familiar to us today . . . that of a fat man with white skin, red cheeks, a smiling expression and the look of a cheap salesman."[9] This figure—often sold in the Fiesta de la Alasita (literally "buy me" in Aymara)— are commonly depicted with numerous objects and commodities attached to his body such as money, food, cigarettes, musical instruments, and others. The symbolism and postcolonial significance of Ekeko was not lost on Inti who mined the multiple meanings of this demigod in Bellas Artes:

> I came to the idea of doing Ekeko in relation to the theme of desires. All of Chile was beginning to move according to their desires, to ask for what was

8. Arnillas, "Ekeko, Alacitas Y Calvario La fiesta de la Santa Cruz en Juliaca," 134.
9. Arnillas, "Ekeko, Alacitas Y Calvario La fiesta de la Santa Cruz en Juliaca," 134.

basic and necessary such as education, health and all those things. That is what Ekeko symbolizes to me. It is not the person who wants things just for the sake of it but it is a person who demands basic needs.[10]

Inti's perspectives on Ekeko challenged in many ways some anthropologists' view of the significance of this figure to Andean indigenous cultures. Jim Weil has argued that Ekeko is part of a growing scene of ritual markets of replicas that reveal "disturbing facets of Bolivian integration into the capitalist world economy."[11] While these markets of commodities, where Ekeko figurines are often sold, do betray the persistence of Aymara ritual spirituality, Weil ultimately concludes that "the underlying displacement of indigenous ideas and ideology in the struggle for an unattainable consumer culture is tragic."[12] For Weil, Ekeko and Bolivian commodities markets represented rather naïve and troubling desires for wealth and the capitalist lifestyle among Aymara populations, but for Inti, this figure also became an allegory of desire but one that seeks equal rights, especially among those most oppressed and marginalized in society. Desire here becomes not a careless search for self-fulfillment but an egalitarian pursuit for greater social justice.

These double murals Inti created in Bellas Artes are composed of two large figures that take up most of the walls' pictorial space, namely a male Ekeko and a female Ekeka. The two figures are similar in terms of size and pose, making clear that these characters are complimentary doubles of one another. The artist borrowed the iconography from traditional representations of Ekeko and depicted them with various objects attached to their bodies. Unlike the representations commonly seen in Bolivian markets though, Inti's figures possess doll or childlike features such as stubby body proportions and rounded eyes. Moreover, they both gaze back at the viewer with a mixture of curiosity and vulnerability. These features make this Ekeko and Ekeka appear "cute" and "adorable," a strategy of affect to demand attention from passersby.

The male Ekeko sports a taupe winter coat and matching bowler hat placed on top of a knit chullo cap, a common attire of Aymara populations from the Andean Plateau. His face is covered with a bandana of sorts embossed with the Chilean flag. This bandana codes him as a radical revolutionary, as these face coverings are common among street protesters throughout Latin America, including Chile. The objects appended to his body represent his desire not for wealth and fortune but rather for greater access to artifacts that can enhance the quality of his life and that of others. Among the many objects appended

10. "INTI . . . EKEKOS—METRO BELLAS ARTES."
11. Weil, "From *Ekeko* to Scrooge McDuck," 7.
12. Weil, "From *Ekeko* to Scrooge McDuck," 23.

to his body, we find an open book, a reference to this Ekeko's demand for an education, an issue that resonates with many Chileans who had witnessed the mass student and teacher political mobilizations of the last decade. The pan flute he also sports is a traditional Andean instrument that speaks of indigenous peoples' important contributions to the musical traditions in the region. In his left hand, he holds a smart phone, demonstrating at the same time that he commands twenty-first-century media technologies thus undercutting the notion that indigenous people are inherently "primitive" and "naturally" disinclined toward the tools of the digital. But Ekeko here also has access to nonmanufactured and traditional objects. He carries a bag of yellow and blue maize as well as a large jug of *chicha,* an alcoholic beverage made of fermented grains and/or fruit and consumed in Chile and elsewhere in South America and parts of Central America. Clearly, his technological savvy does not preclude his access to the natural world and the riches of the earth. While many of the objects attached to his body are broadly Andean in origin, the flag covering his face connects him more specifically to Chile. Moreover, the pick axe on his back and the bag of copper nuggets under his right arm, communicates to the spectator that Ekeko mines Chile's principal national mineral.

Ekeko is a well-known figure in Bolivia but not so much in Chile, yet Inti transforms him into a transnational figure that holds relevance locally. "We could say that [Ekeko] is also a local character," Inti commented, "and the objects he has on him are more local; they are not original elements."[13] The dynamic play the artist establishes between the local, the Andean, and the global creates a decisively hybrid figure that has access to various different realities while not being statically rooted in one place. Though the various objects attached to his persona represent Ekeko's multiple desires, these also signal the simultaneous, overlapping skills and social roles he can take on. This is a bold statement to make about the power of indigenous resilience and adaptability in the middle of Bellas Artes, a locale frequented by a large cross section of Chilean society.

The adjacent or "twin" mural Inti created in Bellas Artes represents the female counterpart to the male figure, namely Ekeka. The equivalent size and visibility of this figure underscores the equal standing and importance Ekeka holds vis à vis the male Ekeko. Though this demigod of good fortune and abundance is almost exclusively represented as a man, in the most normative sense of the word, Inti found in the course of his research that feminist activists in Bolivia had devised Ekeka as a way to challenge the male-centeredness of contemporary Aymara ritual and cultural practices:

13. "INTI . . . EKEKOS—METRO BELLAS ARTES."

Why is it always men? I began to do research and it turns out that the
[female] Ekeka already existed. She was created about 4–5 years ago by
a women's collective in Bolivia who are quite the warriors. Their name is
Mujeres Creando [Women Creating]. They are cholitas [Aymara women]
and very creative. They are doing their feminist movement to change Boliv-
ian society. They had already created this woman, Ekeka.[14]

Mujeres Creando was formed in the 1980s by Bolivian activists María Galindo
and Julieta Paredes. The group emerged as a result of the growing disdain
for the inherent machismo, racism, colonialism, neoliberalism, and hetero-
normativity of the political right and left in Bolivia.[15] Though the group is
lead primarily by middle-class mestizas in Bolivia, their vision of oppression
and equality is an intersectional one that pays close attention to the multiple
forms of marginalization endured by indigenous women who are also active
in the group. Another characteristic of Mujeres Creando is their use of cre-
ative expression in public spaces, including theatrical performance and graffiti
tagging. Leonardo García-Pabón described their street writing in the follow-
ing way:

Of all their public activities, it is their graffiti and their happenings that have
had the greatest impact on Bolivian society, especially those that have been
broadcast on television. Nowadays, their graffitis are permanent fixtures in
the city, they are imprints that cannot be erased from the walls or from the
consciousness of La Paz residents; it is their way of re-territorializing an
alienating space.[16]

Clearly, Inti drew inspiration from the imagery and public arts activism
enacted by Mujeres Creando, the group that created Ekeka to challenge the
notion that Ekeko is, in Raykha Flores Cossío words, "a father provider."[17] In
workshops the group carried out in 2009 and 2012, the collective worked with
artists, college students, and survivors of domestic violence to reimagine this
figure using clay, paint, and an unapologetically feminist lens. The first "pro-
totype" of the Ekeka consisted of a woman riding a bicycle while carrying
a child in her arms as her drunken and unconscious husband/male partner
is appended to her back. She carries numerous other objects that weigh her

14. "INTI . . . EKEKOS—METRO BELLAS ARTES."

15. García-Pabón, "Sensibilidades Callejeras," 240–241.

16. García-Pabón, "Sensibilidades Callejeras," 242.

17. Raykha Flores Cossío, "La Ekeka, resignificación del traidor, la víctima y la justiciera
en el feria popular boliviana de la Alasita."

down, such as a soccer ball, a pan flute, a pineapple, and many other things. The second Ekeka created by Mujeres Creando followed a similar pattern, but this time the woman stands proudly as she looks upward. Her drunken husband/partner is now on the floor as she leaves him behind with a sign that reads "The Ekeka was always me." Though she is still burdened by the heavy load of her multiple responsibilities, symbolized by an enormous stack of objects on her shoulders, her stance is one of resolve as she carries a suitcase with the words "dreams, hope, happiness and rebellion." Both of these incarnations of Ekeka are sold in the Fiesta de la Alasita, thus allowing the participating women to earn some income from the sales.[18] Flores Cossío contends that these Ekeka figures represent all women who carry a "double burden and who want to break the binds that tie them so that they can achieve their dreams because maybe they were all victims of some type of violence perpetrated by patriarchal society."[19]

While Inti's Ekeka in Bellas Artes does not look much like the figures authored by Mujeres Creando, he does replicate some of the feminist impetus and ethos behind them. In this graffiti mural, she is clearly Ekeko's equal in all respects, including in the revolutionary and rebellious aspects. She wears a red shawl with a small bowler hat; her vibrant red hair is styled in a pair of loose braids. A box chest, reminiscent of the suitcase carried by the Ekeka made by Mujeres Creando, appears to float in front of her, prompting viewers to wonder what kinds of treasures, secrets, and wonders might be inside. We can't possible know, but what we can determine is that she has access to these mysteries as she holds the key to this box in her right hand. Other similarly enigmatic objects are attached to her torso, namely a television set, an apple, a sheep, paper money, and a charango, an ukulele-type instrument commonly used among Inca and Aymara populations. All these elements straddle the fine line between different realms of women's lives, especially for those women who deploy various forms of creativity, resourcefulness, intelligence, and resilience to meet all the demands and expectations placed upon them. For indigenous women in particular—be they Aymara, Mapuche, or otherwise—these demands and expectations occur at the same time that they endure racialized and gendered forms of invisibility, denigration, and subordination. Through the enormous scale of Inti's mural, Ekeka here demands visibility and recognition. Moreover, by the mere fact that a feminist Bolivian image is situated on Chilean soil, Inti is making a powerful transnational statement about

18. Raykha Flores Cossío, "La Ekeka, resignificación del traidor, la víctima y la justiciera en el feria popular boliviana de la Alasita."

19. Raykha Flores Cossío, "La Ekeka, resignificación del traidor, la víctima y la justiciera en el feria popular boliviana de la Alasita."

women's rights—a timely one in Chile, where pay inequality, gender violence, and limitations on reproductive rights are unfortunate realities in spite of the two-term presidency of Michelle Bachelet.

The revolutionary iconography with which Inti endows Ekeko is also present in Ekeka's side of this double mural. Though she is represented in a mothering role, as made evident by the two children she carries on her back, she also sports a bandolier or bullet belt across her chest that alludes to her feminist warrior status. The mother/feminist role of this Ekeka may seem contradictory, as Jocelyn Fenton Stitt and Pegeen Reichert Powell explain: "Feminism's difficulty reconciling the practice of mothering with the politics of women's liberation is a complex issue."[20] Moreover, this image actively challenges the notion that indigenous women are, in the words of Margaret Jacobs, "deficient mothers and homemakers" who are "the degraded chattel of their men who failed to measure up to white, middle-class, Christian ideals."[21] Rachel Hallum-Montes has observed that Latin America has a long history of indigenous women mobilizing "around their identities as mothers and care-givers" whereby their activism becomes a way for them to care for "both their families and the indigenous community."[22] Hallum-Montes further explains that "motherist politics" have been an important means by which women have entered into social movements and political activism in the continent.[23] Thus Ekeka here embodies the convergence between indigenous mothering and decolonial activism.

The iconographic elements that radicalize these two figures in Inti's Bellas Artes mural are brought together by a common motif in both walls, namely that of a series of green leaves that seem to hover around the Ekeka and Ekeko. These are coca leaves, the contentious plant that is cultivated in many parts of the Andes. Though the plant has many uses, it is mostly known worldwide for the extraction of its cocaine alkaloid. This crop's farming has been deeply affected by the US-led War on Drugs, which attempts to, according to Ursula Durand Ochoa, "form and implement policies that seek to reduce the cultivation of coca."[24] Coca's traditional consumption and spiritual function predates colonization going back thousands of years, and the discovery of cocaine, which led to the criminalized drug trade, happened much later in the nineteenth century. Durand Ochoa explains that the coca leaf, which is often chewed by indigenous populations in the Andean Plateau to "diminish

20. Fenton Stitt and Reichert Powell, *Mothers Who Deliver*, 3.
21. Jacobs, *White Mother to a Dark Race*, 87–88.
22. Hallum-Montes, "'Para el Bien Común,'" 104.
23. Hallum-Montes, "'Para el Bien Común,'" 120.
24. Durand Ochoa, *Studies of the Americas*, 1.

the effects of hunger, fatigue, low temperatures, and high altitudes,"[25] is also at the center of social and communal life among native peoples. As a matter of fact, coqueo, the act of chewing coca, is "an act of self-identification and defiance."[26] The role of coca as a signifier of anticolonial resistance coupled with the political empowerment of *cocaleros* (peasant farmers who cultivate the crop) became most visible in Bolivia with the 2006 presidential election of Evo Morales, a cocalero labor activist and the country's first indigenous president.

Ekeka and Ekeko in Inti's mural have an intimate relationship to the coca leaves that surround them. They are historically, politically, and spiritually connected to the plant, as the leaves float around them like life forces attributed to their personas. This relationship further cements these figures' decolonial consciousness and politics of resistance. If Ekeka/o is a deity representing abundance and good fortune, then the coca leaves are the sources of prosperity for the Aymara and other Andean communities. The artist refuses to attach the stigma of criminality to the coca plant and to those who harvest it, thus preferring to present it as a symbol of decoloniality and resistance to the state. This imagery represents a powerfully radical message about transnational solidarity with indigenous peoples of the Andean Plateau, a population historically treated with disdain and racism by Chilean elites, in particular after the country saw a sharp increase in Peruvian and Bolivian immigrants in the 2000s.[27]

CHILEAN STREET ART ABROAD

The transnationality of Inti's Bellas Artes mural was primarily centered on its Andean indigenous iconography and secondarily on its location in Santiago, a site in the city frequented by a large cross section of Santiago's social milieu, including tourists and immigrants. But the artist's transnational vision can also be appreciated in the graffiti murals Inti has created outside of Chile. I contend that this work, as well as that of other Chilean street artists who have painted abroad, represents an extension of Chile's post-dictatorship mural and graffiti movement that is not bound by national borders. In 2014, Inti was invited to paint a graffiti mural as part of a grassroots initiative called "Construir un lugar mejor sin destruir lo que tenemos" [Build-

25. Durand Ochoa, *Studies of the Americas,* 28.

26. Durand Ochoa, *Studies of the Americas,* 29.

27. McDonald-Stewart, "Chile Has Fastest Growing Immigrant Population in South America."

ing a better place without destroying what we have] taking place in the town of Quintanar de la Orden in Spain. This initiative, spearheaded by local artist Santiago González, sought to revitalize the urban spaces of the city that were punctuated by large concrete walls with uninterrupted surfaces. These walls, belonging to 1970s-era apartment buildings, made the city look too austere and unattractive to entice tourism. Because Quintanar is located in the emblematic region of La Mancha, the site where the epic narrative of Miguel de Cervantes's *Don Quijote de la Mancha* (1606) takes place, the invited artists were asked to paint murals with the theme of "(de)colonizing Quijote in his context."[28] The idea was to honor the region's cultural history while also prompting artists and spectators alike to rethink and update this canonical work of Spanish Golden Age literature, keeping colonial legacies in mind. But what did it mean for a Chilean artist to come to Spain and make a graffiti mural illustrating this revered and iconic literary figure in a subversive way? What were the transnational and decolonial implications behind this gesture?

Inti's contribution to "Construir un lugar mejor" consisted of a 164-foot-tall mural titled *Don Quijote de la MaRcha* that depicted the figure of Don Quijote himself accompanied by his trusty steed, Rocinante (see figure 5.3). Like most Chileans, Inti had grown up with this book, which is part of the language arts requirements in most schools throughout Latin America. But Inti also professed a special relationship to the text's central character as his family had also instilled in him an admiration for this work by Cervantes:

> I think [Quijote] is a dreamer who believes in utopias. Even though utopias are interpreted as those unattainable dreams, they are still within reach. Those utopias, if anything, provide us with paths to follow. It is good to strive for those impossible dreams. For me, Quijote is just that. I've interpreted him in a more updated manner, putting up on the wall present-day dreamers.[29]

Who are the present-day dreamers the artist alludes to though? Inti presented his audience with a dramatic and bold rendering of this early seventeenth-century character, painted in striking contrasts between crimson and dark brown tones. The foreground of the mural is populated almost entirely by Rocinante's head as the horse looks to one side, revealing a skeleton key that rests between his eyes. If we think of keys as symbols of access to special or alternative knowledges—as the artist's Ekeka in Bellas Artes seemed to inti-

28. "Construir un lugar mejor sin destruir lo que tenemos."
29. "QUINTANAR PROYECT. INTI & LAGUNA."

FIGURE 5.3. Inti, *Don Quijote de la MaRcha* (2014), graffiti mural, Quintanar de la Orden, Spain. Photograph Courtesy of Inti Castro.

mate—then Rocinante perhaps shares in Quijote's singular vision of a reality that imagined a world ruled by romantic chivalry and heroic knights seeking out justice. The figure of Quijote himself is then positioned directly behind the horse; we can assume he is riding Rocinante though the dark shadows that cover his lower body make the visual relationship between the two ambiguous. A far cry from the delusional, foolish, and mentally unstable old man that Quijote was believed to be, Inti renders him with an air of quiet dignity and wisdom. His gaze is a visionary one as he looks out into an invisible horizon, perhaps toward that illusory utopia Inti mentioned.

Quijote's hands in Inti's mural are an important focal point in the composition due to their fairly large scale and gestural quality. A recurring motif in many of his graffiti murals, the distinct hand gestures of Inti's figures often endow his characters with enigmatic and mystical qualities. Moreover, the tattoo-like designs on Quijote's hands further underscore these qualities, for these patterns resemble Andean sacred geometries found in the patterns of preconquest pottery, textiles, and architecture. In one of these hands, however, he holds a more profane symbol, namely a five-pointed red star, which bears a striking resemblance to the well-known Communist emblem. This star symbolizes the hand of the proletariat worker and the five continents of the world. The artist then complements this motif with Quijote's exposed heart, which seems to float in front of his chest. A dagger pierces this heart as two bullets menacingly point in its direction. This iconographic motif recalls the symbol of Christ's heart, which alludes to the suffering and violence he experienced due to persecution, as stipulated in scriptures. The potential subversiveness embedded in the heart symbol is echoed in Quijote's face itself, which—just like his Ekeko in Bellas Artes—is covered with a bandana, but this time bearing the inscription "15 M." Mario Cuche explained that "15 M" refers to May 15, 2011, the day "when about forty people decided to camp at the Puerta del Sol, in Madrid, pro changes in the social structure of the country, which triggered the beginning of the movement 'Los Indignados' [The Outraged Ones]."[30] Los Indignados represented a prodemocracy, anticapitalist movement in Spain, spearheaded by demonstrations and sit-ins in Puerta del Sol, Madrid's most visible and centrally located city square. The protests would then spread throughout other major cities in the country. "The demands of these marches," Rubén Dominguez explained, "included the creation of a new financial system and the rejection of the Euro Pact."[31] Journalists and scholars alike compared these mass demonstrations to the Occupy Wall Street move-

30. Cuche, "If You Run into Inti One Day," 38.
31. Dominguez, "#YoSoy132," 173.

ment in the US, the "Yo Soy 132" ("I am 132") student protests in Mexico and even the Arab Spring in North Africa and the Middle East.

Inti further heightened the radical symbolism of Quijote by showing him donning a military-style epaulette over his shoulder bearing the image of a skull, a symbol used by the Hussars of Death, the nineteenth-century paramilitary, proindependence group in Chile led by Manuel Rodríguez Erdoíza. The symbols of political resistance that the artist incorporates into this graffiti mural are drawn from various parts of the world thus implying that dissent and challenges to state power are transnational in nature. Moreover, the graffiti mural's title, *Don Quijote de la MaRcha* [Don Quijote of the March], is a riff on Cervantes's book title, *Don Quijote de la Mancha* [Don Quijote from la Mancha]. So the present-day dreamers in search of utopias that Inti mentioned in his statements about this work are not just the Quijotes of the world but also the individuals who spearheaded the mobilizations, protests, and social movements included in this mural's iconography.

Inti's rethinking of this classic figure of Spanish literature in *Don Quijote de la MaRcha* generated as much outrage and indignation among the people of Quintanar de la Orden as it did praise and admiration. Some local residents called the mural's imagery "terrorist" in nature and even demanded the work's removal. These pressures prompted the artist to slightly modify the imagery by blurring the inscription "15 M" thus making it less visible—the first time Inti had done anything of this sort with one of his graffiti murals.[32] The controversy spurred by this image rests in large part upon Inti's subversive reading of Quijote's cultural, historical, and political significance, which implies an act of "de-linking," as defined by cultural critic Walter Mignolo. Speaking more broadly about oppositional readings of Quijote in the Americas, Mignolo promoted the idea of de-linking as a way to subvert the colonial power of such figures:

> De-linking means to read Don Quixote, recognizing but not accepting the rules of the game in which Don Quixote was written and has mainly been read until today. De-linking means to admire Don Quixote as an outsider, playing a different game marked by a diversity of "experiences"—not the experiences of the internal history of Europe, but those of the colonies where, for example, the primacy of alphabetic writing, the printing press, and the authority of colonial languages were more of a problem than a victory.[33]

32. Cossio, "Acusan a artista chileno de pintar símbolos terroristas en mural del Quijote más grande del mundo."

33. Mignolo, "De-Linking," 10.

This process of de-linking was made manifest when Inti spoke about his rela-tionship to Quijote; he insisted that he had his own version of the character, which was transmitted to him by his family.[34] It is noteworthy to mention that he did not speak of the character solely within the context of Spain itself, nor did he refer to Cervantes's epic novel as a masterpiece of Spanish literature. He further de-linked Quijote from Cervantes himself by stating that "every-one takes Quijote in their own way," insisting that the author probably had not conceptualized the character in the way that he is imagined today.[35] These statements coupled with the radical iconography in *Don Quijote de la MaRcha* suggest that Inti, as a hybrid and transnational subject belonging to a colo-nized territory, was refusing to play by "the rules of the game" thus disavow-ing "the experiences of the internal history of Europe," to borrow Mignolo's words once again. Moreover, literary scholar Luis Correa-Diaz observed that the reception of the novel in Latin America resonated with the "colonial trau-mas of [the continent's] identity" because this text "brought with itself, in spite of being birthed in an imperial and colonizing world, the critique of the 'rea-son of their unreasons,' and that is the legacy understood in the Americas."[36] The expression "the reason of their unreasons" (*la razón de sus sinrazones*) refers to a dialogue piece uttered by Quijote in the novel, a nonsense pat-tern of speech meant to reflect the meaningless and conceited language of the chivalric romances that Cervantes lambasted in his text. The expression also questions the very concept of reason, a cornerstone of European thought imposed on the Americas to the detriment of indigenous and peoples of Afri-can-descent whose subordination was justified under the rubrics of reason. Thus, embedded in Inti's *Don Quijote de la MaRcha* in Quintanar de la Orden is a radical de-linking that "liberates" Quijote from La Mancha, from Spain, and from strictly European cultural traditions. Such a de-linking was quite a bold statement to make in the place of *Don Quijote's* "origin."

COMING TO CHILE FOR GRAFFITI

Making urban interventions in different parts of the world is part and parcel of the transnationalism of Chilean graffiterx and muralists like Inti. The brand of visual democracy that they have promoted through their wall paintings is not bound by state-sanctioned national territories. But the work that they have done in Chile has contributed toward the creation of a nurturing and support-

34. "QUINTANAR PROYECT. INTI & LAGUNA."
35. "QUINTANAR PROYECT. INTI & LAGUNA."
36. Correa-Diaz, "América y Cervantes/El Quijote," 128.

ive environment that permits and at times even embraces street artists. More-
over, through social media and other forms of online communication, Chilean
muralists and graffiterx have broadcast and disseminated not only their own
work but also the idea that Chile is a place ripe with boundless potential and
great promise for the production of graffiti and muralism. Some artists come
to the country out of their own volition—seeking a freer place to work than
their nations of origin—while others come by invitation from the larger Chil-
ean street art community who wishes to have their work grace city streets and
become a complement to their own. The renowned Belgian street artist Roa,
who began his career tagging in his hometown of Ghent, came to Chile in
2011 precisely as an invitee of the organizers of the Museo a Cielo Abierto, San
Miguel, a mural initiative discussed in greater detail in chapter 2 of this book.
While the murals in this Museo a Abierto were meant to celebrate local cul-
ture and history, Roa's intervention did not make any overt references to the
country, city, or even the población where his mural was located. Instead, his
contribution to this site reflected more closely his individual style as an artist.
Prior to arriving in Chile, the artist had made a name for himself by painting
gigantic animal figures using a color palette composed primarily of black and
white. These animals are often painted in dramatic and even tragic ways, as it
was described in the catalog book for the Museo a Cielo Abierto, San Miguel:

> More than a graffitero, Roa is a great draughts person who makes mutilated
> and injured animals, cadavers, bones, and extinct species. With such scenes,
> it is difficult for the passerby not to be impacted. His use of black and white
> is no accident, nor is it a stylistic whim. Rather, [this palette] symbolizes the
> life-death polarity.[37]

In many ways, Roa's wall in San Miguel reflected the work he had done in
many other parts of the world. Using latex paint and aerosol, his graffiti mural
titled *Horse* presented viewers with a gigantic horse head and hoof rendered
with the artist's characteristic black and white tones (see figure 5.4). At first
glance, the horse appears to be captured in the process of kicking up their
front legs but, upon closer inspection, it is clear that this is an animal who is
experiencing a horrific act of violence, as this head and hoof has been severed
from the body. While Roa avoids more graphic details such as blood and vis-
cera, the jagged and uneven tears of the horse's skin coupled with the bone
that juts out of the hoof certainly add to the violent and painful ethos of the
image. The predominant use of black and white together with the wrenching

37. Centro Cultural Mixart, *Museo a Cielo Abierto en San Miguel*, 93.

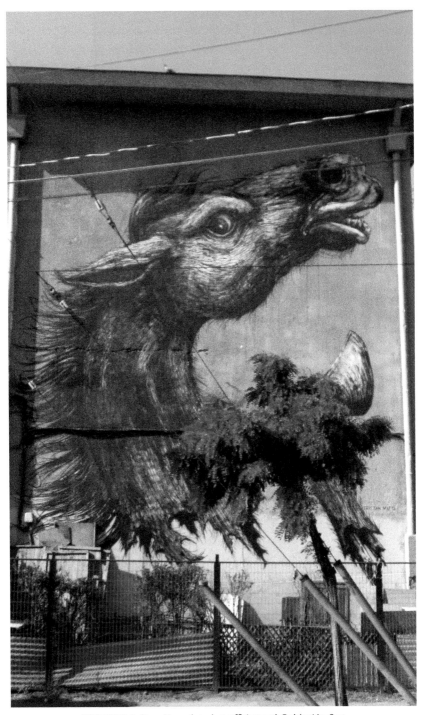

FIGURE 5.4. Roa, *Horse* (2011), graffiti mural, Población San
Miguel, Santiago. Photograph: Guisela Latorre.

expression of the horse recall various prior artistic traditions. For instance, Picasso's suffering horse in his epic antiwar canvas *Guernica* (1937) seem to mirror Roa's image here. Moreover, the line work in this graffiti mural are reminiscent of printmaking and the graphic arts movements in Latin America. Both of these traditions reflect a particularly politicized approach to art making, one committed to social justice ideals.

Though it may appear that Roa was imposing his own individual sensibility as a European artist who does not share in the experiences of San Miguel residents or Chileans for that matter, the image resonated with local realities in Chile at the time of its creation. Muralist, printmaker, and curator of the Museo a Cielo Abierto, San Miguel, Mono González lauded Roa's wall in this locale by underscoring the environmental justice and animal rights message behind the imagery. González argued that with this graffiti mural, Roa was denouncing the abuse of animals and the depletion of our natural environment at the hands of humanity: "It's a warning before it's too late!" González further commented that the horse's facial expression represented a form of resistance before its own abuse: "He wants to continue living!"[38] González at the time had completed as series of prints as a reaction to the destructive earthquake and tsunami that devastated Chile on February 27, 2010. The prints reflected the human toll wrecked on the Chilean population, in particular the poor, but also the adverse effects on animals. Dead and dying horses and dogs with exposed skeletons figured prominently in González's series, calling attention to the forgotten victims of these natural disasters. Having completed his graffiti mural only a year after the earthquake and tsunami, Roa's work in the Museo a Cielo Abierto, San Miguel, seemed to also be responding to the tragic events of February 27, putting particular emphasis on the neglect and mistreatment of animals that is an unfortunate part of Chilean culture. Though this Belgian graffitero brought with him a transnational aesthetic he had utilized in many other parts of the world—namely the rendering of various animal species with a black and white palette—his wall in San Miguel spoke quite powerfully of the recent tragedy of the earthquake and tsunami and of the ongoing calamity of animal abuse and abandonment in the country.

BRINGING CHILEAN STREET ART TO COLUMBUS, OHIO

As I stipulated earlier in this concluding chapter, I was drawn to this project on graffiti and muralism in Chile as a result of my own transnational experi-

38. Centro Cultural Mixart, *Museo a Cielo Abierto en San Miguel*, 29.

ence with migration. My feelings of displacement and ambivalent belonging as an immigrant in the United States provoked in me a desire to reconnect with Chile, the place of my birth, childhood, and adolescence. Moreover, as a recent witness to the vibrancy and richness of the street art movement in the country, I felt compelled to promote and disseminate the artistic significance of this greatly participative and democratic brand of muralism and graffiti in the United States, a place where community-engaged public art had become increasingly difficult to practice as a result of the antigraffiti laws and the strict regulations on public art. I was also seeking ways to bring together the two locales where I coexisted in the course of this project, namely Chile and the United States.

Availing myself of the cultural capital, financial support, and social privilege I enjoyed as a tenured faculty member in the Department of Women's, Gender, and Sexuality Studies (WGSS) at The Ohio State University (OSU), I decided to invite two Chilean street artists to my university, namely Mono González and Gigi (Marjorie Peñailillo.) My hope was that they could interact with students, faculty, and staff on campus and establish critical and transnational dialogues about democratic, liberatory, feminist, and decolonial art practices. Perhaps on a more personal level, I was attempting to bring together what appeared to be two distinct sides of my subjectivity given that my travels back and forth between Chile and the US sometimes made me feel fragmented. I often got the sensation that the person I was in the US was quite distinct from the one who spoke and interacted with street artists and with my own family members in Chile. Unlike other Latinx immigrants, there is not a sizable Chilean community in the United States. Such a fragmentation is not an uncommon experience among bicultural, diasporic, and immigrant populations. Nevertheless, I was overcome by a desire to bridge the gap between those two personas, to become a kind of transnational facilitator capable of translating ideas between those two locales.

MONO GONZÁLEZ'S COMMUNITY ENGAGEMENT AT OSU AND TRANSIT ARTS

The already transnational and well-known work by Mono González made him an ideal candidate for the dialogues I wanted to facilitate between the communities that were familiar to me in the US and Chile. Even though González did not speak English, his visual language, commitment to social justice and political history would need no translation for the local populations I had come to regard as my community in Columbus, Ohio. Mono González arrived

in town during the early fall of 2015 after much preparation and anticipation on my part. I felt that his long and complex personal history with street art, his simultaneous trajectory as a muralist and printmaker, and his steadfast commitment to collectivity and community empowerment would resonate with the feminist, queer, and activist-inclined students, faculty, and staff in my department. I had seen González in action in Chile: painting murals, collaborating with other artists, working with children, exhibiting in galleries, and more. Over the years, I witnessed a socially engaged artist who could work across differences within Chile's highly stratified society, often forging lasting coalitions in the process. I was also aware that González had traveled the world and painted murals in several locations in Europe, the Americas, and even Asia; his appeal as an artist and effectiveness as a coalition builder was transnational indeed. However, the segregated spaces of the United States and the often-bureaucratic culture of university campuses in this country was a new reality for González, for he had never traveled to North America before. Nevertheless, I saw him as a person in possession of a shifting consciousness and highly adaptable skills who knew how to adjust his praxis in different contexts.

I coordinated various activities with González on the OSU campus, but perhaps the most elaborate, interactive, and collaborative one was the Feminist Print Workshop (FPW) he led with the students in my class, WGSS 4375 Women and Visual Culture. The course centered on the numerous ways in which visual culture could be complicit with systems of oppression and domination while also addressing how the power of the visual could, at the same time, be effectively deployed for the purposes of social justice and empowerment. It was my hope that students would experience the latter, in other words, that they could come to understand, through their own praxis, how art and creative expression could operate in liberatory ways. Thus, I now turn to my recollections of this print workshop, fully aware that such a discussion may appear to be out of place in a book on muralism and graffiti. Nevertheless, muralism and printmaking are art forms that possess numerous affinities with one another; their histories in the Americas are closely connected to the emergence of social movements. Moreover, behind the creation of many murals and prints rests the desire to promote more democratic and accessible means of creative expression. Murals can achieve this ideal of greater audience inclusion through their public location often outside of museum and gallery spaces, while prints can similarly embrace democratic aspirations through their inherent capacity to produce multiples of one image. Mono González's dual identity as a muralist and printmaker often prompted him to think organically across the two media, whereby his murals took on the

graphic qualities of prints and his prints adopted the monumentality of his murals. The pedagogic strategies he deployed in the FPW on the OSU campus thus revealed his approach to coalition building and collective art making both within the practices of muralism and printmaking.

In preparation for the FPW, I asked my students in WGSS 4375 to select or design a simple yet iconic image (or text) that embodied to them the spirit of social justice. The goal was for them to create a simple silkscreen or serigraph. Students could draw their own images or just repurpose/copy preexisting designs and motifs found on the internet or elsewhere. It was important not to intimidate or marginalize students who had no artistic abilities, experience, or training. After all, WGSS 4375 was not a studio arts class, but more importantly, it was not a pedagogic space where students somehow had to prove their technical skills in order to create art. González also extended this egalitarian approach to the list of art materials he requested of the students. For instance, rather than specialized printer's ink, he recommended that they buy latex paint and use flour as a thickening agent; upwards of four to five students could share one tub of paint and a few grams of flour. Though he included a screen-printing frame in the list, he also encouraged them to save money and build their own using an old picture frame with organza fabric stretched over it. González had been long cultivating strategies for doing art with the bare essentials, an approach he began putting into practice during his early days with the Brigada Ramona Parra, an art collective that had to make do with house paint and brushes to create murals.

The FPW with Mono González and the students in WGSS 4375 took place not in the print studio on the OSU campus but in the Martin Luther King Lounge of the Hale Black Cultural Center, a charged space often dedicated to events and activities connected to US black culture and history as well as other diversity-related initiatives on campus. Moreover, the workshop was opened to the public, making it clear that this was a community-wide intervention as well as a class activity. With the assistance of Sergio Soave, professor of printmaking at OSU, and Andrea Hanson, undergraduate student in the university's printmaking program, González instructed the participants to take the designs they brought with themselves and start cutting stencils out of them. They would then use these stencils as blocking devices for the screen-printing method. Rather than emboss their images on paper, however, González insisted that the participants imprint their social justice designs on t-shirts. The artist maintained that, by wearing these shirts in public and moving through different social spheres, they would be disseminating their messages of feminist resistance to a larger public, not unlike the ways in which public murals can perform a similar function in urban settings. As I heard and

FIGURE 5.5. Mono González leading the Feminist Print Workshop at The Ohio State University, September 2015. Photograph: Guisela Latorre.

then translated these words to my students and to the other participants in the FPW, I could not help but to think of the performative implications of using the body and clothing as purveyors of radical imagery and feminist politics. My students understood that such performances need not take the form of dedicated art actions but could be enacted through simple everyday gestures such as wearing a t-shirt with one's own social justice design.

The FPW participants found the stimulus of this activity to be deeply generative and invigorating (see figures 5.5 and 5.6). One student decided it was

FIGURE 5.6. Ohio State University student participating in the Feminist Print Workshop led by Mono González, September 2015. Photograph: Guisela Latorre.

important to promote the growing visibility of the Black Lives Matter (BLM) movement, the activist initiative that reacted proactively against the brutal violence black communities experience at the hands of law enforcement, so she printed BLM's name on her shirt. Another student borrowed the visual language of US-based installation and conceptual artist Jenny Holzer who in 1980 created an electronic billboard in New York City's Times Square with the statement "Abuse of Power Comes as No Surprise."

FIGURE 5.7. Jenn Eidemiller showing her finished
design during the Feminist Print Workshop at
The Ohio State University, September 2015.
Photograph courtesy of Jenn Eidemiller.

In conjunction with that massive installation, Holzer had also created t-shirts
and other "merchandize" to disseminate her message. I was quite pleased to
see that this student had decided to reproduce Holzer's conceptual experiment
but did so using the low-tech and more hands-on technique of noncommer-
cial screen printing.

While the use of text was popular among many students participating
in the FPW, inscribing the faces of important feminist icons on their shirts
was also appealing to a number of participants. Jenn Eidemiller, WGSS major

FIGURE 5.8. Jessica Lieberman showing her finished design
during the Feminist Print Workshop at The Ohio State University,
September 2015. Photograph courtesy of Jessica Lieberman.

and student activist at OSU, greatly admired the work of Judith Butler, whose
writings we had read in class. Her design required the painstaking process
of cutting tiny paper stencils to reproduce the likeness of the famed feminist
philosopher (see figure 5.7). Jessica Lieberman, an MFA student in creative
writing, took a similar approach and printed the portrait of Golda Meir, the
first woman prime minister of Israel (see figure 5.8).

In the process of coordinating González's visit to Columbus, I knew it
would be important for him to step out of the fairly privileged space of a col-
lege campus and engage in more grassroots outreach with local communities.

I was aware and had come in contact with the vibrant cultural scene created by the African American population in Columbus. I thus arranged for him to paint a small collaborative mural with Transit Arts, a youth arts development program that serves primarily the near east and near south neighborhoods of the city, sectors with a large African American community. Their curriculum focuses on what they call "multi-disciplinary arts workshops" with a strong emphasis on hip-hop dance, beatboxing, mixed media visual arts, and even muralism.[39] The director of Transit, Jackie Calderone who showed enthusiastic support for González's visit, procured a large canvas (approximately five by eight feet), acrylic paints, and brushes for the artist to work. In an almost organic way, individuals from the OSU and Transit communities—two social spheres that rarely had any contact with one another—joined González to work on this mural: Katerina Harris (poet, visual artist, singer, and educator at Transit), Maria DiFranco (MFA candidate at OSU), Richard Duarte Brown (master artist and educator at Transit), Federico Cuatlacuatl (visiting assistant professor of art at OSU), and others. Though González was meeting many of these individuals for the first time, the spirit of collaborative creativity and mutual respect emerged almost instantly and organically between the participants. There was very little discussion of process, roles, or technique. Basically, work on the mural began almost as soon as Calderone and her staff laid out the canvas and paints.

González approached the Transit mural like he would have approached a collaborative mural in Chile, a method he first developed while still working with the Brigada Ramona Parra (BRP) in the late 1960s and early '70s.[40] The artist began with the *trazado*, the broad black outlines characteristic of the graphic and bold style found both in his prints and mural work (see figure 5.9).

González's brush strokes soon began to reveal a complex composition populated with the artist's characteristic iconography. An otherworldly plant emerges from the bottom register of the mural, sprouting countless leaves, thorns, and stalks, visual elements that fill the compositional space almost entirely. This plant, however, is no ordinary variety of vegetation; it is a hybrid organism that also germinates human beings and birds. González created for the Transit community an image depicting a universe where distinctions, differences, and hierarchies between living things become obsolete and irrelevant. The fluidity and interconnectedness that the artist depicted in the Transit mural was broadly symbolic of the mobile consciousness and magnanimous

39. Transit Arts Workshops.

40. For more information on the BRP's approach to collaborative and inclusive mural making, see chapter 1 of this book.

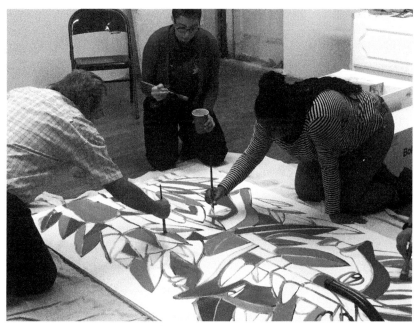

FIGURE 5.9. Mono González, Maria DiFranco, and Katerina Harris working on the Transit Arts mural, September 2015. Photograph: Guisela Latorre.

mindfulness required for collaborative, collective, and coalitional work. As González was completing the trazos, his collaborators began to simultaneously work as *rellenadores* (fillers) and *fondeadores* (backgroundists),[41] adding the vibrant color that defined the BRP aesthetic being introduced to Transit by González (see figure 5.10). The completed mural was met with applause and excitement among those of us who witnessed or participated in its creation. Shortly thereafter we all remained in that space reflecting on the imagery and on the experience of working on the piece together, a spontaneous and unplanned response to this unique collaboration with Mono González. Richard Duarte Brown, one of the participants and an arts educator at Transit, took the opportunity to speak eloquently about his own reading of González's sensibility as an artist. He argued that the mural was the result of the artist's irrepressible need to express himself and his desire to encourage those same kinds of expressions in others. Duarte Brown's eyes swelled up with tears as he turned to González and told him that he too felt the willful longing to be creative yet struggled with the pain of remembering his father's rejection

41. For more information on the role of rellenadores and fondeadores, see chapter 1 of this book.

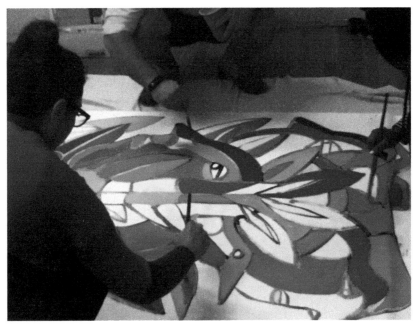

FIGURE 5.10. Maria DiFranco, Federico Cuatlacuatl, Katerina Harris, and others working on the Transit Arts mural, September 2015. Photograph: Guisela Latorre.

of his art. This poignant moment was the fitting culmination to a collaborative process enacted by individuals from different generations, walks of life, and national/transnational realities—along with numerous other social differences—who capitalized on the affinities and points of contact that existed between them.

On the next day, the Transit Arts staff transformed the mural into a banner that they carried along the streets of the city during the 2015 Columbus Children's Parade. The group then arrived at the Hot Times Community Arts and Music Festival where many of the Transit youth artists showcased their beatboxing and hip-hop dancing skills while the mural was displayed on stage right beside them, almost appearing to be an extension of their own performative landscape. Transit's transformation of the mural into a mobile work of art that moved through Columbus's urban spaces and inserted itself within various communities in the city revealed the organization's understanding of art as a dynamic, multimedia, and synergistic force that need not be confined to a fixed location as it thrives when it is always in motion.

However, Transit did find a final "resting place" for González's collaborative mural. As of the time of this writing, the piece is currently installed in the organization's Center for Art and Community, the very site where it was

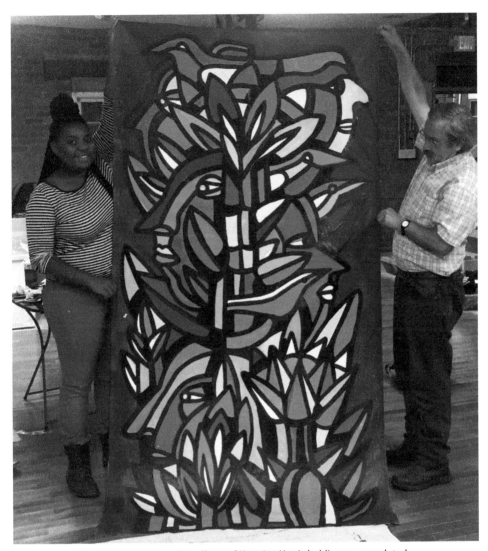

FIGURE 5.11. Mono González and Katerina Harris holding up completed Transit Arts mural, September 2015. Photograph: Guisela Latorre.

produced (see figure 5.12). As Jackie Calderone explained, this space hosts open studios and master classes that include "visual and media arts . . . , performing arts . . . , writing workshops, garden arts, cooking, fashion design/sewing, etc."[42] She further elaborated that this center gives young artists the opportunity to learn from "master artists and also immerse themselves in

42. Email exchange between Jackie Calderone and Guisela Latorre. April 28, 2017.

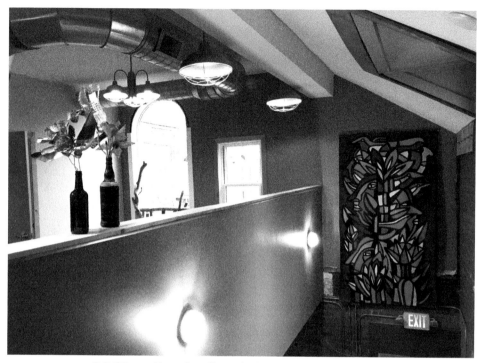

FIGURE 5.12. Mono González and others, Transit Arts mural (2015), acrylic on canvas. Photograph courtesy of Jackie Calderone.

their own projects working independently."[43] The continued life of the mural within the creative and community empowerment space of Transit Arts spoke to the adaptability and relevance of an artist who had been nurtured by local Chilean realities yet had developed a visual vocabulary and a collaborative method that could operate transnationally.

COLLABORATING WITH GIGI ON *FORMACIÓN*: THE WGSS MURAL

The community-driven work that Mono González carried out in Columbus and on the OSU campus reminded me of the potential for radical and even feminist pedagogies embedded in the practice of Chilean street art. I also became aware of how these transformative pedagogical possibilities could work transnationally through the practice of teaching as a form of collec-

43. Email exchange between Jackie Calderone and Guisela Latorre.

tivity and inclusive participation. The Chilean street artist who brought this potential into sharpest focus for me was undoubtedly graffitera Gigi (Marjorie Peñailillo) whose work is also featured in chapter 4 of this book. Her practice as a street artist coupled with her training in art and education from the University of Viña del Mar allowed her to engage in projects that utilized the techniques and strategies of graffiti as tools of instruction. Compared to Mono González, she belonged to a younger generation of artists who had not yet acquired the name recognition that he had garnered. Like González, however, she had worked in Chile and abroad, locales where she put into action her graffiti pedagogies. She too had experience working transnationally, having collaborated with adults and children in her graffiti projects in Brazil and Spain. Moreover, Gigi was heavily influenced by the writings of radical Latin American critical pedagogues such as Paulo Freire, Humberto Maturana, and María Eugenia Calzadilla. I was particularly taken by her idea of bringing an art form like graffiti into a classroom or educational setting. Given the way that graffiti has been marginalized and criminalized in the United States, the notion of highlighting the pedagogical components of street art was quite radical. Like with González, I knew her interactions and conversations with the feminist, progressive, and socially conscious groups at OSU would be productive and generative ones.

During the spring semester of 2016, Gigi accepted my invitation to the OSU campus on the occasion of the 2016 *HipHop Literacies Conference: Black Women and Girls Matter,* organized by education and literacy scholar Elaine Richardson (among others.) There the artist and I copresented a paper on the ways she uses graffiti pedagogies in Chilean classrooms, putting particular emphasis on her work with girls from vulnerable populations. Gigi's unique perspective on feminist pedagogies resonated quite well with the conference's emphasis on hip-hop feminism and pedagogy as well as with the participants' concerns over the increasingly devalued lives of black women and girls in the United States who had been victimized by police brutality and other forms of gendered and racialized violence. During the talk, we discussed the artist's creation of her ongoing pedagogical project called Graffiti School Comunidad (GSC), an initiative Gigi started in 2010. The artist had taken GSC to public schools and community settings. Some of her workshops and activities focused on the actual creation of graffiti pieces on the walls of public spaces while others centered on nongraffiti artwork that nevertheless used the techniques or general impetus of graffiti. In this school, Gigi instilled in her students the development of urban literacies as well as social and emotional skills that allow them to survive and thrive within a patriarchal system. Her goal was "to discover and explore the individual and collective self" among

her participants.[44] GSC operates both within and outside of the Chilean public school system, often taking the shape of afterschool programs or in-school workshops. The funding for her work with GSC comes from various sources, which include private and public funds, thus allowing her to function more independently than public school teachers who are often bound by state-sanctioned curricula.

Gigi's visit to OSU also coincided with my tenure as interim departmental chair. Like with González's visit, I again availed myself of my administrative position to facilitate meaningful collaborations between Gigi and local communities. Moreover, I had entered into the chairship of a department that was quite unique in that the staff—all graduates of our WGSS programs at the time—actively participated in the feminist vision and mission of the department. They were not just there to provide administrative support for the students and faculty in the department; they were integral to the transformation of the departmental office into a physical and discursive space on campus that challenged or decentered the white patriarchal foundations of the academy. The idea that Gigi could create a mural inside the departmental offices emerged organically from our conversations about the different ways we could enhance our own work space, while also making it a welcoming environment for the feminist, queer, nonwhite, and activist populations we served, be they students, faculty, other staff, or community activists.

It was Tess Pugsley, program assistant, who suggested to me that we could have Gigi do a mural in our own WGSS office: "I remember that there was a rash of rebellious behavior happening at that time [on campus]. I recalled that Mono [González] had just come in and I remember thinking 'Let's just do [a mural] here.'"[45] Alluding to the various activist initiatives enacted by WGSS students, Tess's statement was bold yet unsurprising, for the staff had long been caretakers and informal interior designers of the office space. Lynaya Elliott, administrative manager, had assisted in the restructuring of the office space, often creatively securing the funds for media technologies and new furniture for our offices. Moreover, Tess had created a series of portraits depicting well-known feminist icons (Angela Davis, Gloria Anzaldúa, Audre Lorde, and others) that were hung throughout the office. Jackie Stotlar was new to her role as the WGSS program coordinator at the time and had not actively participated in the design of the departmental space but, as a graduate of the WGSS master's program, she already possessed an intuitive understanding of the importance of creating a feminist space. "We talk about [the WGSS office]

44. Latorre and Peñailillo, "Graffiti School *Comunidad* in Chile," presentation.

45. Interview with Lynaya Elliott, Tess Pugsley, and Jackie Stotlar, Columbus, Ohio, May 9, 2017.

as an extension of our own home," Lynaya commented.[46] The encouragement and enthusiasm of the staff—whom I had come to trust and greatly admire during my tenure as interim chair and beyond—galvanized my decision to go along with Tess's idea and have Gigi direct all of us in the creation of a graffiti mural in the WGSS offices. Such an action represented an important milestone in my career as a scholar of mural art; though I had dedicated nearly two decades of my life to researching and writing about the subject matter, I had never participated in the creation of a wall piece myself.

The process of creating the WGSS graffiti mural began with collective and transnational conversations between the staff, Gigi, and I over email and Skype prior to the artist's arrival in the United States. We hoped that the graffiti mural, situated at the entrance of our offices, would signal a shift in modes of thinking, indicating to those who visit our department that they are entering a space that promotes egalitarian and democratic social relations between students, faculty, staff, and others at the university. We wanted to produce an image that was both specific but also broadly symbolic of a feminist and decolonial consciousness while also remaining attentive to the importance of a feminist education. As a result, we formulated a number of preliminary ideas for the graffiti mural that Gigi then put together into a proposal:

- Conceptual single figure with bold outlines (indicating to visitors that they are entering into a decolonial feminist space).
- [The figure will appear to be] gender nonspecific and/or gender nonconforming.
- Indigenous cultural elements: Iroquois matriarchal culture, flag color, Ohio meaning (Big River).
- Nature Ohio motifs: river, cardinal, Ohio Buckeye tree, ladybug, wildflowers.
- Related to education and building community.
- The technique used will be latex and water-based spray paint for a "graffiti mural" look.[47]

As made evident by the bullet points above, the WGSS graffiti mural would focus on a single allegorical figure that could speak of the feminist intellectual mission of our department. This figure would then be surrounded by various attributes alluding to local indigenous environments in the state of Ohio. Gigi's experience with incorporating Andean indigenous motifs into graffiti

46. Interview with Lynaya Elliott, Tess Pugsley, and Jackie Stotlar.

47. Text from the Graffiti School Comunidad Proposal drafted by Gigi and submitted to Lynaya Elliott, Tess Pugsley, Jackie Stotlar, and the author. February 16, 2016.

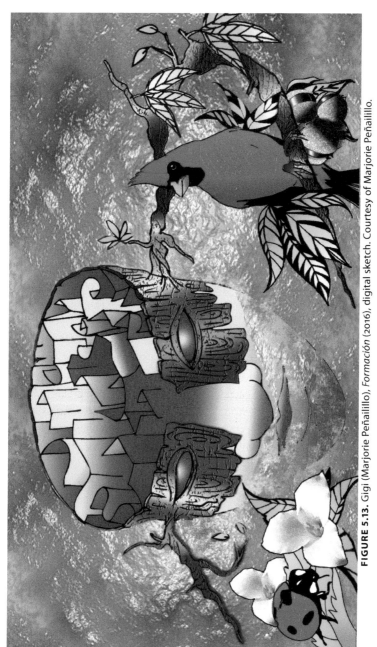

FIGURE 5.13. Gigi (Marjorie Peñalillo), *Formación* (2016), digital sketch. Courtesy of Marjorie Peñalillo.

aesthetics in Chile proved to be quite helpful in this respect. The staff shared various photographs and images of the local natural environment so that the artist could get a sense of our location while still in Chile. Gigi also proposed that the central allegorical figure reveal a maze of knowledge through their head, a motif that would allude to the power of feminist intellectual thought. As a result of these transnational brainstorming and dialogue sessions, Gigi created a digital sketch with the overall composition and design of the mural (see figure 5.13), an image that we approved as a group.

The numerous online exchanges we had with Gigi worked to generate great excitement and anticipation among the staff and I. By the time she arrived on the OSU campus, we had established a clear path toward the vision for this graffiti mural in addition to having forged a positive working relationship with the artist. After numerous introductions, informal tours of the university campus and countless trips to local art stores for spray paint, latex, rollers, brushes, and other arts materials, we hit the ground running, so to speak. Gigi put into motion the pedagogical tools she had developed while working collectively with communities in Chile and elsewhere. The graffiti mural of WGSS thus became yet another installment of her ongoing project, namely her Graffiti School Comunidad. Together with us, she created an artistic collective that validated and capitalized on the creative potential of all those involved. We experienced firsthand her desire "to empower the learning subject through community-based learning, collaboration, mutual respect and shared knowledge."[48]

Work began over a weekend when Gigi and I prepared the wall for the mural by cleaning it and painting over it with a blue background using rollers and large paint brushes. We couldn't paint during regular office hours because our work would interfere with departmental business so we utilized the weekend and afterhours to complete the wall. After Gigi and I finished the preliminary preparation, Tess joined us to sketch out the mural's numerous figures using quick and sketchy lines (see figure 5.14). Some feelings of uncertainty came over us at that point, as we suddenly felt insecure about our ability to transfer the small digital sketch Gigi had made into the large-scale format of the wall. Having worked with populations of all ages and artistic abilities in the past, the artist patiently reassured us by putting her full trust in our abilities. Jackie recalled being surprised by the level of participation that the artist expected from us: "I didn't necessarily connect that we were actually going to do it. I thought we would just assist, watch or do a backdrop, something really

48. Latorre and Peñailillo, "Graffiti School *Comunidad* in Chile," presentation.

FIGURE 5.14. Tess Pugsley and Guisela Latorre working on outlines for *Formación* (2016). The Ohio State University, United States. Photograph Courtesy of Marjorie Peñailillo.

minimal. I didn't realize quite how much we were going to do."[49] Indeed, Gigi expected deep involvement from us while also refusing to pass judgement on our insecurities. Working as an academic for so many years—having to demonstrate and perform expert knowledge and so-called "superior" skills in my profession—it was liberating to operate in an environment where I could admit ignorance and express vulnerability.

Gigi's approach to the WGSS graffiti mural consisted of building up the image in layers, with each "deposit" of paint adding greater complexity, volume, and detail to the wall surface. Our next step was then to paint the broad color areas of the graffiti mural. With Lynaya and Jackie now joining us in the team or crew (how Gigi referred to us), this stage required the use of spray paint for the first time in the process. As first-time graffiteras, the prospect of handling aerosol cans was daunting to us. Could we control the direction and spread of the spray? Didn't it take graffiterx years to master the craft? Lynaya recalled that when she began working on the wall, she "was nervous and that made me feel apprehensive about it, but Gigi snuffed out my anxiety. She

49. Interview with Elliott, Pugsley, and Stotlar.

FIGURE 5.15. Lynaya Elliott, Jackie Stotlar, and Tess Pugsley working on *Formación* (2016). The Ohio State University, United States. Photograph: Guisela Latorre.

just didn't give [my hesitation] any airtime."[50] Unconcerned with our lack of experience, Gigi went to great lengths to instruct us on best practices in the use of aerosol, telling us that we should always direct the spray at an angle in relation to the wall while also advising us to keep the can in constant motion as to prevent unwanted drips.

What began as timid strokes on the wall on our part soon morphed into an all-out aerosol attack (see figure 5.15). The excitement of our new-found aerosol skills coupled with the realization that the general design of the mural was quickly taking shape filled us with a sense of excitement and euphoria. "It felt badass," Tess recalled.[51] When we finalized the details, volume, and shading to the figures and objects in the iconography—as well as putting the finishing touches on the wall—the first WGSS mural in our department's history had become a reality. "I felt that it was such a natural thing for us to do as a group," Jackie fondly reminisced. "It solidified that bond and love we had for each other and for this space."[52]

50. Interview with Elliott, Pugsley, and Stotlar.

51. Interview with Elliott, Pugsley, and Stotlar.

52. Interview with Elliott, Pugsley, and Stotlar.

FIGURE 5.16. Gigi (Marjorie Peñailillo), Lynaya Elliott, Guisela Latorre, Tess Pugsley, and Jackie Stotlar, *Formación* (2016), graffiti mural, Department of Women's, Gender, and Sexuality Studies, The Ohio State University, United States. Photograph: Guisela Latorre.

The resulting composition and iconography of the WGSS mural centered around the aforementioned central figure, a gender ambiguous or nondescript being, neither a man or a woman, or both (see figure 5.16). This figure, rendered completely in shades of blue, appears to ascend from a body of water as they return the viewer's gaze. They wear a mask over their eyes, not unlike those worn in Andean indigenous ceremonies and rituals thus reflecting an important influence upon Gigi's work. From this mask, two large tree branches extend horizontally as they support local wildlife: a cardinal, a white trillium flower, and a *coccinellidae,* or ladybug. In the WGSS departmental website, we described the maze that is revealed through the central figure's head as a mind that is "visibly open to multiple and complex possibilities."[53] This iconography inspired us to title the mural, *Formación* because, as we explained in our artists' statement, the concept represents "the constant state of becoming and

53. "New Mural in WGSS Office: March 31, 2016."

formation that is at the core of non-oppressive and anti-colonial thinking. *Formación* thus celebrates ambivalent, in-between and continually evolving states of being."[54]

Throughout the process of creating *Formación*, Gigi, Lynaya, Tess, Jackie, and I documented our journey by taking multiple photographs and videos of our participation in this project. Among the videos we created were a number of personal testimonies where we reflected on our experience having worked on this graffiti mural. Gigi then produced and edited a three-minute video on the making of *Formación*, which she disseminated transnationally not only as a way to leave a historical record of the graffiti mural we did but also as a means to insert our activities at The Ohio State University into the consciousness of the graffiti community in Chile.[55] Gigi's proactive "broadcasting" campaign called the attention of Chilean online magazines such as *XFem Revista* and *Dope Magazine: Graffiti y Street Art en Chile y el Mundo*, both of which ran stories on the creation of *Formación* in WGSS at OSU.[56]

CONCLUSION

The transnationalism of Chilean graffiti and muralism indicates that this street art movement is not one that is confined to the limitations of the national. The work by the artists discussed in this chapter attests to that reality. Moreover, my own "experiments" with the US visits by Chilean artists indicates how relevant and transformative their art and praxis could be in different national and transnational contexts. The meaningful connections these artists were able to establish with local communities in Columbus, Ohio, validated my own transnational identity as an immigrant and woman of color while also underscoring the power of dialogue and collaboration across national boundaries. I should be clear, however, that I am not implying that these Chilean artists could be casually inserted into any transnational location and be expected to thrive. Nor am I suggesting that all street artists from across the world

54. "New Mural in WGSS Office: March 31, 2016."

55. The *Formación* video produced by Gigi can be found in the artist's YouTube channel at https://www.youtube.com/watch?v=eexu5MMkUsY&feature=youtu.be (accessed on May 31, 2016).

56. See "Gigi TC Creando Escuelas de Graffiti de Chile para el Mundo," *XFem*, May 13, 2016, http://www.xfem.cl/gigi-tc-creando-escuelas-de-graffiti-de-chile-para-el-mundo/ (accessed on May 31, 2016), and Maximiliano Chandia, "Se realiza en Estados Unidos el Graffiti-Mural Comunitario 'Formación," *Dope Magazine—Graffiti y Street Art en Chile y el Mundo*, http://dope.cl/se-realiza-en-estados-unidos-el-graffiti-mural-comunitario-formacion/ (accessed on May 31, 2016).

will find some kind of graffiti or mural utopia in Chile. All of these transnational incursions needed to be carefully coordinated by artists and organizers alike. For instance, my role as interlocutor and cultural ambassador of sorts in the case of Mono González's and Gigi's work in Columbus was critical for effective coalition building and successful communication across difference. Moreover, the commitments to social justice of WGSS at OSU and Transit Arts in Columbus were a good fit, so to speak, for the socially engaged work that González and Gigi had been doing for several years. This kind of coordination and careful vetting had also taken place in the other transnational work discussed in this chapter. Nevertheless, what this radical street art does demonstrate is the democratic potential of a public art that is attentive to the specificity of site but is not bound or regulated by the possible constraints of the local. I ultimately argue that the transnationalism in Chilean graffiti and muralism is also a critical component of the visual democracy that this street art promotes. If visual democracy is about contesting the imagery and discourses that the state and global corporate sectors produce, as I argued in elsewhere in this book, then transnational iconography and praxes in street art become the necessary responses to the power hegemonies that have historically controlled public spaces. The deployment of transnational practices, strategies, and aesthetics in the quest for visual democracy thus becomes a central component to the truly innovative, transformative, and generous character of the Chilean street art movement.

BIBLIOGRAPHY

SECONDARY SOURCES

Adams, Jacqueline. *Art against Dictatorship: Making and Exporting Arpilleras under Pinochet.* Austin: University of Texas Press, 2013.

Aguirre, Estela A., and Sonia Chamorro. *Memoria gráfica del exilio chileno.* Santiago: Ocho Libros, 2008.

Alvarez Vásquez, Raúl. *Muros susurrantes: Graffiti en Santiago Chile y São Paulo Brasil.* Santiago: Ediciones Arthus, 2006.

Anzaldúa, Gloria. *Borderlands/La Frontera: The New Mestiza.* 2nd ed. San Francisco: Aunt Lute, 1999.

Arnillas, Federico "Ekeko, Alacitas Y Calvario La fiesta de la Santa Cruz en Juliaca." *Allpanchis: Revista del Instituto de Pastoral Andina* 28:47 (January-June 1996): 119–135.

Aroca, Patricio. "Territorial Inequality and Regional Policy in Chile." In *Regional Problems and Policies in Latin America,* eds. Juan R. Cuadrado-Roura and Patricio Aroca (Berlin: Springer, 2013): 279–291.

Bacigalupo, Ana Mariella. *Shaman of the Foye Tree: Gender, Power and Healing Among Chilean Mapuche.* Austin: University of Texas Press, 2007.

Barbera, Rosemary. "Community Remembering: Fear and Memory in a Chilean Shantytown." *Latin American Perspectives* 36:5 (September 2009): 72–88.

Barteet, Cody. "Contested Ideologies of Space in Hispanic American Cartographic Practices: From the Abstract to the Real in Spanish and Indigenous Maps of Jucatán." *RACAR: revue d'art canadienne / Canadian Art Review* 38:2 (2013): 22–39.

Bellange, Ebe. *El mural como reflejo de la realidad social en Chile.* Santiago: Ediciones Chile América, CESOC, 1995.

Berger Gluck, Sherna. "What's So Special About Women? Women's Oral History." In *Women's Oral History: The Frontiers Reader,* eds. Susan H. Armitage, Patricia Hart, and Karen Weathermon (Lincoln and London: University of Nebraska Press, 2002): 3–26.

Bresnahan, Rosalind. "The Media and the Neoliberal Transition in Chile: Democratic Promise Unfulfilled." *Latin American Perspectives* 30:6 (November 2003): 39–68.

Carrasco, Eduardo "Mono." *I Sogno Dipinto / El sueño pintado / O sonho pintado: I murals de Cile nella memoria storica / Los murales de Chile en la memoria histórica / Os murales do Chile na memória histórica.* Milan: Hobby & Work, 2004.

Castillo Espinoza, Eduardo. *Puño y letra: Movimiento social y comunicación gráfica en Chile.* Santiago: Ocho Libros, 2010.

Centro Cultural Mixart. *Museo a Cielo Abierto en San Miguel.* Santiago: Fondo Nacional de Desarrollo Cultural y las Artes FONDART, 2012.

Centro de Arte Contemporáneo. *Una acción hecha por otro es una obra de la Luz Donoso.* Santiago: Municipalidad de las Condes, 2011.

Chapman, Anne. *Drama and Power in a Hunting Society: The Selk'nam of Tierra del Fuego.* Cambridge: Cambridge University Press, 1982.

Comité de Defensa de la Cultural Chilena. *Muralismo Wandmalerei Peinture Murale Mural Painting Pittura Murale.* Berlin and São Paulo: St. Gallen, 1990.

Cooper, Martha, and Joseph Sciorra. *R. I. P. Memorial Wall Art.* London: Thames and Hudson, 1994.

Correa-Diaz, Luis. "América y Cervantes/El Quijote; el caso de Chile." *Revista chilena de literatura* 72 (April 2008): 124–140.

Cuche, Mario. "If you run into Inti one day." *ITNI* (Santiago: Ocho Libros, 2014), 10–11.

DaSilva Iddings, Ana Christina, Steven G. McCafferty, and Maria Lucia Teixeira da Silva. "Conscientização Through Graffiti Literacies in the Streets of a São Paulo Neighborhood: An Ecosocial Semiotic Perspective." *Reading Research Quarterly* 46:1 (January/February/March 2011): 5–21.

Davalos, Karen Mary. *Chicana/o Remix: Art and Errata Since the Sixties.* New York: New York University Press, 2017.

———. *Yolanda M. López.* Los Angeles: UCLA Chicano Studies Research Center, 2008.

Deloria Jr., Vine, and Daniel Wildcat. *Power and Place: Indian Education in America.* Golden, CO: Fulcrum Resources, 2001.

Derrida, Jacques. *Rogues: Two Essays on Reason.* Stanford, CA: Stanford University Press, 2005.

Díaz Parra, Alberto. *Muralismo: Arte en la cultura popular Chilena.* Santiago: Comité de Defensa de la Cultura Chilena, 1989.

Dobson, Kit, and Aine McGlynn, eds. *Transnationalism, Activism, Art.* Toronto: University of Toronto Press, 2013.

Dominguez, Rubén. "#YoSoy132: el movimiento que puede ser." *Iberoamericana* 13:49 (March 2013): 172–174.

Dosal, Paul J. *Doing Business with Dictators: A Political History of United Fruit in Guatemala, 1899–1944.* Lanham, MD: Rowman & Littlefield, 1993.

Durand Ochoa, Ursula. *Studies of the Americas: Political Empowerment of the Cocaleros in Bolivia and Peru.* Gordonsville, VA: Palgrave Macmillan, 2014.

Errázuriz, Luis Hernán, and Gonzalo Leiva Quijada. *El golpe estético: Dictadura militar en Chile, 1973–1989.* Santiago: Ocho Libros, 2012.

Fenton Stitt, Jocelyn, and Pegeen Reichert Powell. *Mothers Who Deliver: Feminist Interventions in Public and Interpersonal Discourse.* Albany: State University of New York Press, 2010.

Fernández Bravo, Alvaro. "Material Memories: Tradition and Amnesia in Two Argentine Museums." In *Images of Power: Iconography, Culture and the State in Latin America,* eds. Jens Andermann and William Rowe (New York: Berghahn Books, 2005): 78–98.

Figueroa Irarrázabal, Gricelda. *Sueños enlatados: El graffiti hip hop en Santiago de Chile*. Santiago: Editorial Cuarto Propio, 2005.

Forstenzer, Nicole. "Feminism and Gender Policies in Post-Dictatorship Chile (1990–2010)." In *Social Movements in Chile,* eds. Sofia Donoso and Marisa von Bülow (New York: Palgrave Macmillan, 2017): 161–189.

Fulton, Christopher. "Siqueiros against the Myth: Paeans to Cuauhtemoc, Last of the Aztec Emperors." *Oxford Art Journal* 23:1 (2009): 67–93.

Ganz, Nicholas. *Graffiti Women: Street Art from Five Continents*. New York: Harry N. Abrams, 2006.

———. *Graffiti World: Street Art from Five Continents*. New York: Harry N. Abrams, 2004.

García-Pabón, Leonardo. "Sensibilidades callejeras: El trabajo estético y politico de 'Mujeres Creando.'" *Revista de crítica literaria* 29:58 (2003): 239–254.

Garrard-Burnett, Virginia. *Terror in the Land of the Holy Spirit: Guatemala under General Efraín Ríos Montt, 1982–1983*. Oxford; New York: Oxford University Press, 2010.

Gilligan, Carol. "Images of Relationship." In *Applied Ethics: A Multicultural Approach,* eds. Larry May, Shari Collins-Chobanian, and Kai Wong (Upper Saddle River, NJ: Prentice Hall, 1998): 331–341.

Gottlieb, Lisa. *Graffiti Art Styles: A Classification System and Theoretical Analysis*. Jefferson, NC; London: MacFarland, 2004.

Greaves, Edward. "Dilemmas of Urban Popular Movements in Popular-Sector Comunas of Santiago, Chile." In *Social Movements and Leftist Governments in Latin America,* eds. Gary Prevost, Carlos Oliva Campos, and Harry Vanden (London: Zed Books, 2012): 88–115.

Guzmán, Virginia. "Discursos de género e institucionalidad pública." In *Desigualdad en Chile: La continua relevancia del género,* ed. Claudia Mora (Santiago: Ediciones Universidad Alberto Urtado, 2013): location 3658–4060 [Kindle Edition].

Hallum-Montes, Rachel. "'Para el Bien Común' Indigenous Women's Environmental Activism and Community Care Work in Guatemala." *Gender & Class* 19:1/2 (2012): 104–130.

Han, Clara. *Life in Debt: Times of Care and Violence in Neoliberal Chile*. Berkeley: University of California Press, 2012.

Held, Virginia. *The Ethics of Care: Personal, Political, Global*. New York: Oxford University Press, 2005.

Ilevic, Milan and Gaspar Galaz. *Chile, Arte Actual*. Valparaiso: Ediciones Universitarias de Valparaiso, 1988.

Jacobs, Margaret D. *White Mother to a Dark Race: Settler Colonialism, Maternalism, and the Removal of Indigenous Children in the American West and Australia, 1880–1940*. Lincoln: University of Nebraska Press, 2009.

Jarra Parra, Natalia. "El arte como ejercio experimental de la libertad: El pensamiento sobre artes visuales de Mario Pedrosa y su influencia en la concepción y formación del Museo de la Solidaridad." In *Educar para transformar: El rol de la educación artística en el legado de Paulo Freire y Mario Pedrosa,* ed. Museo de la Solidaridad Salvador Allende (Santiago: Coloquio Agosto 2013): 12–25.

Kunzle, David. "El mural chileno: de una revolución. La arpillera chilena: arte de protesta y resistencia." In *Centro de estudios económicos y sociales del tercer mundo, Chile vive* (Coyoacan, Mexico: Consorcio Editorial Comunicación, 1982): 78–84.

Lord K2. *Street Art Santiago*. Atglen, PA: Schiffer Publishing, Ltd., 2015.

Lost Art, Caleb Neelon, and Tristan Manco. *Graffiti Brasil (Street Graphics / Street Art)*. New York: Thames & Hudson, 2005.

Klein, Jennie. "Goddess: Feminist Art and Spirituality." *Feminist Studies* 35:3 (Fall 2005): 575–602.

Latorre, Guisela. *Walls of Empowerment: Chicana/o Indigenist Murals of California*. Austin: University of Texas Press, 2008.

Latorre, Guisela and Marjorie Peñailillo. "Graffiti School *Comunidad* in Chile," presentation. *Hip-Hop Literacies Conference,* March 2016, Columbus, OH: The Ohio State University.

Lorde, Audre. *A Burst of Light: Living with Cancer.* Ithaca, NY: Firebrand Books, 1988.

Lugones, María. *Pilgrimages/Peregrinajes: Theorizing Coalition against Multiple Oppressions.* Lanham, MD: Rowman & Littlefield Publishers, 2003.

———. "Playfulness, 'World'-Travelling, and Loving Perceptions." *Hypatia* 2:2 (Summer 1987): 3–19.

Ma, Michelle. "Anticipating and Reducing the Unfairness of Monsanto's Inadvertent Infringement Lawsuits: A Proposal to Import Copyright Law's Notice and Takedown Regime into Seed Patent Context." *California Law Review* 100:3 (June 2012): 691.

Macdonald, Nancy. *The Graffiti Subculture: Youth, Masculinity and Identity in London and New York.* New York: Palgrave Macmillan, 2001.

Mallón, Florencia. "Decoding the Parchments of the Latin American Nation-State: Peru, Mexico and Chile in Comparative Perspective." In *Studies in the Formation of the Nation State in Latin America,* ed. James Dunkerley (London: Institute of Latin American Studies, University of London, 2002): 13–53.

Mazanderani, Fawzia Haeri. "'Speaking Back' to the Self: A Call for 'Voice Notes' as Reflexive Practice for Feminist Ethnographers." *Journal of International Women's Studies* 17:3 (February 2017): 80–94.

McLaren, Margaret A. *Feminism, Foucault, and Embodied Subjectivity.* Albany: State University of New York Press, 2002.

McSherry, J. Patrice, and Raúl Molina Mejía. "Chilean Students Challenge Pinochet's Legacy." *NACLA Report on the Americas* 44:6 (November-December 2010): 29–34.

Mignolo, Walter. "De-Linking: *Don Quixote,* Globalization and the Colonies." *Macalester International* 17:8 (Spring 2006): 3–35.

Molina Jara, Jorge, and Nicolás Molina Vera. "Expresiones de lucha en contra de la dictadura: La población la Pincoya y el Frente Patriótico Manuel Rodriguez." *Revista divergencia* Number 3, Year 2 (January-July 2013): 49–69.

Monteón, Michael. "John T. North, the Nitrate King and Chile's Lost Future." *Latin American Perspectives* 30:6 (November 2003): 69–90.

Mora, Claudia. "La imperceptibilidad del género." In *Desigualdad en Chile: La continua relevancia del género,* ed. Claudia Mora (Santiago: Ediciones Universidad Alberto Urtado, 2013): location 227–559 [Kindle Edition].

Moulian, Tomás. *Chile actual: Anatomía de un mito.* Santiago: LOM Ediciones, 1997.

———. "La vía chilena al socialismo: Intinerario de la crisis de los discursos estratégicos de la Unidad Popular." In *Cuando hicimos historia: La experiencia de la Unidad Popular,* ed. Julio Pinto Vallejos (Santiago: LOM Ediciones, 2005): 35–56.

Murphy, Edward. "In and Out of the Margins: Urban Land Seizures and Homeownership in Santiago, Chile." In *Cities from Scratch: Poverty and Informality in Urban Latin America,* eds. Brodwyn Fischer, Bryan McCann, and Javier Auyero (Durham, NC: Duke University Press, 2014): 68–101.

Museo Arte de Luz, ed. *Chile a la luz murales de Catalina Rojas/Chile in light Catalina Rojas Murals*. Santiago: Ocho Libros, 2012.

Muzaffar, Hanan. "'Do You Surprise? Do You Shock? Do You Have A Choice?' Assuming the Feminine Role: Subverting the Patriarchal System." *Women's Studies* 40 (2011): 620–644.

Neruda, Pablo. *Canto General*. Santiago: Pehuén Editores, 2005.

[No author cited], "El graffiti es un medio de comunicación transversal y tiene el poder de llevar el arte a la calle," *El Observador* (newspaper from Quilpue and Villa Alemana, Chile), May 17–23, 2013: 19.

Noddings, Nell. *Caring, a Feminine Approach to Ethics & Moral Education*. Berkeley: University of California Press, 1984.

Pabón, Jessica. "Be About It: Graffiteras Performing Feminist Community." *TDR: The Drama Review* 57:3 (Fall 2013): 88–116.

Palmer, Rod. *Arte callejero en Chile*. Santiago: Ocho Libros, 2011.

———. *Street Art Chile*. Berkeley, CA: Ginko Press, 2008.

Patton, Paul. "Derrida, Politics and Democracy to Come." *Philosophy Compass* 2/6 (2007): 766–780.

Peñailillo Endre, Marjorie. *Graffiti-mural y cultura urbana: Construcción dialógica-social a través de imaginarios urbanos para y con la comunidad*. Viña del Mar, Chile: Thesis for the Universidad de Viña del Mar, 2010.

Peñaloza, Carla. "La memoria en imágenes." In Kena Lorenzini, *Marcas Crónicas: Rayados y panfletos de los 80* (Santiago: Ocho Libros, 2010): 115–127.

Pérez, Laura. *Chicana Art: The Politics of Spiritual and Aesthetic Altarities*. Durham, NC: Duke University Press, 2007.

Perot Quevedo, Estefanía, and Patricia Ulloa Salvo. *Stgo. Style(s): Tribus Urbana*. Santiago: Catalonia, 2009.

Pinto, Julio, Azun Candina, and Robinson Lira. *Historia contemporánea de Chile, Volumen II: Actores, identidad y movimiento*, series eds., Gabriel Salazar and Julio Pinto. Santiago: LOM Editores, 1999.

Piper Shafir, Isabel, and Evelyn Hevia Jordan. *Espacio y recuerdo: Archipiélago de memorias en Santiago de Chile*. Santiago: Ocho Libros, 2012.

Phillips, Susan A. *Wallbangin': Graffiti and Gangs in L.A.* Chicago: University of Chicago Press, 1999.

Quay Hutchison, Elizabeth, Thomas Miller Klubock, Nara B. Milanich, and Peter Winn, eds. *The Chile Reader: History, Culture and Politics*. Durham, NC: Duke University Press, 2014.

Quayson, Ato, and Girish Daswani, eds. *A Companion to Diaspora and Transnationalism*. London: Blackwell Publishing, 2013.

Richard, Nelly. "Women's Art Practices and the Critique of Signs." In *Beyond the Fantastic: Contemporary Art Criticism from Latin America*, ed. Gerardo Mosquera (Cambridge, MA: MIT Press, 1995): 145–151.

Robinson, Fiona. *The Ethics of Care: A Feminist Approach to Human Security*. Philadelphia: Temple University Press, 2011.

Rochfort, Desmond. "A Terrible Beauty: Orozco's Murals in Guadalajara 1936–1939." In *¡Orozco! 1883–1949* (Oxford: Museum of Modern Art Oxford, 1980): 74–87.

Rodríguez-Plaza, Patricio. *Pintura callejera chilena: Manufactura estética y provocación teórica*. Santiago: Ocho Libros, 2011.

Rojas, Catalina. "Museo Arte de Luz/Art of Light Museum." In Museo Arte de Luz, *Chile a la luz: Murales de Catalina Rojas/Chile in Light: Catalina Rojas Murals* (Santiago: Ocho Libros, 2012): 59–67.

Ruddick, Sarah. "Injustice in Families: Assault and Domination." In *Justice and Care: Essential Readings in Feminist Ethics,* ed. Virginia Held (Boulder, CO: Westview Press, 1995): 203–224.

Ruiz, Maximiliano. *Graffiti Argentina.* New York: Thames & Hudson, 2009.

———. *Nuevo Mundo: Latin American Street Art.* Berlin: Gestalten Verlag, 2011.

Salazar, Gabriel, and Julio Pinto. *Historia contemporánea de Chile, Volúmen IV: Hombría y feminidad.* Santiago: LOM Ediciones, 2002.

Sandoval, Alejandra. *Palabras escritas en un muro: El caso de la Brigada Chacón.* Santiago: Ediciones Sur, 2001.

Sandoval, Chela. *Methodology of the Oppressed.* Minneapolis: University of Minnesota Press, 2000. [Kindle Edition]

Sandoval, Chela, and Guisela Latorre. "Chicana/o Artivism: Judy Baca's Digital Work with Youth of Color." In *Learning Race and Ethnicity: Youth and Digital Media,* ed. Anna Everett (The John D. and Catherine T. MacArthur Foundation Series on Digital Media and Learning. Cambridge, MA: The MIT Press, 2008): 81–108.

Saraswati, Swami Satyananda. *Kundalini Tantra.* Bihar, India: Yoga Publications Trust, 8th ed., 2001.

Saúl, Ernesto. *Pintura social en Chile: Nosotros los Chilenos.* Santiago: Empresa Editora Nacional Quimantú, 1973.

Schneider, Cathy. "Mobilization at the Grassroots: Shantytowns and Resistance in Authoritarian Chile." *Latin American Perspectives* 18:1 (Winter, 1991): 92–112.

Smith, Susan. "Oral History and Grounded Theory Procedures as Research Methodologies for Studies in Race, Gender and Class." *Race, Gender & Class* 9:3 (2002): 121–138.

Snyder, Gregory J. *Graffiti Lives: Beyond the Tag in New York's Urban Underground.* New York: New York University Press, 2011.

Toledo, Carla. "El nuevo graffiti femenino." *Ya: El Mercurio,* March 14 (2017): 24–26.

Trumper, Camilo Daniel. "'A ganar la calle': The politics of Public Space and Public Art in Santiago, Chile, 1970." PhD diss., University of California, 2008.

———. *Ephemeral Histories: Public Art, Politics, and the Struggle for the Streets.* Oakland: University of California Press, 2016.

Undurraga, Rosario. "Mujer y Trabajo en Chile ¿Qué dicen las mujeres sobre su participación en el mercado laboral?" In *Desigualdad en Chile: la continua relevancia del género,* ed. Claudia Mora (Santiago: Ediciones Universidad Alberto Urtado, 2013): location 1958–2529 [Kindle Edition].

Ureña, Carolyn, "Loving from Below: Of (De)colonial Love and Other Demons." *Hypatia* 32:1 (Winter 2017): 86–102.

Valdebenito Acosta, Sandra. *Tinta papel ingenio: Panfletos políticos en Chile, 1971–1990.* Santiago; Corte Madera, CA: Ocho Libros, 2010.

Varas, Paulina. "Un obra termina al volverse una acción." In *Una acción hecha por otro es una obra de la Luz Donoso,* ed. Centro de Arte Contemporáneo (Santiago: Pontificia Universidad Católica de Chile, 2011): 2–7.

Vico, Maurico, ed. *El afiche politico en Chile 1970–2013.* Santiago: Ocho Libros, 2013.

Vico, Mauricio, and Mario Osses. *Un grito en la pared: Psicodelia, compromiso político y exilio en el cartel chileno.* Santiago: Ocho Libros, 2009.

Whitehead, Jessie L. "Graffiti: The Use of the Familiar." *Art Education* 57:6 (November 2004): 25–32.

Weil, Jim. "From *Ekeko* to Scrooge McDuck: Commodity Fetishism and Ideological Change in a Bolivian Fiesta." *Ideologies & Literature: Journal of Hispanic and Lusophone Discourse Analysis* 4:1 (1989): 7–29.

Wolff, Alejandra. "Marcos y perspectivas de la postdictadura: Narrativas de la pintura en Chile." *Pintura chilena contemporánea: Práctica y desplazamnientos disciplinares desde de la Escuela de Arte UC,* eds. Carlos Ampuero, Patricia Novoa, and Francisco Schwember (Santiago: Ediciones Universidad Católica de Chile, 2015): 74–87.

Yano, Christine R. *Pink Globalization: Hello Kitty's Trek Across the Pacific.* Durham, NC: Duke University Press, 2015.

Yrrarázaval, Pablo. "Invitación al museo/Invitation to the Museum." In Museo Arte de Luz, *Chile a la luz: Murales de Catalina Rojas/Chile in light: Catalina Rojas Murals* (Santiago: Ocho Libros, 2012): 15.

Zenteno Sotomayor, Ignacio. "Población Chacabuco, una aproximación a la dimension simbólica del sujeto poblador." *Revista CIS* 20 (July 2016): 86–106.

ORAL HISTORIES, INTERVIEWS AND CONVERSATIONS WITH ARTISTS

Alterna, interview with the author, Santiago, Chile, December 22, 2011.

Anis and Wend, Abusa Crew, interview with the author, Santiago, Chile, December 23, 2011.

Calderone, Jackie, email exchange with the author, April 28, 2018.

Dana, interview with the author, Santiago, Chile, November 23, 2012.

Dana, email exchange with the author, March 7, 2016.

Elliott, Lynaya, Tess Pugsley, and Jackie Stotlar, interview with the author, Columbus, OH, May 9, 2017.

Fisek, interview with the author, Santiago, Chile, March 26, 2015.

Gigi, interview with the author, Viña del Mar, Chile, December 21, 2011.

González, Mono, phone interview with the author, Columbus, OH, and Waterloo, Canada, June 14, 2017.

Hernández, Roberto, interview with the author, Santiago, Chile, March 23, 2015.

Hozeh from 12 Brillos Graffiti Crew, interview with the author, Santiago, Chile, April 3, 2015

Las Crazis Graffiti Crew (Naska, Cines, Dana, Shape, and Bisy,) interview with the author, Santiago, Chile, December 26, 2015.

Rodríguez, Ricardo and Mono González, interview with the author, Santiago, Chile, March 25, 2017.

Shape, email exchange with the author, March 9, 2016.

Villaroel, David and Carol Arce, interview with the author, Santiago, Chile, March 31, 2014.

Wend, email exchange with the author, July 15, 2018.

ONLINE SOURCES

Aniss. "Seth Interview." FATCAP. https://www.fatcap.com/article/seth-interview.html (accessed on December 19, 2018).

Centro Cultural Estación Mapocho. http://www.estacionmapocho.cl/historia/ (accessed on January 16, 2016).

Campos, Laura. "Voces fuera del pacto Nueva Mayoría: 'Es la misma cuestión con otra ropa.'" *diarioUchile*, August 19, 2013. https://radio.uchile.cl/2013/08/19/voces-al-interior-del-pacto-nueva-mayoria-aseguran-que-la-concertacion-esta-muerta/ (accessed on December 17, 2018).

Chandia, Maximiliano. "Se realiza en Estados Unidos el Graffiti-Mural Comunitario 'Formación,'" *Dope Magazine—Graffiti y Street Art en Chile y el Mundo*. http://dope.cl/se-realiza-en-estados-unidos-el-graffiti-mural-comunitario-formacion/ (accessed on May 31, 2016).

Charmy, Constanza Hola. "Rodrigo Avilés, el estudiante en coma por el que miles se movilizan en Chile," *BBC Mundo,* May 29, 2015: www.bbc.com/mundo/noticias/2015/150529rodrigoavilesestudiantecomachile.cl (accessed January 28, 2016).

Cossio, Hector. "Acusan a artista chileno de pintar símbolos terroristas en mural del Quijote más grande del mundo." *El Mostrador* (online), April 10, 2014. http://www.elmostrador.cl/cultura/2014/04/10/acusan-a-artista-chileno-de-pintar-simbolos-terroristas-en-mural-del-quijote-mas-grande-del-mundo/ (accessed on March 26, 2016).

González, Alejandro Mono. "El arte brigadista." Chile: breve imaginaría política—1970–1973. http://www.abacq.net/imagineria/arte4.htm (accessed on December 17, 2018).

Elliott, Lynaya, Guisela Latorre, Tess Pugsley and Jackie Stotlar. "New Mural in WGSS Office: March 31, 2016." Artists' statement posted on WGSS department website. http://wgss.osu.edu/news/new-mural-wgss-office (accessed May 31, 2016).

Escobar, Santiago and Ivan Weissman, "Los negocios de Piñera en Perú siendo Presidente y en medio del fallo de La Haya." *El Mostrador,* Novermber 14, 2016. https://www.elmostrador.cl/destacado/2016/11/14/los-negocios-de-pinera-en-peru-siendo-presidente-y-en-medio-del-fallo-de-la-haya/ (accessed on December 17, 2018).

Espejo, Valentina. "El largo papeleo que tendrán que hacer los grafiteros en Valpo,"*Las Ultimas Noticias,* August 24, 2015. http://www.lun.com/Pages/NewsDetail.aspx/dt=2015-08-24&Paginald=28&bodyd=0 (accessed on August 24, 2015).

Fernández, Fernanda."#NiUnaMenos: La marcha que se realizará en Chile y Argentina contra la violencia hacia la mujer," *Emol,* October 18, 2016. https://www.emol.com/noticias/Nacional/2016/10/18/827131/NiUnaMenos-la-marcha-que-se-realizara-en-Chile-y-Argentina-por-la-violencia-contra-la-mujer.html (accessed on December 20, 2018).

Flores Cossío, Raykha. "La Ekeka, resignificación del traidor, la víctima y la justiciera en el feria popular boliviana de la Alasita." Essay published in the official website for Mujeres Creando. www.mujerescreando.org/pag/articulos/2013/ekeka/26-05-2013-ekeka.html (accessed May 19, 2016).

Germanos, Andrea. "'Monsanto Law' Brings Uproar to Chile," *CommonDreams: Breaking News & Views for the Progressive Community,* August 19, 2013. http://www.commondreams.org/news/2013/08/19/monsanto-law-brings-uproar-chile (accessed on January 29, 2016.)

Long, Gideon. "The Chilean muralists who defied Pinochet." BBC News, September 6, 2013. https://www.bbc.com/news/world-latin-america-23970034 (accessed on December 17, 2018).

McDonald-Stewart, Lucy. "Chile Has Fastest Growing Immigrant Population in South America." *MercoPress: South Atlantic News Agency,* May 26, 2009. http://en.mercopress.com/2009/05/25/chile-has-fastest-growing-immigrant-population-in-south-america (accessed on December 21, 2018).

[No author cited]. "Historic Quarter of the Seaside Port of Valparaiso," United Nations Educational, Scientific and Cultural Organization (UNESCO). http://whc.unesco.org/en/list/959 (accessed on August 1, 2014).

[No author cited]. "Mining in Chile Copper Solution," *The Economist,* April 27, 2013. https://www.economist.com/business/2013/04/27/copper-solution (accessed on December 18, 2018).

[No author cited]. "MODIFICA EL CÓDIGO PENAL Y LA LEY 20.066 SOBRE LA VIOLENCIA INTRAFAMILIAR, ESTABLECIENDO EL "FEMICIDIO," AUMENTANDO LAS PENAS APLICABLES A ESTE DELITO Y REFORMA LAS NORMAS SOBRE PARRICIDIO," Biblioteca del Congreso Nacional de Chile, https://www.leychile.cl/Navegar?idNorma=1021343 (accessed on April 6, 2017).

[No author cited]. "Muchachitas Pintoras, el primer festival de arte urbano con enfoque de género en la RM," *Ministerio de las Culturas, las Artes y el Patrimonio, Gobierno de Chile,* http://www.cultura.gob.cl/agendacultural/muchachitas-pintoras-el-primer-festival-de-arte-urbano-con-enfoque-de-genero-en-la-rm/ (accessed on July 16, 2018).

[No author cited]. "Museo a Cielo Abierto en la Pincoya: Construyendo sueños de unidad." https://museoacieloabiertoenlapincoya.wordpress.com/ (accessed on December 19, 2018).

[No author cited]. "School of the Americas, Western Hemisphere Institute for Security Cooperation," explanatory map providing an overview of US intervention in Latin America produced by the School of the Americas Watch (SOAW), n.d.: http://www.soaw.org/presente/images/stories/artists/ilcinkhighressm.jpg (accessed on June 23, 2017).

[No author cited]. "Gigi TC Creando Escuelas de Graffiti de Chile para el Mundo," *XFem,* May 13, 2016, http://www.xfem.cl/gigi-tc-creando-escuelas-de-graffiti-de-chile-para-el-mundo/ (accessed on May 31, 2016).

[No author cited]. "Construir un lugar mejor sin destruir lo que tenemos." Project website. http://construirlugarmejor.wix.com/culm (accessed May 24, 2016).

Valenzuela, José Luis. "Ricardo Rodríguez, líder de la brigada muralista del PC: 'Ojalá que de aquí a dos años no sea necesaria la Chacón." *The Clinic Online,* July 2, 2014. http://www.the-clinic.cl/2014/07/02/ricardo-rodriguez-lider-de-la-brigada-muralista-del-pc-ojala-que-de-aqui-a-dos-anos-no-sea-necesaria-la-chacon/ (accessed April 4, 2016).

Zurita, Raúl. "Colectivo de Acciones de Arte (CADA)." Memoria Chilena: Biblioteca Nacional de Chile. http://www.memoriachilena.cl/602/w3-article-98248.html (accessed on December 18, 2018).

ONLINE VIDEOS

Bolsillos Vacíos Producciones. *Brigada Ramona Parra: Rayando en la clandestinidad.* 2008. https://www.youtube.com/watch?v=sTMnEUcFWnM (accessed May 14, 2014).

"El arte del muralismo callejero brigadista Chileno." EditorialUsach. Published on April 16, 2012. http://www.youtube.com/watch?v=CDwtBqnGDfE (accessed June 21, 2013).

Gigi, Formación video. https://www.youtube.com/watch?v=eexu5MMkUsY&feature=youtu.be (accessed on May 31, 2016).

"INTI . . . EKEKOS—METRO BELLAS ARTES." Stgo Films Producciones, STGO Design. Published December 10, 2013, filmed on December 5, 2013. https://www.youtube.com/watch?v=N5JPgUGSkEw (accessed January 1, 2016).

Manquez, M. Fernanda. *BRP "Huellas de Color."* 2005. https://www.youtube.com/watch?v=zQbB-oXvMSo (accessed May 14, 2014).

"Museo a Cielo Abierto de San Miguel." Published November 28, 2014. Medios. http://youtu.be/YTFhsYK1SrU (accessed January 20, 2014).

"Trazo mi ciudad: Pedro Lemebel, Santiago, Chile." http://www.trazomiciudad.cl/2011/08/pedro-lemebel/ (accessed January 13, 2015).

"QUINTANAR PROYECT. INTI & LAGUNA," WRITERS MADRID. Published on June 15, 2014. https://www.youtube.com/watch?v=d3zgd_jNGD8 (accessed May 2015).

Video uploaded to Chile Estyle, Facebook blog by León Calquín. https://www.facebook.com/chileestyle/posts/104120769682870 (accessed August 24, 2015).

INDEX

12 Brillos Crew (artists), 76–80, 102, 112–18; Población José María Cano graffiti mural, 113–17. *See also* Museo a Cielo Abierto in San Miguel

Abusa Crew (artists), 157–61; Muchachitas Pintoras (arts collective), 160n69; *Espíritu de Mujer,* 157–61

Adopta un Gato, 157

Aesthetics of necessity, concept of, 111–12

Aislap (artists), 80–86. *See also* Museo a Cielo Abierto in San Miguel

Albornoz, Pato (artist), 73. *See also* Museo a Cielo Abierto in San Miguel

Allende, Salvador, relationship to muralism, 14–19, 33–34, 39

Alterna (artist), 138, 154–57; *Niña,* 154, 155; *Devuélvenos la Imaginación,* 154–57; *Adopta un Gato,* 157

Alvarez Reyes, Hernán, 20

Amaranta (artist), 96–100. *See also* Museo a Cielo Abierto San Miguel

Anis (artist), 138, 144, 147, 157–63; Muchachitas Pintoras (arts collective), 160n69; *Espíritu de Mujer,* 157–61; *Puta 2,* 161–63. *See also* Abusa Crew

Anti-graffiti laws and practices, Chile, 102–5

Año, El (artist), 92–94 *See also* Museo a Cielo Abierto in La Pincoya

Arpilleras, 20–21

Artisinal fishing, 78. *See also* Museo a Cielo Abierto in San Miguel

Aymara, 84–85, 178

Bachelet, Michelle, 42, 55n76, 117, 142, 183

Bahamondes, Danilo (artist), 29, 33, 53, 55, 56. *See also* Brigada Chacón

Balcells, Fernando (artist), 20. *See also* CADA

Balmaceda, José Manuel, 18

Basti (artist), 73. *See also* Museo a Cielo Abierto in San Miguel

Bisy (artist), 124–30. *See also* Las Crazis Crew

Black (artist), 119–23

Black Lives Matter (activist movement), 197

Boa (artist), 96–100. *See also* Museo a Cielo Abierto in La Pincoya

Brigada Chacón (BC), 7, 51–62. *See also* Ricardo Rodriguez and Danilo Bahamondes

Brigada Ramona Parra (BRP), 1, 12, 14, 19, 33–51, 111, 195; *fondeadores,* 35–36; *rellenadores,* 35–36; *trazadores,* 35–36. *See also* Mario Carrasco, Mono González, Sebastián González, Verónica Loyola, Francisca Muñoz Tralma, Boris Rivera, and Juan Chichín Tralma

Brown, Richard Duarte (artist), 200, 201–2

Bustos, José, 92, 99. *See also* Museo a Cielo Abierto in La Pincoya

Cáceres, Carlos, 53

CADA (Colectivo de Acciones de Arte), 20, 116. *See also* Fernando Balcells, Juan Castillo, Diamela Eltit, and Raúl Zúrita

Cagde (artist), 96–100. *See also* Museo a Cielo Abierto in La Picoya

Calderone, Jackie, 200, 203–4. *See also* Transit Arts

Carnival of Oruro (Bolivia), 164–65

Carrasco, Eduardo "Mono" (artist), 32

Carrasco, Mario (artist), 36. *See also* Brigada Ramona Parra

Castillo, Juan (artist), 20. *See also* CADA

Causa (artist), 96–100. *See also* Museo a Cielo Abierto in La Pincoya

Chacón Corona, Juan, 52–53

Characters (graffiti), 138–139n23; b-boy, 165–66

Charango (musical instrument), 182

Chicha (alcoholic drink), 180

Chile's Future, 17–19

Cines (artist), 124–30. *See also* Las Crazis Crew

Cleary, Patricio (artist), 15

Coca, cultivation of, 183–84

Colectivo Amancay (artists), 96–100. *See also* Museo a Cielo Abierto in La Pincoya

Colectivo Brigada Ramona Parra (CBRP), 39–46. *See also* Juan Chichín Tralma

Con las Manos (artists), 94–96. *See also* Museo a Cielo Abierto in La Pincoya

Consejo Nacional de la Cultura y las Artes, 21

Copper mining, Chile, 44–45, 80, 180

Coqueo, 184

Crazis Crew, Las (artists), 124–30, 147–48; Bisy, 124–30; Cines, 124–30; collaboration with Nocturnas (Tikka and Pan), 126, 128, 130; Dana, 124–30; Naska, 124–30; Shape, 124–30; strategic femininity, 126; Tucapel Jiménez graffiti mural, 126–30

Cuatlacuatl, Federico (artist), 200, 202

Dana (artist), 124–30, 138, 147–48, 149–54; *Untitled* (graffiti in Santiago), 149–51; *Untitled* (graffiti in Valparaiso), 151–54. *See also* Las Crazis Crew

Death to the Invader, 13–14, 15

Decolonial love, concept of, 133–34, 135–37

Defos (artist), 96–100. *See also* Museo a Cielo Abierto in La Picoya

Degra (artist), 96–100. *See also* Museo a Cielo Abierto in La Picoya

De-linking (Walter Mignolo), concept of, 188–89

Democracy, theories of, 4–6, 9, 173

Devuélvenos la Imaginación, 154–57

Díaz Parra, Alberto (artist), 2–3

DiFranco, Maria (artist/student), 200, 201, 202

Dittborn, Eugenio (artist), 20

Don Quijote de la Mancha (Miguel de Cervantes), 185–87

Don Quijote de la MaRcha, 185–89

Donoso, Luz (artist), 16–19

DP (artist), 96–100. *See also* Museo a Cielo Abierto in La Pincoya

Ekeka (Bolivian feminist figure), 180–82. *See also* Mujeres Creando

Ekeko (Aymara deity), 178–79

Elliott, Lynata (artist/staff), 206–13

Eltit, Diamela (artist), 20. *See also* CADA

En Memoria a Carlos Fariña, 94–96. *See also* Museo a Cielo Abierto en La Pincoya

Escámez, Julio (artist), 20

Escuela México (Chillán, Chile), 13

Espíritu de Mujer, 157–61

Estación Mapocho (Santiago), 107

Ethics of care, 133, 135–37

Fabi (artist), 96–100. *See also* Museo a Cielo Abierto in La Pincoya

Fariña Oyarce, Carlos Patricio, 94–95. *See also* Museo a Cielo Abierto in La Pincoya

Faundéz, José, 70. *See also* Museo a Cielo Abierto in San Miguel

Faya (artist), 101

Fernández, Alfredo Guillermo (Freddy Filete), 92–94. *See also* Museo a Cielo Abierto in La Pincoya

Feminism, gender and Chilean graffiti, 140–44

Feminist Print Workshop (The Ohio State University), 194–99. *See also* Mono González

Festival of La Tirana (Chile), 164–65

Fisek (artist), 107, 108, 109, 118–23

Fisura (artist), 101

FONDART (Fondo Nacional para el Desarrollo Cultural y las Artes), 21, 22, 22n43, 70, 72. *See also* Museo a Cielo Abierto in San Miguel

Fondeadores, 35–36, 201. *See also* Brigada Ramona Parra

Formación (digital sketch), 208, 209

Formacion (mural), 209–13

Frei Montalva, Eduardo, 15

Gabriela Mistral Cultural Center, history, 40–42

Galindo, María, 181. *See also* Mujeres Creando

Gesak (artist), 73. *See also* Museo a Cielo Abierto in San Miguel

Gigi (Marjorie Peñailillo, artist), 138, 146, 163–69, 214; *Luisa del Bosque*, 167–68; *Luisa Playera*, 167–68; *Luisa Rayando a Zade*, 165–67; Untitled (Gigi graffiti), 163–65; visit to Columbus, Ohio, 205–13. *See also* Turronas Crew

Golpe estético (aesthetic coup d'état), concept of, 30

González, Mono (artist), 29, 30, 32, 33, 34–35, 36, 37, 39–40, 55, 56, 192, 214; participation in the Museo Abierto in San Miguel, 71, 86–89; perspectives on anti-graffiti laws, 103; perspectives on graffiti, 108–9; visit to Columbus, Ohio, 193–204. *See also* Brigada Ramona Parra, Museo a Cielo Abierto in San Miguel and Feminist Print Workshop

González, Santiago (artist), 185

González, Sebastián, 36. *See also* Brigada Ramona Parra

Graffiti, Chilean history and culture of, 106–12; relationship to commercialization, 109–10; relationship to muralism, 108–9; seeking permission, 110–11, 111n24, 151; social class, 111–12

Graffiti crews, 144–48

Graffiti School *Comunidad* (arts program), 205–6, 209. *See also* Gigi

Guanaco (water cannon truck), 113, 113n28

Guernica (Picasso), 192

Guerrero, Xavier (artist), 13

Hale Black Cultural Center (The Ohio State University), 195

Hanging out, concept of (María Lugones), 133

Hanson, Andrea (artist/student), 195

Harris, Katerina (artist), 200, 201, 202, 203

Hecho en Casa (Made at Home), street art festival, 176

Heidemiller, Jenn (artist/student), 198–99

Hernández, Roberto, 69–72, 76, 89–90. *See also* Museo a Cielo Abierto in San Miguel

Holzer, Jenny (artist), 197

Homenaje a trabajadores que luchan, 76–80. *See also* Museo a Cielo Abierto in San Miguel

Horse, 190–92. *See also* Museo a Cielo Abierto in San Miguel

Hozeh (artist), 73, 102, 110, 111, 112–13. *See also* 12 Brillos Crew and Museo a Cielo Abierto in San Miguel

Indignados, los (activist group), 187–88

Injusticia (artist), 96–100. *See also* Museo a Cielo Abierto in La Pincoya

Integración, 86–89. *See also* Museo a Cielo Abierto in San Miguel

Inti (artist), 24, 175–89

Jae (artist), 96–100. *See also* Museo a Cielo Abierto in La Pincoya

Jano (artist), 96–100. *See also* Museo a Cielo Abierto in La Pincoya

Japanese manga and animé (influence on Chilea street art), 151

Johnson, Carmen (artist), 16–19

Jony (artist), 110

Juventudes Comunistas (JJCC), 39

Lemebel, Pedro (artist/writer), 70

Ley de Pesca (Fishing Law), 42, 59

Lieberman, Jessica (artist/student), 199

Lord K2 (David Sharabani, artist), 101

Lorenzini, Kena, 30

Loyola, Verónica (artist), 36. *See also* Brigada Ramona Parra

Luisa del Bosque, 167–68

Luisa Playera, 167–68

Luisa Rayando a Zade, 165–67

Machis, 80–83. *See also* Museoa Cielo Abierto San Miguel and Mapuche, history, traditions and activism

Machuca (film), 1–2

Man on Fire, 114–16

Mapocho River, 17–18, 22

Mapuche, history, traditions and activism, 43, 49–51, 83n45, 114. *See also* Machis

Marcos, Fernando (artist), 20

Matta, Roberto (artist), 20

Meli Wuayra, 80–86. *See also* Museo a Cielo Abierto in San Miguel

Meschie, Hernán (artis), 17–19

Military Coup, Chile, 19–20, 99

Millar, Pedro (artist), 16–19

Monsanto controversy (Chile), 117

Morales, Evo, 184

Mothering politics, concept of, 183

Muchachitas Pintoras (arts collective), 160n69. *See also* Anis, Wend, and Abusa Crew

Mujeres Creando (Bolivian Feminist Group), 181–82

Muñoz Tralma, Francisca (artist), 36. *See also* Brigada Ramona Parra

Museo a Cielo Abierto in La Pincoya, 90–100: Alfredo Guillermo Fernández (Freddy Filete) 92–94; Amaranta, 96–100; Año, El, 92–94; Boa, 96–100; Cagde, 96–100; Carlos Patricio Fariña Oyarce, 94–95; Causa, 96–100; Colectivo Amancay, 96–100; Con Nuestras Manos, 94–96; Defos, 96–100; Degra, 96–100; DP, 96–100; *En Memoria a Carlos Fariña*, 94–96; Fabi, 96–100; Injusticia, 96–100; Jae, 96–100; Jano, 96–100; José Bustos, 92, 96, 99; *La Pincoya* (mural) 92–94; Naturaleza, 96–100; Nestha, 96–100; Pati, 92–94; Pecko, 96–100; Plek, 92–94, 96–100; Población La Pincoya history and politics, 90–92; PP, 96–100; Richy, 96–100; Rouse, 96–100; Sam, 96–100; School of the Americas (Western Hemisphere Institute for Security Cooperation), 96; School of the Americas Watch (SOAW), 96–97; Seba, 92–94, 96–100; Sofrenia, 96–100; Tikai, 92–94; US intervention in Guatemala, 98–99;Vidaingravita, 96–100; *Yankee Interventionism in Latin America*, 96–100; Yono, 96–100

Museo a Cielo Abierto in San Miguel, 69–90; 12 Brillos Crew, 76–80; Aislap, 80–86; artisanal fishing, 78; Basti, 73; Camila Vargas, 71; David Villaroel, 69, 71; FONDART funding, 70, 72; Gesak, 73; *Homenaje a los trabajadores que luchan*, 76–80; *Horse*, 190–92; Hozeh, 73; *Integración*, 86–89; Jorge Peña y Lillo, 73; José Faundéz, 70; Julien "Seth" Malland, 86–89; *Los Prisioneros* (mural), 73–76; Los Prisioneros (rock group), 73; machis, 80–82; *Meli Wuayra*, 80–86; Mono Gonzalez participation, 71, 86–89; neighborhood improvements, 89–90; Pato Albornoz, 73; Población San Miguel history, 69–70; Pobre Pablo, 73; political polarization, 72–74, 72–73n31; Roa, 190–92; Roberto Hernández, 69–72, 76, 89–90

Museo de Arte de Luz, 22–23

Museo de la Solidaridad, 41–42

Museos a Cielo Abierto (Open-Sky Museums), concept of, 65–67; connection to mural environments, 65; Mario Pedrosa, 66; relationship to spatial segregation, 66, 66n10

Naska (artist), 103, 124, 139, 149. *See also* Las Crazis Crew

Naturaleza (artist), 96–100. *See also* Museo a Cielo Abierto in La Pincoya

Neruda, Pablo, 18

Nestha (artist), 96–100. *See also* Museo a Cielo Abierto in La Pincoya

Niña, 154, 155

#NiUnaMenos (feminist hashtag), 161

Nocturnas (artists Tikka and Pan), 126, 128, 130. *See also* Las Crazis Crew

Nueva Mayoría (New Majority), 55, 55n76, 137

Olfer (artist), 110

Osorio, Jorge (artist), 15

Orozco, José Clemente (artist), 114–16

Paredes, Julieta, 181. *See also* Mujeres Creando

Parque Fluvial Padre Renato Poblete (Santiago), 119–20

Parra, Catalina (artist), 20

Parra, Ramona, 35

Pati (artist), 92–94. *See also* Museo a Cielo Abierto in La Pincoya

Pecko (artist), 96–100. *See also* Museo a Cielo Abierto in La Pincoya

Pedrosa, Mario, 66

Peña y Lillo, Jorge (artist), 73. *See also* Museo a Cielo Abierto in San Miguel

Peñailillo, Marjorie (artist). *See* Gigi

Pincoya, La (mural), 92–94

Piñera, Sebastián, 23n49, 36, 58, 61–62, 117, 137

Pinochet, Augusto, 6, 7, 19, 20, 21, 25, 29, 38, 39, 43, 44, 55, 68, 137

Plek (artist), 92–94, 96–100. *See also* Museo a Cielo Abierto in La Pincoya

Población (Chilean working-class neighborhood), 1, 67–69; history, 67; sites of political activism, 67; social attitudes, 67–68; neoliberalism, effects on, 68–69

Población Chacabuco (Santiago), 46–48

Población José María Cano, graffiti mural by 12 Brillos Crew, 112–17

Población La Pincoya (Santiago), 69–70. *See also* Museo a Cielo Abierto in La Pincoya

Población San Miguel (Santiago), 69–70. *See also* Museo a Cielo Abierto in San Miguel

Pobre Pablo (artist), 73. *See also* Museo a Cielo Abierto in San Miguel

Post-dictatorship, concept and time period, 6–7, 29

PP (artist), 96–100. *See also* Museo a Cielo Abierto in La Pincoya

Prisioneros, Los (mural), 73–76. *See also* Museo a Cielo Abierto in San Miguel

Prisioneros, Los (rock group), 73–75. *See also* Museo a Cielo Abierto in San Miguel

Pugsley, Tess (artist/staff), 206–13

Puta 2, 161–63

Quintanar de la Orden (Spain), 185, 188

Ramón Barros Luco Hospital, mural, 16–17

Recabarren, Luis Emilio, 18

Rellenadores, 35–36, 201. *See also* Brigada Ramona Parra

Reyes, Osvaldo (artist), 20

Richy (artist), 96–100. *See also* Museo a Cielo Abierto in La Pincoya

Rivera, Boris (artist), 29, 38, 39. *See also* Brigada Ramona Parra

Roa (artist), 190–92. *See also* Museo a Cielo Abierto in San Miguel

Rodríguez Erdoíza, Manuel (Hussars of Death), 188

Rodriguez, Ricardo (artist), 52–59, 61–63. *See also* Brigada Chacón

Rojas, Antonio (rojas), 52. *See also* Brigada Chacón

Rojas, Catalina (artist), 22–23. *See also* Museo de Arte de Luz

Rosenfeld, Lotty (artist), 20

Rouse (artist), 96–100. *See also* Museo a Cielo Abierto in La Pincoya

Sam (artist), 96–100. *See also* Museo a Cielo Abierto in La Pincoya

School of the Americas (Western Hemisphere Institute for Security Cooperation), 96. *See also* Museo a Cielo Abierto in La Pincoya

School of the Americas Watch (SOAW), 96–97. *See also* Museo a Cielo Abierto in La Pincoya

School of Fine Arts, University of Chile, 13, 13n21, 16

Seba (artist), 92–94, 96–100. *See also* Museo a Cielo Abierto in La Pincoya

Selk'nam, 84–85, 84n48

Shape (artist), 124–30. *See also* Las Crazis Crew

Siqueiros, David Alfaro (artist), 12–14, 15

Soave, Sergio (artist), 195

Sofrenia (artist), 96–100. *See also* Museo a Cielo Abierto in La Pincoya

Stgo Undercrew (graffiti crew), 119

Stotlar, Jackie (artist/staff), 206–13

Strange, Alejandro (artist), 15

Strategic femininity (Chilean graffiti), 126, 144, 165

Street writing, term, 119

Student protests, Chile, 44, 157

Subjectivity, concept of, 146–47

Teitelboim, Volodia, 53, 56

Throwup (graffiti), term, 119n38

Tikai (artist), 92–94. *See also* Museo a Cielo Abiert in La Pincoya

Tralma, Juan Chinchín (artist), 31, 34, 36–37, 38, 39. *See also* Brigada Ramona Parra and Colectivo Brigada Ramona Parra

Transit Arts (Columbus, Ohio), 200–204

Transit Arts Mural, 200–204

Trazadores, 35–36. *See also* Brigada Ramona Parra

Tucapel Jiménez street (Santiago), graffiti mural, 126–30. *See also* Las Crazis Crew

Turronas Crew, 146, 163

Untitled (Dana graffiti in Santiago), 149–51

Untitled (Dana graffiti in Valparaiso), 151–54

Untiled ("Ekeka" Inti graffiti mural), 177, 180–84

Untitled ("Ekeko" Inti graffiti mural), 176–80, 183–84

Untitled (Gigi graffiti), 163–65

Valparaiso (Chile), 152–53

Vargas, Camila, 71. *See also* Museo a Cielo Abierto in San Miguel

Vidaingravita (artist), 96–100. *See also* Museo a Cielo Abierto in La Pincoya

Villarroel, David, 69, 71. *See also* Museo a Cielo Abierto in San Miguel

Visual democracy, concept of, 4, 5–6, 27, 29, 32, 36, 40, 45, 54, 63, 100, 102, 112, 131, 170, 172, 189, 214

Walls of Empowerment (Latorre), 3

Wend (artist), 133, 140, 144, 147, 157–61; *Espíritu de Mujer,* 157–61; Muchachitas Pintoras (arts collective), 160n69. *See also* Abusa Crew

Wildstyle (graffiti), 138n22

World-travelling (María Lugones), concept of, 136–37

Yankee Interventionism in Latin America, 96–100. *See also* Museo a Cielo Abierto in La Pincoya

Yisa (artist), 109

Yono (artist), 96–100. *See also* Museo a Cielo Abierto in La Pincoya

Zúrita, Raúl (artist), 20, 116

GLOBAL LATIN/O AMERICAS

FREDERICK LUIS ALDAMA AND LOURDES TORRES, SERIES EDITORS

This series focuses on the Latino experience in its totality as set within a global dimension. The series will showcase the variety and vitality of the presence and significant influence of Latinos in the shaping of the culture, history, politics and policies, and language of the Americas—and beyond. We welcome scholarship regarding the arts, literature, philosophy, popular culture, history, politics, law, history, and language studies, among others. Books in the series will draw from scholars from around the world.

Democracy on the Wall: Street Art of the Post-Dictatorship Era in Chile
GUISELA LATORRE

Gothic Geoculture: Nineteenth-Century Representations of Cuba in the Transamerican Imaginary
IVONNE M. GARCÍA

Affective Intellectuals and the Space of Catastrophe in the Americas
JUDITH SIERRA-RIVERA

Spanish Perspectives on Chicano Literature: Literary and Cultural Essays
EDITED BY JESÚS ROSALES AND VANESSA FONSECA

Sponsored Migration: The State and Puerto Rican Postwar Migration to the United States
EDGARDO MELÉNDEZ

La Verdad: An International Dialogue on Hip Hop Latinidades
EDITED BY MELISSA CASTILLO-GARSOW AND JASON NICHOLS